2109 $9.80

ENTITLED

Entitled

Discriminating Tastes and the Expansion of the Arts

Jennifer C. Lena

PRINCETON UNIVERSITY PRESS

PRINCETON AND OXFORD

Requests for permission to reproduce material from this work
should be sent to permissions@press.princeton.edu

Published by Princeton University Press
41 William Street, Princeton, New Jersey 08540
6 Oxford Street, Woodstock, Oxfordshire OX20 1TR

press.princeton.edu

The epigraph to chapter 6 is from *Hip: The History* by John Leland. Copyright © 2004 by
John Leland. Reprinted by permission of HarperCollins Publishers and John Leland.

ISBN 978-0-691-15891-4
ISBN (e-book) 978-0-691-18984-0

British Library Cataloging-in-Publication Data is available

Editorial: Meagan Levinson and Jacqueline Delaney
Production Editorial: Kathleen Cioffi
Jacket Design: Amanda Weiss
Production: Erin Suydam
Publicity: Tayler Lord and Kathryn Stevens

Jacket images: (top to bottom) 1) Shutterstock; 2) Collection of the Smithsonian National Museum
of African American History and Culture, Gift of Bootsy Collins; 3) Shutterstock; 4) Shutterstock

This book has been composed in Adobe Text Pro and Gotham

Printed on acid-free paper. ∞

Printed in the United States of America

10 9 8 7 6 5 4 3 2 1

CONTENTS

PREFACE

Halfway through the Academy Award–winning screenplay of the 1941 film *Citizen Kane*, we witness an exchange between the titular character and his surrogate father, Walter Parks Thatcher. Thatcher is breaking the news to Kane that his wife Emily is leaving him: "She hasn't any friends left since you started this oil business, and she never sees you," Thatcher begins. But then Thatcher argues that it was actually Kane who abandoned Emily, niece of the president of the United States, and for a wholly different reason: "You only associate with your inferiors," Thatcher tells Kane. "I guess that's why you ran away from Emily. Because you can't stand the company of your equals." Thatcher continues,

> You talk about the people of the United States as though they belonged to you. When you find out they don't think they are, you'll lose interest. You talk about giving them their rights as though you could make a present of liberty. Remember the working man? You used to defend him quite a good deal. Well, he's turning into something called organized labor and you don't like that at all. And listen, when your precious underprivileged really get together that's going to add up to something bigger than . . . than your privilege and then I don't know what you'll do.

Kane spits back, "Are you finished?" Leland assents and asks to be excused to travel to Chicago; Kane offers a small smile and responds, "You're not going to like it in Chicago. The wind comes howling in from the lake. And there's practically no opera season at all and the Lord only knows whether they've ever heard of Lobster Newburg."[1]

Thatcher accuses Kane of treasonous abandonment of both the class to which he has risen ("your equals") and the class he once purported to defend ("the working man"). Kane responds by skewering Thatcher's elitism: he won't enjoy Chicago's lack of sophistication—they may not have even *heard* of Lobster Newburg, and "there's practically no opera season at all."[2]

This two-minute exchange, in what many have called the greatest film ever made, pillories the myth of a classless American society. Kane's wry observation of Thatcher's highbrow cultural tastes (for Lobster Newburg and opera) illuminates the class tensions that fuel many American jokes. The joke's humor is supercharged by the effects of the Great Depression. And the exchange reveals Kane's particularly American personality: supremely and ambitiously self-interested, and contemptuous of elitism. Accompanying his contempt, as viewers of the film know, is Kane's quest to live an elite lifestyle.

At the heart of this book is a question about American elites: How did they become sophisticated cosmopolitans while maintaining the myth of equal access to opportunity? Directing his critique toward elites of his time, great American writer Frederick Douglass wrote: "We affect contempt for the castes and aristocracies of the old world and laugh at their assumptions, but at home foster pretentions far less rational and much more ridiculous."[3]

American highbrow snobs, like Thatcher, issue from a nineteenth-century world, dominated by the aspirations of a still-new American republic. Used as both a noun and an adjective, the term "highbrow" was inherited from phrenologists and originally described people who enjoyed unusually large foreheads. By the end of the nineteenth century, the term came into use as a way to refer to someone who was an intellectual or an elite ("No marvel of much wisdom Eustace was,—You know him, Hal,—no highbrowed intellect" [1876])[4], and to the culture associated with elite tastes ("Mr. Hope had suggested that we would be at some highbrow part of the Exhibition—looking at pictures I think" [1884]),[5] and, finally, to culturally superior people ("You were very much amused, I suppose—to see me sitting bras-dessus-bras-dessous with the highbrowed and precious" [1908]).[6] It is perhaps the last definition that leads the Oxford English Dictionary to note that the term is, in its colloquial use, "occasionally depreciative."

This isn't just an exercise in etymology. The association of elite people with sophisticated tastes is borne out by research. Members of the upper classes—people with high income, wealth, educational attainment, social status, and political and social power—have "highbrow" tastes for opera, ballet, classical music, and other culture that helps to maintain a distinction between themselves and others.[7]

These highbrows still exist, but they are increasingly rare. Only 2 percent of Americans attended a live opera in 2014, 2.8 percent attended a ballet, and 8.8 percent went to a classical music concert. In 2015, the National

Endowment for the Arts (NEA) reported that adult attendance rates have declined since 2002 for all of the highbrow arts activities they tracked.[8] Classical music sales are down, classical radio stations are nearly extinct, and the audience is graying so quickly at least one journalist fast-tracked them into the grave, announcing that "classical music is dead."[9] But, as we are well aware, elites still exist.

In fact, statisticians have been noticing a drift of elite tastes away from highbrow culture for some time. A growing majority enjoys a range of popular entertainment, including rock and roll music, craft fairs, and blockbuster films. This discovery, initially built from the analysis of musical tastes, suggested that "highbrow snobbery" has been replaced by what the authors of the NEA report called "highbrow omnivorousness."[10] While some scholars have argued these changes indicate a devaluation of art—a decline in the power of the arts to indicate membership among elites—more experts believe we are instead seeing a shift in which particular tastes accomplish those ends.[11] In fact, they argue, the definition of art has expanded to incorporate other forms of culture.

This book is an investigation of that shift, using the tools of comparative-historical research, cultural studies, and statistics. Mine is a novel approach, for its combination of methods and its intention to build a general theory of artistic legitimation—or the transformation of folk, vernacular, and popular culture into art—and to link that theory with the comparative study of multiple fields as they undergo that process. What I will demonstrate is a massive expansion in the kinds of cultural objects and performances that are defined as artistic over the course of the twentieth century. This expansion both reflects and encourages the consumption of this culture by art lovers.

Outline of the Book

Unlike the cloistered elites of the nineteenth century, today's elect are likely to interact with people from other social classes in the workplace and in grocery store queues.[12] Like the rest of us, they use mass culture, including television and popular films, to build relationships with strangers and acquaintances.[13] Generational politics have contributed to a trend away from snobbishness.[14] So, there are both practical and political reasons for this drift toward interclass interaction. But, elites are still *elite*—they still have and display sophisticated tastes.[15] The trick that contemporary elites need to pull off is to display sophisticated tastes without being perceived as snobs.

Part of the puzzle this book will seek to solve is how our culture came to be "more open but still unequal."[16]

In chapter 1, I analyze the institutional and organizational factors that led to the invention of "the arts" in America. You might think of this as the climate or context for the analysis that will follow. Wealthy reputational entrepreneurs seeking to establish domestic arts organizations contributed to the birth of highbrow arts as both idea and organizational practice.[17] This first wave established the pathway by which creative forms came to be seen as art. As new orchestras, art museums, and symphonies were formed, advocates for ballet, modern dance, theater, and opera employed the same process to generate legitimacy. This second wave of legitimation was initiated by new groups of reputational entrepreneurs, including wealthy women, Jews, immigrants, and intellectuals. They advocated for the creation of novel American artworks to reflect the diverse character of the nation. In this chapter, I join together existing sociological research on these two waves of change with research on the teaching professions that trained protoartists, the nonprofit professionals who administered arts programs, and the funders who supported their development.

The infusion of state subsidies during the New Deal accelerated the pace of artistic legitimation and widened its path, which is the focus of chapter 2. Federal and state governments paid for the production and display of an enormous amount and variety of culture. This diversified the content and personnel in American creative fields and accelerated the transformation of many forms of vernacular culture into art. It was this world, rich with variety, in which an artistically voracious group of Americans was born and enculturated.[18]

In chapter 3, I analyze a case study that is positioned at a hinge moment in this process: the creation of the Museum of Primitive Art (MPA). The history of the Rockefeller primitive art collection provides an ideal case study of the process of artistic legitimation. Through a detailed analysis of the complete organizational archive—including memos, publications, journals, and administrative paperwork—we can observe this process in detail. The small group of MPA administrators fought to promote artistic interpretations of the objects in the collection against the established view that they were anthropological curiosities. Rockefeller's triumph was the eventual inclusion of his collection in the Metropolitan Museum of Art (Met), as the Michael C. Rockefeller Wing.

Later in the twentieth century, multiple forms of vernacular, popular, and folk culture came to be seen as art. In chapter 4, I seek an explanation

for why this massive explosion in the number and variety of arts took place. I identify some of the broader causes of this transformation, including changes in the economy and political attitudes, and as a result of technological innovation. The chapter focuses on changes within art organizations and the field of arts management, both as a result of the professionalization of art experts and managers and shifts in the sources and methods of financial support for these organizations. In chapter 5, I trace this process as it impacted the arts after 1950. Based on an analysis of primary and secondary texts documenting the history of ten creative fields—two forms of music (rock and roll and jazz); visual arts, including graffiti, photography, primitive, and outsider art; two forms of literature (African American novels and graphic novels, or comics); tap dance; and film—I identify the resources that helped advocates convince skeptics that these fields were, in fact, forms of art. My analysis focuses on the role of organizational change, the rise of spaces for production and consumption (including, importantly, universities), changes to law and funding, and changes to institutions. I explore shifts in critical discourse and examine how artistic identities shift and are shaped to conform to expectations of authenticity. As each field nears the end of the legitimation process, I observe the emergence of segmentation within the field, as well as specialization within those derivative forms.

The expansion of the artistic canon to include the cultural work of so many nonelite, nonwhite, non-"Western" artists suited the cosmopolitan values of twentieth-century American elites. But their work as reputational entrepreneurs, who promoted these forms of culture as art, revealed some of the internal contradictions of cosmopolitanism as a status-seeking mechanism. Modern elites tried to show they were not elitist by celebrating diverse arts; however, demonstrating that diversity meant they separated or labeled these diverse arts as different from existing art. In chapter 6, I explore the dynamic debates around cultural appreciation and cultural appropriation that animate the process of artistic legitimation. The propensity for cross-cultural engagement, which typifies many efforts at artistic inclusion, can both reproduce and disrupt stereotypes—that is, sometimes when you celebrate "difference" or novelty, you just end up reinforcing the fact that something is atypical. The admission of diverse work within the fine arts marks both a tribute to, and a dismantling of, their context of production. I seek to understand how the engagement of other people through cultural consumption is viewed as political and ethical action.

The conclusion in chapter 7 reviews the book's major arguments, and then briefly addresses some questions that remain. I evaluate the possibility

of detecting patterns, or trajectories, in how vernacular culture fields become art. I explore the potential reasons for these patterns, including the possibility of an aesthetic movement that spans many fields—an American "vernacular modernism." I ask if it is possible to fight the legitimation process, and on what basis objections are raised. I consider two cases in which claims to legitimacy have been contested: the kitsch paintings of Thomas Kinkade and the designer toys movement. I then close with some thoughts on the consequences of this argument for public policy.

ACKNOWLEDGMENTS

I am drafting these acknowledgments during a break from a course on arts management that I am teaching at Bethlehem University in Palestine. Twenty years into my career as a teacher, I happily remain a student as well. In that spirit, I must first thank, with a full heart, the students who worked as research assistants on this project: Sammy Shaw, Katherine Everhart, Tatiana Stola, Michele Kumi Baer, Megan Friel, Robert Hanson, and Pilar Vicuna Dominguez.

Thank you to the participants in the following classes, workshops, and professional conferences who commented on this work at various stages: Teachers College, Art and Pop (2016, 2017); Columbia Journalism School, MA Arts and Culture Fall Seminar (2017, 2018); the Notre Dame Culture Workshop, the Seminar in Classification at Rutgers University's Center for Cultural Analysis, the Northwestern Culture Workshop, Social Science History Association, and the American Sociological Association (2014, 2015).

I have a truly remarkable group of friends and colleagues—too many to mention—but I extend my thanks to those who provided specific support on this manuscript: Peter Bearman, Ansley Erickson, Sasha Frere-Jones, Dani Friedrich, Andrew Goldstone, Joe Gross, Rose Hackman, Peter Levin, Adam Reich, Sarah Sobieraj (and her students), Stanley Thangaraj, Fred Wherry, and Chuck Woolridge. I must single out Omar Lizardo, my collaborator on the data manipulation and analysis of childhood arts exposure, who contributed advice and feedback on the remainder of the argument.

My thanks to the many anonymous reviewers and the emergency panel of experts I called upon at a moment when I was most desperate for trusted, critical advice: Shamus Khan, Gemma Mangione, Terry McDonnell, John Levi Martin, Jonathan Neufeld, and Iddo Tavory.

I also extend my gratitude to my editors. Eric Schwartz signed this book and the only bad thing I can say about him is that he once suggested I title

it *Yes! Generation*. I also thank Meagan Levinson, who took over responsibility for the book and shepherded it through multiple revisions. Amy Rosenberg provided editorial assistance and encouraged me to think better of my own skills.

Finally, thanks to my cheerleading squad, which includes Tammy Smith, The Boys, The Ladies Room, and my parents.

ENTITLED

1

The Invention of American Art, 1825–1945

The arts in America are, in many ways, the invention of a group of influential, rich Bostonians called the "Brahmins."[1] Before 1850, there were few distinctions between American forms of entertainment. Operettas, symphonic pieces, and comedic songs would be featured on the same concert bill; portraits and landscape paintings hung next to stuffed animals; and Shakespearean plays were followed by performances of contortionists.[2] Most culture organizations were commercial enterprises, owned by entrepreneurs like P. T. Barnum, who had a for-profit museum, and Theodore Thomas, the most renowned figure in orchestral music at the time.[3]

Between 1850 and 1900, bourgeois urban elites built organizations that could define, isolate, and "sacralize" some of this culture.[4] To view these fields as art, people needed to have "a vocabulary of concepts and adjectives, reasoning logics, and justifications to explain . . . aesthetic qualities."[5] "High" art was "grand," "good," and "best," like what could be found "in all the large European cities"—"true" and not "vulgar."[6] This "sacralization" of high art, with a "strong and clearly defined" boundary between it and entertainment, established the outlines of a legitimate, elite culture.[7]

Museums and Symphony Orchestras

The decisions made within the Boston Museum of Art and the Boston Symphony Orchestra would have a sizeable influence over what cultural objects

and performances other organizations would select to display, and, therefore, what Americans would define as "art." They would also influence the kinds of people who would have the authority to make these decisions. The Boston Brahmins were those kinds of people: a highly connected, self-conscious social group tied together by kinship, philanthropic endeavors, commerce, and club life. Threatened by waves of immigration and an emerging middle class, they were driven to create a boundary around refined tastes to symbolically mark their cultural and social superiority.[8]

As argued by sociologist Paul DiMaggio, Brahmins engaged in three key activities while inventing art in America. First, they adapted the existing organizational form of the nonprofit corporation—familiar to them from their educational and philanthropic experience—to a new purpose. Second, they engaged in the classification of works as art or entertainment. In making decisions about what works to exhibit or to present in performance, these elites introduced distinctions between what was museum-worthy and what was not, between what was symphony-worthy and what was merely entertaining. Finally, they taught audiences how to relate to art—how to behave in its presence, how to make meaning from viewing it. Their challenge was estimable:

> Boston's cultural capitalists would have to find a form able to achieve all these aims: a single organizational base for each art form; institutions that could claim to serve the community, even as they defined the community to include only the elite and upper-middle classes; and enough social distance between art and audience, between performer and public, to permit the mystification necessary to define a body of artistic work as sacred.[9]

In orchestral music, for instance, the sacralization process involved a shift from playing work by contemporary authors to playing compositions authored by a small number of "great" dead composers.[10] (Sacralization, in this sense, refers to the process by which people begin to talk about some works as if they were separate from everyday life—"sacred." It does not refer to the content of the works themselves, nor is it meant to indicate any "religious" content, although that may be present in some work.) Through the efforts of the Brahmins, "high culture" became a strongly classified, consensually defined body of art distinct from "popular" fare.[11]

It is important to note that the establishment of an artistic canon in Boston influenced, but did not determine, the activities of arts organizations elsewhere. For example, three decades after the Boston Museum of Art was

founded, the Art Institute of Chicago still included a curatorial department called the "Antiquarian Society," staffed by women who collected "lace, fans, textiles, antiques, and occasional sculpture." The acquisition of "non-artistic" objects and works by amateurs indicates the gradual and uneven application of artistic legitimation processes.[12] In New York, the existence of a relatively large and powerful middle class meant that elites were never able to exert exclusive control over arts organizations, and commercial orchestras survived their invention.[13] The New York elite was large and fractured, so contending nonprofits emerged, competing for audience members and donor dollars by developing particularized programming long after the Boston Symphony's repertoire had become limited and repetitive.[14] Despite dissimilar starting conditions in the two cities, according to DiMaggio, "the increasingly national institutional basis of high and popular cultures . . . eroded regional differences."[15]

Rationalizing Governance

While elites like the Brahmins formed and governed these organizations, the organizations received public charters and municipal aid and were institutionally committed to provide service to the "masses."[16] The evidence suggests that most founder-trustees were proud to be engaged in service work on behalf of their communities. They built cultural centers similar to those in Europe but founded them on American, democratic principles. Orchestras and museums were designed to educate, promote moral uplift and enlightenment, and produce and reinforce a shared public culture—something we might view as critical to a modern, heterogeneous republic.[17]

Arts organizations were chartered as public institutions and eventually granted nonprofit status as *educational* organizations. Wall labels, tours, program books, lectures, classes for amateurs, and other programming were designed for the purpose of training the public to understand great works of art. Free or subsidized admissions programs and school tours targeted young, poor, and new audiences. Institutionally, nonprofit organizations were bound to principles of service, even while their governors defined and required respect for highbrow culture, without input or appeal.[18] While the invention of "high art" in America depended on the work and tastes of elites, the story of the arts in America is incomplete if it is a tale of the noblesse oblige of the wealthy; rather, it is better characterized by the tension between elitism and populism.

This tension is nowhere clearer than in the strain over the increasingly rationalized governance structures of art museums. From 1870 to 1900, fewer than five museums per year were founded in the United States. Born into wealthy families, their directors were "art men" with connections to artists and collectors who bought or donated works, helped administer finances, and even engaged in artistic direction. In recruiting these art men, the criteria included a "pleasant demeanor," familial social ties to powerful people, and good taste.[19] In 1910, the president of the American Association of Museums asserted that "a curator is born and not made. I do not believe you can train a man to be a curator. He is the result of natural ability and circumstances. He must be a man . . . who must know something of everything and everything of something. Such a man is difficult to find."[20] There was little training available to educate curators, preservationists, or museum administrators in the task of managing these organizations. The abjuring of formal job criteria, and reliance on charismatic authority, affirms an institutional reliance on patrimonial staff arrangements and helps to explain why administrators in this era were praised by trustees but failed to engage the public. While they were legally serving the educational needs of the public, these administrators were organizationally subject only to the approval of the board members. This also helps us to understand why criteria governing standards of "artistic excellence" were not immediately and universally adopted.

Wealthy founder-trustees unquestionably felt a sense of ownership over these organizations, even while paid staff did much of the work. Reviewing this moment in American history, one commenter noted that board members could have viewed a museum as

> an extension of their livingroom, where they could enjoy parties and theatricals; an educational institution of a quasi-tutorial or finishing-school type; a gallery to professional artists; an 'attic' to store personal collections in security while vacationing; or memorials for the dead and, importantly, a locus for cementing contacts with similarly situated individuals.[21]

Wealthy founder-trustees benefited from their control over these organizations, enjoying them both as entertainment and as mechanisms to advance their social, economic, and political capital.

The first full-time director of the Metropolitan Museum of Art, and perhaps also its most colorful, was General Luigi Palma di Cesnola, an Italian military veteran who built powerful links to New York elites as a language

tutor. After surviving capture by the Confederate army and then a court-martial for misappropriating funds during the Civil War, Cesnola married a New York City debutante. He then took a series of positions in the consular services, and, while posted in Cyprus, he trained himself as an amateur archeologist. Cesnola came to the attention of the museum board when he began selling his archaeological finds (some of which proved to be fabricated from fragments of broken statues) upon his return to New York.[22] Once he was installed as the director of the Met, Cesnola had his glass-faced office built on the balcony of the museum building and surveilled his employees at his leisure, wearing metal-studded shoes so they would snap to attention when they heard him approach.[23] His autocratic governance, impresarial management style, and unethical management of the museum's finances were typical of directors from this era.

As arts organizations grew in number, size, and complexity, they could no longer be run by administrators whose qualifications rested primarily on their networks and taste. Curatorial or programming decisions were increasingly made with an eye toward encyclopedic, canonical, and democratic concerns, although trustee preferences could still govern individual decisions. A shift in the kinds of people who were allowed to make decisions about what counted as art was taking place. At this moment in American history, nonprofit trustees were joined by an emerging class of professional administrators.

Colleges and universities provided critical support to the professionalization of arts administration and curatorial work. While in 1876 just seven universities offered courses in art history or appreciation (a qualifying course of study for the curatorial arts), by 1930 almost every college and university offered them. These courses were consolidated into art history departments, and graduates of these programs eroded the dominance of "art men." Academic art historians who worked as consultants to museums or art dealers exerted additional influence on the institutionalization of administrative practices.[24]

The creation of trade organizations like the Association of American Museums marked another key moment in the artistic legitimation process. Along with the College Art Association and the American Federation of the Arts, the Association of American Museums worked to establish not just professional ethics, but also standards for the care and preservation of objects, the design of exhibitions, codes of conduct for employees and board members, and even guidelines for the teaching of art in universities.[25] National philanthropic foundations like the Carnegie Corporation and the

Rockefeller philanthropies lent economic and human resources to support the professionalization of the arts field.[26] Once European refugees fleeing fascism arrived in the US in great numbers, the market for curators exploded so quickly that professional associations stepped in to regulate hiring through employment services.[27] A similar process was playing out in music, including, importantly, a shift from instruction in music performance to instruction in music appreciation and theory (in addition to the other steps noted above).[28]

The rationalization of administration and the creation of arts administration as a profession is a critical step in the artistic legitimation process. After all, legitimacy is evaluated as a function of both "the right to make claims, and the bases on which those claims are made."[29] Academic training and credentials, and affiliation with a professional association, are commonly accepted bases for the right to make claims of legitimacy. As arts administrators acquired these credentials and affiliations, they acquired the right to make claims and influence what forms of culture were presented as art.

The creation of the nonprofit arts organization was of extraordinary importance to the history of culture in America. Brahmins established organizations (the Boston Museum of Art) and institutions (the idea of "art in America") that remain at the core of culture today. While we can certainly appreciate and value the staying power of these organizations and institutions, we must simultaneously understand that the relationship between art and popular culture is, and always has been, dynamic. This fungible boundary between art and entertainment is characteristic of the second wave of artistic legitimation, which touched modern dance and ballet, theater, and opera.

The Second Wave: Ballet, Modern Dance, Theater, and Opera

While classical music and the visual arts achieved their legitimacy as high culture by the start of the nineteenth century, the same was not the case for theater, opera, modern dance, or ballet. Each of these was a form of commercial culture, so they all had to free themselves from the "grip of the market place" to "make credible the professions of 'disinterestedness' on which claims to high cultural status ride."[30] In this section, I examine how the legitimation process—the process of defining, isolating, and sacralizing some domains as forms of high art—played out in each of these fields.

While, in each case, making "art" meant independence from the market-place, advocates in each domain experimented with different funding models, failing in many cases to stay open for business. As university and individual patronage (and then foundation support) accumulated, each domain established a dominant funding model, and the critical establishment agreed on a set of valued artistic conventions, while training proceeded in an orderly fashion to repopulate the field with generations of performers. Finally, members of each field advocated for features of the emerging "American canon" of works, and contestations over what should be included featured significantly in debates during the maturation of each artistic field.

THEATER

The extension of the high culture model to theater would have seemed entirely unlikely in 1900. Commercial theater was extremely popular, not at all in need of elite patronage, and it "did not lend itself to the transcendent, quasi-religious discourse employed to sacralize classical music or the visual arts."[31] Nevertheless, it adopted the high culture model far earlier than opera or ballet.

Between 1910 and 1940, advocates worked to create over one thousand noncommercial stages in what might now be referred to as "alternative spaces," a number that peaked in 1929.[32] These forms of community theater were distinguished from their commercial peers by several features: they relied on both ticket sales and donations to support their costs; they had few, if any, paid, professional staff members; and they were dedicated to an educational function—teaching citizens how to act and teaching audiences how to enjoy new forms of theatrical content.[33]

Advocates of the burgeoning noncommercial theater movement made clear that they were producing an alternative to commercial theater and projecting "an image of reform, struggling against a conservative corporate society," adopting what amounted to a "spirit of anti-commercialism."[34] For example, in 1910, the Drama Committee of Boston's Twentieth Century Club published a report in which it upbraided theater owners for failing to classify productions by quality and merit.[35] This criticism of the blurring of entertainment and art was joined with reprimands around appropriate, "respectful" audience behavior. If commercial culture was characterized by audience-driven programming and evaluated based on sales, these critics sought to define an artistic theater that was the opposite: driven by artistic values and assessment.

The impulse to legitimate theater was clearly present by this point, and the rejection of musical comedies from its stages indicates growing consensus around the boundaries of the canon and modes of audience appreciation. To wit, one theater director, writing in 1928, suggested that an audience for comical, light dramas didn't belong in a community theater playhouse; he pointed to the "fine distinction between amusement, which is a proper function of the commercial theater, and enjoyment, which is the object of the Play House," or nonprofit community theater.[36] He was not alone in suggesting that the educational function of community theater was served, in part, by *training* audiences to enjoy their productions: "Such an audience has to be built up slowly," he argued, "just as does the patronage of the art galleries, the libraries and the orchestras."[37]

The link with educational and reformist ends existed not only in community theater programming, nor in the notion that it was "one way of training intelligent audiences, though a slow one."[38] On community theater stages, untrained local actors intermingled with performers "trained at elite schools like Carnegie Institute of Technology," Harvard, and Yale, and writers, activists, and professors found their way to noncommercial theater.[39] Universities played host to conferences that served to unite and coordinate efforts in the "Little Theatre movement"; in 1925, a "Conference on the Drama in American Universities and Little Theatres" was hosted by the Carnegie Institute of Technology, the first university to offer a theater degree.[40] The legitimation of theater received critical forms of support from higher-education organizations.

Participants in the Little Theatre movement wrote and mounted plays that ranged from abstract and avant-garde to trenchant, realist social critique. While "abstract, rhythmic, stark productions garner[ed] more attention in print, the pull and fascination of realism and the recognizable made Little Theatre usable for 'bohemians' and reformers in the 1910s as well as for educators, civic boosters, and the spiritually hungry."[41] In fact, some argue that the "American belief that theatre is spiritually and emotionally fulfilling, socially elevating, of civic importance, a site for assaying social change, and an enriching locus of cultural capital" originated in these years.[42] Advocates for this domestic theater movement believed that it could "offer its participants and audiences a chance to explore social issues and to resist the numbing lure of predictably scripted spectacle shows. They believed that on a personal and also a collective level, Little Theatre could improve American society."[43]

Theater was supported by a wealthy patronage of women and Jews who subsidized art houses. Still, most theaters were forced to charge admission, and prices were set high enough that few working- or lower-middle-class people could afford to attend.[44] One financial model in common use involved audience groups collaborating to buy advance block tickets or subscriptions to secure the staging of a production.[45] A second model, which may have begun at the Toy Theatre of Boston, combined a shareholding model with something like a membership subscription, offering buyers both season seats and a share of the profits.[46] However, most theaters that made this move perished in the attempt, and, of those that remained committed to amateur production, the majority became private social clubs that staged a small number of crowd-pleasing, entertaining but escapist plays.[47]

Other theater organizations adapted organizational structures and institutional practices from proximal arts fields. Henry Jewett's Boston Repertory Company (est. 1916) was incorporated as a trust for "educational, literary and artistic purposes," run by a board with civic and educational leaders, and was exempt from local taxes.[48] The organizations that attracted subsidy and managed to survive and grow moved into larger houses, hoping to "finance growth and professionalize with subscription revenues."[49] The Cleveland Playhouse (CPH) was consciously modeled on a symphony orchestra and described by its director as "a resident producing theatre, professionally organized, and operated not for profit and trusteed by a representative group of people drawn from the cultural, social and business life of the city of Cleveland."[50]

Although most of these theaters ultimately failed to remain solvent, they provided a model for nonprofit theater organizations. They also "were part of a movement that made theater legitimate" even if it took another two decades before that perception was widespread among Americans.[51] According to many, "it was the Little Theatre movement that generated the college theater major, the inclusion of theatre in secondary school curriculums, and the prototypes for nonprofit producing."[52] By 1929, the nonprofit organizational form was common enough that a Carnegie Corporation survey of the field could conclude that "because [theaters] are incorporated on a nonprofit-making basis and devoted to an educational purpose, they have succeeded in escaping certain taxes, along with schools and art museums."[53]

In fact, some theaters had relationships with other nonprofits, suggesting any isomorphism was a result of some direct learning that took place, leading to one description of "the association of drama, the poor drab of the arts,

with her more pampered sisters."[54] Art museums were particularly common partners, as in the case of the Goodman Theatre (associated with the Chicago Art Institute) and the Little Theatre Society of Indiana (John Herron Art Institute).

Finally, the emergence of the motion picture industry played a critical role in the legitimation of theater. Working-class audiences were better able to afford an evening's entertainment at the movies, and observers noted lower-income audience members had left the theater for the movies as early as 1912.[55] By that time, a ticket to a film was one-fifth the cost of a theater seat. "Movie palaces" were being built and theaters refurbished to show films in towns and cities across the country. In the fifteen years leading up to 1925, the number of halls operating as theaters outside of New York dropped from 1,490 to 564.[56] With working-class audiences absent, theater was a de facto form of elite entertainment, encouraging a widespread perception of its status as an art form and of film as popular entertainment.

The legitimation process for theater involved defining, isolating, and sacralizing some culture as "art" and distinguishing it from commercial, popular fare. It was accomplished by reputational entrepreneurs—not the cloistered elites we found in Boston, nor a loose aggregation of wealthy men in New York, but a confederation of Jews, women, immigrants, and intellectuals that created new organizations, adapted older ones, and established ties with communities and universities. Over time, isomorphic pressures resulted in the resemblance of theater to other arts organizations and the adoption of the trustee-governed nonprofit form. Theater maintained throughout its central commitment to the creation of avant-garde, anticommercial, populist, and civic-minded, realist drama—a constellation of topical matter that would contribute to an interdisciplinary "American" artistic canon. It might come as no surprise, then, that the Cleveland Play House decided in 1917 to adopt the motto "Art in Democracy."[57]

MODERN DANCE AND BALLET

As in theater, advocates for American dance fought to distinguish their work from commercial forms of popular culture. While American ballet dancers made their careers in Europe and filled the lower ranks of the opera ballet corps, dance in the United States was a mélange of commercial and academic styles, including clogging, cake walks, Spanish dances, and "aesthetic gymnastics."[58] Reputational entrepreneurs who wanted to distance themselves from associations with sex work programmed stages with only "re-

fined vaudeville" acts, performed for women or college students. In fact, " 'ballet girl' had a pejorative connotation until the mid-twentieth century," so closely aligned were such "girls" with sex work.[59] Those seeking to legitimate ballet would dance in costumes that, ironically, gave them the appearance of figures in a classic painting or a sculpture, and dancers often performed to a classical or symphonic score, cloaking their performance with legitimacy.

Ballet wouldn't begin its ascent into the arts and nonprofit organizational contexts until the 1930s. As one scholar opines, "Of what are today the two major forms of artistic dance . . . [in the 1930s] ballet was merely 'a shadow of grand opera'. . . . The other, aesthetic or 'modern' dance, was inchoate, a hazy figure on the busy ground of the vaudeville stage. Practitioners of each were in moral and aesthetic disrepute."[60]

This haze began to dissipate as forms of freer movement coalesced into styles, first in the studio of impresario Isadora Duncan, and, later, in the studios of Martha Graham and Doris Humphrey.[61] Educated middle-class women and newly formed university programs provided much of the support for this new kind of dance.[62] The first program in dance education, fortuitously named "art-dance," was initiated at Teachers College by Gertrude Colby.[63] Across the street, Bird Larson instituted a dance program at Barnard College in 1914; drawing upon anatomy and physics, she called her training program "Natural Rhythmic Expression."[64] Several years later, in 1922, her Teachers College colleague would publish a book documenting her teaching methods, *Natural Rhythms and Dances*, which allowed for the dissemination of the "art-dance" curriculum.

While Teachers College and Barnard graduates may have seen the dancer as "a symbol of new-found personal, physical and sexual freedom, particularly for women . . . dance was still largely thought of as sinful and silly, precious and titillating, 'fancy,' 'risqué,' rarely serious. In 1920, American dance was nothing to 'really' think about."[65]

Academic programs continued to spread and find homes in a diversity of disciplines. Margaret H'Doubler staffed an undergraduate major in dancing at the University of Wisconsin by 1927 within its Department of Physical Education. At prestigious women's colleges, modern dance found a place in the curriculum as "aesthetic gymnastics."[66] H'Doubler's mentee Martha Hill, along with her colleagues at Bennington College, "reoriented the nature of college dance during the 1930's toward a vocational and professional model, reshaping dance as an arts-based discipline," pushing back against a curriculum grounded in physical education.[67]

Despite their divergent perspectives, H'Doubler and Hill would work together within the American Physical Education Association (APEA) to design national standards for dance education. They were successful in petitioning the organization to create a national section on dancing. They relied especially on the support of Mabel Lee, the first female president of APEA, who took office the year their section was approved.[68] The first stages of modern dance's artistic legitimation depended on the labor of educated female advocates.

Support for modern dance forms remained in university incubators and elite enclaves for much of the remaining century. While some dance programs established themselves as artistic disciplines, most remained affiliated with physical education programs until the 1972 Title IX and 1974 Equal Educational Opportunity Act. The passage of this legislation resulted in the merge of physical education departments with coeducational programs. In many cases, dance programs were moved into newly created "Colleges of Fine Arts." Once they were housed with programs in music, visual arts, and theater, dance curricula were reshaped to resemble instruction in these fields. Dance students were no longer only trained in dance history and performance, but also took courses in "critical thinking skills, deconstruction and reconstruction, critical analysis, comparative and evaluative analyses, etc. as well as in cultural, historical, social and artistic contexts of dance."[69] Thus, modern dance acquired the dimensions of an artistic discipline.

Modern dance was seen as having a "uniquely American movement vocabulary." In contrast, ballet was "dismissed by many as a decadent Old World import that could not truly speak to the experiences of the young nation." Ballet was also viewed as an expressive form that failed to "advance the left-wing political beliefs to which numerous choreographers and performers—many of whom were women and Jews (or both) from marginalized immigrant populations—were passionately committed."[70] For these reasons, many argued that modern dance should be supported over and above ballet to form a distinctly American performance art.

In its struggle for artistic legitimacy, ballet had to seem of a piece with sculpture, painting, and classical music, but also equal to American modern dance, "which by 1934 had established its primacy as a high art practice."[71] But it would be incomplete to cast the relationship between American modern dance and ballet in these years as that of competitors; they were united against their common enemy—commercial dance. For much of the twentieth century, ballet and modern dance "developed and defined themselves in a subtle if sometimes unacknowledged dialogue with one another as well

as through a shared antagonism toward existing popular and commercial dance cultures."[72]

American ballet had been performed for many years as an accompaniment to opera. Instruction was provided by American opera companies, or dancers learned and performed in Europe. In the United States, the first seed of independence was arguably planted by Lincoln Kirstein, who co-founded the School of American Ballet in 1934 with George Balanchine as artistic director and himself as director of theatrical sciences (and, from 1940, as school director). In 1935, the company, American Ballet, became the resident troupe at the Metropolitan Opera, an association that not only provided steady employment for dancers and legitimacy for dance but also encouraged the perception that it was a secondary or an ancillary form of entertainment. A brief examination of the troupe will reveal the obstacles and opportunities that ballet faced in establishing its legitimacy as an American art form.

A broadly engaged intellectual, Kirstein had been involved in editing a literary quarterly and in the founding of the Museum of Modern Art (MoMA). In 1936 Kirstein formed a traveling ballet company called Ballet Caravan, hastily organized "as a practical response to an array of institutional crises facing the American Ballet," including Balanchine's poor health.[73] A group of students at the School of American Ballet assembled; Kirstein designed it, in his words, to be "self-sufficient, using a dozen of our best dancers, who would also serve as stage managers and stagehands. We could travel by bus and truck with our own lighting equipment, portable switchboard, drapes, and bits of scenery."[74] During the seven weeks of that summer tour, we witness in miniature the process by which ballet cashed in on, and then severed its association with, opera, capitalizing upon its association with artistic forms of modern American dance to accelerate the legitimation process.

Caravan's summer 1936 tour began with a performance at the Bennington Festival, an annual event hosted by Bennington College in Vermont. The festival typically hosted only modern dance performances, so Kirstein's request of founder and organizer Martha Hill for a slot must have come as some surprise; Kirstein was, after all, a somewhat outspoken critic of "what he regarded as modern dance's less structured and more idiosyncratic movement vocabularies."[75] While Hill was friendly to the idea, records indicate that other festival organizers objected. Hill's solution was to schedule the Caravan's performances separately from the official program (among "lectures, special events, recitals, and student demonstrations").[76] According to Kirstein's diaries, Caravan dancers feared they would face heckling on the

stage, but instead they received a warm welcome, including positive reviews from audience members and the press, and special praise from modern dance choreographer Martha Graham.[77]

Caravan employed Frances Hawkins to manage its tour; Hawkins had established her reputation as a booking agent for modern dance groups and as Martha Graham's manager. The group subsequently patched together a summer season, completing twenty-five performances in seven weeks, making stops at other colleges and universities, civic auditoriums, film theaters, and private venues.[78] They continued on to Easthampton, Long Island, where the troupe enjoyed mention in the society pages as the "entertainment du jour," although the absence of any program details suggests they were "not invited due to any special interest on the part of the hosts in their artistic agenda."[79] For the grandes dames of the south shore, ballet was merely afternoon entertainment, as opposed to an enriching cultural experience.

The most important contribution of Caravan to American ballet may have been to create an organizational model that placed dance at the foreground of attention. For many decades, ballet had been relegated to a subordinate position on opera stages. The Caravan, particularly on tour, "boasted several innovations with respect to the institutional positioning of ballet performance in the existing cultural infrastructure, performing in venues previously not hospitable to ballet, whether city halls or summer stock theaters," while also presenting *ballet* as the main attraction.[80] But the model of the summer tour was borrowed directly from numerous *modern dance* companies.

Historical evidence supports the argument that American ballet entrepreneurs like Kirstein relied upon the organizational structures and the institutional legitimacy of modern dance to push forward their own disciplinary aims. For the present argument, it matters very little if he consciously devised a parasitical strategy to rely on modern dance festivals, audiences, and booking agents to build ballet's legitimacy. It is, however, worth noting that many dance scholars argue that Kirstein's embrace of modern dance was a cunning and strategic decision.[81]

OPERA

For many years, ballet depended fiscally and programmatically on the existence of opera. American audiences of all classes enjoyed forms of operatic singing since the late nineteenth century.[82] It was, at least until the nine-

teenth century, an important part of shared public culture in the United States.[83] To transform opera into art, reputational entrepreneurs needed to demarcate a canon of artistic works and provide organizational and institutional supports for them distinct from various forms of musical theater and light opera.

Until the 1930s, most opera companies were governed through trustee companies, with patrons controlling the houses and commercial bookers hiring the talent and producing the shows.[84] The reliance on commercial bookers was in part a function of the high cost of production, which included musicians, vocalists, dancers, a chorus, and set designers, among others. With commercial entrepreneurs in charge, stages hosted a variety of kinds of musical performance, all designed to delight the broadest possible paying audience. This meant that English-language translations of French, Italian, and German operas were preferred in many cases, as were English-language works in opéra bouffe, comic opera, and the operettas of Gilbert and Sullivan. As long as managers, designers, soloists, and stages were open to "grand opera, light opera, musical comedy, and vaudeville," then the boundary of grand opera could not be defined, and the artistic legitimation of American opera could not proceed.[85]

In order to define the boundaries of American opera, isolate it from commercial entertainment, and sacralize it, advocates had to establish spaces dedicated to operatic performance. The Metropolitan Opera House (Met Opera) in New York opened in 1883, founded itself as a stock company, and sold shares to men of new wealth who were unable to buy box seats at the older Academy Opera. One newspaper reported that opening-night box seats at the Met Opera were occupied by those whose combined wealth amounted to $540 million—so this "new wealth" was substantial.[86] New-wealth families defended their control over the organization by requiring that "transfers of shares required ratification by the shareholders as a group."[87] Yet these opera companies still depended upon commercial booking agents to provide the programming. These agents' desire to find and satisfy a market is evident in the programmatic game of whack-a-mole they played during the first several seasons: Italian opera in the first, German in the second, Italian and French after the house was rebuilt in 1893, and a mélange of opéra bouffe, theater, and grand opera for some time thereafter.[88] Seeing an opportunity, entrepreneur Oscar Hammerstein opened the Manhattan Opera House in 1906, specializing in a French and Italian repertoire and big-name stars. His concerts drew huge crowds of New Yorkers, as well as substantial press attention.

In 1908, the Met Opera responded by announcing it would no longer operate for profit, and revenues would be dedicated toward the improvement of the company and to a pension fund for artists.[89] The president of the Met Opera, Otto Kahn, and the vice president of the Metropolitan Opera and Real Estate Company, William Vanderbilt, bought the stock of any shareholder who opposed this transition.[90] Yet the Met Opera still failed to out-compete Hammerstein's commercial Manhattan Opera House in either its first or second season. Kahn, Vanderbilt, and their board responded a second time, but with a different business strategy: they formed a trust. Leveraging their relationships with theater owners in Boston, Philadelphia, and Chicago, they began locking up the rights to performances and performers. Now faced with a significant competitive disadvantage, Hammerstein took a $1.2 million payday and handed over the rights to his property, performance rights, and contracts with many of his star performers to the trust, along with a promise to refrain from producing opera in major cities for a ten-year period.[91] Though the Chicago and Philadelphia companies broke with the Met Opera soon thereafter, and the Boston Opera Company closed, the New York opera engaged Toscanini as a conductor and enjoyed a twenty-year period of profitable administration.[92]

In 1931, the Met Opera trust transformed into a national network of nonprofit houses. The shift to a nonprofit organizational model was seen as decisive in promoting its dominance among American opera organizations.[93] But it had struggled to get there, seeing a $1.1 million cash reserve disappear in the two years before it converted to a nonprofit organization. During the conversion, the board increased in size, cut costs, initiated fundraising drives, and made an effort to present the organization as an educational service organization. Seat prices were lowered, some shows were broadcast on the radio, American performers were used more often, and a supplementary season of English opera was offered at even lower seat prices.[94] At least one historian viewed this as a watershed event, because "opera as 'high culture' [was] linked physically and finally to its institutional model."[95]

PATHWAYS TO ARTISTIC LEGITIMACY

First museums and symphonies adopted the nonprofit organizational form; modern dance, ballet, opera, and theater then followed suit. Each had to free itself from ties to forms of popular commercial entertainment. When entrepreneurs presented commercial entertainment, they elided distinctions between forms of culture to fill the house, happily programming

comedic opera and grand opera, modern dance and ballet together. Art theaters benefited from associations with museums, ballet companies from their work with opera companies and modern dance troupes. Opera companies modeled themselves on symphonies, after having tried other management models. While entrepreneurs, administrators, and creators in each of these disciplines relied on, learned from, and even piggybacked on each others' initiatives to advance their own agendas, establishing the boundaries of a new art form depends upon demarcating it from other disciplines.[96]

Nonprofit organizations isolate culture and sacralize it, allowing domain experts to provide audience members with an understanding of how to appreciate each art form. Associations with universities are critical to this process, as they educate and engage young people, providing future audiences for high-culture organizations. Universities also lend credibility to culture, as cultural authorities that engage in criticism, analysis, and classification.

Some have argued that the growth of a salaried and professional middle class at the start of the twentieth century gave way to widespread status anxieties within this group. It was a period marked by "progressive politics, middle-class assertiveness and attempts—albeit often patronizing—at urban reform and cultural enlightenment."[97] Since high culture carried with it associations of elite social status, some members of the upper middle class were drawn toward arts participation.[98]

Multiple indicators reveal a swell of interest in the arts during the 1920s among the middle classes. First, as opera, theater, and ballet moved with varying speed and success toward adopting the nonprofit organizational model, there was an explosion of museum foundings at the start of the twentieth century, fueled, some argue, by "growing public interest in elite culture."[99] Second, there was a 75 percent increase in the number of people reporting their employment as artists, sculptors, and art teachers between 1920 and 1930.[100] Third, surveys from the 1930s suggest high and rising levels of domestic arts engagement in the form of piano and phonograph ownership, music lessons, instrument playing, radio listenership, and attendance at performing arts events.[101] These indicators of artistic engagement are critical to the present argument, as they suggest a relationship between the organizational and institutional changes outlined above and changing cultural tastes. Establishing a causal link between macro- and meso-level structural changes and tastes is challenging given the number of mediating and mitigating factors, but generating evidence of a correspondence between the advance of artistic legitimation and artistic tastes is an important first step, and one we take in the next section.

Early Life Exposure

In 1973, the Americans and the Arts survey (fielded by the National Research Center of the Arts) contained a series of items in which interviewees were asked about their level of exposure to the arts when they were growing up.[102] Respondents were selected via a multistage, cluster, random-sampling design; thus, when weighted, the data are representative of the US population at the time.[103] Respondents were asked:

> When you were growing up how often did you go to [activity] with your family or with friends—often, sometimes, hardly ever, or never?

The survey ($N = 3,005$) asked this question for seven activities: 1) plays, 2) art museums, 3) concerts, 4) opera, 5) science or natural history museums, 6) historical sites, and 7) ballet/modern dance. Six of these activities (excepting science museums) count as arts-participation activities.[104] The preceding historical analysis suggests that we should see higher levels of exposure to art museums and opera in the oldest cohorts, and to plays, ballet, and modern dance among those born in the interwar years.

The results demonstrate that children born in the post-Progressive era experienced higher odds of having at least some exposure to the arts when they were young than members of the immediately preceding cohorts (see figure A.1 in appendix A). Americans born in the late 1930s, 1940s, and the first half of the 1950s reported having experienced (substantively and statistically) significantly higher levels of childhood exposure to theater, ballet and modern dance, music concerts, art museums, and historical monuments than those born before 1930.

For instance, while somebody born in the 1910s or 1920s had a less than 30-percent chance of having visited an art museum while growing up, people born in the later 1930s to the early 1950s had closer to a 40-percent chance of having this experience. Differences are starker with respect to attendance at historical sites, with those born before 1930 demonstrating more equivocal results.[105] In all, these figures provide evidence for the notion that those born between the 1930s and 1950 experienced greater levels of childhood exposure to the arts than their parents. Indeed, their parents would have witnessed the birth of ballet, modern dance, and artistic theater, as well as profound investments in the creation of historical monuments, thanks to the New Deal. With the exception of opera, orchestral music, and museums, their parents would likely not have been able to ac-

cess any of these cultural forms in their childhoods due to the small number of venues, their concentration in a handful of eastern cities, and their relatively low status.

Indeed, the historical analysis indicates that museums and symphony orchestras enjoyed a "first mover" advantage, having asserted their hold on the American arts in some cases a full century before the others. They accounted for the majority of philanthropic foundation arts spending between 1920 and 1940. They invested some of those funds to support a ground campaign that spread awareness of their canons, using public school teachers and womens' clubs as advocates. The effect was felt in higher education, as painting, sculpture, and "classical" music were the only disciplines that entered the core curriculum of most colleges and universities as humanistic disciplines after World War I.[106] By the start of the New Deal, you could speak of the "seven arts" (architecture, sculpture, painting, music, poetry, dance, drama) but they were, in fact, points on a spectrum "varying in prestige, institutional stability, and the degree to which each was insulated from commercial entertainments."[107]

The pace at which America legitimated these art forms was slow, which serves to remind us that, while works of art may connote indelible, transhistorical value and prestige, their presence in our culture is contingent and arbitrary. It took more than a hundred years to create what existed elsewhere (notably, in Europe).

What Is an "American Art"?

Both ballet and opera companies struggled to establish themselves as American art forms. They were slow to assimilate to the "third party system" of mixed public and private funding that characterizes support for other art fields. Each ultimately relied on large infusions of cash from foundations to secure robust national systems to recruit, train, and support domestic producers and fund the staging of an American canon. While these fields evolved to establish stable funding systems, they also hosted prolonged debates around what "counted" as an American art form. Those in opera and ballet were among the most contentious. To this day, they remain the least well-attended forms of performing arts in this country, perhaps because they failed to adequately resolve these disputes. These arguments over the boundaries of each field were focused on *who* is an artist and *what* was the best art, but equally concerned what counted as *American* art.

Let's begin with the question of what defines an American ballet. In 1930, *New York Times* critic John Martin framed an effective response, which is worth quoting at length:

> The term "American ballet" is open to a diversity of definitions as intricate and hair-splitting as Polonius's catalogue of dramas. For general discussion it falls easily into two main subdivisions, in one of which the 'American' refers to the dancers and in the other to the dances. It is this latter classification, of course, that is more interesting and contains infinitely greater potentialities; but the dance that belongs particularly to American life and thinking must evolve as the self-motivated externalization of this life and thinking. It is not yet matured to the point where it awaits only organization to allow it to function. No amount of money, or favor, of enthusiasm, can force into being an artistic entity dependent upon natural growth and a certain esthetic adventuring cannot be hurried.[108]

This debate over which matters more—the national origins of the performers or the choreographer—echoed in debates over what kind of opera could be judged as "American."

Is the first American opera defined by the nationality of its protagonist, subject, musical score, composer, singers, conductor, or language? The first opera written by an American-born composer was William Fry's *Leonora* (1845), and it features that most American mythological character: the self-made man who triumphs over class barriers.[109] Yet Fry obscures its American character by staging it in Spain "during the period of the American conquests"—a strange, imaginary conceit.[110]

The first opera to focus on an explicitly American subject was also composed by an American: George Bristow's *Rip Van Winkle* (1855), which debuted at Niblo's Garden in New York in 1855.[111] Before an earlier version of the Garden was destroyed by fire, it hosted P. T. Barnum's first exhibition in 1835, making it an important site for the evolution of American performing arts in several respects.

A third contender for the first American opera is the Met Opera's world premiere of Puccini's *La fanciulla del West* (1910). It is not only set in the American west, with sheriffs, miners, Native Americans, and whiskey-fueled card games, but it is also musically American: Puccini's score includes banjos, and, in Puccini's words, "two cowboys dance, singing a queer song: 'Dooda Dooda, Day.'"[112] The opera featured an "all-American" cast including Enrico Caruso, Emmy Destinn, and Pasquale Amato and was conducted by

Arturo Toscanini (all Italians), but the *New York Times* reported that the "auditorium had been specially decorated with Italian and American flags."[113] The flags must have been a visual reminder to the audience that these Italians sought to stage an American drama.

Another contestant is the January 1920 Met Opera debut of *Cleopatra's Night,* a two-act opera by American composer Henry Kimball Hadley, with libretto by Alice Leal Pollock. Hadley took the baton for the sixth and final performance, making him the first American composer to conduct his own opera at the Met. Moreover, three of the four principle singers were Americans: Orville Harrold, Jeanne Gordon, and Marine Tiffany.[114]

A final pair of candidates for the first American opera are "Four Saints in Three Acts" and "Porgy and Bess," both of which premiered in 1934 and "represented effective, new ways of setting text in English, and both incorporated uniquely American stylistic elements (hymn tunes for the former, and jazz for the latter)."[115] Obviously, the question of what characterizes an American opera is not an easily settled one.

A similar question was being raised in ballet. By 1938, Lincoln Kirstein began to describe his ballet troupe, Caravan, and the school as "a permanent laboratory for classic dancing by, with and for Americans."[116] As former Caravan dancer Ruthanna Boris proclaimed with some enthusiasm, it was "a dream of American ballet dancers dancing America!"[117] And its dancers, choreographers, designers, and audience members *were* Americans; the dance was ballet. But few who saw their performances remarked upon any stylistic innovations that we might define as American. They were, by most accounts, very much in keeping with the Franco-Russian balletic traditions. Moreover, Caravan presented few ballets with explicitly American subjects: *Pocahontas, Billy the Kid,* and *Filling Station* each "evince[d] an explicit commitment to native and vernacular themes, inspired by and in turn contributing to regionalist and politically activist trends in the visual and performing arts in Depression-era America."[118] These were, however, the exceptions within a program that mainly featured European works.

American opera advocates faced similar difficulties: leaders of powerful companies like the Met Opera advertised themselves as American organizations, but audiences failed to find much innovative or valuable content in English-language songs, performers, or American thematic content. With the exception of the program at Columbia University, opera workshops and academic departments, including those at the New England Opera Theatre, The Juilliard School, and the Manhattan School of Music, had students sing English translations of European works.[119] Training students in English did

not prepare them for professional work in opera, because most company trustees had successfully insisted on the presentation of foreign language operas.[120] While workshops and academic departments prepared American singers in English, there were few domestic works to perform, or audiences interested in patronizing them.

Efforts within opera to cultivate a domestic canon were largely unsuccessful. The Met's administration was committed to developing opera and presented a new work almost every year, starting in 1920 and highlighting American composers like Charles Wakefield Cadman. However, few of these were popular with audiences, and "most of them are forgotten."[121] In opera, the need to sell tickets and memberships was at odds with the need to develop an American canon. Opera companies also needed to balance their own legitimacy within the field—operatic excellence—against the desire to generate distinctively American programming or performers. The tension between these was never more clear than in the almost immediately laughable theme that the Metropolitan Opera Guild chose for 1935: "Democracy at the opera."[122]

By 1940, writers were starting to comment on a "ballet boom" attributed to "the 'seasoning' of a generation of young American dancers, the discovery of a generation of new American choreographers, and the maturation of an educated, sophisticated audience."[123] They felt the time was right to build consensus around, and codify, what would become the American balletic canon. The work of defining the boundaries of the field, and, simultaneously, of describing who legitimately belongs within it, of course involved many individuals in a field as large as dance:

> This included not only dancers, teachers, and choreographers, but also critics like Denby who laid the foundations for an American school of dance criticism, historians like Lincoln Kirstein who established the first of the city's dance archives at the Museum of Modern Art, photographers, managers, publishers, booksellers, and editors—all of whom in different ways brought the art to its public.[124]

Kirstein's status within the field and self-stylized reputation as an innovator made him one of the most powerful actors in the field.

Lincoln Kirstein placed himself at the forefront of these efforts to define American ballet through a series of lectures and publications, pointing toward the importance of public communication to artistic legitimation. In the fall of 1936, after returning from the summer Caravan tour, Kirstein and

several dancers presented a lecture-demonstration on "the development of the ballet" at the New School in New York, part of a series of talks on the topic of "The Dance in the Social Scene."[125] In 1942, Kirstein began a six-year tenure as editor of *Dance Index*, a magazine that published illustrated scholarly texts on a spectrum of dance topics; it would later be bound and serve as a critical reference work for dance scholars. Kirstein's desire to secure for himself a position as the most esteemed expert on American ballet drove him to publish a book on the history of the form, *Movement and Metaphor: Four Centuries of Ballet*, which detailed fifty masterworks, tracing the history of the ballet and including hundreds of images.[126] In each of these efforts, Kirstein did the work of a reputational entrepreneur, deploying his own legitimacy in the service of asserting the content of an American ballet canon and its conventions.

Decades later, the work of establishing an American balletic and operatic canon was still not complete. Private foundations tried to turn the tide in both fields, providing the resources necessary to engender robust domestic production. On December 16, 1963, the Ford Foundation announced it was undertaking a ten-year, $7.7 million aid program to support ballet companies associated with George Balanchine, and to support his School of American Ballet.[127] These efforts were advanced two years later by the National Endowment for the Arts Dance Program, established in 1965.[128] Yet Balanchine chose to make his company an auxiliary to the Met Opera, causing influential dance critic John Martin to ask: "Is the organization to attempt the fulfillment of its original policy of developing an American ballet, or is it to follow the direction of its present season and go on being merely 'Les Ballets Americans?' "[129] It seemed to many that Balanchine had given up on the potential audience for ballet, and delivered American ballet back to opera audiences.

Foundation support for opera did not yield better results than it had in dance. The Julliard Foundation, as an institution charged with the cultivation of singers, provided a grant earmarked to support American opera performers.[130] But the financial incentive to satisfy the Julliard Foundation was at odds with the Met Opera leadership's need to "perform the 'sacralized repertoire' with the highest quality performers to retain its 'high culture status,'" and this meant importing European operas and European operatic singers.[131] The NEA began funding opera in 1966, and a 1971 grant helped the newly formed national service organization, OPERA America, establish an office.

And then, "opera was made un-popular."[132] It eventually would become one of the least frequently enjoyed forms of American culture. Only 2 percent of Americans reported that they attended a live opera in 2014, according to the National Endowment for the Arts. Ballet did not fare much better, capturing only 2.7 percent of Americans in 2011.[133] Yet ballet and opera connoisseurship continue to be the most strongly "classifying" activities, in part because the group that participates in it is so small, so well educated, and so rich.

Heading into the Great Depression

By the outbreak of the World War I, reputational entrepreneurs were advocating for distinctively *American* arts. The bohemians and educators, Jews, professors, and women of the Little Theatre movement presented an "American belief that theatre is spiritually and emotionally fulfilling, socially elevating, of civic importance, a site for assaying social change."[134] Modern dance advocates wanted "new-found personal, physical and sexual freedom, particularly for women."[135] Even the largely conservative ballet field "evince[d] an explicit commitment to native and vernacular themes, inspired by and in turn contributing to regionalist and politically activist trends in the visual and performing arts in Depression-era America."[136]

If the first wave of artistic legitimation in America established the path by which high art was made, the second wave struggled to steer it toward a vision of what an *American* high art must be. That vision was still blurry; debates raged around the importance of thematic content and staffing. Reputational entrepreneurs sought to shape the mythological origin stories and collective sentiment in the field, both in their essays and presentations, as well as in their omissions and silences. Lincoln Kirstein, the progenitor of American ballet, began to omit any mention of the private parties Ballet Caravan performed at society homes. Some dance historians have suggested that Kirstein may not have wanted to advertise elite support for his early work because such support would be incommensurate with the politically leftist ethos he later assigned to his ballet troupes.[137] The significance of politically progressive definitions of American arts, built on regionalist or local concerns, free inquiry, and experimentation, and designed to foster a civically engaged public, lit a spark that would transform into a raging fire during the New Deal era.

That era would begin in September 1929, when the London Stock Exchange crashed after English investor Clarence Hatry and his associates

were jailed for fraud and forgery. A little more than a month later, panicked trading in the United States resulted in a two-day market loss of over $30 billion, marking the start of what is now known as the Great Depression.

The brief, fifteen-year period between 1930 and 1945 may have had the most profound effect of all on art in America. The New Deal arts programs—work subsidy for unemployed artists—paid for the production of a great number of artworks and employed thousands of artists. But the more impactful consequence of these programs may have come from an increasingly broad definition of the arts. That expanded definition has continued to influence the American arts and to define the character of artistic legitimation in this country. If the first wave established the pathway for artistic legitimation, and the second contoured it, the massive injection of federal dollars during the New Deal both accelerated the pace of artistic legitimation and widened the path, allowing new and more diverse forms of cultural work to be seen as art.

2

The WPA and the Opening of the American Arts

America as a multiple civilization was being recorded, studied,
and archived as never before. The White House sponsored and
was delighted by the opening up of Washington and the country
to further exploration of what kind of place America was, of who
Americans were in all their ethnic variety. The Roosevelts and the
bright, young, intellectuals of the New Deal and Congress under
Roosevelt's baton put their arms around the whole of American
culture: ¾ minorities, ethnics, blacks, poor whites, Indians, coal
miners, unemployed.

— ALAN LOMAX[1]

Facing massive unemployment and poverty, President Franklin Delano
Roosevelt established federal agencies charged with employing out-of-work
artists and with achieving a "picture of democratic justice and spiritual
beauty."[2] (The administration famously also built work programs for those
in other fields.) This phrase comes from the memoir of lawyer-turned-artist
George Biddle, prep-school friend of Roosevelt and the man who credited
himself with suggesting an artist's work relief program.[3] While the purpose
of the Works Progress Administration (WPA) was to provide an income for
starving artists, its unintended consequence was a radical opening of access
to the arts and heretofore "illegitimate" culture.

State-level support for indigent artists began as early as 1931, but the first federal, nonrelief project for artists, the Public Works of Art Project, was initiated in 1933.[4] This program, with the Treasury Relief Art Project (1935–39), awarded commissions to artists for the production of paintings, sculptures, and murals for display in federal buildings across the nation. A more comprehensive work relief program was announced in August 1935: the WPA. Under the WPA, the four programs referred to as "Federal Project Number One" provided subsidies for the production of visual art, music, theater, and literature (and, later, the historical records survey).

Artists employed under Federal One produced a great variety of artworks, including paintings, graphics, motion pictures, murals, photographs, posters, sculptures, and plates for the Index of American Design. Still others taught art and art appreciation; mounted exhibitions, tours, and lectures; built frames and dioramas; and sketched maps. Art Project glassblowers in New Jersey made vases, paperweights, perfume bottles, bowls, pitchers, and candleholders to sell. Woodworkers made furniture for government offices, while women employed by the agency made rugs and wall decorations from scrap material.[5] Some creative workers even developed color standards and tested paint in cooperation with the Bureau of Standards. Artists enjoyed a variety of work contracts: while some exchanged the product of their week's work for a paycheck, others competed for commissions, and still others reported their work hours. State and local relief agencies supported the federal projects, often providing as much or more support to artists on relief.

The WPA's Impact

The resulting output of creative material is nothing short of astonishing: from 1935 to the closure of the WPA in June 1943, artists created 2,566 murals, 17,744 sculptures, 108,099 paintings, 250,000 prints from 11,285 images, 2 million posters from 35,000 designs, and more than 22,000 design plates.[6] The Federal Music Project produced a similarly massive array of works, including over 1,500 compositions by 540 American composers.[7] Concurrently, the Treasury Department's Section of Painting and Sculpture was responsible for installing over one thousand murals in federal facilities, including post offices.[8] The Federal Writers' Project paid creators of books, poetry, pamphlets, leaflets, and radio scripts, including socioethnic studies; expositions on industrial, labor, society, and community issues; and documentation of American and Native American folklore.[9]

Estimates of the total cost of the WPA hover around $35 million.[10] Many critics complained that the large scale of production involved a concurrent reduction in overall quality. Alfred Stieglitz famously suggested that the government provide registered artists with their weekly subvention but keep them away from paint.[11] The agencies were dogged by controversy. To cite one example: New York City WPA supervisor George K. Gombarts came under investigation because, months into constructing an art school, the only project he had finished was the creation of a luxurious office for his private use. A news report described a room festooned with a Flemish-style wall tapestry depicting a knight. "The knight is George K. Gombarts," Gombarts said to the press. "'It's a dream we had . . . a 20-year dream come true. I intended it as a kind of monument.'"[12] The inanity of a construction supervisor dreaming of his private office when an art school for children remained unfinished was offensive enough, but the obvious joy he took in the misery of others inflamed the public. Critics argued that the lack of oversight and large budgets for WPA projects invited both criminals and narcissists like Gombarts to take advantage of taxpayer dollars.

Did the WPA achieve its goal of "Art for the Millions?" If you wish to argue it did not, you could point to the results of audience polling and weak sales figures for visual artworks subsidized by the agency. Audience surveys from the Federal Theatre Project revealed that most were middle class, despite a concerted effort to attract low-income groups (although those surveys may not have been executed well).[13] National Art Week did not, as its slogan promised, result in "A Work of Art for Every American Home." Instead, the biggest purchaser was Thomas J. Watson of IBM, who had been appointed by Roosevelt to serve as the national chairman of the event.[14]

There is a stronger argument to be made in favor of the agency's breadth and volume of impact. Consider, for example, that the staging of *Macbeth* at the newly refurbished Harlem Lafayette Theatre generated so much interest that an open dress rehearsal "left 3,000 people on the street without seats, and a squad of riot police . . . [had to] disperse them." By the time the play debuted, the Federal Theatre projects had employed 10,700 workers and operated in 31 states; 11 cities had black companies and 2 states had Yiddish theatres.[15] Between January and September 1936, an estimated 32 million Americans are said to have attended a Federal Music Project performance. Because the best of these performances were recorded and made available free to radio stations across the country, 32 million probably undercounts the total listener base.[16] The radio was an important and a modern

way to distribute WPA-subsidized material; one estimate holds that by 1936, 431 radio stations were using Works Progress Administration programs.[17]

In addition, within a year of providing funds to support art centers that offered courses in appreciation and art making, over one million people had completed a free program.[18] Music classes were also popular; those offered by the WPA or its partners ultimately employed over 6,000 teachers of music.[19] And as much as the WPA programs did to stimulate amateur production and audience appreciation of the arts, they also trained a new generation of professionals. Jacob Lawrence, Romare Bearden, Gordon Parks, and Margaret Burroughs all took courses at agency art centers.[20] One historian claims that, in total, the Federal One programs "presented 225,000 concerts to audiences totaling 150 million, performed plays, vaudeville acts, puppet shows, and circuses before 30 million people, and produced almost 475,000 works of art and at least 276 full-length books and 701 pamphlets."[21]

Federal One programs generated programming in urban arts nonprofits, but the provision of education and engagement programs in nonurban spaces was more consistent with its mission: "The introduction of urban amenities, both material and cultural, into rural America was one of the basic purposes of the New Deal, and manifested itself in the arts no less than in rural electrification."[22] Roosevelt's famous estimation that only one of ten Americans had ever seen a "fine picture" surely overestimated the levels of access ordinary citizens had to the arts before the New Deal. Even in culturally rich cities like New York, there were only two dozen art galleries in the 1930s, and galleries and museums were located in wealthy areas where middle- and working-class Americans might not venture.[23]

Since professionally trained artists were less likely to live or wish to travel to nonurban spaces, Federal One, like the other relief programs, primarily employed unskilled labor.[24] And most unskilled or semiskilled culture workers were more familiar with folk art traditions. In that sense, it should come as little surprise that much of the work produced under Federal One was "vernacular art."[25] Thus, the New Deal art projects represented the first infusion of tax dollars to support a broad array of native art forms. These investments would pay dividends years later in the expansion of the arts to include some of the culture created in the New Deal.

Beyond the volume of artistic production, and its ubiquity, some historians note that the real impact was on policy: "The Works Progress Administration (WPA) Arts Projects were on the cusp of the modern bureaucratization of culture, at the moment when the federal government

exponentially extended its reach into people's daily lives. They make particularly vivid the imbrication of publicly funded art in the governmental making and regulation of a national citizenry—with all the benefits, limitations, complicities, and power relations that process implies."[26] Another argues that it was

> an explicitly cultural effort to bring art into public consciousness and use it to shape ideas about, among other things, citizenship, politics, gender, class, and race. For a brief period, the New Deal art projects applied to cultural life the liberal creed: the idea that the government should play a central role in the nation's development. Thus, cultural advocates sought to use the state to democratize and Americanize art, although they disagreed about what that meant and how best that might happen.[27]

Yet it would be three more decades before the National Endowment for the Arts (NEA) was created.

Congress repeatedly attacked federal arts divisions, based on reports of inefficiency and fraud. In 1939, it abolished the Federal Theatre Project, charged with inefficiency, immorality, and infiltration by communist agitators (for example, "it had spent $1,468,365 producing 27 plays, many of them flops").[28] The Writers' Project faced many of the same charges; its national director was accused of provoking a sit-down strike in 1937, during which 200 employees on the WPA-Writers' Project rolls seized and occupied the headquarters in Manhattan. The other programs limped forward into the war years, when they were abandoned.

A Cultural Democracy

Despite claims of administrative abuse and poor oversight, many WPA administrators fervently endorsed the vision of a cultural democracy taken up by Roosevelt—to "redefine American culture and to create a 'cultural democracy' by establishing a bureaucracy that would provide 'culture' for the people."[29]

What was a "cultural democracy?" It was, in our contemporary parlance, marked by "equality of access," as Americans immigrant and native, rich and poor, in rural towns and cities, had opportunities to enjoy a variety of cultural productions. According to one historian,

> The WPA's Federal One had freed the arts from their need to please commercial tastes and elite patrons. With the government funding . . . work

had spilled out of haute temples in big-city theater districts and gallery rows into parks, schools, churches, and community centers. Millions of Americans, many for the first time in their lives, thronged to concerts and plays and studied paintings and drawings, much of the time without having to take a penny from their pockets. They were sending their children to free art and music classes, and attending those classes on their own.[30]

It was also characterized by "equality of representation" as the various divisions worked to "show a living culture and understand its function in a democracy."[31] This progressive vision of a democratic republic was anchored by a commitment to documenting, preserving, and aestheticizing the cultural production of immigrants, nonwhites, and "untrained" creators. For example, the Farm Security Administration sent writers and photographers into the Dust Bowl states to document the lives of the people there and to demonstrate "the need for government programs and their benefits"; this work has become famous thanks to James Agee and Walker Evans's *Let Us Now Praise Famous Men*.[32] The Writer's Project sent reporters into every state to collect what Ben Botkin, director of the folklore division, called "living lore," including the testimony of European immigrants and former slaves. That impulse toward national self-recognition had at its core a reconciliation mission—to confront forced and voluntary immigration very much in the spirit of a "melting pot" philosophy. Advocates viewed it at the time as a radical, progressive vision of community.

REGIONALISM

Regionalism is a key word ("almost an article of faith—for intellectuals in the 1930s") that activated links between the land and its people, the people and their cultures, and the patchwork of cultures that formed the nation. Many WPA administrators and artists opined that " 'regional' diversity . . . was essentially an expression of national unity" and "therein lay America's true richness and its full independence from Europe."[33] That is, "American artists believed that depictions of real people in real settings would help them reveal American democracy and create a uniquely American art form."[34]

"Regionalism" was also adopted as a genre term to describe the work of several notable artists, among them muralist Thomas Hart Benton.[35] Benton may be familiar to visitors at the Smithsonian Art Museum, where his 1947 mural *Achelous and Hercules* hangs. Art lovers in New York may have seen

America Today, an installation of ten canvas panels depicting machines, industry, and subways, all in glowing relief on the walls of a gallery in the Metropolitan Museum of Art. Benton was among the best painters and muralists in the Regionalism movement, and he was also one of the most typical. Understanding his objectives as an artist can help us to understand why Regionalism came to exemplify the values and practices of a "cultural democracy."

Benton's Regionalist style might best be described using the words of one biographer: as "a calculated mixture of documentary fact and epic drama."[36] Like many other WPA employees, Benton traveled across the nation noting the landscapes, lifestyles, and dialects of Americans. He was seeking out both "American subject matter" and "local thematic concerns."[37] He perceived no conflict between "panoramic" views of American life and particularistic details. He also saw no conflict between the American character and his own: his autobiography, *An Artist in America*, attempts to make his own trip across the nation a metaphor "for the spatial and temporal movements of American history."[38] It was an era of great projects and even greater egos.

Benton suggested that "the historical restlessness of the American Everyman is . . . [the artist's] restlessness."[39] For many, this was a radical argument. The WPA programs classified artists as workers. Benton describes them as "Everyman." These notions combine in a rejection of urban artists, influenced by European modernism—an "erosion of artistic elitism."[40] Together, they promote regionalist populism as the domain of the American artist.[41] In the words of one of Benton's contemporary critics, Edward Alden Jewell, "These artists . . . have in common, first—a passion for local Americans, and second—a contempt for the foreign artist and his influence."[42] Even the American Guide Series, part tourist guide and part ethnography, can be seen as a means "for shaking off European cultural imperialism" and consequently found "purchase in a period whose public discourse was heavy with cultural self-consciousness."[43] No less a figure than author Ralph Ellison mounted a defense of the Writers' Project in 1983, describing it as work done to define a new nation: "We are *creating* American history; we are not reliving European or African history."[44] Establishing an American vernacular artistic style was at once a way for communities to find recognition within the national tableau and to celebrate its cultural diversity, itself "a sign that the country had come of age on the international stage."[45] As the London *Times* put it, on July 22, 1939, "One is amazed at what appears to be the country-wide emergence of a contemporary American style."[46]

Painters like Benton were by no means alone in this regionalist turn. At least one observer argues that Benton was informed of a similar focus in other fields, as regionalism or hyperlocalism took hold in fiction, literary criticism, and sociology.[47] Moreover, this attention to local concerns was in many cases mandated by the WPA and other art sponsors. For example, the Treasury Department's Section of Painting and Sculpture asked artists to focus on at least one of three themes: the post office, the local scene, and local history.[48] The section advocated that visual artists use the same documentary techniques as oral historians:

> The Section stresses . . . the creation of vital design, but it recognizes that a work of art carries more meaning for the people for whom it is intended when it deals with familiar subject matter and reflects their local interests, aspirations, and activities. For this reason, each artist is urged whenever possible to visit the community. . . . There he talks with the townspeople, gathers their tales of folklore and history . . . [and] selects subject matter which typifies that community.[49]

Regionalism became a clarion call, uniting those who sought to define a new era in American civic and social life and an art suited to it. Indeed, at the 1937 American Writers' Congress in New York (the same one at which Ernest Hemingway and Martha Gellhorn begged writers to join the antifascist cause), professor Benjamin Botkin delivered an address titled "Regionalism and Culture." In it, he argued that "the United States has a culture rich with life and imagination" and "realistic regional literature can serve as an organizer, as well as an interpreter of social thoughts . . . by helping us to understand and respect one another, and by showing the failure and breakdown of old patterns and the growth of and hope for new ones."[50] Botkin's arguments were so aligned with the official political doctrine, expressed through the agencies, that he was soon invited to succeed John Lomax as the head of the folklore division of the Writer's Project.

Before we move ahead in developing our understanding of how this new Regionalist style impacted the evolution of American arts, and away from Benton's biography, it is worth noting his work in commercial, folk, and popular culture fields. Benton was an avid folk musician, and he collaborated with his son on a Decca Records album of flute, harmonica, and voice recordings.[51] This was not his only foray into commercial culture. In 1946, Benton worked at Walt Disney Studios on a libretto for a new American folk opera based on the life of frontiersman Davy Crockett. Although the film was never completed, Benton's partnership with this commercial juggernaut

"provides additional insight into his thinking on the possibility of a fruitful merger between high and popular art."[52] He also worked with Disney, in collaboration with Salvador Dali, to bring a second *Fantasia* film to the market, scored with songs influenced by Latin American and North American music.[53] The Disney archives reveal that on one of Benton's first visits to the studios, in May 1940, he was joined by the self-styled "inventor" of the WPA agencies, George Biddle.[54] Benton's combined interest in Regionalism and artistic approaches to commercial culture mirrors the dispositions of most aesthetic entrepreneurs in the later twentieth century. His experiences provide a clear link between New Deal institutions and the American art world that resulted.

SOCIAL REALISM

Regionalism was not the only term used to describe New Deal–era art movements; others preferred the term "social realism."[55] This label was more commonly applied to those who examined urban and industrial life and work, and to critics of the American project.[56] Social realist painters, muralists, playwrights, and poets examined "corruption, slums, and blighted lives" and often deployed "scathing caricatures" of powerful men to convey their "outrage."[57] For example, WPA Theatre Project division head Harry Hopkins pushed directors to depict the deplorable conditions in tenements in the hope that they might encourage support for the construction of decent housing. Regionalism and social realism are labels for artistic fields unified in their concern with working peoples' lives, and with community and social life.

Many voices, past and present, have celebrated the diversity of art and culture supported by the WPA agencies as a demonstration of national unity. Presentations of community and cultural life in murals, songs, and other WPA projects often highlighted the ways in which work, civic, and community life drew diverse Americans together in a happy cooperation of different, but equal, people. However, America was not a nation of equals. In equivocating the experiences of European immigrants, "conquered" native communities, and the abduction and enslavement of African and Caribbean peoples, the WPA agencies (unwittingly?) obscured the terrible acts that had been committed to bring the nation together and distracted attention away from the forces that kept many trapped in poverty. As one critic has noted, the projects are arguably "marked by a tendency to naturalize social difference—even social dysfunction—as 'local color,' part of an ulti-

mately harmonious landscape defined as 'the nation.' "[58] One might argue that the government "appropriated" the folk and vernacular cultures of minoritized people as propaganda. Yet cultural engagement largely came to be seen as a moral action—a positive form of engagement with community and nation.

Of equal importance to this argument is the fact that the WPA created opportunities for reputational entrepreneurs to sacralize a new and more diverse group of works as art, and an organizational context within which to do so. As a result of the creation and presentation of hundreds of thousands of artworks, essays, books, radio, and concert programs, and concerts under the auspices of the WPA, Americans arguably experienced more voluminous, diverse culture than ever before.[59] Creators of vernacular culture, including design, quilts, and folk songs, to name just a few, were endorsed as art through the provision of public subsidy that had previously been extended only to the "high" arts—opera, ballet, modern dance, theater, and classical music.

The Long Arm of WPA Influence: Artists, Organizations, Administrators

The expansion of access to artistic production and presentation provided by state and federal subsidy produced two outcomes that are critical to this argument: first, the content and personnel in American creative fields diversified; second, new genres were presented as objects for aesthetic appreciation—that is, as art—within benchmark art organizations and were endorsed by legitimate art experts like curators, collectors, and critics.

ARTISTIC CAREERS

Hundreds of artists personally benefited from association with the WPA agencies. The financial and social support offered by the New Deal arts agencies, the camaraderie and spirit of friendly competition, the expansion of the market for art, and perhaps also the stimulation of interest in its more avant-garde forms proved a boon for many artists. Among those who received support from the WPA were Willem de Kooning, Lee Krasner, Jacob Lawrence, Alice Neel, and Arshile Gorky. Ralph Ellison famously worked on the New York City guide, which was said to have given him a unique insight into the lives of those in Harlem—insight that is delivered in the authenticity of the characters in his novel *Invisible Man*.

Organizations in minoritized neighborhoods launched or advanced the careers of local artists; the Harlem Art Center presented such shows, including work by now-famous painters including Jacob Lawrence. It is also said that the documentary form finds its roots in 1930s America, and in the skills and information that filmmakers, journalists, photographers, and artists generated in documenting American life for the WPA. Moreover, the WPA "workforce" included those who would continue onto careers in the arts: "The WPA arts projects were a crucial mediator. . . . They proved to be a way-station for young plebeian artists and intellectuals of ethnic working-class backgrounds who would go on to careers in federal bureaucracies, the culture industries, and the universities," thereby contributing to the professionalization of the arts.[60]

While the arts diversified, arts administrators worked to legitimate particular forms of vernacular culture. Operating under the aegis of federal, state, and local governments, some of these works were presented in benchmark arts organizations including the Smithsonian, the National Gallery, the Museum of Modern Art, and the Federal Art Gallery in New York.[61] The Public Works of Art Project closed with a gigantic exhibition in Washington, DC, at which high-ranking government employees were encouraged to take what they liked and to display the art in their offices. President and Mrs. Roosevelt hosted a series of nine concerts by "traditional" musicians at the White House, including one in June 1939, attended by the king and queen of England, the first reigning British monarchs to visit the United States. The playbill included the mountain string band the Coon Creek Girls; Marion Anderson, the contralto opera singer; the North Carolina Spiritual Singers; and musicologist Alan Lomax, who performed cowboy songs. Federal One contributed to a transformation in the organization of art in America: curators and preservationists developed new competencies, organizations presented new kinds of work, new markets opened, and audiences acquired new modes of appreciation.

THE CIRCULATION OF ART WORKS

The WPA's influence was also felt through the circulation of these artworks through networks of display, as they were lent to world's fairs, museums, galleries, and consulates, and presented at conferences, festivals, concerts, and on stages.[62] The Smithsonian's Traveling Exhibition Series was particularly active in circulating WPA-produced works. They also initiated the Festival of American Folklife in 1967, and the estimated one million people who

attend each year makes it the largest annual cultural event held in the US capital.[63] Its programming is a near-mirror of New Deal art initiatives: combining song, dance, craft, and workshops, the festival is organized to spotlight specific nations, states, and regions, and to highlight the vernacular culture of these places.

The catalog for the 1968 Festival of American Folklife draws a clear line of influence between the WPA arts programs and the festival. Secretary Dillon Ripley's prologue identifies the New Deal as an era in which America began to recognize and celebrate an "aesthetic tradition of its own" and develop a "culture in which the arts could flourish." He continues: "We know today that such a culture has been our heritage. . . . We hope this Festival will serve to bring American people together more fully into touch with their own creative roots, and that from this acquaintance the way may be pointed towards a richer life for some and a more meaningful understanding of the roots of our society."[64]

The point bears repeating: the resemblances between the mission of the National Folklife Festival and the WPA arts programs are striking. Former Director of the Center for Folklife and Cultural Heritage Richard Kurin stated that the festival's purpose is to display and preserve regional, folk, tribal, and other "non-elite and non-commercial" cultural forms that are "not otherwise likely to be heard in a national setting." The festival is designed, in his mind, to legitimate folk cultures using the instrument of a national office and its "standards of authenticity, cultural significance, and excellence." It is determined to convey these cultures' "value to artists, to home communities, to general audiences and to specialists" thereby providing a "needed counterweight to other forms of delegitimization."[65]

To Kurin, the festival is an instrument that promotes the visibility and legitimacy of hidden or marginal cultures, and it performs a socialization function as well: training general and specialist audiences to view these cultures as valuable. The language could not possibly be more revealing— the festival is designed to promote aesthetic legitimation through the demonstration of artistic excellence and authenticity. The administrators of the WPA and the festival were "open to an expansionist dynamic" that included folk, vernacular, and popular culture.[66]

NETWORKS OF ARTS ADMINISTRATORS

Just as we can trace the influence of the WPA through the circulation of artworks, we can do the same through the circulation of arts administra-

tors.[67] Many of the WPA arts administrators sought employment at large and influential arts organizations, and they carried with them a desire to diversify the art on offer. To trace just a single, important lineage: Holger Cahill worked as the interim director of MoMA for a year (1932–33) before he became a curator at the Newark Museum, a position he left to become the Director of the Federal Art Project (FAP; 1935–43). In all three jobs, he worked to canonize material that drew upon the nation's folk traditions. Barr was succeeded at MoMA by René d'Harnoncourt, former Manager of the WPA's Indian Arts and Crafts Board. An advocate of folk art, d'Harnoncourt was an expert in Mexican, vernacular, and modern American art. During his tenure at MoMA (1949–68), d'Harnoncourt supervised and curated numerous exhibitions of folk material from the United States. These included displays of "African Negro Sculpture" (1952), American woodcuts (1952), "young American printmakers" (1954), paintings by "amateurs" (1955), graffiti (1956), and film posters (1960). He became a close advisor to Nelson A. Rockefeller, and they would work together to create the Museum of Primitive Art (MPA) (the focus of chapter 3). In sum, the WPA administration produced a small, interlocking network of influential arts administrators who would direct the expansion of the arts canon for the next five decades, just as the Boston Brahmins and others had been engaged in establishing it over the previous five.

While some arts administrators went immediately into nonprofits after the WPA projects were disbanded, others found work within the emerging war propaganda agencies. In June 1942, the Office of War Information (OWI) formed, hiring former WPA administrators to perpetuate and even expand federal cultural programs in the service of the war effort. The State Department paid for concert tours and art exhibitions. The OWI hired John Houseman, former director of two Federal Theatre units in New York, to head the official government radio network, Voice of America (VOA). VOA was initiated in 1942 as an information news program broadcast to Germany; it quickly expanded to include other program formats and multiple languages, and to reach greater geographic distances.[68] Other federal cultural programs were more covert efforts to influence public opinion. One such program was the Central Intelligence Agency's support of the literary and cultural magazine *Encounter*.[69] The magazine, in operation from 1953–91, was originally associated with anti-Stalinist leftist politics, although it served the needs of its paymaster seemingly only in refraining from criticizing American foreign policy.[70]

ORGANIZATIONAL IMPACTS

These years marked the advance of our awareness that culture could and would be a powerful propagandistic tool—a form of soft power that would give America an advantage in fighting the forces of fascism first and communism later. These programs were also pointed toward developing relationships in our own hemisphere. The very first federal cultural units to succeed the WPA were devoted to Latin America: the State Department's Division of Cultural Relations was established in June 1938, and the Office for Coordination of Commercial and Cultural Relations between the American Republics (OCCCRBAR) in 1940. President Roosevelt appointed Nelson Rockefeller to head the latter, later renamed the Office of Inter-American Affairs (OIAA). It would grow to have 1,500 employees and a budget of over $38 million by 1943.[71] Although Rockefeller did not work for the WPA, his "brain trust" of art advisors were all alumni of the agencies. Rockefeller's awareness of the importance of cultural diplomacy would inform his collecting, as well as his diplomatic and political career, and would make him a singularly important figure in the history of American art.

It is the impact of the WPA programs on subsequent organizational structures and institutional practices in the arts that shapes the remainder of the argument of this book. The WPA projects supported the creation and distribution of folk culture, minority culture, immigrant cultures, women's cultures, and many other local and regional forms of expression that contributed to the mosaic of contemporary life. They trained a generation of arts administrators, artists, and audience members to celebrate an enormous diversity of culture as components of the American tableau. By promoting a "cultural democracy" while equivocating the experiences of groups with unequal access to the American dream, they contributed to that peculiar fantasy of a classless American society.

Conclusion

In the epigraph to this chapter, Alan Lomax is quoted as saying that the WPA years were notable because "America as a multiple civilization was being recorded, studied, and archived as never before." I have begun to chart a plumb line from midcentury to the present in the role of benchmark arts organizations, the Federal government, and a small group of reputational entrepreneurs in documenting, preserving, and displaying American

vernacular art. The governors of these organizations and events contributed to the growth of new arts institutions and organizations. They effectively legitimated a form of vernacular American culture through the consumption of this culture by elites, who then condoned such consumption as a form of moral and civic engagement. The WPA art projects fostered two tendencies that are critical to this argument: as one historian defined it, "a greater awareness of art on the part of the American people, and a greater awareness of America on the part of the American artist."[72]

The New Deal arts programs, in all of their manifestations and via the long arm of their influence, created an opportunity for the aesthetic legitimation of a large number of cultural forms. The American public was exposed to an astonishing range of types of art and viewed this art as an important component of civic life and identity. These cultural forms were "harnessed to a clearly articulated ideology embodied in the exhibitions and performances of organizations that selected and presented art in a manner distinct from that of commercial entrepreneurs."[73] The representation of the manifold character of our nation, its many people and traditions, cultures and identities, was something the American public seems to have welcomed. Growing up in the Progressive and post-Progressive Era must have had profound consequences for how that generation viewed their lives and their country.

In the previous chapter, I argued that the first wave of aesthetic legitimation in America established the pathway by which creative forms came to be seen as art. After visual art museums and symphony orchestras were established, a second wave of aesthetic legitimation ensued, which contoured the pathway, shaping the American character of opera, ballet, modern dance, and theater. The infusion of state subsidy during the New Deal both accelerated the pace of artistic legitimation and widened the path, allowing new and more diverse forms of cultural work to be seen as art. This process, by which high-culture institutions increased in number and kind and expanded to include additional forms of culture, is an important indicator of the shifting cultural tastes of Americans.

So far, this argument and its evidence have been sweeping in scope—an effort to describe broad social processes and patterns. But these forces were felt by individuals, at specific organizations, in specific and interesting ways. In the next chapter, we examine the post–New Deal legitimation process in detail, with a focus on a single organization: the Museum of Primitive Art.

3

The Museum of Primitive Art, 1940–1982

More than seven million visitors walked through the gold and glass doors of New York's Metropolitan Museum of Art (Met) in 2017.[1] The Met's Michael C. Rockefeller Wing is larger than many museums, at forty thousand square feet, with nine galleries containing eleven thousand works from 3,000 BCE to the present.[2] The collection includes objects from sub-Saharan Africa, the Pacific Islands, and North, Central, and South America. The highlights of the wing include ceremonial objects from the Kingdom of Benin, sculptures and images from West and Central Africa and Polynesia, and pre-Columbian gold. By any measure, it is an impressive collection, and it contributes to the Met's reputation as an "encyclopedic" museum. But why is the Rockefeller collection housed at the Met? The masks, canoes, engraved poles, even the jewelry and adornment, are more reminiscent of the material in the American Museum of Natural History, across the park and a few blocks north. Why were these objects in an art museum? Are they art?

The answers to these questions reveal the tumultuous history of this wing: how its objects came to form a collection, why they are associated with the Rockefeller name, and why, for decades, the Met refused to include them in the museum. We might ask the same questions about any collection in the Met—the Arms and Armor, the Costume Institute, or the painting galleries, where photographs, Impressionist art, and neon sculptures all

hang on the walls. Each of these collections, at one point in history, contained items that educated and reasonable people refused to view as art. Over time, through what might seem like alchemy, these objects transformed into art.[3] They ceased to be seen as craft, or handiwork, or forms of entertainment, and began to be lauded as artistic achievements, hung in art museums, desired by collectors, and bought and sold at auction houses. This is the process of artistic legitimation.

We have already begun to understand the process by which art is separated from vernacular culture. But the rationale for the addition of fields to the artistic canon in the twentieth century is arguably different from that for the previous century. The motivations of the Brahmins and the power they wielded over their city are different from what nonprofit benefactors and administrators faced after the Great Depression. The spirit of democratic inclusiveness that issued from the New Deal era had anchored itself in the arts in a way that could not easily be dislodged. This isn't an argument about people's inner commitments or intentions: those would be ultimately impossible to gauge. This is an argument about how *institutions* operate.

The arc of history bent toward the rapid artistic legitimation of multiple creative fields. Yet progressive administrators, many of whom worked in WPA posts, did face resistance from an older guard, who questioned whether vernacular culture could ever be exhibited alongside the highbrow arts. We witness such resistance to the Rockefeller collection, which makes it a good case study for a more thorough investigation of the processes of artistic legitimation in the second half of the twentieth century. Moreover, the reputational entrepreneurship of Rockefeller illuminates a complexity we will observe in most struggles toward the expansion of the arts. On the one hand, Rockefeller's ability to appreciate non-Western art made it possible for others in the art world to view these works as more than anthropological artifacts or curiosities. On the other hand, these objects were removed from their sites of production and early circulation and left in the care of American curators and tastemakers to make of them what they will; in Rockefeller's case, he leveraged them to produce capital he used in a struggle with other collectors and museum administrators. What he did not do is redistribute those resources toward living artists or register much hesitation about moving those objects to New York. Nor did he have to acknowledge the labor done by earlier advocates of these arts in black internationalist movements.[4] Thus, this case study widens our view of the cultural and economic politics of artistic legitimation.[5] Finally, it provides an opportu-

nity to explore how culturally voracious elites used their cosmopolitan orientations to engage in processes of artistic legitimation.

With this chapter, we shift from understanding the world that these elites inherited to understanding the world that they produced. Here, I rely on primary data gathered from the extensive organizational archive located in the Metropolitan Museum's Robert Goldwater Library in the Department of the Arts of Africa, Oceania, and the Americas (see appendix A for more information).

Nelson Rockefeller, Art Collector

The core of the Rockefeller Wing is a large gift of objects from former Governor Nelson Rockefeller's personal collection. This may come as a surprise, since most comprehensive biographies of Rockefeller spend only a few pages on his contributions to art in America.[6] Yet Rockefeller amassed quite possibly the largest collection of what was referred to as "primitive art."

Rockefeller's first "primitive" art piece was a "Sumatran knife adorned with a sculptured head and human hair" that he bought while on his honeymoon in Hawaii. Beginning in the 1930s, he traveled extensively in Mexico and Latin America, dedicated to fostering economic development.[7] While there, Rockefeller "swooped down on the local markets, acquiring a cornucopia of native handicrafts of all varieties—the good, the bad, and the ugly. In the ancient Inca city of Cuzco . . . Nelson walked away with vast armloads of woolen blankets and serapes. In another town, one of his companions was offered a hideous travel bag festooned with alligator claws."[8]

Nelson's mother, Abby, collected both primitive and modern artworks—he called her "one of the great influences I have had"—and, as her collection grew and her philanthropic portfolio matured, she decided to found a new museum to house her modern works.[9] In May 1939, Abby co-founded the Museum of Modern Art (MoMA), and Nelson was asked to serve as president of the board. According to Rockefeller, she and her peers founded MoMA to "try to help to reduce the time between creation and appreciation by the public."[10] That is, modern artists could be recognized by the public while they were still working, and thereby "avoid poverty and lure potential artistic ingenuity into new forms of creativity." This was impossible without MoMA, because the Met "would not show any so-called Modern art. They would not collect it and they would not show it."[11] When he was just thirty-two years old, newly appointed by President Roosevelt to the Office of Inter-American Affairs, Rockefeller supervised his first major exhibition at

MoMA: "Twenty Centuries of Mexican Art." While planning the exhibit, Rockefeller met curator René d'Harnoncourt.

D'Harnoncourt is a fascinating figure in twentieth-century American art. He started his career as an assistant in Frederick Davis's folk art shop in Mexico City, one of the first to sell the work of emerging Mexican artists like Diego Rivera, José Orozco, and Rufino Tamayo.[12] In 1930, while still living in Mexico, d'Harnoncourt organized an exhibition of Mexican fine and applied arts that opened at the Metropolitan Museum of Art and was then sent on a national tour of museums. He moved back to the United States to become the Manager of the Works Progress Administration's Indian Arts and Crafts Board (IACB). In that post, he mounted one of the first national exhibitions of Native American arts at the Golden Gate International Exhibition in 1939.[13]

Rockefeller and d'Harnoncourt's friendship was built upon their mutual regard for Mexican murals and their shared commitment to expand the canon to include folk, vernacular, and primitive culture. Prevailing institutional tendencies had long isolated those traditions from the academic history of art.[14] The two men sought to effect change through existing organizations: both had worked for President Roosevelt during the years that he funded the most ambitious, expansive public arts program in the history of the country. However, Rockefeller and d'Harnoncourt's endorsement of primitive art alienated them from most art historians and collectors.

While they pushed for change at MoMA—d'Harnoncourt would become its director in 1949—they also scoured private and public sales for more items to add to Rockefeller's growing collection. D'Harnoncourt acted as advisor and agent, helping Rockefeller to "develop lists of desiderata, including detailed drawings and photographs of particularly good examples of certain types of sculptures."[15] These indexes or reference documents helped document and determine the value of pieces Rockefeller owned or would acquire.

By the 1940s, the collection included over a thousand objects; there was very little space left in Rockefeller's Manhattan townhouse, where the collection was housed, and some of the objects were deteriorating and required restoration. Rockefeller approached the director of the Metropolitan Museum of Art, Herbert Winlock, and offered the collection to the museum. To Rockefeller's surprise, Winlock refused, suggesting that the Museum of Natural History was a more natural fit. After all, the Met had deaccessioned its own collection of pre-Columbian art to its uptown neighbor in 1914, and

there was skepticism and resistance toward viewing non-Western art as part of the organization's mission.[16]

Cultural artifacts produced in Latin America, Africa, and Oceania were traditionally housed in anthropological or "ethnographic" museums and therefore isolated from equally old and functional works created in the so-called "West." Rockefeller and d'Harnoncourt's museum sought to challenge the prevailing institutional tendency to isolate these traditions.[17] In this moment, primitive art objects are paradigmatic "boundary objects," which is to say that they are tools used by multiple communities of practice (here, anthropology and the burgeoning primitive art world), and are useful in both, while having different meanings in the different sites.[18] The museum's acquisition policy demonstrates that Rockefeller and d'Harnoncourt felt strongly that experts and audiences needed to start seeing primitive works as having "artistic qualities" rather than viewing them as "complete representation[s] of cultural areas," and noting their "artistic excellence" rather than seeing them as "illustration[s] of specific cultural characteristics" as an anthropologist would do. [19]

Instead of taking Winlock's recommendation to heart, Rockefeller continued to add to his collection—that is, until Dr. Julio Tello called with an urgent request to save his *paracas* bundles. Tello, a keenly inquisitive and energetic man, studied linguistics, medicine, and anthropology.[20] By the mid-1920s, working as a credentialed archeologist but making his money as a physician, Tello excavated several gravesites where the paracas, an Andean civilization that inhabited the mountains of present-day Peru between 800 BCE and 100 BCE, preserved their dead, seated and bound in detailed textiles, or "bundles." While working at the site, Tello had, in Rockefeller's words, "made the mistake of getting elected as a Senator" in Peru. But, in 1930, Tello lost his seat when a new party gained control of the government, and then he lost his position in the Museum of Peruvian Archeology. He had sixty paracas bundles in his possession when he moved out of the highlands and down to the city of Lima, and they began to quickly deteriorate in the city's moist and salty air. The new government had no interest in preserving Tello's collection, in assisting a political rival, or "in what they considered was Indian art. They were Spanish colonials, in their point of view and in their thinking."[21] Tello asked Rockefeller to export them or help him to find a suitable, climate-controlled, and safe space in Peru. Rockefeller first gave Tello some funds to unwrap several of the bundles and then approached the President of Peru. In Rockefeller's words: "I explained to him that they had

not only national treasure here, but one of the great treasures from a cultural point of view in the world, and that it was to their interest to rise above politics and to provide for the case of these materials."[22] The president agreed, and, as a gesture of gratitude, Rockefeller was gifted one bundle to take home to the United States.

Rockefeller returned home with the bundle and, in his words:

> had the idea that maybe I could get the Metropolitan Museum and the Museum of Natural History, which . . . has some very magnificent works of art in the pre-Columbian field, but they are all treated from an ethnological point of view and not from an artistic point of view. . . . I thought that if we could combine the two, that we would then have . . . a very exciting program for the Americas, and that we could carry on digs and joint operations the way the British had in Egypt and other areas.[23]

Rockefeller's reference to the Met's work in Egypt was particularly clever, because Director Winlock was a famous Egyptologist and had continued to build the Met's Egyptian collection even after he sent their sub-Saharan African collection uptown to the Natural History Museum.

Yet again Rockefeller offered Winlock and the Met over one thousand works from his own collection, in addition to the paracas bundle.[24] But Winlock and Rockefeller had recently clashed over a proposed gift to the museum—a sculpture by Rodin of two nude figures embracing, which Winlock felt was in questionable taste. "Such prudery left Nelson incredulous," but he held out hope that Winlock would back away from his initial resistance.[25] Unfortunately, Winlock informed Rockefeller that collecting non-Western art was still not part of the Met's mission, despite its ostensible status as an "encyclopedic" museum. Rockefeller chose to believe that Winlock rejected the request not on disciplinary grounds but rather because he "viewed this whole pre-Columbian field as a major threat to his program in Egypt, and [Winlock] was successfully able to snuff [the pre-Columbian collection] out before it got started."[26]

Thankfully, "far from discouraging [Rockefeller], the rejection only intensified his commitment to the artwork and the culture that produced it."[27] Undeterred, he incorporated his own museum.[28] The Museum of Indigenous Art was given a charter on December 17, 1954. It was housed at 15 West 54th Street, next door to Rockefeller's childhood home.[29] On February 21, 1957, after a change to the name was approved by the board, the Museum of Primitive Art (MPA) opened to the public.[30] At the time, it was the only

museum in the United States devoted to the presentation of art from the indigenous cultures of the Americas, Africa, and Oceania.[31]

The decision to build a new museum might seem like a costly response to the Met's refusal to accept his collection, but remember that Rockefeller's mother co-founded MoMA from her collection of artworks, themselves deemed ill fitted to the mission of an encyclopedic museum. Abby's collection focused on what would be known as "modern art," including works by Picasso, Matisse, and Degas. Both mother and son were seen by many at the time to have unconventional tastes: for both "primitive" and modern.

Primitive and Modern: Frontiers of Legitimacy in the Midcentury

The Museum of Primitive Art was one of the most innovative, daring, progressive institutions in midcentury New York.[32] If we make sense of the MPA's impact through comparison with other organizations, its closest peer was not the Fields Museum in Chicago, nor the American Museum of Natural History on the Upper West Side of Manhattan. Instead, its closest peer was across 54th Street, and it was founded by Rockefeller's mother.

Perhaps the most important reason to compare the MPA and Abby Rockefeller's MoMA is not the Rockefeller connection, but rather the fact that both institutions mounted effective challenges to the disciplinary narrowness of museums in the midcentury. Both modern and primitive art were battlegrounds: arenas for reputational entrepreneurship, where wealthy speculators asserted the value of their own collections by seeking institutional sponsorship. They did so by offering donations, seeking to sponsor or loan objects for exhibitions, supporting the creation of new ventures (including organizations), and strategically buying and selling works to stimulate the market for those works.

MoMA and the MPA were both created from private collections that did not fit within existing American museums. Both reflected the Rockefellers' commitment to a global vision of "authenticity that could plumb native sources of modern art within an academic tradition."[33] Both mother and son were committed to transforming a diverse cross-section of vernacular culture into art by placing it in art spaces and producing an art-historical argument to legitimize its beauty and importance. As Rockefeller wrote in the press release announcing the opening of the MPA: "We do not wish to establish primitive art as a separate kind of category, but rather to integrate it

with all its amazing variety, into what is already known of the arts of man."[34] Abby could have said much the same about modern art.[35]

Abby and Nelson Rockefeller were by all accounts captivated by the aesthetic similarities between primitive and modern art. Starting in the early twentieth century, European painters Paul Gauguin, Maurice de Vlaminck, Henri Matisse, and Pablo Picasso; sculptors Jacob Epstein and Amedeo Modigliani; anthropologists, like Franz Boas; photographers, including Alfred Stieglitz; and precious few collectors, like the Rockefellers, honored these associations. But reverence for the aesthetic value of primitive art remained confined to this small group for many decades. Very little credibility was transferred from modern to primitive art, in part because modern art had so little shelter to offer. Modern art was not popular among elite art collectors and was rarely included in the collections of encyclopedic museums, so primitive art had very little to gain from the association. But what Rockefeller must have realized, from his mother's tutelage and his time at MoMA, was how to trigger and control the process by which artists, objects, styles, and genres enter the artistic canon. Both modern and primitive works would be subjected to reputational entrepreneurship by the Rockefellers. In the founding of a museum, that process had already begun.

Inventing the Field of Primitive Art

When the concept of "primitive art" first emerged, it wasn't clear to everyone that such a thing could even exist. Were the terms really consonant? The MPA's original name included a reference to "indigenous art," which was later replaced with "primitive art." While "indigenous" simply means "native to a place," in this case it was meant to refer more specifically to tribal or aboriginal peoples. Director Goldwater described the museum's collection even more narrowly, as containing works from preindustrialized societies with no writing system.[36] But Rockefeller's definition was broad, encompassing vernacular, folk, popular, and ordinary objects, including those from the precolonial and colonial United States. ("the popular art of the early days of this country—primitive art, whatever you want to call it"); he was often at pains to note "how unprimitive primitive art really is." [37] He rejected the association of primitive art with functional household or religious use; Rockefeller is quoted as saying, "Don't ask me whether this bowl which I am holding is a household implement or a ritual vessel. I could not care less."[38] So we see that Rockefeller thought about primitive art in a mod-

ern way: for him, the category included both household and folk objects, and it was skilled, modern, and civilized.

Until the MPA was founded, primitive art objects were presented in ethnographic or ethnological museums. In these museums, the technical, social, and/or religious function of each object was presented to the viewer, both in text and in the context of display. Usually, that meant that the object was presented as foreign and exotic—that is, the explanation provided to us helped us "make sense" of what the object "is" by drawing a comparison with familiar things: rituals, family life, and so forth. These wall labels or pamphlet texts typically did not focus on the object's place within a history of innovation or craftsmanship of similar objects, nor did they allow the aesthetic qualities of the work to be focal, or to "speak for themselves."

In contrast, Western aesthetic objects were presented "as having been made by named individuals at specific points in an evolving history of artistic styles, philosophies, and media . . . as part of a documented history (with names, dates, political revolutions, cultural and religious rebirths and so forth)," even if much of that was presented outside of the gallery, in art history texts, lectures, and art magazines.[39] In fact, this was the way you could distinguish anthropological objects from art objects: Does it have "tombstone text" (the work's title, medium, dimensions, and the creator's name and birth and death dates) or artifactual information including geographical origin, function, and meaning (in which case it is not art)?

PRODUCING THE IDEA OF PRIMITIVE ART

Although the academic study of "primitive" objects and cultures pre-dated Rockefeller and d'Harnoncourt's interest by centuries, the treatment of them *as art* was novel. Rockefeller and d'Harnoncourt set out to convince other collectors, critics, and art experts to treat the truly diverse set of objects they collected from half of the globe as a coherent body of material that should be referred to as "primitive art." They advanced an argument about the placement of these objects within a formal and aesthetic idiom. They were "producing" the field of primitive art—seeking to legitimate it as art.

In their correspondence, in interviews with the press, and in official museum publications, MPA administrators noted the need for experts and audiences to start seeing primitive works as having "artistic qualities." If claims to legitimacy are made on the basis of conformity to "norms, values, or rules," then advocates for protoart forms like Rockefeller and d'Harnoncourt

must establish what those norms, values, and rules will be through the arguments they make.[40] They need ways to debate and explain art.

Soon after Robert Goldwater became the director of the MPA, he was introduced to the board as someone who is "particularly anxious to get away from the museum-of-science type of show in order to give the public an idea of the esthetic [*sic*] quality of the collection rather than its scientific merit."[41] And yet, despite the emphasis that Museum directors placed on the aesthetic value of the objects in the collection, and their consistent and forceful rejection of the anthropological qualities of these works, we still find traces of this mode of value. For example, a press release from the museum included the following:

> As different as the Egyptian sculptor of ancient times may seem from the Dogon wood-carver of present way Africa. . . . they lived—or live—in societies where communal life was filled with religious intensity. . . . In such 'primitive societies' a work of art—or what is today termed *art*— was in reality a religious object permeated with magical significance.[42]

The text emphasizes that art is a modern invention, and so there was no possibility these objects could have been seen as such in their native environments, and the emphasis on religion, magic, and communal life draws our attention to their anthropological significance. Even for employees at the MPA, the distinction between anthropological and curatorial approaches to classification could be quite thin.

Printed and digital material, including news, magazine, and scholarly articles and books, play an important role in circulating arguments about the legitimacy of protoart forms. Some published material carries enormous cultural authority and can act as guides for sophisticates.[43] When publications are devoted, in whole or in part, to identifying emerging trends and to identifying worthy choices within a new or less familiar field of options, they guide readers toward consensus over legitimate options among what is available. More than simply pointing readers toward acceptable choices, these texts provide readers with a rationalization or justification for these selections. These justifications provide important evidence of the ideologies that motivate artistic legitimation in general, as well as in the specific case.

The MPA's own director Robert Goldwater made his career from the publication of his PhD dissertation, "Primitivism and Modern Painting," in which he drew comparisons between twentieth-century western art (Miró, Dali, Klee, Modigliani, Picasso, Gaugain) and non-Western traditions, focusing on the formal or technical affinities between modern and primitive

works. Comparisons such as these would shape the field and influence cu-
ratorial practices: "By such means the public, almost without being aware
of the process, began to be acclimatized to the primitive arts: the admiration
that Picasso and Modigliani aroused in their viewers unversed in primitive
art was often transferred to primitive art itself."[44] Publications provide space
for critics, connoisseurs, and artists—aestheticians—to create knowledge
about art.

Aestheticians provide fans and practitioners with a dictionary of terms
they need to describe artworks, and with justifications of their artistic le-
gitimacy.[45] Aestheticians make arguments that specific art forms are legiti-
mate, adapting criteria from other fields, using those to sort examples by
quality and qualities, attacking performances that did not merit the com-
mercial acclaim they received, and seeking to highlight undercapitalized
material of high quality.[46] Aestheticians are primarily employed on the fac-
ulty of colleges and universities, and, partly for this reason, universities are
often held up as model legitimating organizations.[47]

Why are universities so successful at artistic legitimation? Disciplines
and courses of study are simply organized knowledge. Curricula are catalogs
of items that educated people are compelled to know. The inclusion of a
work of art, or an idea about art, in a course of study communicates that it
is part of the body of consecrated, legitimate, and necessary knowledge
about the world. Universities are credentializing institutions—they send
graduates into the world with degrees that reflect an assessment of their
learning and achievement. And so, the inclusion of an artist, performance,
object, or genre within that curriculum, as part of the body of knowledge
an educated person must have, is a strong signal of legitimacy. Colleges and
universities and their faculties and students can be critical instruments in
the aesthetic legitimation of fields.

PRODUCING OBJECTS

Producing primitive art objects did not only require a transformation in
awareness and thinking; in some cases it required transformations of the
objects themselves. These pieces were often, in the context of the modern
museum, "unruly" objects, not "easily stabilized and transformed into time-
less 'objects' of formal delectation."[48] For example, the intricate Navajo sand
paintings that were made on a surface designed to be sat or stood upon, and
thereby erased, were unruly until they were fixed in a medium for display.
Artisans were contracted to design them on surfaces covered with glue or

to paint them to make them durable and portable, and, thus, able to be "hung on walls as 'art.'" But are those hung sand paintings a new art form, invented by art dealers?[49]

You could claim that art buyers invented a new form of Gobonese reliquary figurines when they stripped off their original fibrous materials to facilitate shipping and display. In general, primitive-art buyers tended to do this with sculptures and jewelry made from organic material, including feathers and leaves, if they bothered buying them at all. In fact, the avoidance of objects manufactured from certain kinds of material, fueled by concerns over the limits of our conservation technology and training, shipping and maintenance, and the "unstated and largely unconscious link . . . between the permanent and the civilized, the durable and 'high' civilization and the arts," means that "hardwood sculptural forms predominate" in collections of primitive art.[50] Whole categories of art might have been eliminated from the canon as a result of the failure to obtain or discipline those objects.

Fixing sand to a surface and stripping off material that will quickly rot are both processes designed to prepare art for display—to transform docile objects into ruly ones, to turn non–art objects into art objects that can be presented in frames, both literal and figurative.[51] These frames communicate to the viewer that these are not ordinary objects—that they are "sacred." Art appears within a boundary that sets it off and tells the viewer, "This is not a regular object. It is an art object." That boundary might be a frame, a pedestal, a stage, or any mode of separation of "profane" or everyday life from "sacred" artistic space.[52]

PRODUCING AUTHORS

The creators of primitive objects were often seen not as artists but rather as "what remains of the childhood of humanity": untrained, innocent, unindividuated.[53] Some argued that "the artists of Africa, Oceania, and Native America [are] . . . the servants of communal tradition, fashioning objects according to prescriptive rules inherited from past generations." Others "argued that its authors are in particularly close touch with the fundamental, basic, and essential drives of life—drives that Civilized Man shares but buries under a layer of learned behavior," leading to comparisons with the drawings of children, and the doodles of the insane. Others simply viewed the makers as servants of the community, providing (ritual) objects as cooks provide food: "In Africa there is no creative artist as such. . . . [The African

craftsman] produces the masks and fetishes according to the needs of the moment, always on order of the dignitaries of the tribe and never following his inspiration of the moment."[54] Many people did not view these works as art, nor their creators as artists.

It comes as little surprise that authorship was a battleground in the founding of the MPA, because many experts argue that what is primarily at stake in any field of cultural production is defining who is entitled to call themselves artists.[55] Artworks almost always have authors—it's one of the things that sets them apart from other forms of culture. In fact, the signature of an artist is often what we use to authenticate the work as a piece of art. Credibility, legitimacy, authenticity, and authorship are bound up together; Michele Foucault famously referred to this as the "author function."[56]

The fact that whole classes of objects, like some forms of sculpture, or quilts, may not have single creators, or might not be "signed" (literally or figuratively) is perplexing to many people.[57] In September 1958, MPA Director Robert Goldwater appeared on a radio program called "The Fitzgeralds at the Astor." Asked if the objects in the MPA collection were signed, Goldwater answered as follows:

> In a few cases you get signatures, either actual signatures or signs that indicate artists. The artist is anonymous in the sense that in most cases we don't know his name. That doesn't mean he's anonymous in the artistic sense, because the primitive artist has as much personality, as much individuality I would say, as a great many artists in the Western world. It used to be the rather romantic notion that primitive art was sort of made by everybody together. Well, this we know today is certainly not the case. The artist, in other words, in primitive societies the artist is as individual, as respected, as separated in most cases from people around him and admired as he is in our own culture.[58]

Goldwater's answer, and the question he was asked, get to the heart of one problem that must be addressed to build an art world—you need to have artists. And in Goldwater's answer, you see him preemptively rebut a set of arguments against the view that these creators are artists. He says they work individually, and that they are admired as creative workers.

In cases where authorship could not be known, an author was "invented" by substituting the name of a (Western) owner of the object. Such was the case with the "the 'Brummer Head' . . . [which] got its name not from the African sculptor who made it, but rather from a Hungarian who once owned it."[59] Thus, in primitive art, an object "that was once owned by Henri

Matissse or Charles Ratton or Nelson Rockefeller is unrelated, in this system, to a sculpture made by the same artist that was not."[60] Collectors function as author names function elsewhere, establishing quality and even style for potential buyers.[61]

Provenance is established through the documentation of ownership. The provenance for an object includes a manifest that lists all prior owners and dates of possession and documentation of each, including photographs, if possible. This documentation is presented by an auction house or gallerist to prospective buyers to establish the work's authenticity and value. When a work is unsigned and its provenance unknown or contested, art authenticators work to establish any resemblance between the object and other works attributed to that author (or known authors). They evaluate whether the work has achieved the same level of quality as known works, and if the ideas or aesthetic elements bear a stylistic uniformity with them. In the absence of a signature, authenticators seek to suggest categorical authorship in the form of associations with regional styles, known authors, and craftsmanship. While the absence of an author can frustrate the evaluation process, it can add to the "exotic" luster of the collecting experience for some. Apparently, the actor Vincent Price was a collector of primitive art until his death, and he allegedly praised the fact that so much primitive art is unattributable to a single creator, stressing that this enhances the seductive appeal of collecting and adds to the "mystery of creation."[62]

PRODUCING DISINTERESTEDNESS

Even in cases where authorship was documented, MPA staff had to ensure that the creator had the "right kind" of identity. Just as particular subject matter and materials are more likely to be seen in the West as "legitimately" or "authentically" primitive, certain kinds of biographies are more legitimately "artistic."[63] In particular, we tend to view creators who proclaim their disinterest in financial reward as artists, while those who create art to make money are not viewed as favorably or are seen as simple craftsmen. This "disinterestedness" is part of how we traditionally distinguish between mass-produced goods, like entertainment products, and unique artistic objects.

If an artist "gives off" the impression that they are "disinterested" in market success, they are, in the inverted economy of the fine arts, more worthy of success in that market. It is the "losers" who become winners, while artists who are seen to pursue success (especially if they are framed

as members of some kind of avant-garde, or outsider group) can be pilloried as "sell-outs" or simply disregarded as unskilled, crass, or ill defined as artists.[64] An artist who successfully gives the impression of disinterestedness helps to convey the value of the work she produces: "The symbolic communication of disinterestedness assures audiences that such objects are authentic works of art, and not some other form of commodity that was produced for a market—a discourse that is paradoxically confirmed through high market price."[65]

Sometimes, the desire to proclaim the disinterestedness of protoartists lead their advocates to advocate a kind of dignified poverty. This is a particularly pernicious tendency among advocates for the untrained artists we refer to as "outsiders," but it applies equally as well to living "primitive" artists. Distinterestedness is thus transformed from a description of an artist's relationship to the marketplace into the romantization of poverty and dispossession. So, poor or dispossessed artists, be they "outsiders" or "primitives," can't criticize a field that expects them to remain poor in order to generate profit for others.[66]

The association of the disinterestedness of the artist with legitimacy meant that primitive artists who were seen to be immune to a Western influence on their work were more highly valued. The concern was that the introduction of Western art market concerns could pollute the "pure intent of indigenous artisans" and distort the value of primitive art, which "is authentic, expressive of the truly different Other, only when it originates outside of Western contact, in a precolonial past."[67] When "indigenous" art was created with the tastes of Western art markets in sight, the works may reflect "romantic notions of Africa" instead of a local, authentic self-image, although Rockefeller's curators and buyers worked hard to combat these prejudices.[68]

The irony here lies in the clear fact that "objects of Primitive craftsmanship do not constitute art until Western connoisseurship establishes their aesthetic merit."[69] When buyers and collectors source primitive objects, they often make a decision about the life or death of these objects since so many of them are made from soft woods and fibrous material that would decay without attempts at preservation. For example, Philip Allison, collector of Yoruba art, said: "It was better that these important pieces should be preserved in the national collection than that they should fall into the hands of private dealers and collectors, or be left to rot on neglected shrines. Even works in less perishable materials than wood were not safe. In Igalla, I found antique brass balls being broken up to mend iron cooking pots.'"[70]

Western collectors often exert unilateral control over what objects are "safe," and these are then displayed as representations of whole cultures—"in short, Westerners have assumed responsibility for the definition, conservation, interpretation, marketing and future existence of the world's art."[71] Yet the art is deemed most valuable when the traces of this external influence are totally hidden from sight. It is these objects that are far more likely to be acquired by collectors and included in museums like Rockefeller's; thus, disinterestedness and "pure" indigenous content (or authenticity) are aspects of how primitive artworks are evaluated and selected for aesthetic legitimacy.

PRODUCING AUTHENTICITY

Disinterestedness and the artistic orientation of the creator are just two aspects of an artist's identity that are evaluated in the process of establishing artistic legitimacy; her authenticity is also considered by evaluators. Claims to authenticity are claims to a legitimacy that flow from the artist's technical proficiency, or from her personal attributes and experiences. Such claims establish the work as "genuine," "natural," and without "artifice."[72] Authenticity is often something associated with, or gauged from, emotion, as when popular music is seen to be "fundamentally a release of feelings."[73] Alternatively, an artist may be viewed as authentic when there is a convincing link between her work and her background. Attributions of authenticity frequently rest on the personal characteristics of artists, including their race or gender.[74]

Evaluations of authenticity are sometimes based on the unique, handmade, or traditional characteristics of an item or on assertions about its geographic origins.[75] The more specific the referent, the stronger the assertion of the object's quality. Of course, claims about the geographic origins of an object, performance, or practice are almost always linked to the handmade, unique, and traditional character of their manufacture or source. Simple, untaught, natural, local, created without commercial motivation—these are some of the building blocks of authenticity. In primitive art, these amounted to signals of a specific tribal, or at least regional, identity that was revealed in details of style, composition, and materials.[76]

This is the simplest notion of authenticity: the ability of a place, environment, person, or object to conform to an idealized representation of reality—that is, to a set of expectations regarding how something ought to look, sound, feel, smell, and so forth.[77] For the art forms that underwent artistic

legitimation in the twentieth century, these include a fascination with the handmade quality of objects, their relationship with tradition and specific geographic places and nature, and their nonindustrial production and simplicity or rusticity.[78] In short, "influential and powerful actors *create the creator* through the shaping of biography."[79] This is true of all art, but particularly true in the "domain of self-taught art in which the authenticity of the artist justifies the authenticity of the artwork."[80] In primitive art, these biographical dimensions—particularly, the rusticity, simplicity, rurality, spirituality, and non-Western lifestyle *imagined* for the creators of the objects *by viewers*—came to serve as a measuring stick for their authenticity. The irony is that museumgoers believe they can judge the absence of "pollution" by colonial (especially Western) outsiders.[81]

This irony points toward the fact that authenticity isn't an intrinsic or objective quality of a person place or thing, but rather a perception, a socially constructed set of beliefs, something that is "produced," made, or enacted. To illustrate this principle, scholars have highlighted the efforts of artists, managers, agents, producers, and other artistic support staff to "fabricate authenticity."[82]

PRODUCING EXCELLENCE

Primitive art lacked an art historical classification system that would order works. We can view the invention of one such system by Rene d'Harnoncourt, because he assiduously documented it within the indexes he assembled between 1940 and 1956. These four notebooks, titled "Catalog and Desiderata," are stored inside a periwinkle blue file box that stands on a shelf in the climate-controlled basement of the Met. The frontispiece of each notebook features a carefully hand-ruled table with typewritten column labels for broad geographic region ("Central Africa"), "territory or political division" ("East Belgian Congo"), and then "tribe" ("Basonge"). On the opposing page, there is a numbered list of these tribes, and these numbers are used to label crosshatched regions sketched on an exactingly hand-drawn map of a portion of the world ("sub-Saharan Africa"). The remainder of the pages in each notebook feature expert illustrations in pencil or pen by d'Harnoncourt of individual objects. Each page is topped with geographic identifying information (region, territory, tribe, and the assigned tribal number), a typed brief description of the object ("mask"), and sometimes, handwritten notes ("good one at Carlesbaad"). The handwritten or typed notes invariably include some comparison between the drawn object and

others known to be in museum or private collections ("a very fine example in Collection Samuel Lothrup"). Photographs were added as works were acquired.

What the notebooks reveal is the process d'Harnoncourt followed to define the characteristics of museum-quality primitive art. The association of works with geographic regions and the particularistic cultures of people within them form his first criterion for assessment. The anchoring of difference in geography is a first-order process in both anthropology and curatorial work. So too is the focus on provenance and medium. These are key criteria in the assessment of art objects and anthropological objects. The illustrations and notations of form and style capture the aesthetic features of each object, while the comparison with known objects help experts assess their level of artistic accomplishment. This text indicates—sometimes explicitly, sometimes through comparison—an assessment of the quality of workmanship, and of the size of the market for, and value of, the object. The notes include comparisons between the drawn object and others that d'Harnoncourt knows are in museum or private collections. D'Harnoncourt's comparisons establish what similar objects are known to exist, and whether the drawn object is the best of these.

In these notebooks, d'Harnoncourt is working to define a new field of art. He first encounters the broadest question: What commonalities do objects within the field share? Then, what are the major subgroups, genres, or styles? Within those subgroups, genres, and styles, which objects best exemplify or typify the category? Why these and not others? What are the meaningful differences, or forms of internal variation, within these categories? This classification work is essential to establishing a new field of art.

The system he devised emphasized beauty and mastery. Rockefeller and his staff sought to include beautiful objects that would belong "among other supreme artistic achievements in the world."[83] In press releases and gallery cards, they discuss the objects' exemplary craftsmanship, emotional resonance, and beauty.[84] Rather than seeing their goal as encyclopedic, or, like anthropologists, aiming to highlight various aspects of culture, MPA administrators encouraged viewers to consider objects' "artistic excellence."[85]

Their approach to acquisitions was to acquire both broadly and with an eye toward "best in class" or "transformative" works. Rockefeller prized formal aspects of works that would interest any art appreciator. In his own words,

My own interest is purely aesthetic. The beauty and fascination of form, texture, color, and shape provide never-ending excitement. Whatever we

can learn about the art displayed in these galleries, the objects themselves transcend all explanation. In that sense, they are like all works of art.[86]

In emphasizing the primacy of aesthetic criteria, Rockefeller and d'Harnoncourt were compelled to acquire objects of exemplary craftsmanship and great emotional impact.

Just as a conventional museum might purchase a portrait by Rembrandt, or a masterpiece by Mary Cassatt, the MPA needed its own masterworks. The MPA's Benin ivory pendant mask was one such work. Here is how Director Goldwater described it to the museum's board:

> I believe this mask . . . in [its] delicacy of workmanship and penetration of expression . . . is thus the best object of its kind known, nor will any others ever turn up. . . . The purchase of this mask would give the Museum a permanent, primary attraction—a popular masterpiece. It is one of those objects that "has to be seen" by scholars, art lovers, and the public alike. As René [d'Harnoncourt] has suggested, it is the kind of object that would . . . have to be put permanently on view.[87]

Delicacy, penetration of expression, a masterpiece. This description guided museum directors, and ultimately would guide viewers of the object, toward an understanding of what "beauty" looks like in the perhaps unfamiliar form of an ivory mask.

The MPA staff placed emphasis on acquiring "transformative" works: "works, it was believed, that epitomize creative expression in a given tradition and distill it in a single, exemplary, artistic interpretation."[88] These works are essentially contradictory: they are at once exemplary—without equal—and they are examples of or guides toward stylistic, aesthetic, and craft standards to be sought within a class or group of objects. Director Goldwater's description of another object, the Great Bieri Mask, illustrated this point:

> For every style, and every period, in the history of the arts of mankind, a few works stand out above the rest. Somehow they both contain and surpass all these qualities which we value in the art of the culture from which they come. They seemed to have captured the ideal of design and expression toward which many artists [have] tended. We refer to these works as classic examples of their kind, and they impress upon our memory with a particular clarity. The GREAT BIERI is such a work: it is the embodiment of Fang sculpture, and one of the great classics of African art.[89]

In his celebration of the mask as peerless, a classic, Goldwater guided experts toward certain of the object's characteristics as emblematic of a group ("Fang sculpture"), and its manufacture as an ideal manifestation of those characteristics. Establishing these points of reference and having the expertise of Goldwater and the museum behind them compelled other people to view them as influential.

The museum had a propensity for acquiring works that displayed what experts call "iconic signification," or a resemblance to some object in the world, like a person or an animal. The MPA was not alone in this; objects with these characteristics are much more likely to "become Primitive Art than are objects that are 'decorated,' even beautifully, but have little or no iconic content."[90] As a consequence of the limitations of art display, purchase, and conservation, then, "a hierarchy of primitive art substances emerges, in which Benin bronzes, ivory masks, and hardwood sculptural forms predominate over ritual figures made of leaves, disintegrating fabric, deteriorating tapa cloth, fraying baskets, breakable pottery."[91] Much of what we treat as "primitive art," then, corresponds with dominant Western notions of art; most of the objects in the MPA passed for, and passed as, sculpture. Thus, iconic signification is a final, if implicit and unevenly applied, criterion the MPA used for inclusion in the collection.

Influencing the Postcolonial Art World

Having assembled its collection, loaded the galleries, and opened its doors, the Museum of Primitive Art enjoyed immediate success. In a press release from February 1958, the date of the museum's first anniversary, Dr. Goldwater communicated the institution's growing commitment to becoming a peerless museum:

> We feel it is our obligation, not only to help the general public become . . . aware of the infinite variety and wealth of material created by the primitive artist, but to fulfill another need. . . . More and more scholars and students are requiring a central source of information where their research efforts will be aided and simplified. This past year has seen the beginning of our effort to satisfy that need.[92]

By April 1966, Rockefeller was pushing the board to approach the Ford Foundation to collaborate on creating a "study center [in the museum] for the Primitive Arts with space, facilities and staff for aesthetic research." He further suggested that "an appeal should be made for underdeveloped coun-

try support for the Museum as a place to which the people of these countries may come and participate in its programs."[93]

Rockefeller correctly viewed culture as a powerful diplomatic tool—a distinctly useful form of "soft power." When he was appointed as the Coordinator of Inter-American Affairs by President Roosevelt in 1940, he organized the first exchange of cultural works with Latin American countries. Rockefeller then tried to establish a national Council on the Arts, which failed; a state theater at Lincoln Center, which worked; and a State Council on the Arts, which also worked. By 1967, every state had its own council, and a federal council had also been put in place.[94]

The MPA administrators worked to establish relationships with national leaders and arts organizations in several of the countries whose cultural patrimony was represented in the museum's collection. These efforts gained momentum after Rockefeller was elected governor of New York and was invited to join a US delegation to celebrate Nigeria's independence from British rule. In 1961, upon his return to New York, the MPA presented "The Traditional Arts of Africa's New Nations," an exhibition that featured one hundred objects from sixteen African countries. Rockefeller, the American ambassador to the United Nations (UN), and the UN representatives of those sixteen nations attended the opening. The message was clear: Rockefeller's museum would celebrate the end of colonialism with the inclusion of African and Oceanic arts in the art historical canon. Those works would be treated with the same respect and reverence as their peers in the encyclopedic museums: they would have provenance, be interpreted in the context of their production and their aesthetic achievement, and serve to exemplify a set of creative communities, or genres, from which they emerged.

Works from the MPA collection also traveled to Africa—notably, to the Rhodes National Gallery in Salisbury, Rhodesia (1962), and to the First World Festival of Negro Arts in Dakar (1966). Both of these loans "were intended to support Africa's pride in its artistic patrimony and cultural history."[95] The loans were initiated by the director of the Rhodesian National Gallery and the festival organizers in Dakar, and both exhibitions emphasized the importance of "African arts and their impact on Western culture," rather than the reverse.[96] Although intended to "inspire more understanding," by highlighting the influence of Africa on Western culture, these exhibits were "perceived as subversive" by many art experts.[97] President Lyndon B. Johnson read a statement of support for the newly independent nation of Senegal, and the festival's representation of "L'Art Negre," including those works on loan from the MPA. He said: "Nowhere outside of Africa

itself have the values and the influence of Negro arts achieved greater vitality than here in the United States. These values, so familiar to Americans, have yet to be fully appreciated beyond our borders. The Festival should do much to win for the genius of Negro artists the recognition it desires."[98] Rockefeller could not have hoped for better publicity for the museum than if he had written the speech himself.

Move to the Met

The museum thrived in the subsequent years, expanding its footprint by annexing an adjacent building, partnering with peer institutions for exhibitions, and expanding and circulating its collection around the globe.[99] By the end of the 1960s, Rockefeller was again considering the need to move the collection to the Met. The board meeting minutes indicate that the question of deaccessioning the collection was raised in January 1967, and again in November 1968, by Rockefeller himself, who formed a committee to "consider the conditions and results of such a move."[100] Robert Goldwater was succeeded as director of the museum by Douglas Newton, a British African art expert who arrived on the staff having left a position as chairman of the newly formed Department of Primitive Arts at the Met. By the time Newton took the chair, the decision had already been made to transfer the MPA's collection to the Met, a move which would follow two years later, in 1976. In 1982, the Michael C. Rockefeller Memorial Wing of the Met opened to the public.

In a note of thanks to Rockefeller on the occasion of the opening of the Wing to the public, Met President Arthur A. Houghton described the debut exhibition as

> an unbelievable success, with complete acclaim from the world of art, the critics, and the thousands of persons who are coming to see it. Thanks to you, the Metropolitan Museum has made—in one moment— one of the greatest forward strides of its history. I am as anxious as you that the momentum not be lost and that we build the new Department of Primitive Art into a major and most active element of the museum. It is the most exciting thing that has happened in my seventeen years association with the Metropolitan Museum of Art.[101]

It must have been a welcome note: the president of the Met congratulating Rockefeller on his collection, its success, and its contribution to the work of New York's cornerstone museum. (That it was named in tribute to Nel-

son's son Michael, a trustee of the MPA since his Harvard graduation, lost under mysterious circumstances while sourcing objects in New Guinea, must have also been a source of comfort for the elder Rockefeller. On his two trips to New Guinea, Michael had documented and acquired over six hundred objects, forming "the largest and best-documented corpus of art from any single Oceanic tradition" objects that were now a source of pride for the Met.)[102] But, in the largest sense, the president's note to Rockefeller stands as a symbol of the success of the MPA's artistic legitimation efforts on behalf of primitive works. It demonstrates the process by which influential actors began to shape the acculturation of others, toward a broader view of what is included among the "highbrow arts."

In its nineteen years of operation, the Museum of Primitive Art faced opposition from critics. While some welcomed the display of primitive art objects based on their aesthetic merits, others felt the collection would be more fitting with the mission of anthropological or ethnological museums. There were complaints that museums were feeling an increase in the price of objects after the opening of the Museum of Primitive Art and their competitive bidding at auctions.[103] Even while the directors of the museum struggled to define the boundaries of primitive art, critics questioned the exclusion of folk and modern Indian art, and many critiqued the use of the term "primitive" to describe the collection. Much to—I imagine—Rockefeller and d'Harnoncourt's delight, "it was sometimes argued that the objects displayed were not really the products of a 'primitive people,' but of cultures with sophisticated art traditions."[104]

Primitive Art and Artistic Legitimation

By the 1980s, the aesthetic legitimation of African tribal or primitive art was essentially complete. The Rockefeller Wing opened at the Met and a National Museum of African Art opened its doors in Washington, DC. There were no fewer than five major primitive art exhibits in New York City during the winter of 1984: "Northwest Coast Art" (IBM Gallery), "Ashanti Gold" (American Museum of Natural History), "African Masterpieces from the Musée de L'Homme" (Museum of African Art), " 'Primitivism' in Twentieth-Century Art" (MoMA), and the exhibits at the then-two-years-old Rockefeller Wing of the Met. Primitive art was, arguably, "at the peak of its acceptance and validation."[105]

But this validation was not without controversy, and perhaps no controversy in this period was more vivid and revealing than the one surrounding

the 1984 MoMA exhibition "'Primitivism' in Twentieth Century Art: the Affinity of the Tribal and the Modern." As the title suggests, the show was curated to illustrate similarities between modern and primitive objects. The presentation of these "affinities" was unequivocal: the work of a prominent Western artist (Rubin, Picasso) was mounted next to a non-Western or tribal piece that had similar properties. In some cases, the similarity was presented as fortuitous, an effect of the "universality" of certain shapes or themes. Other similarities were presented as a function of intent, as modern artists claimed to have taken inspiration from existing works. For example, Picasso was said to have been influenced by sculptures from the Ivory Coast and Gabon: "In 1907 [Picasso] embarked upon the extraordinary paintings that include almost direct renderings of African sculptures. The faces on the right side of *Les Demoiselles d'Avignon* can only be Picasso's own disturbing vision of Senufo or Bakota figures."[106] Art historians also argued that the stone head sculptures that Modigliani carved after 1909 echo the design on masks by the Guro and Baule tribes in the Ivory Coast. In fact, the immediate prewar era is filled with examples of artists who are said to have taken inspiration from the primitive arts.

Critics asserted that any suggestion of universal themes was a justification "to support the Modernist narrative of contemporary Western art practice as representing the finest expression of human art."[107] In art historical circles, it is well known that "exhibitions that position artists as artistic peers emphasize a flow of influence connecting the artists. Such connections may serve to create a narrative of 'progression' in art."[108] Progression narratives such as these adapt well to the textbook format, where certain artists are presented as innovators contributing to the advancement of art history, and others are viewed as derivative. In this case, the fear was that modern art would be viewed as the evolutionary result of primitive art. Moreover, primitive objects that did not have similarities with modern artworks were excluded from the MoMA exhibition. This gave some critics just cause to complain that the emerging field of primitive art was being defined only through its relationships to modern styles, rather than on its own merits.

The exhibition also came under fire for presenting primitive art objects without context, abstracting them from whatever environment or function they may have previously served. One might reasonably argue that this is an important means by which we come to appreciate these objects *as art*. Yet some argued that, in presenting objects on pedestals and hanging them on white walls, we chance universalizing "the aesthetic doctrine of Western Modernism—emphasizing the formal, material dimensions of art objects as

their central quality and indirectly supporting a separable or autonomous dimension of human life that was 'art.' "[109]

While these critics bemoaned the application of Western modern aesthetic doctrines to primitive art, the MoMA show represented the fulfillment of Rockefeller and d'Harnoncourt's ambitions: to wrest the display of primitive works from anthropologists and others who would portray them in their functional capacities. But even within these art contexts curators were at pains to explain to museum boards that the galleries "must avoid the dark, king kong treatment often given to African art. [W]e should avoid rustic touches (rough textured walls, jungle plants). Music in the galleries should also be forgone, much as I like it (I like it in the supermarket too). It is important that this art be treated just like white peoples' art."[110] That is Susan Vogel, one of the most important African arts curators of the twentieth century, admonishing the curators at the Met as they suggested design ideas for the galleries hosting the Rockefeller collection. She wanted to avoid typical display formats "like a boy-scout's collection of arrowheads" or "swamped in raffia, spot-lighted with jungle colors and given a special Muzak of clicks and bongos."[111]

In fact, the field moved quickly to develop and apply aesthetic modes of display to both classical and contemporary African art. The number of galleries displaying art from the continent increased significantly in the 1980s. Objects that would not previously have been seen as art—"artifacts," like slingshots and wooden household goods—were available for sale and the market diversified.[112] Casual collectors were edged out: "The art market was booming, and the supply of such tribal objects was growing scarce. With new investment-oriented collectors from the United States, Europe, and Japan entering the market, prices for the most desirable pre-colonial objects were in the millions of dollars, pricing out many institutional and private collectors."[113]

In these years, high-status, legitimate spaces, like museums and galleries, continued to specialize in older works—"high tribal art."[114] Smaller galleries in emerging arts districts began to acquire and sell contemporary works by living artists—what sociologist Craig Rawlings refers to as "named" art. But few galleries or museums displayed both older and modern works.[115] One African art curator said the same pattern extended to collectors: "Most of the people who collect classical African art don't like contemporary African art. They are quite hostile towards it even, and regard it as a bunch of crap."[116] There had emerged parallel markets for related but distinct forms of African art and galleries and collectors began to specialize in one or the other.

As the market for contemporary African art diversified, and actors within it specialized in the mid-twentieth century, so too did the students seeking advanced degrees in this emerging field of art history. The number of universities offering degrees in African art increased, as did the number of students registered to complete them. However, the available funding for dissertation fieldwork—fieldwork that had traditionally compelled students to work in Africa—was drying up. By the late 1980s, American students seeking to complete research projects in African art history had to study African artists working abroad, or they had to work on artists whose material was already included in libraries and museums. Thus, the scholarship needed to legitimate existing tribal works expanded severalfold.[117] Primitive art, particularly from Africa, had successfully spawned its own avant-garde in the form of contemporary African artists.

The expansion of scholarship on, markets for, and interest in primitive art was increasingly described in the press as a function of "an enormously commendable broadmindedness and largesse on the part of the host culture."[118] Americans, and New York art insiders in particular, congratulated themselves for their tolerance, charity, and kindness, made manifest in their enlightened appreciation of cultural diversity. In Hilton Kramer's laudatory review of the Rockefeller Wing's opening, he announced: "The disposition to regard primitive modes of culture and experience as equal in value to our own and in some respects even superior and more vital . . . has ceased to be a possession of a minority of cultural visionaries and achieved a new status as part of the mainstream of cultural life." In fact, Kramer argued, "we are entering a new phase not only in the history of taste but in the history of the moral imagination."[119]

This defense of elites' embrace of primitive art should give us pause. Collectors and museums act in their own self-interest, asserting a great deal of power in deciding the fate of objects. They have the resources available to bestow legitimacy and recognition on whichever objects they prefer, often proclaiming their moral obligation to preserve and protect these artifacts. Curators acquire responsibility for "interpreting the meaning and significance of artistic objects produced by people who, they argue, are less well-equipped to perform this task." In short, we have reason to question the value of asserting the primacy of Western curators and collectors.

Exploring the process by which folk, popular, and craft culture transform into art is at the heart of this book's purpose, and this will inevitably lead us to question the difference between appreciation and appropriation. On the one hand, it is critically important that we value diverse forms of

creative activity and expand our definitions of art beyond the canon of "dead, white men." The proclivity to regard other cultures as equal and in many respects superior and more vital to our own is no longer reserved for a "minority of cultural visionaries" but is instead an ordinary attitude for regular people: progressive, tolerant, antiracist, cosmopolitan people.[120] But before we congratulate ourselves on our excellent moral and political values, we should remind ourselves of the fact that our invitations to half the world's artists to "partake of the Brotherhood of Man" were centuries late, and that those artists have good reasons to refuse to rejoice with us.[121] The "'equality' accorded to non-Westerns (and their art) . . . is not a natural reflection of human equivalence, but rather the result of Western benevolence" and that much less valuable as a result.[122] Our pride in our own broadmindedness, in our unique ability to appreciate cultural diversity, is its own kind of exclusionary status discourse, built, as we will explore in more detail later, on a particular understanding of taste, class, and race.

Consider briefly some of the benefits and hazards of the Museum of Primitive Art for the artisans and artistic cultures represented within its walls. On the plus side, dedicating thousands of square feet in a museum to the most beautiful, finely crafted, most rare examples of these works gave them prestige and legitimacy. Rockefeller and his staff "wanted peoples across the planet to feel enfranchised through pride in being represented in one of the world's most influential and remarkable cultural institutions"— the Met.[123] And with prestige and legitimacy come respect, which would surely impact contemporary craftspeople working in these traditions, their communities, and nations, through trade and tourism.

Moreover, it simply is the case that the "documentation and preservation of Primitive art constitutes a contribution to human knowledge."[124] In many instances, we can assume that conservationists at the MPA saved objects that would otherwise have been destroyed by the elements, accident, war, or civil strife; displaced by migration; or simply remained unknown.

What, then, are the hazards or negative impacts of an organization like the Museum of Primitive Art on artistic communities? First, critics argue that curators or museum buyers have chosen to "bestow international artistic recognition on their personal favorites from the 'anonymous' world of Third World craftsmanship."[125] The argument is that, because there are effectively no internationally recognized "local" art experts, foreigners arrive and choose the works that appeal to their own aesthetic tastes and preferences, rather than the works that might be the most prized within the creative community that produced them. Then, those same foreigners have

"the job of interpreting the meaning and significance of artistic objects produced by people who, they argue, are less well-equipped to performing this task."[126] Some dealers even claim that the creators of primitive art have no appreciation for the artistic qualities of the objects they create, and that it falls to Western experts to discover and establish their value.[127] The choices made by these cultural "outsiders" are choices made for the history of the field, and they may benefit the Rockefellers and the art elite more than they do the communities that created them. The concern, succinctly, is that outsiders select and then "write the histories" of these objects in imperialist ways. These are, I think we can agree, enormous potential hazards.

Conclusion

At the memorial for Rene d'Harnoncourt, speakers continually referred to d'Harnoncourt's curatorial ability. MoMA staff and board member Monroe Wheeler had this to say:

> His installations were world famous, and this drawing was the secret of it. He first drew each object separately, then in meaningful relationships, and, finally, a carefully scaled floor plan with each thing in its place. He did not bind them by mere chronology or geography, but established juxtapositions and sequences that illuminated certain universals and interrelationships between one culture and another, and inheritances from generation to generation. One of his devices was to indicate cultural and artistic kinships, emphasizing things with lighting and color contrasts in such a way as to stimulate the visitor to make his own comparisons.[128]

What Wheeler is addressing sounds like the ordinary work of a curator who finds allegiances between objects and represents those in the space of a gallery. But what he means to describe is an act of invention from a void. D'Harnoncourt was not simply reproducing a known classification of objects into categories in the gallery space, but, rather, inventing that classification and convincing other art historians, art experts, and the public that it was the correct one.

On the whole, Rockefeller's collection and its role in the legitimation of primitive art in America illustrates the continuing impact of powerful, elite reputational entrepreneurs on the arts in America. The transmutation of ceremonial, ornamental, or household objects into "primitive" art was not the outcome of one man's will (even if he was a Rockefeller). Primitive art

was a battleground in the mid-twentieth century, a field in which wealthy speculators, art historians, and arts administrators asserted the value of their own tastes. Advocates for the legitimacy of primitive art provided persuasive arguments that these "illegitimate" objects were being misunderstood, and that they, in fact, conformed to the expectations, norms, and rules that governed "legitimate" arts. The close analysis of the Museum of Primitive Art that I've given here provides another angle of sight on the aesthetic legitimation process, one with a granular resolution.

4

Opportunity Structures

Aesthetic legitimation efforts, like those of Rockefeller and his staff at the Museum of Primitive Art, do not happen in a void. Sociologists have argued that certain favorable conditions facilitate the artistic legitimation process—what they refer to as "opportunity structures."[1] The term is meant to describe exogenous factors that encourage or inhibit collective action. Previous studies of artistic legitimation have focused on changes in the demographic character of communities, the rise or activity of political interest groups, shifts in political attitudes, the emergence of new technology, and changes in the legal environment.

These opportunity structures generally issue from "outside" of the field, providing the conditions for change. In this chapter, I explore several exogenous factors that might reasonably have aided or limited the efforts of aesthetic entrepreneurs to access, enjoy, or offer a diverse palette of culture as art. These include forms of economic, political, and technical change, like class formation or dissolution, the liberalization of political and social attitudes, and the emergence or decline of technologies. Changes within the arts sector can also facilitate the diversification of the field. Here I discuss the advance of rational management; the professionalization of curatorial and programming department staff; shifts in audience demographics, funding sources and objectives; and changes in law and regulations.

In this chapter and the next, I draw upon a large corpus of primary and secondary sources and existing sociological analyses of the maturation of ten fields of creative production that were legitimized in the twentieth cen-

tury. These fields are tap dance, jazz, rock and roll music, outsider art, photography, African American literature, graffiti, comics, film, and tattooing. Interested readers can find a discussion of the selection of these fields, data collection processes, and analyses in appendix A. In brief, the fields were chosen on the basis of the volume and quality of existing social science research, their prominence in scholarly discussions of the diversification of the American arts, and their ability to reflect legitimation processes across the century and multiple identity groups. The objective of analysis was to identify, through parallel comparison, forces that impacted the ability of legitimate authorities to view various forms of nonart as art.

Economic, Political, and Technological Change

Rapid changes in society can produce opportunities for new creative communities to grow, and for the artistic legitimation of communities that exist. Although Boston's Brahmins were powerful economic, political, and social elites before the 1850s, the increase in the size and wealth of this group in the wake of the Civil War played a key role in the process that resulted in the invention of high art in America.[2] Insurgent political interest groups, like new immigrants or upwardly mobile groups, can stake a claim on American civic life and make that claim (in part) through culture.

In the case of twentieth-century protoart worlds, the rising fortunes of their advocates produced the opportunity space for legitimation processes to take place. For example, the transformation of film into art was encouraged by the postwar rise in the number of Americans who went to college and who then formed the core audience for cinema.[3] The rise of rock and roll music as an art form was facilitated by the emergence of a newly affluent baby boom of teens and preteens who composed rock and roll's national, white audience in 1955.

Conversely, a reduction in economic power can result in decreased control over the legitimation process. The Great Depression reduced the fortunes of many arts patrons, "forcing them to share control with wealthy people of different ethnicities and backgrounds."[4] It also meant that museum administrators began to encourage the growing middle class to visit their institutions more often and to pay the admissions fees that could help stabilize museum budgets. As a fascinating study of New York Philharmonic patrons has shown, the expansion of access to educated middle-class audiences did not diminish, but instead enhanced, the value and authority of the art form.[5]

Shifts in the political climate can facilitate the artistic legitimation pro-cess. Perhaps the clearest example can be found in the case of jazz, when a surge of nationalism in the wake of World War I led advocates to promote their music as quintessentially *American* art: fresh, spirited, innovative, and independent.[6] The rise of favorable attitudes toward African Americans also facilitated the legitimation of jazz.[7] Similarly, the civil rights movement shifted American attitudes toward blacks, both here and abroad, and this encouraged the rise of favorable attitudes toward black authors: "American intellectuals in the 1950s were becoming increasingly sensitive to the claims of racial minorities. Following the Supreme Court decisions of the mid-1950s, the growing civil-rights movement broadened this awareness, but, among literary intellectuals, the ground had been softened by the fiction of black writers such as Richard Wright, Ralph Ellison, and James Baldwin."[8] The legitimation of the African American novel was easier once people stopped viewing literary prestige as value neutral and started viewing it as a social and political process; this rendered the perception of racial exclu-sion untenable.[9]

New technologies can play a key role in the rise of artistic fields, like the inventions in transportation technology that fueled the birth of gastronomy in France; these made new, fresh foodstuffs available for purchase.[10] The massive popularity of rock and roll after 1955 is due in part to the invention of transistor radios, which were cheap and portable ways for people to listen to music more often and in more places.[11] Television's impact was indirect: because it was seen (rightly or not) as a threat to the music industry, net-works withdrew their objections to licensing more stations, opening the floodgates for rock and roll radio.[12] Television's impact on film's artistic le-gitimation was more direct: television provided accessible, affordable, au-diovisual entertainment to the masses, opening the possibility for elites to claim film as their own (and to rechristen it "cinema").[13] A generation ear-lier, the invention of films and film theaters attracted lower-status audiences, presenting the opportunity for elites to justify theater as art.[14] Finally, the invention of the virtually unbreakable vinyl 45 rpm record meant that even small record companies (like those that made a lot of rock and roll) could afford to ship albums in bulk. Independent record companies could have hits, which meant that rock musicians could have hits.[15] Thus, technological advances often clear the way for elites to capture for an older form, and for less powerful groups to gain access to other culture and promote it. Tech-nological advances can result in new forms of regulation, or changes to those that exist; laws and regulations are forms of political control that, with their

impact on arts funding, have a powerful combined effect on the trajectories of artistic legitimating fields.

Changes to Regulations

Changes in laws and regulations, and the enforcement of those already on the books, can impact the ability of art forms to be presented. Consider, for example, the Tariff Act of 1930, which stipulated in paragraph 1807 the characteristics of a "sculpture." Classifying objects as art sculpture allowed importers to bring them into the United States without paying a duty. Thus, many of the objects included in primitive art collections match the act's definition of sculptures: they must be original (or one of the first two re-productions), by a professional sculptor, and not for industrial use or utilitarian function. In order for an object to be art (and not simply "utilitarian"), it must feature "imitations of natural objects, chiefly of the human form . . . in their true proportion of length, breadth and thickness."[16] Therefore, many of the objects in primitive art collections are realistic depictions of humans or natural life. Taxes and fees can also squelch the display of art. The postwar federal tax on dance floors resulted in the closure of many large ballrooms; the swing orchestras and big bands that accompanied tap dancers were replaced with small jazz groups, leading to a "virtual blackout" of tap dance.[17]

Restrictions on ownership structures, particularly of the vertically integrated or monopolistic firm, have had a significant effect on what forms of culture get produced. A prohibition on vertical integration, which was adjudicated as an antitrust violation, had an enormous impact on the film industry. The 1948 Supreme Court case *United States v. Paramount Pictures* held that film studios could no longer have exclusive rights to show their films in their own theaters. As a result, studios began to make fewer films, imported more films from abroad, raised the rates they charged theaters, and began to rent out their production spaces to independent directors. Because independent directors innovated content, the films on offer became more diverse, and the locus of connoisseurship shifted from the studio to the producer, who was increasingly viewed as the author (or auteur) of the work. This "provided film criticism with a powerful tool for connecting with existing beliefs about the nature of art and artists"; these explanations or justifications "identified the creative imprint of (American) directors whose artistic impulses survived the homogenizing influence of the studio system."[18] In this case, a legal decision had a significant influence on the kind

of work that was made and distributed and manifestly contributed to the legitimization of some American films.

Legal regulations and decisions can assist the legitimation of art worlds, or they can serve as obstacles.[19] The US Constitution secures "for limited Times to Authors and Inventors the exclusive Right to their respective Writings and Discoveries" in order "to promote the Progress of Science and useful Arts." The notion is that copyright encourages innovation by protecting the creator's right to profit from their work for a period of time and thereafter ensures it will be available to others to use as creative material and inspiration. As Kembrew McLeod points out, "A balance between the author and the public good was the guiding principle of the law."[20] The problem is that works created after 1978 give the author exclusive rights for the duration of their life plus seventy years. This means that most of the culture created in one's lifetime (or, sometimes, in two lifetimes) will not be not available as creative material. In this sense, copyright law and its provisions thwart certain forms of art-making, particularly "new modes of cultural production, from postmodern novels to hip-hop, that challenge our definitions of borrowing and infringement."[21] If the legal environment succeeds in stifling these forms of creativity, it could impede the progress of creative fields toward legitimation.

Codes and regulations over content also impact the legitimization process. Film and comics both suffered and benefited from codes intended to regulate content and access. Concerns about the link between comics and juvenile delinquency plagued the field since its start. The Comics Code was self-imposed by industry leaders in 1954 after criticism of two titles: *Crime Does Not Pay* and *Tales from the Crypt*. The elimination of most adult-content comics in compliance with the code resulted in an overall decline in sales.[22] Changes were made to the code in 1971, relaxing some of the restrictions on sex and violence, and new sections on drug use and abuse were added; these changes were implemented in order to deal with a slump in sales, the rise of underground "comix," and changing social mores. They had the unintended effect of affirming that comics were a medium for children.[23] There was a final round of revisions in 1989, as a result of changes in audience demographics and comic-book distribution systems, and to respond to competition from a new group of "independent" publishers.[24] Like the earlier alterations, there was no positive effect on sales.

In terms of the film industry, the Motion Pictures Production Code, or Hays Code, stipulated content that would be censored (for example, miscegenation), or that would be permitted if presented in ways that promoted

"traditional values" (e.g., sex outside of marriage). Like the Comics Code, the Hays Code was a form of self-censorship, as studio owners preferred industry control to government oversight. Compliance with the code became less tenable as the industry faced increasing competition from television and foreign films (which were not subject to the code) in the 1950s, and as directors openly flaunted it. By the end of the 1960s, the Hays Code was abandoned and replaced with the Motion Picture Association of America (MPAA) rating system. The Hays Code had the effect of reducing cinematic diversity; the argument has been made that it "cut the movies off from many of the most important moral and social themes of the contemporary world" and thus limited the content that would appeal to elites and reputational entrepreneurs.[25]

In graffiti, the increase in police surveillance and violent treatment of graffiti writers led to the collapse of the informal "writers' corners" (on park benches and subway platforms) by 1983. As a result of "the absence of writers' corners, and the transit authority's success at erasing most murals on subway cars" muralists would "enjoy neither personal nor artifactual contact with other muralists. Consequently, the social and material bases for sustaining their ideology of fame" was lost.[26]

Regulations and laws can have significant indirect effects on the artistic legitimation process, as was the case with the GI Bill. The bill effectively covered tuition for former servicemen and women and dramatically reduced opportunity costs associated with college matriculation.[27] Total college enrollment increased by more than 50 percent from 1939 to 1946, and approximately one in eight returning servicemen enrolled in college.[28] As universities expanded to accommodate a growing student body, so did their curricular offerings. In the postwar years, new media departments opened (e.g., film), and new area- and identity-focused departments (for example, Latino studies, African American studies) conferred authority on various forms of cultural taste. New students—especially women, people of color, and those from working-class backgrounds—were drawn to new courses that were different from those that interested previous generations. Recently trained faculty were interested in new research topics and in teaching courses in those areas. Scholars across existing disciplines, like English, history, foreign language, sociology, and art, began to investigate contemporary popular culture and entertainment; they taught "popular culture" courses, and "doctorates were awarded for dissertations on 'hard-boiled' detective novels and western pulp fiction, and journals devoted exclusively to popular culture were launched."[29] These students and faculty were curious

about and supported art made by more diverse artists, and this provided the conditions and fueled markets for the artistic legitimation of a group of creative fields, including primitive art, film, rock and roll, and jazz.

These shifts in politics, social life, and the economy rippled through society, impacting artists, aesthetic entrepreneurs, and organizations. Changes within the nonprofit culture sector were particularly important, as those organizations served as critical actors in the legitimization process.

Changes within Arts Nonprofits

At the start of the 1950s, the United States had "a strongly classified high culture organized around university training of artists and consumers and nonprofit producing and exhibiting organizations commanded by trustees drawn from their communities' wealthiest and often oldest families."[30] But emerging forms of "high" culture, and changes to the climate around and within arts nonprofits, would disrupt this system.

The number and size of arts nonprofits exploded in the second half of the twentieth century. By 1950, approximately ten museums were being founded each year, and thereafter the rate rose significantly.[31] The number of nonprofit performing arts organizations increased by over 80 percent between 1982 and 1997, yet average real revenues declined, suggesting that many of these new organizations were small. There was a corresponding building boom: between 1980 and 1993, over one-third of venues operated by members of the Association of Performing Arts Presenters were built. [32] Older nonprofits, including those discussed at length in chapter 1, significantly increased in size and budget after 1950.[33] Correspondingly, many organizations experienced an increase in task complexity: nonprofit organizations became presenting organizations that also contained libraries, restaurants, retail stores, theaters, schools, educational program departments, and restoration departments.[34]

As the nonprofit arts sector expanded and many new administrative positions became available, those administrative fields underwent a period of rapid professionalization. This process unfolded in three distinct phrases. In the early 1960s, corporations loaned personnel to arts organizations to assist with accounting, legal services, budgeting, and fundraising; in some smaller organizations, this practice continues to the present. In the second phase of development, service organizations like the American Symphony Orchestra League provided short courses to train arts administrators. By 1979, the NEA supported these efforts by providing operating support for

seventy such organizations.[35] Meanwhile, some colleges and universities established courses of study that systematized the training of arts administrators in core methods, theories, and principles, which marked the start of the third phase of development.

These degree programs facilitated the provision of knowledge and the building of social ties among arts administrators. The first arts administration graduate programs were founded in 1966 at Yale University and Florida State University; both specialized in training theater managers.[36] A decade later, twelve such programs existed, and by 1981 there were twenty-three postgraduate programs in performing-arts administration, and thirteen in museum administration or museology.[37] Since the mid-1980s, most programs have required that students take financial management courses, including accounting, budgeting, marketing, organizational behavior, and basic legal training. The older "impresario" style of management, in which training was primarily provided via mentorship, survives only in a required half-year internship. The field now offers professionals the opportunity to publish in quasi-scholarly and practical journals, present at disciplinary conferences, and even access a small number of PhD-granting programs in the field.

In the last decade of the twentieth century, curatorial and programming departments in arts organizations became fully professionalized, fed by graduates from professional degree programs at universities across the country that taught a standardized curriculum. As a result of curatorial departments' enhanced academic perspective, museum collections were cataloged and often represented in chronological sequences by medium and style. By the mid-1960s, exhibition design shifted from "scholarly and curatorial to a more popular and managerial approach."[38] Both niche and encyclopedic museums were able to quickly identify gaps in their collections and direct their acquisitions accordingly.

Over the previous two decades of the twenty-first century, great efforts have been made to address the obstacles that lie in the path of aspiring arts administrators from underrepresented groups, with modest effects. A diverse staff is valuable to an arts nonprofit for a variety of reasons; for this argument, the most critical reason may be that nonwhite staff can bring the knowledge and social capital that are essential to alter organizational routines to include new forms of art. While artistic disciplines vary greatly with respect to the diversity of their members, arts administrators largely identify as white, well educated, middle-aged, and female. In 2013, Americans for the Arts reported that 86 percent of full-time employees in its Local Arts

Agency survey identified as non-Hispanic whites. In the same study, nearly three-quarters (72 percent) of full-time employees were women, and only one in five reported being under age 35 (19 percent).[39] Other studies confirm these results, even when the survey population includes diverse communities, like those in New York City. A recent study of New York City arts administrators found that the work force is 61.8 percent white and 53 percent female.[40] It also revealed that a larger staff size increases the likelihood of a less diverse staff; smaller organizations have more nonwhite employees. It is also important to bear in mind that, across larger organizations, nonwhite staff are often disproportionately represented in the facilities and security departments.[41] We must assume that many, if not most, arts organizations are managing this period of rapid legitimation without abundant staff who specialize in these protoart forms.

In the midcentury, nonprofit visual arts administrators acquired greater control both as a consequence of rising professional standards, and because of changes within organizations wrought by tax law. While in the preprofessional era museum administrators sought to please trustees by accepting any donations, in the postwar era museums routinely rejected donations that came with restrictions.[42] Directors of museums had more negotiating power with donors as a result of the 1936 federal policy granting tax exemption for donations of artworks. From then on, arts administrators were in a position to counsel potential donors about which works would make the best donations. Within a decade, the power of donors and trustees had eroded significantly. In 1945, the director of the Metropolitan Museum of Art, Francis Henry Taylor, observed that "trustees are . . . gladly suffered as highly ornamental, and occasionally useful, sacred cows to be milked on sight. But god forbid that they should have ideas in art beyond their station, for if they ever really got the upper hand, then the public . . . might question the omniscience of the expert."[43] As a result, many museums consider the works they acquired between 1950 and 1970 to be among the strongest in their collections.[44]

Research on the number of exhibits with donated works reveals a countervailing tendency. Art prices, especially for works at the top of the market, exploded between 1984 and 2010. Art Market Research Modern Art 100 Index reported that the most expensive tenth of items increased 900 percent over that nearly 30-year span. For contemporary works, average prices have increased 2,300 percent. This astronomical growth in cost has not been matched by interest rates, and museum endowments have not kept pace. This has effectively forced museums to "appeal to benefactors for additions

to museum collections" because they cannot afford to add (much) new art to their permanent collections.[45] A study of New York City exhibits with named collectors helps us to understand how administrators managed to serve two masters (the public and wealthy donors): by increasing the number of special exhibits. While the absolute number of special exhibits with named collectors has increased since the 1960s, they comprise a shrinking percentage of shows at the Met and MoMA, as well as the Guggenheim and Whitney Museums.[46]

Trustees and arts impresarios watched their influence wane over the twentieth century as bureaucratic, rational management styles became more dominant in the field. Some worried that management by efficiency experts produced such obedience to financial incentives that the art would suffer; they reasoned that arts organizations should be run by people who know and love the arts, not by people who know and love money. Others argued that effective management is essential to retaining the public's trust and to securing earned and contributed income. They also contended that nonprofit organizations are charged with serving the public good, and that, to do so, they must ensure that their community finds itself and its cultures represented and respected.

These arguments were inflamed by a rise in what has been referred to as an "accountability" movement. Foundations and other grantors increasingly sought to support effective organizations, which they defined as a function of both vitality and viability. The element of viability involves the long-term survival of the organization by virtue of its fundraising and operations, and a continuing need for its services. Vitality "concerns the competitiveness, identity and distinctiveness" of the organization.[47] The goal for most funders is to evaluate a "balanced scorecard" that includes data on financials, customer satisfaction, the effectiveness of internal processes, and efforts toward innovation.[48] Noting that larger organizations may find it easier to produce these data, some foundations provide access to experts who assist in designing and implementing assessment strategies. They can thereby compel organizations to use the same measures of effectiveness, which encourages comparison across organizations, and allows them to test new measures.

Administrative members of arts nonprofits continue to debate how artistic and market-driven governance can be reconciled so that these organizations continue to serve a public, educational purpose. After all, arts organizations receive their nonprofit status by virtue of their categorization as educational institutions. But opinions differ on whether organizations should achieve this purpose by satisfying audience desires or through their

didactic function, "civilizing" citizens by defining a sophisticated national culture. The former position encourages the expansion of programming to include blockbuster exhibits, displays of commercial culture or its variants, and the inclusion of minority cultures. The latter position does not prohibit such expansion, but rather places emphasis on the judgment of curators and programmers as to what should be shown, and how. Both encourage the diversification of the art on offer and thus promote the legitimation of new art forms.

The professionalization of arts administration, rational management strategies, and a rise in the number of postwar nonprofit arts organizations each impacted the opportunity space for legitimating art forms. These changes in arts nonprofits are both a cause and consequence of changes to the regulatory and funding environment.

Changes to Funding

In the postwar period, a number of interest groups and agencies acted to increase the formal accountability of arts organizations by tethering their expectations to forms of subsidy. Regulations of the governance and operations of these organizations, in combination with those set by donors, impacted the ability of newly legitimating art forms to find a place within them. In the discussion of ballet and opera in chapter 1, I described the foundation grants dedicated to support the creation of novel American operas and ballets. Foundations with arts portfolios continue to inject funds into the arts to "course correct" against structures that produce unequal economic, political, and social outcomes. Federal and state arts funders play a similar role, but together these contribute a minority of the funding for the arts. The remainder is generated from individual donors, admissions fees, and other forms of earned income (including building rentals). This has led policy scholars to describe the US system as one of "third-party" support, in contrast to "architect" states that use centralized ministries to fund culture, or "engineer" states that promote art that facilitates their political objectives and suppresses the rest.[49] The third-party system used by the US was designed and implemented in the mid-twentieth century and thus contributed to the opportunity structure for the artistic legitimation of many forms of vernacular culture.

With the exception of the New Deal arts agencies, federal subsidy for the arts existed only after the Kennedy Administration. In 1953, 91 percent of the board chairmen of the nation's five hundred symphony orchestras op-

posed public subsidy for the arts.[50] Nevertheless, a system of federal support was established in the creation of the National Endowment for the Arts (NEA) in 1965, funded by congressional vote with an initial budget of $2.5 million. Its primary grants function was to disburse funds to organizations that mounted exhibitions of visual or performing arts, or that employed artists. At the Senate's urging, the NEA also gave block grants to states to establish public arts councils; by 1974, all fifty states had one. In turn, state arts agencies encouraged the growth of a network of public and private community arts agencies; by 1980, there were approximately 1,500 community arts councils.[51] The NEA also provided "Service to the Field" grants, often enjoyed by disciplinary service organizations, like the American Symphony Orchestra League or the Theatre Communications Group. In the twelve years after the creation of the NEA, the program's budget increased from $3 million to $96 million. Both financial exigency and the involvement of the government in supporting these organizations led to an increased effort to draw working- and middle-class artists, and racial minorities, into their halls. This, in turn, promoted the legitimation of a more diverse body of work as art, because existing offerings were not seen as fitting the tastes of these new demographics.

While absolute and relative federal funding has declined since the early 1990s, state and local funding have increased to make up the gap. There have been corresponding changes in the average size of grants, and the characteristics and programming of grant recipients. Local and state funders tend to favor considerations of the economic benefits to local communities over other criteria (including aesthetics and excellence).[52] Critics have argued that these shifts in funding had three consequences for nonprofit arts organizations: they expanded the definition of the arts and arts audiences, eroded the power of nonprofit boards, and increased the dependence of nonprofits on the market.[53] These changes facilitated the specialization of small organizations in protolegitimate local culture, while "distinctions between what is 'popular' and what is 'high' art will continue to erode as both sets of organizations seek to produce the next blockbuster."[54]

The financial contributions of local, state, and federal bodies have become of major importance to art organizations. Although such subsidy typically constitutes a minority of funds provided to any organization, the belief is that they have a "multiplicative effect," providing a form of legitimacy that encourages other donors to contribute.[55] (In 2012, the NEA estimated that 10 percent of financing for nonprofit arts organizations came from local, state, and federal grants; 7 percent from corporations; and 13

percent from foundations.[56]) Reliance on these forms of contributed income has remained steady over time, even as ticket prices have risen in the performing arts.[57]

Funding from federal and state bodies was buttressed by the support of foundations, led by the Ford Foundation.[58] Ford's influence on the field is likened to "a chain reaction": "Between 1955 and 1970, large national foundations increased their annual number of arts grants from under five hundred to over two thousand."[59] During that same period, the proportion of foundation grants for the arts increased from 10 to 20 percent. As a result of this swell of funding, almost 60 percent of nonprofit organizations' unearned income was provided by private foundations. In the 1980s, corporate foundations joined the cause with an eye toward the public goodwill it could generate; by the mid-1980s, corporate assistance for museums alone rose to nearly $400 million.[60] Most of these dollars went to supporting large, old organizations, relieving their debt. In 1966, the Ford Foundation made its largest single arts grant: $80 million to retire the debt and shore up the financial stability of sixty-one symphony orchestras. (Granted, only $25 million of that was in cash, and the rest in Ford Motor Company stock, with stipulations on its sale.) By 1980, Ford was no longer the leading foundation donor to the arts; the J. Paul Getty Trust took that honor, granting $250 million annually to the arts—more than all fifty state arts councils combined.[61]

Accessing these subsidies compelled arts administrators to complete formal grant applications, which exposed organizations to financial and programmatic accountability.[62] Philanthropic foundations and corporations serving the arts rationalized their grant-making process at the same time.[63] Arts organizations that sought these grants had to initiate formal audits of their financial accounts and increase the amount and rigor of research on their community impact, and most had to expand the size of their administrative staff to accomplish these goals.[64] Moreover, "the major national foundations and the public agencies, believing that art is a good thing and that it should be spread around, have encouraged cultural institutions to evince some interest in expanding their publics and serving their communities."[65] The intensified focus on community impact, and the turn toward good financial stewardship, combined to incentivize the expansion of the art on offer.

As these changes expanded access to arts organizations for many forms of art, they posed problems for others. Consider, for example, the case of jazz: until the late 1980s, jazz was not presented in nonprofit organizations

dedicated to this purpose. Instead, it was performed by rotating groups of players in multiple organizational contexts. Former director of the NEA Music Program Ezra Laderman has said that "despite the popularity of, and demand for, jazz, there are basic problems in assisting the field. Unlike other art forms that have a strong organizational base, jazz for the most part does not function within an organization form as do theaters or orchestras." The organization of the field did not lend itself well to the procedures and expectations of most public and private grantors. It was only in 1979 that Laderman was able to announce the dedication of more than $1 million to jazz programs.[66] First was the Jazz Masters fellowships, which the NEA introduced in 1982, "with the first three awards given to giants of the jazz canon: Roy Eldridge, Dizzy Gillespie, and Sun Ra." The Jazz Preservation Act was passed in 1987, mandating that jazz history and its canon were preserved through public performances, historical research, and educational programs. It furthermore defined jazz "as a black American art form." That definition of jazz "was integral to its role in federal funding schemes such as the NEA. Being recognized as a fine art allowed jazz to adopt the approach of classical music institutions while focusing on black American contributions that had long been ignored by funding bodies."[67] The success of organizations like Smithsonian Jazz in Washington, DC, and Jazz at Lincoln Center can be credited to the creation of a pathway to NEA funding and the identification of jazz as America's indigenous art form. To put it, bluntly, "being recognized by Congress as 'high' art has been essential to gaining access to music classrooms, as well as building the programs and facilities that attract millions of dollars in public and private funding."[68]

Tap dancing suffered a worse fate. Philanthropic support from the NEA or state agencies like the New York State Council for the Arts "has been negligible."[69] Funding from alternative sources has also not been forthcoming; with the exception of a few popular Broadway musicals in the 1990s that featured dance, there are almost no commercial venues that host such performances. Advocates for tap dance history and performance, including the Tap America Project, have consistently pursued solutions to these obstacles. Their efforts resulted in the passage of a US Joint Resolution declaring May 25th National Tap Dance Day. (That date was selected because it is the birthday of Bill "Bojangles" Robinson, who was the most highly paid African American performer in the first half of the twentieth century.) The resolution was introduced by Congressman John Conyers (D-MI) and Senator Alfonse D'Amato (R-NY) and signed into law by President George H. W. Bush in 1989.[70] The resolution stated that tap dance is "a manifestation

of the cultural heritage of our Nation, reflecting the fusion of African and European cultures into an exemplification of the American spirit."[71] Tap advocates clearly hope that the designation as American art will clear a path to funding, as it did for jazz.

Both foundation and government grantors earmarked grants to support "audience development," or increases in the size and diversity of the public they engaged.[72] This encouraged changes in several departments: curatorial departments felt pressure to develop "blockbuster" shows that would drive traffic, marketing departments were created to develop advertising and branding techniques for catching the public's attention, and management allocated funds to support audience surveys in order to determine their demographic characteristics and to design strategies for attracting new visitors.

Over the last forty years, achieving gains in "audience development," and particularly "audience diversity," has become an increasingly critical requirement for arts organizations to access grants. This leaves them to cover their operating expenses out of their earned income. Together, these moves provide incentives to diversify programming and to find ways to incorporate culture that is familiar to nontraditional audiences for the arts. These include many of the cultural forms experiencing artistic legitimation in the second half of the twentieth century: film, tap dance, rock and roll, fashion, graffiti, and so forth.

In other cases, it simply involves a continued shift away from a European canon. Consider, for example, the 1992–93 Orchestra Repertoire Report by the American Symphony Orchestra League (ASOL). Based on a survey of the repertoires of the one hundred largest orchestras in the United States, the report concluded that there was a "strong preference of this country's orchestras to programme from a limited canon, and to project the sound and speak the language of the 18th and 19th Century European repertoire."[73] By the 2012–13 report, American composers constituted 21.9 percent of the works presented by US orchestras.[74]

Conclusion

The opportunity structures for the legitimation of diverse art in the twentieth century include both large-scale changes in political attitudes and laws, and very local changes, like grants, to single institutions. Changes in social, political, and economic life; shifts in the technological and legal contexts; and transformations within arts organizations each contributed to the

"opportunity space" for fields to gain artistic legitimacy. Given these shared conditions, it should come as little surprise that the process of gaining artistic legitimacy is similar across domains. In the next chapter, I explore the features of these creative fields in their progression toward artistic legitimacy.

5

Expansion: 1900–2000

In the pages of the April 11, 1949, issue of *Life Magazine*, readers found an illustrated table titled "Everyday tastes from high-brow to low-brow are classified on chart." In it, the tastes of four groups—including the two in the title—are illustrated along ten dimensions, including clothes, entertainment, salads, sculpture, records, and social causes. Starting with "lowbrow" Americans, who are depicted as fans of mass-produced entertainment, beer, and craps, each step up in class is marked by ever more customized, rare, and expensive material. While many of the objects of "highbrow" appreciation are denoted with the names of their creators (e.g., an Eames chair, Kurt Versen lamp, Calder sculptures, and Bach recordings), others are decidedly more anonymous and more . . . humble. For both "town" and "country," we find that the most sophisticated class wear a "fuzzy Harris tweed suit, no hat," and drink "a glass of 'adequate little' red wine," perhaps out of the "decanter . . . from chemical supply company." And what is the social issue that united these midcentury elites? Art.

And what a cause that was. Over the subsequent five decades these highbrows would legitimize as art many of the passions associated with their 1949 status inferiors: Westerns and comic books (both lowbrow), and theater, martinis, "better novels," symphonies, and even Planned Parenthood (all upper-middlebrow). The cause of art led more aesthetic entrepreneurs and voracious elites to ascribe legitimacy to more art forms than ever before. It is the aesthetic legitimation of creative fields in the postwar period that is the focus of this chapter.

MERCER BOOKS
206 MERCER ST
NEW YORK NY 10012
212-505-8615

Terminal ID: *****010 ***4

6/17/22 4:55 PM

VCB VISA PAYWAVE - INSERT
AID: A0000000031010
ACCT #: ************1075

CREDIT SALE

UID: 216837441325 REF #: 2029
BATCH #: 145 AUTH #: 896255

AMOUNT $42.79

APPROVED

ARQC - A9E74C58B6D528E4

CUSTOMER COPY

Building a Model of Aesthetic Legitimation

As Vera Zolberg argues in the following passage, the redefinition of aesthetic categories involves status groups and cultural institutions and results in a democratic opening of art organizations to new styles of work and to new audiences:

> We must remember that aesthetic culture itself is not reducible to reified categories, but is constantly being redefined. Art may now include academic, craft, folks, pop, or mass cultural products. The redefinition of these products as art involves status groups composed of collectors, patrons, donors, and intermediaries such as dealers, experts, and critics, as well as creators, such as painters or composers. And art museums and their personnel, no less than other cultural institutions, are involved in the process of changing the definitions. One of the consequences is that even the curatorial goals have become more democratic as the museums welcome into their halls works that were not considered Art until they were granted entry: African "primitive" works, folk art, comic strips, and even industrial artifacts. The outcomes are a change in the nature of the experience they provide, as well as a change in the characteristics and expectations of their public.[1]

As I have chronicled in the previous chapters, there is a pathway to the artistic legitimation process. Aesthetic entrepreneurs assert the existence of a creative producer who can be convincingly described as an artist. Zolberg, like most experts, contrasted the artist with the craftsperson—they maintain a position of disinterestedness. To be viewed as artists, other aspects of these creative producers' biographies are inspected to service claims that they are authentic members of a creative community with particular stylistic and identity traits. In addition, they must be producing work that reputational entrepreneurs, especially critics and academics, can place within a formal and aesthetic idiom, for interpretation.

This chapter focuses on the techniques that aesthetic entrepreneurs utilized in order to treat folk and vernacular culture and forms of entertainment as art. I analyze primary and secondary documents charting the artistic legitimation of ten different fields in postwar America (see appendix A for more information). I am not presenting evidence of how these entrepreneurs advanced elites' "capacity to appreciate" vernacular culture on its own terms. This evidence does not support the argument that sophisticated elites broadened their tastes to indiscriminately appreciate vernacular culture as

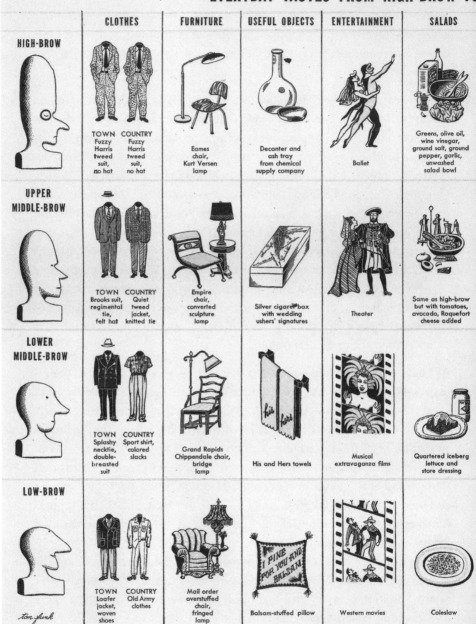

FIGURE 5.1. Everyday tastes from high-brow to low-brow are classified on chart. *Source*: Tom Funk / *Life* in Lynes 1949: 100–101.

LOW-BROW ARE CLASSIFIED ON CHART

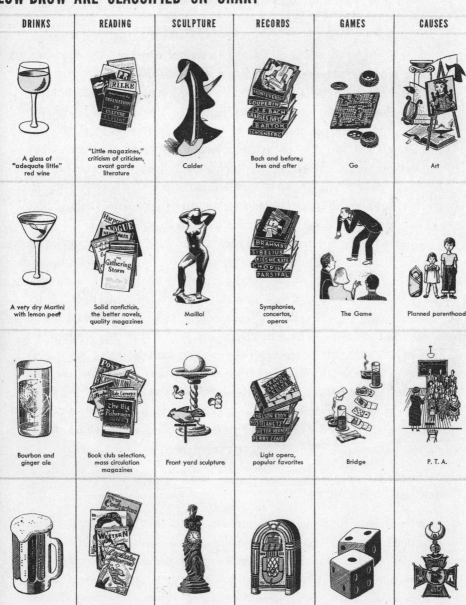

DRINKS	READING	SCULPTURE	RECORDS	GAMES	CAUSES
A glass of "adequate little" red wine	"Little magazines," criticism of criticism, avant garde literature	Calder	Bach and before, Ives and after	Go	Art
A very dry Martini with lemon peel	Solid nonfiction, the better novels, quality magazines	Maillol	Symphonies, concertos, operas	The Game	Planned parenthood
Bourbon and ginger ale	Book club selections, mass circulation magazines	Front yard sculpture	Light opera, popular favorites	Bridge	P. T. A.
Beer	Pulps, comic books	Parlor sculpture	Jukebox	Craps	The Lodge

art. Rather, it demonstrates how entrepreneurs increased the ability of elites to apply what Alvin Gouldner calls the "culture of critical discourse" to vernacular culture.[2]

Gouldner describes this "culture of critical discourse" as a reflexive, problematizing, and open disposition, characterized by a breadth of interest and a compulsion to mastery.[3] That is, it is a mode of appreciating the culture of diverse other groups. This is a modern evolution of the same techniques that the Boston Brahmins utilized to legitimate American classical music and painting. In the postwar years, aesthetic entrepreneurs worked to define, isolate, and "sacralize" particular objects and performances, just as they had done in the late nineteenth century. Aesthetic entrepreneurs focused on establishing a "strong and clearly defined" boundary between objects and performances they considered commercial and those they argued were art, just as they had done for opera and modern dance.[4]

Later in the twentieth century, this mode of aesthetic legitimation would be applied broadly, to multiple forms of folk and vernacular culture, but for a more modern purpose: to support the legitimacy of a modern, cosmopolitan elite. This purpose and this "new class" have been noted in earlier research, notably including that by Gouldner, and also by Ulf Hannerz, who argues that this elite—whom he refers to as "cosmopolitans"—adopt "an intellectual and aesthetic stance of openness toward divergent cultural experiences" and that, through their engagement with other cultures, they can "turn into an *aficionado,* to view [those cultures] as artworks."[5] What the analysis in this chapter reveals is the application of this "culture of critical discourse" in the service of legitimizing a "New Class" of elites who are not *elitists.*

BOUNDING OBJECTS

At the memorial for Rene d'Harnoncourt, one of the themes that speakers returned to time and again was d'Harnoncourt's curatorial sophistication. For example, curator and art scholar Monroe Wheeler had this to say: "He did not bind [objects] by mere chronology or geography, but established juxtapositions and sequences that illuminated certain universals and interrelationships between one culture and another, and inheritances from generation to generation."[6] In his curatorial work, d'Harnoncourt was not simply reproducing a known classification of objects in the gallery space, but rather inventing a classification in an effort to convince other art historians, art experts, and the public that it was the correct one.

The sorting of objects, whether they are fields, genres, styles, or "schools," into groups is the work of classification.[7] Classification is the process of making, sustaining, debating, or rejecting distinctions between objects, people, practices, and other social objects. By engaging in classification, people and social groups "struggle over and come to agree upon definitions of reality."[8] Groups are often characterized by their agreement upon the principles of classification, which lies at the heart of how we understand legitimacy. Thus, the work of distinguishing artistic from ordinary objects, of sorting those objects into artistic categories, and of identifying them as members of the same field, constitutes a primary directive for aesthetic entrepreneurs seeking to legitimate a field as art. Classification is a key process that allows art organizations and participants to sustain order, distribute value, and provide legible objects of knowledge.[9]

Classificatory work in the arts is ongoing, as experts and audiences debate the fittingness of objects, artists, and genres within the field of art. For example, tap dance in the twentieth century had been the domain of the soloist, but in the 1980s, thanks especially to the work of several women artists, it was redefined to include choreographic performance art by groups.[10] In the world of tattooing, trade magazines and members of online forums distinguished simple tattoos (a butterfly or a four-leaf clover traced from stock images) from tattoo art, and then artistic styles proliferated to include primitivism, photorealism, abstraction, and minimalism, among others.[11] The work of classification also includes the exclusion of works previously included within the category. For example, as American ballet matured, experts eventually excluded ballet in the form of Broadway musicals, like the 1949 box-office hit *Carmen*.[12]

Just as the work of establishing an art object involves creating a boundary and defining the contents of the category, producers of works need to be defined as artists to establish an artistic field. It is, as Michael Baxandall and Arthur Danto have argued, "the inalienable link between material form and the artist's self and creative agency that renders artworks meaningful and what separates them from other types of artifacts."[13] This link assists those seeking to redefine vernacular culture as art.

DEFINING THE AUTHOR

Many experts argue that what is primarily at stake in any field of cultural production is the question of which creative producers are entitled to call themselves artists.[14] However, many cultural objects have no (known)

author. This is true for industrial objects like ordinary household furniture, oral culture like myths and jokes, domestic culture including recipes, and even the clip art or stock photography that is included in our software programs (to say nothing of that software). But artworks almost always have an author—it's one of the things that sets them apart from other forms of culture. In fact, the signature of an artist is often what we use to authenticate the work as a piece of art.

The fact that whole classes of objects, like quilts or some forms of sculpture, may not be "signed" (literally or figuratively) by single creators is perplexing to many people. As critic Grave Glueck said in her review of an opening at the Center for African Art, "In our name-oriented Western culture, it boggles the mind that works such as these are anonymous."[15] It may "boggle the mind," but, perhaps more to the point, it makes valuation all but impossible. It's important to identify a single historical person who can be identified as the author of the work, because, as sociologist Howard Becker argues, evaluating the author is one key to evaluating the work: "Who writes the words and when they are written affect our judgment of what the work consists of and therefore of what it reveals about the person who made it."[16]

In other cases, drawing the line between an author and an *artist* is a critical moment in the legitimation process. Films created in the United States before 1960 were often viewed as simple entertainment; while "some individual filmmakers may have been motivated by artistic impulses in working on these productions, the aim of the studios was clearly to generate profit."[17] Midcentury critics who adapted "auteur theory" from Europe consequently began to treat directors as the primary creative force behind a work of art and, therefore, worthy of the designation "artist." In post-1960s film, artistic directors like Martin Scorcese could state with authority: "What matters to me is that I get to make the pictures—that I get to express myself personally somehow."[18] The director became both author and artist. The distinction between creator and the honorific "artist" was also a battleground in photography. The first American show of photography presented and judged works in two distinct categories—art photographs and nonart photographs—and the distinction between the two was viewed as a function of aesthetics. Pictures "which may be termed 'impressionist' if produced intelligently with definite art aim" were different than snapshots, portraits, and other commercial forms.

Authorship can be elusive. When objects are unsigned or when there is a reasonable presumption that objects were produced by multiple individu-

als, then it can be difficult to determine who is the author. There are cases in which there is some intent to deceive—some effort by artists to appear to be other artists, or to disguise their identity.[19] But the value of a signed object is so great that craftspeople have been cajoled into signing works they have not created. For example, while working as the superintendent of Pueblo pottery revivals, Kenneth Chapman of the Museum of New Mexico suggested to potter Maria Martinez that she sign her pots to increase their value. She began to do so and was so successful in raising the value of her work that other potters asked Martinez to sign *their* pots, and she obliged. Seeing that she was risking the value of her own work, as well as that of other potters, Santa Fe authorities eventually intervened and asked Martinez to stop signing any pots.[20]

When objects have no named creator, and no prior owner, proximity to the person who bought or sourced the object can be substituted. Adit Agam, an assistant buyer at the Asian Art Museum of San Francisco gift shop, described in an interview a procurement trip her boss had recently made—a story she said always "sells a textile." It begins in Bhutan, a country that restricts tourist visas, and that has a mountainous landscape and an underdeveloped infrastructure. Agam's boss traveled to one of Bhutan's many villages that are inaccessible except on foot, this one known for its excellent textiles, and "bought so much stuff that he couldn't get it back down the mountain." He then "had to buy a donkey in the village, and strap all of the textiles onto the donkey, walk it back down the mountain, and at the bottom of the mountain he had to sell the donkey to someone else." Agam says that every time she tells this story to her customers, she sells a textile, because it is "very romantic"; customers love the knowledge that they "got something really special and different," and they

> want to be able to tell that same story to someone who came into [their] house. Say you are giving a dinner party, and they say, oh, what a lovely textile!, and you could tell them how this guy walked up this mountain and bought all of these textiles and packed them on a donkey . . . you want to know the origin as much as possible. It's like when you are buying an art print and the lower the number of the print the more expensive because it's supposed to be closer to the artist.

This proximity to the artist, and to the person who purchased it from them, is a means of establishing provenance, and therefore of establishing value. The fewer steps between the artist and the collector, the better. This process

of "selling stories" and maximizing proximity to artists is common enough to have its own name: "contagion effects."[21]

Before something can be called art, it must have an author. Reputational entrepreneurs orient themselves to the production, or even fabrication, of authors. However, having an identifiable human to credit with the production of a work is only one part of this process. Once authors are identified, advocates can begin to assert that they are credible and sincere— authentic artists. This involves first establishing their work is art, not entertainment or "commercial" culture. We refer to this process as the establishment of the artist's disinterestedness.

DISINTERESTEDNESS

To understand the concept of disinterestedness, we can return to the distinction aesthetic entrepreneurs made between artistic and commercial photography. Professional societies like the National Photographic Society and the American Daguerre Association sought to make the "distinction between [a] worthy artistic gentleman—the 'man of mind'—versus the less worthy 'operator,' 'machine' and 'money-getter'" by making membership a privilege open to only gentlemen.[22] Although art photographers were selling their work, it was considered unprofessional "to view service as 'product' or payment as 'profit.'"[23] Photographers who sought to fulfill their personal creative vision were artists because they are "disinterested" in profit. Aesthetic entrepreneurs assured collectors that the object or performance in question was art and "not some other form of commodity that was produced for a market."[24]

The potential contamination of art by money is at the core of this distinction between craftwork and artwork, and it is in fact central to establishing a legitimate field of artistic production (or, more precisely, of establishing "field autonomy").[25] In this case, the word "disinterested" suggests that the artist is "unbiased" (or uncontaminated) but does not mean that that artist is indifferent to their work receiving praise. Disinterestedness is a word that describes an artist who creates "art for art's sake and creates work regardless of "practical, utilitarian, or any other not purely aesthetic consideration.[26] For example, in *Metronome*, jazz pianist and composer Lennie Tristano said of America's great musical innovation: "Jazz is not a form of popular entertainment; it is art for its own sake.'"[27] The jazz artist must "profess a degree of 'disinterestedness' in economic matters to enjoy credibility."[28] Disinter-

estedness is a more persuasive description when powerful, legitimate actors endorse it. It is a perceived state, rather than an attribute.[29]

Of course, commercial culture fields face the most substantial obstacles in being seen as aesthetically—and not commercially—driven. As in film, it is hard to hold pop music creators to the purest standard of disinterestedness; they're working in a commercial industry. But artists who are seen as fighting hard against certain commercial pressures can be perceived as artists by the public; this was certainly the case for Marvin Gaye, Stevie Wonder, and Loretta Lynn. There are also some bands and artists who manage to be depicted as avant-garde, "pioneering and being faithful to an aesthetic vision"; the rock and roll band the Velvet Underground is the exemplar case for many.[30]

Sometimes, the desire to proclaim the disinterestedness of creators lead their advocates to defend a kind of dignified poverty. This is a particularly pernicious tendency among advocates for those untrained artists we refer to as "outsiders": "These days it is not enough for an outsider artist to lack a diploma or other cultural consecration; he or she is expected to evidence some sign of social wretchedness." In this marketplace, such artists' "depravity" has been turned into "an artistic qualification"; they are "symbolically desired for the very reasons they are socially reviled."[31] Take, for example, this comment inspired by the career of Albert Louden, a British outsider artist: "It isn't easy being an outsider. Once elected, there are appearances to be kept up: the solitary lifestyle, the nutty habits, the freedom from artistic influences. Above all, indifference to earning money."[32] These artists are situated in a paradox: being attuned to the rules of authenticity in their field allows them to succeed within it, but they must of course hide from others their knowledge of the rules.[33]

The myth that artists are born, not trained; that they are engaged in a "labor of love"; that they have a "calling," follow an "inner drive," or receive a "psychic income" that covers any financial deficit—all of these are part and parcel of an ideology that keeps wages and prestige low and attrition from the profession high.[34] Each myth supports the romantic ideology of art we see manifest in the value of disinterestedness. I hasten to add that this ideology is constitutive of artistic fields. It is part of the "illusio," or "the collective adhesion to the game that is both cause and effect of the existence of the game" that characterizes work in the arts, and a principle by which the relative autonomy of the field is defended.[35] It is of course also a mechanism of social exclusion.

AUTHENTICITY

Like disinterestedness, claims to authenticity are potent claims to legitimacy. They are also simply arguments, made by or for someone, thing, or performance.[36] Authenticity isn't an intrinsic or objective quality of a person, place, or thing, but, rather, a perception, a socially constructed set of beliefs, which is "produced," made, or enacted. I am resolutely not arguing that these descriptions or perceptions are always false, or that claims to authenticity are craven attempts to generate legitimacy. Instead, I expect that most people in culture fields are matching, as best they can, the reality of their experience to the rules that determine what kinds of people, objects, and performances are widely viewed as authentic. That is, they play according to the rules of a game they did not design.

We can understand this best by illuminating some themes in the way authenticity is judged across time, in many art forms. These themes include reference to the personal characteristics of creators, and to their sincerity as individuals and as members of a group (defined by education, geographic location, and ethnic or cultural identity). Their work is often also judged with reference to standards set within a relevant historical or ethnocultural tradition. Finally, as discussed in the previous section on disinterestedness, people creating art are expected to abjure commercial culture and mass-production techniques in favor of handmade, "traditional" methods of creation.

To start with, authenticity is often something associated with, or gauged from, emotion, as when popular music is seen to be "a release of feelings."[37] Such claims establish the work as "genuine," "natural," and without "artifice."[38] To give one example, a gallery owner argues that "you can't be an Outsider Artist and stand there and tell me you are."[39] Persuasive claims to authenticity often reflect circumstances in which artists are in synch with professional trends and norms but act as if they are ignorant of them.

Writing about folk and outsider art, one critic says that "the absence of any academic training or consecration" constitutes not only a virtue, but also a defining trait, one so crucial that the term "self-taught" has displaced "folk artist" in discussions of the field.[40] Although I have discovered no case in which graffiti art is described or categorized as folk art, both fields grant prestige to artists who lack formal artistic training. By the late 1980s, one scholar had reported that "the original graffiti muralists could be viewed as naïve artists in that they lacked any sort of training yet produced new forms of art."[41] The emphasis here is not on a lack of training, but rather a rejection

of formal "Western" training as an avenue that folk, outsider, or vernacular creators should use to refine their skills.

In other cases, the authenticity of the artist is defended by reference to their formal training in the arts. We find this among the "second generation" of tattooists, who established themselves by demonstrating that they "possess one or more of the following characteristics: academic training; [and] some knowledge of the fine art canon."[42] In jazz, as early as the 1920s, "professional musicians felt compelled to stress their status as highly skilled artists."[43] Similarly, the first "artistic generation" of film directors—the "New Hollywood"—were distinctive because "they studied film in an academic setting. In contrast, the typical career path of earlier directors had begun with on-the-job training through apprenticeships."[44]

These present interestingly different exceptions to the expectation that authentic, vernacular creators are untrained. While film is devoid of associations with marked categories (and instead is viewed in such terms, if ever, as white and male), tattoo has strong associations with blue-collar male bodies, and sometimes also with "traditional" cultures from the Pacific Rim. In the process of legitimization, tattoo shifted from a "distasteful badge that permanently blights the [blue-collar] body" to art on "more high-status individuals." Thus, "it is not coincidental that both the media and institutional experts would begin to recognize tattoo as having a greater degree of aesthetic-cultural value."[45]

An emphasis on tradition, and specifically on traditions tied to particular places and groups of people, is a key element in some authenticity claims. We have witnessed this in outsider and African art. As a consequence, attributions of authenticity frequently rest on stereotypes of artists, including their race or gender.[46] In music communities dominated (or perceived to be dominated) by black performers and fans, critics and fans may find it difficult to ennoble music without invoking essentializing narratives of racial consciousness or musical talent. Thus, the authenticity of performers in jazz, blues, rap, and gospel is often a function of how "well" the performers express or demonstrate attributes associated with blackness. By the 1950s, jazz critics and enthusiasts of the modern jazz renaissance located authenticity in the "primitive" and "folk" practices of black musicians, and the "exciting life of the lower class world of jazz."[47]

Dance had particularly suffered from pseudobiological debates concerning the fittingness of bodies to particular choreography. These concern both the ethnoracial background and the gender of the dancers. In tap dance, only male performers were deemed appropriate until the 1970s; as Gene

Kelly stated in a 1958 CBS television special, "Dancing Is a Man's Game."[48] As a field dominated by African American performers, tap dance communities spent the 1980s debating "who was legitimized to partake in and sustain the black rhythm-tap tradition. . . . Individually and collectively, white women of the tap resurgence—confronted by questions of race, gender, and sexuality" had to devise strategies to continue to perform.[49] These examples reveal a relationship between how "authentically" raced and gendered bodies and expectations of authentic performance promote exclusion. This is equally true for Hispanic or Asian ballet dancers, for men in certain forms of dance, for disabled artists or performers from lower-class backgrounds.

Art audiences have expectations—prejudices—about what artists working within that field will look like and sound like, how they will have been trained (or not), where they will live, and other aspects of their biography. This is the simplest notion of authenticity: the ability of a place, environment, person, or thing to conform to an idealized representation of reality, to a set of expectations regarding how something ought to look, sound, feel, smell, and so forth.[50] But audiences for the art forms that underwent artistic legitimation in the twentieth century share a preoccupation with the exotic social conditions of the producers (compared with consumers). Ideas about how their environment influenced the production of art dominate discourses of legitimation. Specific places and spaces are also critical to the artistic legitimation process as sites for the creation and presentation of culture, and as sites where experts congregate to establish consensus over who and what is legitimate.

SPACE AND PLACE

The space that is available to a creative community impacts the form and nature of its functioning. The size of the space, the amount of distance and interaction between producers and consumers, and the comfort, safety, and ease of use of the space or spaces "all guide participants as they figure out how to act and interact, and determine what they should expect about the other 'rules of the genre.'"[51] Across these ten fields, the kinds of places where work was shown over the last century nearly exhaust the imagination. They include personal and public spaces, public transportation, specialized commercial establishments (including galleries and stores), larger and more diverse commercial establishments, clubhouses and meeting spaces for fans and producers, radio and television, conventions and festivals, and specialty museums.

The kind of space in which work is created and presented can communicate the artistic ambitions of its creators. In some fields, reputational entrepreneurs and artists create new spaces especially designed for their work. For example, as photographers sought to entice elite collectors, "photographic practices were moved out of the laboratory, through steamy storefronts and brutish factories, and into the genteel setting of the bourgeois parlor."[52] These "genteel" parlors had waiting rooms that were outfitted with fine furniture, books, and even caged songbirds. By 1905, Alfred Stieglitz "led the movement toward a photographic elite" by opening the Little Galleries of the Photo-Secession, also known as "291" after its address on Fifth Avenue in New York City.[53] He adopted the title of "secessionists" in reference to movements using the same name in Germany and Austria, making the association clear in his manifesto: "Photo-Secession really hitches up with the art world."[54]

Some organizations play a critical role in the field by solving the problem of limited resources. In film, particular kinds of spaces provided access to otherwise unavailable artistic works; until the 1950s, these included "little cinemas, repertory theaters, museum theaters, university theaters, or film societies."[55] To overcome the problem of accessing foreign, old, or fragile films, collecting organizations were created to preserve these works and to make them available. The first such library was begun at MoMA in 1935, and by the mid-1950s, a commenter noted, it "contains prints of most of the outstanding foreign motion pictures, American classic, and films of historic value."[56]

Theaters, archives, and libraries seek to generate legitimacy for their constituency by offering resources, including reference materials and venues for social events, and, in so doing, they provide a foundation for collective identity and action. For example, a series of joint exhibitions by the Boston Camera Club, the Society of Amateur Photographers of New York, and the Photographic Society of Philadelphia rotated through the three cities from 1887 to 1894, the goal being "the promotion of the artistic, scientific and technical excellence of photography."[57]

Creating designated spaces for the development of an art form and creating rules governing entry go hand in hand. Jazz entrepreneurs created the United Hot Clubs of America in 1935 and encouraged "real" and artistic jazz spots to register.[58] In graffiti, City College of New York student Hugo Martinez created the United Graffiti Artists (UGA) and membership was "restricted to writers who had demonstrated the highest aesthetic ability and had achieved 'king' status in the subculture. . . . [This] elite group of 'style

masters'" was supposed to serve as "role models 'rechanneling' their graffiti into the products of fine art."[59] Not coincidentally, the *New York Times* review of the inaugural UGA show was the first instance when writers were referred to as "graffiti artists" in the media.[60] Tattoo organizations encouraged members to "work clean," in neat and professional spaces, to ensure that clients are sober adults, to decline invitations to ink obscene or racist content, "and to otherwise avoid practices that would perpetuate a negative reputation of tattooing and tattooists." Each of these norms serves the goal of differentiating tattoo art, so that "the process of artistic definition can progress more smoothly and result in at least some degree of institutional acceptance."[61]

Existing art spaces like concert halls, museums and galleries can be adapted to host legitimating fields. Reputational entrepreneurs recognize that these places, in effect, lend their legitimacy to the legitimizing form. After "movie palaces" began hosting classical music performances, reputational entrepreneurs for jazz maneuvered to have jazz standards performed as well.[62] They also sought to "invade the sacred concert halls of America."[63]

Artists working in the visual arts followed much the same path in seeking admission to artistic galleries and museum spaces. At first, the fate of tattoo display was uncertain: a 1971 exhibition at the American Museum of Folk Art was "raided by police because tattooing was illegal in New York City at the time—tattoo collections remained in storage or were exhibited in alternative spaces far from the center of the museum and gallery system."[64] But the laws were changed, and by the mid-1990s tattoo artists used galleries and museum spaces to display their works.[65] In 2002, Enid Schildkrout, emeritus curator for the American Museum of Natural History, proclaimed in the pages of the *Wall Street Journal* that "many people who have tattoos see it as art, collect it as art and wear it as art."[66]

The importance of particular art spaces to reputational entrepreneurs is never more clear than in cases where conditions for participation lead to failed cooperation. As I noted in chapter 3, Rockefeller's artistic ambitions for his collection of primitive objects led him to refuse anthropological or ethnological museums as hosts. He was willing to invest his own time and money into starting a museum rather than have primitive art shown in the "wrong" context. Similarly, Stieglitz's Photo-Secessionists were invited to display their work at the 1904 St. Louis World's Fair, but when he was told that their pictures would not be hung in the fine arts building, but instead

in the industrial pavilion, Stieglitz refused to attend.[67] He later argued that "other expositions had already displayed photography as fine art, not a craft, so why should they fight a battle already won?"[68]

Conferences and festivals are temporary locations that are nonetheless dedicated to the pursuit of collective identity for art worlds. The first New York Comic-Con (comics convention) was in 1964, followed six years later by one in San Diego. These conventions, in combination with fanzines and comic book shops, "made the construction of a community or sub-culture possible by fostering the group-formation of stigmatized individuals."[69] Festivals have also been essential to keeping tap dancing alive. Organizers of the 1962 Newport Jazz Festival devoted a whole Saturday afternoon to tap dance, hosting dancers Baby Laurence, Bunny Briggs, Pete Nugent, Cholly Atkins, and Honi Coles, while jazz writer and historian Marshall Stearns presented a narration of tap history.[70]

The value of conferences and festivals may be particularly acute for art worlds where commercial producers block the pathway to artistic excellence by prioritizing sales. Viewed at its 1993 inauguration, the New York Outsider Art Fair was a "very speculative affair," perhaps because radio advertisements stressed the artists' "anticredentials": "the Southern preacher who paints his religious visions," "the former slave who drew powerful figures on bits of cardboard," and "the artist who was hospitalized."[71] However, within a few years it was an "established event of the city's winter art season" and a place where folk and outsider art accomplished "what trained artists could only 'aspire' to do: maintain their independence from established cultural institutions and the marketplace."[72]

Festivals and conventions also promote status distinctions within the field. These are sites in which performers and audiences pursue the search for excellence. Convening bodies often elect to provide prizes or awards, or simply to use a juried selection process to facilitate the selection of the most artistic presentations. Film festivals serve to designate films that have artistic merit, given that entry to the festival often depends upon a peer review. In point of fact, the number of film festivals expanded dramatically after 1960, "as part of a formally organized effort to celebrate the artistic potential of film in a public manner"; they gave critics the ability to cite festival awards as evidence of artistic merit, contributing to legitimation efforts.[73]

Finally, the characteristics of the spaces themselves can determine who is able to access the work. In film, the installation of air conditioning in theaters in the 1930s increased the size of audiences and encouraged theaters

to move away from genre specialization and offer many kinds of films; this then reduced class segregation.[74] Less than twenty years later, the introduction of outdoor theaters—"drive-ins"—impacted how audiences saw films, and who would see them. Although film audiences were smaller in the 1950s, the number of drive-ins increased from 102 in 1946 to 4,000 nationwide in 1958.[75] In part, this was an effect of suburbanization; after the war, theaters moved with homeowners outside of city centers. Drive-ins were popular for their novelty, informal dress codes, proximity, and because it was easier to care for children there. However popular they were among certain audience members, they did not produce an increase in the size of the audience but rather made filmgoing more available and appealing to certain groups.[76]

Spaces for the production and consumption of culture can stimulate community, collective identities, status distinctions, and opportunities for teaching and learning, and they can convey the artistic qualities of the work on display. Certain spaces can also encourage consensus among critics about appropriate artistic conventions, essential to the production of intellectualized discourse. The particular importance of the college or university campus deserves additional description.

COLLEGES AND UNIVERSITIES AS LEGITIMATING ORGANIZATIONS

Universities, like museums, are held up as model legitimating organizations.[77] Colleges and universities are centers of cultural authority and are the "organizations most responsible for engaging the interest of young people in elite culture."[78] This was of course true first for painting, sculpture, and classical music, all of which entered the "humanistic (as opposed to professional) curriculum as core departments in most colleges and universities" before World War I.[79] In contrast, dance was taught as part of the physical education curriculum at women's colleges, and theater and drama were part of the professional education curriculum, while opera was taught as a component piece of classical music courses.

The creation of film studies departments in the 1960s helped to establish the artistic merit of film: "As centers of cultural authority, universities helped redefine a range of cultural products as high art" and produced a "film generation" of college-educated aesthetes in the 1960s.[80] Consider that while "only 10 undergraduate major programs [in film] existed in 1959, in 1971 there were 47; while there were 859 courses offered in 1964, there were

2,400 in 1971."[81] In these same decades, colleges and universities were producing a generation schooled in jazz performance theory and jazz studies classes:

> As jazz enthusiasts worked to build a hot jazz movement, they were looking to create jazz connoisseurs who could appreciate jazz as a serious American art form. This righteous elite of a rising jazz art world [who] were mostly white, male, college educated, and middle to upper class enthusiasts, many [of whom] pursued the sacred mission of jazz appreciation and jazz criticism.[82]

The "literation" of jazz, or the process by which "jazz would become a legitimate American high art music worthy of the same criticism, history, and instruction as European cultivated music," depended upon acknowledgement by the academy in coursework and study.[83]

Similarly, African American studies and other cross-departmental centers provided a greenhouse for the maturation of critical discourse on black novelists.[84] The provision of resources, including academic positions, doctoral fellowships, and training and research funds, were critical to this growth.[85] The efforts of administrators and faculty to expand access to the academy for experts in black literature were joined by support from libraries, university presses, anthology editors, and professional associations.[86] The University of Pennsylvania played an important role in advancing the legitimacy of black literature, particularly during the tenure of critic Houston Baker. His Center for the Study of Black Literature and Culture "was the site of a number of important conferences, lectures, and symposia that pushed the field ahead."[87] The slightly later emergence of American studies and interdisciplinary and communication studies departments gave rise to an "official culture" of academic discourse on comic books and graphic novels, propelling them toward artistic legitimacy.[88] The introduction of courses on comic-book art is similarly thought to be critical to their artistic legitimation.[89]

Tap dancing struggled to develop a stronghold in the academy. The earliest known college instruction in clogging (with tap as a variant) was a summer school course in physical education at Teachers College, Columbia University, in 1916. The course was situated within the existing curriculum on folk styles, which encouraged later programs to categorize tap dance and clogging as forms of folk dancing.[90] The designation of tap dance as folk dance in a physical education curriculum had several impacts on later instruction. First, the association with folk culture "helped to disassociate tap

from its professional 'stage' version and its mass popularity." However, this classification tended to obscure African American influences in favor of links to European-based folk dance.[91] Also, "since many of the college and university graduates who majored in Physical Education became teachers in elementary or secondary schools," university courses focused on teaching tap dance. Tap dance instruction was designed to satisfy beginners and those needing exercise, and did not include courses or modules on history, theory, or choreography.[92] Moreover, tap dance classes were almost exclusively taught at the introductory level and did not provide instruction that could lead to a professional performance career.

Like juries for festivals, university and college faculty helped to determine what fields, and what work within those fields, merit artistic status.[93] In some cases, the faculty of colleges and universities focused attention not on the artistic qualities of the field, per se, but rather on understanding its societal impacts. This was the case in comics, where educational researchers set themselves to the task of investigating "the relationship between comics and the development of reading skills," which they argued was largely a positive one.[94] Comic-book manufacturers responded by promoting these studies as a defense of comics, and some of the major publishers appointed academics to their advisory board.[95] However, it took many more decades before scholars and university presses began to publish works dedicated to understanding the aesthetics of comics. Books like David Carrier's *The Aesthetics of Comics* (2000) and *The Language of Comics: Word and Image* (2001) were published seventy years after the birth of the field.

Colleges and universities can be singularly important as incubators of creativity. Consider, for example, the Savannah College of Art and Design and the now-defunct Black Mountain College, the latter of which was the ultimate home of several professors and students fleeing European fascism. Both are renowned for nurturing creativity in this postwar period.[96] They were also spaces where future arts administrators could receive their initial training, through participation in student groups that organized gallery shows, plays, and concerts; through work-study and paid student employment; and through internship programs, on and off-site.

The faculty of colleges and universities play a critical role in providing the vocabulary for artistic legitimation within a field. They serve as aestheticians, charged with the responsibility for creating ideologies or "theories of art and criteria by which art, good art, and great art can be distinguished and identified."[97] They were instrumental to the legitimization of dance, film, primitive art, and a range of popular music styles, including jazz and

rock and roll.[98] Academic publications also play a key role. In order for a book to be appreciated as "literary and of a high standard" it has to "pass through the selection filters of a publishing house and of the three forms of criticism": journalistic, essayistic, and academic (in order of prestige).[99] These three forms of criticism are central to the development of an intellectualizing discourse in the field.

INTELLECTUALIZING DISCOURSE

Rockefeller and his staff were not hesitant to wax poetic about the beauty of the objects in their collection, believing them to belong "among other supreme artistic achievements in the world."[100] In the text of the Museum of Primitive Art (MPA)'s acquisition policy, its administrators sculpted the shape of the field; they stipulated that "the Museum proposes to emphasize artistic qualities rather than complete representation of cultural areas. It will limit its acquisitions and displays to objects of artistic excellence and will in no way attempt to be representative in terms of anthropology.[101] In press releases and gallery cards, the administrators discussed the objects' form, color, texture, and shape; their exemplary craftsmanship and emotional resonance; and their beauty. The words that Rockefeller, d'Harnoncourt, and Goldwater used to describe the objects in the MPA—art, brilliant, genius, inspired, intelligent, master, and work—are a form of "intellectualizing discourse."[102]

This intellectualizing discourse reframes objects of use or entertainment, or of disregard, into those worthy of careful study as art. An example from an analysis of African American literature can illustrate this:

In order for [the novel] *Their Eyes Were Watching God* to move from being understood as simpleminded folklore or an untenable political statement to being heralded as an "Afro American Classic" . . . the evaluative criteria used to judge the novel had to change. The criteria applied by the original reviewers became understood as inappropriate, and new criteria, influenced by changes in the larger environment as well as changes in literary-critical theory, were applied.[103]

Evaluative criteria as described above—the qualities that make something "good" or even "excellent" within a field—are elements that feed into the application of an intellectualizing discourse. In the case of *Their Eyes Were Watching God*, they allowed critics to "reposition the novel as central to both

the emerging pantheon of African American literature and the mainstream American canon."[104]

Any intellectualizing discourse relies upon a set of standard descriptions that were deployed as early as the nineteenth century by the "founders of the nation's first art museums and orchestras [and] served as ready-made ideological resources that cultural entrepreneurs could employ across a range of other art forms."[105] Authors of this discourse provided fans and practitioners with the "vocabulary of concepts and adjectives, reasoning logics, and justifications [they needed] to explain . . . aesthetic qualities."[106] In film, one indicator of advancing legitimation was a statistically significant increase in the number of reviews that included specific art terms: composition, genre, irony, metaphor, satire, symbol, and tone. Film critics wrote longer reviews, particularly after 1965, which "allow[ed] them to provide fully elucidated analyses, as opposed to . . . more superficial treatments."[107] Reviews posited the value of conflict and nuance, conveying the sense that "high art is complex and does not lend itself to easy interpretation or appreciation" and promoting films that, like other "highbrow art," rely "on resolving tensions between beauty and harshness to achieve its effect."[108]

By the midcentury, artistic work in jazz was lauded as "interpretive," used "larger and better orchestras" (as opposed to small ensembles), and was "free from discordant harmony." In rock and roll music, songs were evaluated on the basis of "expertise, virtuosity, innovativeness, and originality" by the start of the 1970s.[109] By the 1990s, tattoo artists called attention to their use of "formal rules or elements of visual art, like line, shape, space, value (light and dark), color and texture," in order to position their work "within an aesthetic context that has been well defined by cultural specialists—tattoo art is conceptually reframed."[110] Tattooists also began to use words like "biker," "sailor," or "scratcher" to "refer to working-class tattoo practices" and to differentiate them from "professional" modes of inking that can be described as "fine art." Of course, these tattoos were made by and for different groups, revealing that the distinction serves to mark class differences.[111]

The intellectualizing discourse of a field often includes comparisons with already legitimized fields.[112] For example, according to Paul Lopes, by the 1920s, the "cultivation of vernacular jazz was described by critics as applying 'symphonic' techniques to jazz performance."[113] Photographic artworks were also compared to classical music: "[Alfred] Stieglitz himself photographed clouds as 'symphonies;" photographer Edward Weston fa-

mously stated: "Whenever I can feel a Bach fugue in my work, I know I have arrived."[114]

In other cases, suggesting that such a trajectory of influence *could and should* exist is a way to employ this same technique. In his attempt to promote graffiti's place in art history, Norman Mailer wrote in 1974 that he "went to the Museum of Modern art" and it "confirmed the . . . notion with which [he] began: that if subway graffiti had not come into existence, some artist might have found it necessary to invent it for it was in the chain of evolution."[115] Will Eisner, writing in the *New York Times* in 1990, asserted the legitimacy of comics in comparison to other forms of art writing: "Everything has changed now; comic books are the arena for some of the most inventive expressions of literature. . . . It is the promised land for a reading medium with humble origins. . . . But I feel that my original sense of the potential of comics is about to be realized and that the medium can finally lay claim to legitimacy."[116]

Other aestheticians argue against the legitimation of fields, often using the same criteria employed by defenders. Soon after the department of photography was established at MoMA, it was "called 'snobbish' and 'pontifical,' and accused of being shrouded in 'esoteric fogs.' "[117] Similarly, tattoo artists who are "increasingly engaged in concerted efforts" to achieve "the valued redefinition of tattooing as art and the related advantages which follow" are working toward those goals "in spite of internal resistance from tattooists who are satisfied with the current commercial status quo." This resistance occurs along with the objections of "agents of the conventional art world who refuse to acknowledge the legitimacy claims of tattooing."[118] Just as academics studied the impact of comics on children's development, the authors of a 1987 article asked "What Is Rock Music Doing to the Minds of Our Youth?"[119] Concerns about the hazardous effects of commercial culture on children animate arguments objecting to its artistic legitimation.

Authors of an intellectualizing discourse "provide the rationale by which artworks justify their existence and distinctiveness, and thus their claim to support."[120] Aestheticians make arguments that specific art forms are legitimate, adapt criteria from other fields and use them to sort examples by quality and qualities, attack performances that do not merit the commercial acclaim they receive, and seek to highlight undercapitalized material of high quality.[121] The aesthetic legitimation of the field is indicated by the proliferation of available and legitimate gatekeepers, whether they are critics, academics, or other[s].[122] French sociologist Pierre Bourdieu is

among those who have argued that such canonical authority is contested, yet the " 'multiplication of authorities having the power to consecration but placed in a situation of competition for cultural legitimacy' is an historically intensifying process."[123] These experts find opportunities for expression in the simultaneously proliferating pages available for discussion of the protoart form. These are found in magazines and newspapers, scholarly publication sites like journals and books, and specialty journals dedicated to the field.

PUBLISHING

Printed and digital material including magazine, news, and scholarly articles and books play an important role circulating arguments about the legitimacy of protoart forms. Some published material carries enormous cultural authority and can act as manuals for cultural sophisticates.[124] When publications are devoted, in whole or in part, to identifying emerging trends and to identifying worthy choices within a new or less familiar field of options, they guide readers toward consensus on legitimate options. More than simply pointing readers toward acceptable choices, these texts provide readers with a rationalization or justification for these selections. These justifications make the legitimation process transparent and provide important evidence of the ideologies that motivate artistic legitimation.

Publications provide space for critics, connoisseurs, and musicians to create knowledge and develop their position as leaders. The music publications *Metronome* and *Down Beat* "became intellectual forums for the promotion of the different ways that jazz performance both moved out of its original location in jazz clubs in urban entertainment districts and developed a more refined high art aesthetic."[125] The boom in artistic tattooing in the 1980s was encouraged by, and reflected in, specialty magazines like *Tatootime* or the *Tattoo Advocate*. These magazines were "produced by people who wanted to show more than chopped motorcycles and the bodily decorations of the people who rode them.[126] In film, readers could turn to *Cahiers du cinema*, *Movie*, *Film Quarterly*, *Film Comment*, and *Cineaste*. Finally, art photography pioneer Alfred Stieglitz considered the distribution of knowledge about the field so essential that he founded and edited the journal *Camera Work* (1903–17).[127]

While trade magazines promoted a discourse that defined the emerging artistic core of jazz, rock and roll, and film, books served this purpose in other fields. In graffiti, it was Henry Chalfant and Martha Cooper's beautiful

1984 text *Subway Art* and Chalfant and James Prigoff's *Spraycan Art* that anchored text-length treatments of the style, by providing description and analysis alongside full-color images of important works.[128] While academic texts on African American literature as art date from the 1950s, it took another two decades before university presses, anthology editors, and professional associations put resources behind the publication of substantial critical works, including Barbara Christian's *Black Women Novelists: The Development of a Tradition, 1892–1976*, the title of which highlights its critical role in the field.[129] Texts focused on outsider and self-taught art were few until the 1974 publication of Herbert Hemphill and Julia Weissman's *Twentieth Century American Folk Art and Artists*.[130]

Aesthetic criticism, or the "literation" work of critics, reaches audiences through reviews and feature pieces but also finds expression in other forms. One of the most significant events in the legitimation of jazz was a concert series organized by John Hammond at Carnegie Hall titled "From Spirituals to Swing." The concerts took place in December 1938 and December 1939 and "were designed to show 'Negro music from its raw beginnings to the latest jazz'" and included extensive program notes, as well as brief lectures between performances.[131] Like a syllabus or curriculum, program notes, retrospectives, public lectures, even memorials can instruct audiences on the formulation of protoart fields and guide them toward emerging canonical understandings of great performances, signal events, transformative works, and artists of note. They can also inform readers about emerging divisions within the field, or even promote them.

SPECIALIZATION AND SEGMENTATION

A key moment in the artistic legitimation process is the evolution of distinct positions within the field. As I have demonstrated, some of these status positions are a function of the application of an intellectualized discourse, which serves to distinguish artistic from nonartistic works and people. As the field matures, positions evolve styles, made of variations on the dominant field conventions. The research on art worlds teaches us that newcomers to the field—both novices and young people—are more likely to work within these styles. One expert reports that creators with "new dispositions" seek to "impose new positions" in the field—they're looking to stage a "specific revolution . . . [to] overthrow the power relations in the field."[132] They do this by attacking standard activities and conventions with manifestos, critical essays, and revisionist history, and by celebrating new work. They aim to take

over sources of support, audiences, and distribution facilities.[133] These challenges to the dominant mode "last when participants make them the basis of a new mode of cooperation, or incorporate a change into their ongoing cooperative activities."[134] This section examines evidence of specialization and the resulting segmentation of the field.

Stylistic innovation in comics was constant; starting in the 1940s and for every decade thereafter, dozens of thematic concerns shaped production.[135] But the evolution of styles that started in the 1980s is the most relevant to the current argument. That decade saw the advent of the autobiographical comic by artists like Harvey Pekar and Robert Crumb.[136] Of even greater importance, the graphic novel was inaugurated with the publication of three titles: *Maus*, *Batman Returns*, and *The Watchmen*.[137] Graphic novels were viewed as new "serious" comics that "would fit just as well in the highbrow literary world as they would at a comic book convention," in part because they enjoyed recognition by major media gatekeepers, including critics at the *New York Times* and *Village Voice*. Moreover, artists began to win awards like the MacArthur "genius" grant (Ben Katchor, 2000) and the *Guardian* First Book Prize (Chris Ware, 2001).[138]

In contrast to comics' decadal devolution into multiple styles, it appears that almost all of the stylistic innovation in tattooing took place (or was recognized) over the two decades between 1990 and 2010. Art school–trained tattooists developed styles, including biomechanical, black-and-grey, and "new school."[139] In the subsequent decade, these were joined by an extraordinary variety of new templates, including contemporary Japanese, color specialist, photo-realism, portraiture, Tibetan, and tribal styles.[140] As major producers sought inspiration from diverse cultural sources, they may have thought that "influential representatives of the art establishment can be expected to pay more sympathetic attention, thereby increasing the prospect of redefinition and artistic legitimation."[141]

While specialization and segmentation in some fields (for example, comics) were responses to political trends, other fields developed as a consequence of the legitimatization process itself. In graffiti, the proliferation of styles from the 1970s onward is viewed by most experts as a response to commercial entrepreneurs who sought to transform the public art form (writing on walls and subway cars) into something collectible.[142] The intensified social control of neighborhoods where graffiti writers lived and places where they worked provided an opportunity for established visual artists who "enthusiastically co-opted the themes and styles of graffiti."[143] These include Keith Haring and Jean-Michel Basquiat: "Neither was considered a

'writer' (that is, someone working in the original graffiti style) but both had made graffiti."[144] Galleries sought work by Haring, Basquiat, and others, and this resulted in "the commercial packaging of an eclectic range of artists and practices under titles such as "post-graffiti" and served to elevate a handful of high-profile artists, of which only a few subscribed to the graffiti subculture's traditions."[145] Thus, the spread of work to different locations within the field was accompanied by the evolution of different styles, and artists who "imposed new positions" within each.

The segmentation and specialization of fields and their aesthetic discourse is a key component of the aesthetic legitimation process. It supports the professionalization of the field, in which artists, curators, organizations, and audiences identify and then maximize a position within the field. Specialization within some segment of an artistic field allows curators to compete for jobs, grant-proposal writers to identify their organization's unique contributions, and art world members to develop sophisticated and targeted mastery. As aesthetic techniques, conventions, or philosophies are hived off, creativity can flourish, providing opportunities for the emergence of new art fields.

Conclusion

In the previous chapters, we observed three periods where flux in the opportunity structures for artistic legitimation led to the expansion of the artistic canon. One followed on the birth of the nonprofit arts in the United States. It included the national diffusion of museums and symphony orchestras, and the adoption of the nonprofit organizational form by three art fields: dance, theater, and opera. The second stage was sparked by the profound organizational and institutional transformations begun in the New Deal era. During those years, Americans attempted an encyclopedic rendering of vernacular, folk, and minority art that was presented to the public as a manifestation of the American character. These federal, state, and local arts agencies created the opportunity for a great variety of culture to be interpreted as art. The third and final period of artistic legitimation was promoted by opportunity structures that changed the social, economic, legal, and political landscape for the arts. These provided the conditions for the artistic legitimation of a final group of creative fields that included primitive art, film, rock and roll, and jazz.

The similarities among burgeoning artistic fields are hard to miss. Framed as disputes, these include debates over what objects and creators

"belong" within the field and how objects should be valued, including important discussions among experts over which aesthetic or formal criteria of assessment are appropriate. Expanding legitimacy is signaled by the evolution of an intellectualized discourse and the maturation of critical and academic study. Increases in the provision of resources accompany this process, as spaces for publication or consumption of the work are created or adapted; of particular importance, legitimacy is signaled when fine-arts organizations provide such space. These dimensions formed the core elements of the analysis that proceeded. To briefly summarize, as the legitimation process proceeds, and consensus builds about how to act artfully within it, entrepreneurs are able to stake out new positions within the field. As they do so, communities of fellow artists begin to work in similar styles and compete for resources (e.g., money, artists, stages). Instead of draining the energy from a field, this energizes the legitimation process, lending credibility to those entrepreneurs who are seen as innovative and creative.

The success of aesthetic entrepreneurs who promoted the legitimization of folk culture, vernacular culture, and forms of entertainment is all the more remarkable considering the sustained objections from so many corners. In 1950, David Riesman, author of the landmark midcentury work of social and cultural criticism *The Lonely Crowd*, proclaimed that "the study of popular culture—radio, movies, comics, popular music and fiction—is a relatively new field in American social science." What explained the midcentury rise in interest, according to Riesman, is the fact that

> a good deal of current interest in popular culture springs from the motives, seldom negligible in scientific investigation, of dismay and dislike. Gifted Europeans, horrified at the alleged vulgarization of taste brought about by industrialization, left-wing critics in the traditions of Marx or Veblen who see popular culture as an antirevolutionary narcotic, highbrows who fear poaching on their preserves by middlebrow "culture diffusionists."[146]

Defensive, elitist highbrows, left-wing revolutionaries, and "gifted" Europeans were driven by horror, fear, and dislike to study popular culture, at least in Riesman's mind. More than fifty years later, these critics are fewer in number, but the debates rage on.

This chapter focused on the shared attributes of ten fields that underwent the artistic legitimation process in the wake of the New Deal. But, as I have argued, each field's possession of these attributes was in dispute. The goal of the chapter was to identify the core positive arguments that experts in

each of these fields identified as critical to the given field's success. The following chapter focuses in-depth on one additional argument that has come to characterize artistic legitimation: the difference between cultural appreciation on the one hand and cultural appropriation on the other. The relationship of this argument to the rapid artistic legitimation of multiple forms of vernacular and folk culture should be an obvious one. Every extension of artistic legitimacy to a new field allows for a counterargument, in which critics describe that aestheticization as a kind of symbolic violence. That is, they charge reputational entrepreneurs with "co-opting" or appropriating the culture of others.

6

Cultural Appropriation

Poor societies worry about growing enough corn; rich societies can worry about being corny.

—JOHN LELAND

As chapter 6 demonstrated, a remarkable range of folk, vernacular, and popular culture came to be treated as legitimate artistic activity during the twentieth century. This process necessarily involves changes in the definitions of artistic techniques and excellence. Categories expand, and so do our notions of which techniques are considered artistic. This expansion is conflictual, as the previous chapters illustrate. We observed that, in many cases, including those of primitive art and African American literature, it provokes disputes between status quo hardliners who seek to preserve the past, and aesthetic entrepreneurs who advocate for an expanded definition of the arts. But even innovators who defend such an expansion express concerns about the impact of this process on the cultures undergoing aesthetic legitimation.

Aesthetic entrepreneurs working on behalf of legitimizing fields often voice these concerns in terms of cultural appropriation. We find a similar concern about cultural appropriation in discussions of another modern class: cosmopolitans. Those discussions may aid us in understanding how, when, and why voracious elites voice objections to the artistic legitimation of vernacular and folk culture.

Cosmopolitanism

Cosmopolitans are citizens of the world, and this requires an openness to others, and the ability to rejoice in people's differences.[1] This characteristic is essentially the same as elites' interest in adopting "an inclusive cultural ethos" that differentiates them from the narrower cultural choices of their parents' generation.[2] Cosmopolitans and voracious elites also share the ability to transform their "inclusive cultural ethos" into a marker of high social status. Although this ethos is framed in meritocratic or democratic language, their tastes are viewed as sophisticated, interesting, and wise. And because these and all tastes are treated as individual preferences, the people who hold them also seek to gain esteem as fair, broad-minded, and tolerant. Thus, in a context in which elites do not benefit from being seen as *elitist*, cosmopolitan tastes provide the opportunity for voracious elites to be viewed positively. That said, even as they enjoy this positive regard, "an ideology of status and distinction operates implicitly to suggest that only certain individuals can appreciate and understand 'quality' culture."[3] In selecting from among the increasingly varied forms of culture on offer, elites demonstrate their power and capital through the correct identification of particular cultural objects and experiences. The framing of these choices as individual and broad-minded, and the perception that they were grounded in an inclusive, meritocratic process of selection, disguises the power relations at play.

There is an additional trait that voracious elites share with cosmopolitans, and that is their engagement with other cultures through market exchange. Most of the cultural experiences enjoyed by elites are purchased: it is by virtue of a vacation, an admission ticket, or bargaining in a souk that they consume culture made by others. This is not a particular trait of American, art-consuming elites; rather, "we persist in believing that shopping is a realm of freedom from work and politics—a form of democracy open to all."[4] In fact, some argue that contributing to markets for goods and services in emerging economies is

> deeply intertwined with democratic ideals, with the material and political welfare of others across the world, and with the well-being of the global environment. This "authentic" form of cosmopolitanism, which sees consumption as a potentially civic act, emphasizes the political as opposed to aesthetic dimension of global citizenship.[5]

Markets give us access to other cultures and encourage us to think we have a right to that access, while also minimizing any discomfort we might experience.[6] That is, the markets for cosmopolitan goods are instruments of privilege. They are premised on one class or group being the arbiter of taste, or—in the case of nonprofit culture—being the caretaker of another's culture.[7]

When cosmopolitans experience various forms of difference, the question becomes, Have they achieved a more sophisticated understanding of the world? Or have they returned home as they left it, potentially holding the same widely held assumptions about other cultures and people? These determinations can be frustratingly difficult to make. At a Vanderbilt University workshop on culture in 2010, my former colleague Greg Barz played portions of the album *Kampala Flow: East African Hip Hop from Uganda*, which he coproduced. The lyrics focused on rape, gender roles, HIV/AIDS, spousal abuse, love, school fees, and community life. Barz had to explain some of the lyrics to us because the rappers switched between English and various other languages; he explained that the lyrical content is pretty risky and courageous given the political landscape in Uganda. But even without being able to understand the lyrics, you would be able to notice that most of the songs feature beats and vocal styles that resemble American hip-hop from the 1980s and 1990s, more than they do contemporary rap music in the United States.

As Barz explained, this is a function of the rap music these artists and their fans consume, which is largely American and a decade old. In their aspiration to earn a living performing locally, these rappers make music that sounds like the music their fans enjoy.[8] Consequently, "authentic" local Ugandan hip hop didn't "sound African" to most of the people in my workshop (with the exception of "Man's Lady," by Twig, which opens with a field recording of a pit xylophone, a "traditional" instrument used in the Busoga Kingdom).

Music or culture that is produced with the intent of generating cross-cultural exchange often involves intentional hybridization, where "local" conventions are combined with those designed to interest a foreign audience. Ethnic food restaurants—say, Chinese food prepared for American eaters—often reveal such hybridization. These restaurants can be battlegrounds where the tension between cultural appreciation and cultural appropriation are fought on cosmopolitan palates.

Restaurant owners, seeing their clients struggle with unfamiliar ingredients or spices, may make adjustments to facilitate these cosmopolitan ex-

changes, and to keep their businesses afloat.[9] They may substitute ingredients, adjust levels of spice, and rename dishes so patrons will find them less frightening or foreign. The commercial exchange is often predicated on the ethnic differences between the producer and consumer. Any disruption of this balance leads to a negative assessment of the encounter: that it was inauthentic, disorienting, unwelcoming, or impolite. The cosmopolitan consumer implicitly expects some concessions to be made to her own preferences and cultural predispositions while also managing some discomfort, and the restaurateur must be willing to alter the food while offering the performance of authenticity.

From a distance, it's easy to see that there's a sweet spot for cosmopolitans, where the barriers to access are low enough for them to be comfortable, but the feeling of exoticism convincingly delivers an authentic experience. Scholars of culture know the difficulty of hitting that sweet spot: communities that are entering the world pop marketplace tend to arrive with products that are roughly hewn, slightly dated versions of dominant styles, like a lot of the songs on *Kampala Flow*. Sometimes, global media experts step in and encourage artists to reformulate their products to reflect what Western consumers will interpret as more "authentic" aesthetics. But these "authentic" cultural performances may be successful because they are reinforcing Western stereotypes about the host culture (even if they are not *negative* stereotypes).

Sometimes this blending is seen as a kind of muting or dilution, a "homogenized heterogeneity," whereby the very differences that draw cosmopolitans' interest are transformed in the process of bringing the products to the marketplace. Cosmopolitanism is linked to appreciation and appropriation because, on the one hand, it is an orientation toward consuming difference. On the other hand, "the very act of consuming difference results in, at best, a hollowing-out or watering-down of that difference, and at worst, a form of appropriation and symbolic oppression of the Other."[10] Where the cosmopolitan impulse to engage with someone else's culture is solely focused on the market value of that person's cultural goods, "engagement with others becomes a question of knowing their value: 'Is their culture worth knowing, experimenting with?' "[11]

These cultural preferences are tightly related to political and social attitudes. It isn't a trait of people who have given up on status seeking, but rather of people who seek status in "newly selective ways."[12] Voracious elites and cosmopolitans are still snobs; they're just not *snobby*. Sociologist Jennie Molz concludes that "cosmopolitan consumption is as much a market of

exclusion, then, as it is a means of transcending hierarchies of difference."[13] Studies have found that elites are more likely than (white) working-class Americans to display primitive or tribal arts from Africa, and those who do are generally left of center politically, with inclusive attitudes toward American blacks.[14] A study of collectors of self-taught artists (the former were predominantly white and wealthy, while the artists hailed from poor and rural areas, were black, mentally ill, and often illiterate) reveals that elites have become a "group that values a multi-cultural perspective"; they are "awash in tolerance," and, for this reason, "the work of vernacular, marginalized artists is . . . valued."[15] This progressive, tolerant, anticlassist, antiracist disposition of elites is arguably demonstrated by their willingness to take an interest in, and purchase, the cultural goods of status inferiors.

This chapter is devoted to a series of case studies that illustrate aspects of the tension between cultural appreciation and cultural appropriation. They span the globe—from Paris, India, Boston, to South Africa. Although these examples weren't designed to be an exhaustive sample of the kinds of debates that exist around cultural appropriation, it is my hope that they remind readers of other arguments, past and current.[16] Each example illustrates the difficulties in differentiating between productive and destructive consequences of artistic legitimation. Throughout, you will meet people and read about situations in which there was no obvious intent to do harm. The motivations of these choreographers, fashion designers, museum arts administrators, tour operators, nongovernmental organizations, and shoe advertisers needn't be questioned. The problem is with the game, not the players.

Slumming

Starting in the mid-1880s, first in London and later in New York, "slumming parties" brought affluent whites into immigrant and working-class districts. Reflecting the rising trend toward the heterosocialization of public leisure, both men and women, with and without police escorts, traveled into poor neighborhoods, patronized immigrant restaurants and shops, and indulged in the liquor and sex that were available in dance halls and saloons.[17]

Take, for example, "Arrest of Booth-Tucker," an article from the April 29, 1896, *New York Times*. It relates the following events: on the afternoon of April 28, Frederick Booth-Tucker, commander of the Salvation Army in the United States, put on a "preposterous wig of oily brown tow and grizzly whiskers that proclaimed themselves artificial" and joined business owner "Steve" Brodie and newspaper reporter Harry Cogan on a trip to New York's

Chinatown. Commander Booth-Tucker later explained to police and reporters that he donned the wig for the purposes of disguise, as he did not want to tour Chinatown "with an army of reporters at my heels, especially after my portrait had been in the papers."[18]

Over the course of that afternoon, Booth-Tucker, Cogan, and tour guide Brodie "sampled all sorts of Oriental menus, banged the sacred gongs, and investigated all the opium dens and fantan games."[19] At one point, a heated discussion between Cogan and Brodie led police to approach the group; they later arrested Booth-Tucker for disorderly conduct because he had "disguise[ed] himself with a false beard and hair." According to the *New York Times*, Magistrate Simms discharged Commander Booth-Tucker after determining that "it was an offense for three or more persons to masquerade in the public street, but none for one to do so." However, he advised Mr. Booth-Tucker to be more careful not to cause another public disturbance when he next went slumming.[20] While Commander Tucker's sentence was being delivered, the show window of Brodie's Bowery saloon featured a hairy display and a tag reading: "Wig and Beard worn by Com. Booth Tucker on his Trip to Chinatown."[21]

Booth-Tucker was by no means the lone sophisticate in the slums. In 1884 a headline in the *New York Times* proclaimed: "A fashionable London mania reaches New York. Slumming parties to be the rage this winter."[22] Visitors to New York's Chinatown flocked to see gun battles on Mott Street that were scripted to echo news coverage of the local Tong Wars and arranged by local tour operators. Once in Chinatown, slummers might view the ministrations of George Yee, preparing a dose of opium for a thin white woman. But Yee was a professional actor, and his wife—the "addict"—was a forgotten actress from the vaudeville stage; the couple would perform this act "anywhere from ten to twenty times a night, for pay."[23] It did become quite the rage: Charles Dickens is said to have enjoyed a tour of the gambling dens of lower Manhattan, and Stephen Crane, son of leading evangelists from New Jersey, acted as a Bowery guide in the 1890s.[24]

The idea of respectable people being entertained by demonstrations of working-class or poor lifestyles is as old as the bourgeoisie is as a class. What is distinctive here is the association with a putatively *democratic* aestheticization process. This opens slummers to charges of exploitation, a cousin to the accusation of cultural appropriation.

Marketed as an "insider's" view of these communities, slum tours were often staged productions of local nightlife. An investigative reporter for the *New York Times* discovered that Protestant missionaries, led by the

Reverend A. C. Arnold, had been bribing bar owners, rat-pit proprietors, and street thugs to put on "salvation shows" for the benefit of visitors to the Howard Street Mission. (A rat pit is exactly what it sounds like—a hole in the ground in which rats are set, along with a terrier, while humans bet on how long it will take the dog to kill the vermin.) Notorious rat-pit owner Kit Burns laughed after finding out saloon owner John Allen was hosting these prayer meetings: "I've known Johnny Allen fourteen years and he couldn't be a pious man if he tried ever so hard. You might as well ask a rat to sing like a canary bird as to make a Christian out of that chap."[25] These businesses grew into a carnival for the rich: residents gave tours in "rubberneck wagons," as "slumming guides." Lower East Side theaters staged melodramas—such as Stephens's "On the Bowery" (1893) and Price's "In the Tenderloin" (1894)—that later toured other cities.

Slumming reinforced the increasingly widespread perception of the city as a patchwork of internally homogenous neighborhoods with residents from some working- or lower-class group, segregated by ethnicity, race, culture, and perhaps also sexual preference or gender identity (for example, "boystown," "Chinatown"). Slum neighborhoods were places where nighttime revelers who lived elsewhere could indulge in various "immoralities," perhaps under the impression that this would insulate their own families and homes from harm. Yet it was often the case that these revelers were the authors of the harm they brought home to those "safe" neighborhoods.

As you might expect, residents of these slum districts often objected to the noise, disorder, and disrespect of slummers and placed pressure on local politicians and police to increase their surveillance within slum districts. Instead of focusing their regulatory efforts on wealthy visitors, however, community leaders directed their attention toward residents who, unwittingly or not, encouraged slumming in their districts. Clergy and community leaders formed community organizations to clamp down on slumming, and some joined forces with white middle-class reform organizations. This ostensible "progressive crusade" was particularly effective in drawing attention to conditions within red-light districts, and, by the early 1910s, slumming excursions were routinely interrupted by raids, and nightlife venues closed at a rapid rate.[26]

Slum visitors also included so-called "sociological workers," who went to these slums and "labored to understand the social and physical conditions of poverty 'in order that intelligent action may be taken in the direction of remedy or restraint.'"[27] Reform writers like Charles Loring Brace, Helen Campbell, and Jacob Riis combined statistics with melodramatic descrip-

tions and interviews to convey just how difficult it was to be poor in the city at the turn of the century.[28] They sought to present "moral interpretations of poverty" to motivate campaigns for urban renewal.[29] Readers of newspaper articles, sociological monographs—for example, Jacob Riis's *How the Other Half Lives* (1890)—and travel guides swelled the ranks of those visiting slums.

Thus, slumming had a twofold character. It was, on the one hand, a set of "ritual encounters between those whose lives were privileged to observe, regulate, and detail the behaviors of others" and those who were being observed and regulated.[30] That is, whether the slummers were intent on party or reform, elites had the power to access the leisure spaces of the poor, and the reverse was not the case. On the other hand, it was a set of ritual encounters between rich and poor reproduced by the desire of the rich to reassert their superiority through this mechanism—through maintaining that social distance and developing an explanation or account that regulated or explained it. In the case of the Protestant reformers or the sociologists, that language involved commentary on health and safety, civil society, social interdependency, and social responsibility. In the case of the slummers, it involved a mix of reformist language, cosmopolitanism, and hedonism.

Slumming didn't equalize social divisions: elites were slumming because they viewed lower-class cultures as exotic, and upper-class cultures as cultivated.[31] The way that these elites slummed reinforced their sense of superiority and called attention to the existence of social distance. What may have appeared at first to be an attempt to reach across social divides revealed itself to be a means of social reproduction and stratification. When elites slum, lower-class culture is enjoyed as a commodity, and the experience of consumption is designed to satisfy and thrill without too much discomfort. While this move to consume broadly across the social class spectrum will be "celebrated by some as a significant movement towards the break-up of old hierarchies of fashion, style and taste in favor of an egalitarian and tolerant acceptance of differences," in point of fact this consumption signifies not "the implosion of the social space" but instead "merely a new move within it."[32]

Slum tourism persists in the twenty-first century. In Chicago, "Ghetto Bus Tours" bring visitors to the site of the now-demolished Robert Taylor Homes, and former residents lead tours of what was the city's largest housing project complex. But the largest trend in slum tourism brings the jet-setting elite to places outside the United States. Visitors to Brazil can employ the Favela Tour operators to visit Rio de Janeiro's poorest districts, and in

New Delhi they can view the "railway underworld." There are similar slum tours in the black townships of South Africa, the slums of Mumbai, and the garbage dumps outside Mazatlán, Mexico.

Many contemporary slum tours sell the opportunity to exercise one's tolerance and commitment to multicultural appreciation, or to be, as Victoria Safaris's "Nairobi City Slum Tours" advertised, "Pro-Poor." These tours are so popular that the *Guardian* published an article in January 2011 documenting their presence and impact. For about twenty pounds, visitors could take a guided tour through Kibera, a slum that is only a short drive from the luxury hotels that host many foreign visitors. According to the report, "Kibera's sole attraction is its open-sewer poverty—with residents on parade like animals in a zoo."[33]

Slumming is also rampant in the fashion industry, where forms of exaggerated ethnic dress are still tolerated, as are various forms of class-based dress. I am reminded of a now-infamous comment on American race relations published in the magazine *Commentary* in 1963. Leslie Fiedler wrote, "Born theoretically white, we are permitted to pass our childhood as imaginary Indians, our adolescence as imaginary Negroes, and only then are expected to settle down to being what we are told we really are: white once more."[34] Fiedler's essay touches upon one feature of white privilege in America: we have uniquely broad access to other cultures, without any concurrent requirement to consider their experiences or to honor their exclusion and discrimination. We experience a feeling of entitlement to the cultures, genres, and stories of others. Markets and culture industries give us access to those, while virtually eliminating the potential that we will experience discomfort while enjoying them. We have, as Greg Tate so brilliantly put it, "everything but the burden."[35]

As Fiedler intimates, some white Americans do "dress up" in the costumes of other cultures. For example, in 2012, undergarment manufacturer Victoria's Secret sent model Karlie Kloss down the runway in a "Native American headdress replica" (and a bikini studded with turquoise stones) for a fashion show. In response to strong criticism in the pages of the *Wall Street Journal*, the company later released a public apology for its cultural insensitivity.[36]

Slummers appear to love *ethnic* dress, but the underlying attraction appears to be the result of of social distance (between ethnoracial groups, between social classes), and the exploration of that distance through fantasy and costume. To wit, not all slumming fashion trends capitalize upon ethnic tropes. There was, for example, the "heroin chic" fashion trend, sparked in

1996 by Calvin Klein's "Be" campaign. In 2000, House of Dior launched "hobo chic" and "asylum attire" lines, and a year later sold "laddered" (torn) hosiery for thirty-five dollars a pair.[37] According to one account of the designer's runway show that year,

> They came down the runway raggedy and baggy, some swathed in newspapers, with torn linings and inside-out labels, accessorized with empty little green J&B whiskey bottles, tin cups dangling from the derriere, bottle caps, plastic clothespins and safety pins. Some posed as lunatic ballerinas in frayed tulle, others in straitjackets with white madhouse makeup.[38]

Designer Xuly Bet has marketed "street-person chic" fashion and Rei Kawakubo designed a similar look for Comme des Garçons. Kawakubo was described as admirably accomplishing "a poor-girl look that only a rich one could afford."[39] As a *Washington Post* reporter put it, "The height of chic is to look downtrodden, poor, disadvantaged. . . . The rich . . . are distinguishing themselves with clothes that stand out because they are . . . so mockingly lower-class."[40]

Slumming—the clearest and perhaps most exaggerated form of cultural appropriation—is also arguably the least common. While it is helpful to use extreme examples to illuminate the concept, our attention is more usefully spent on the ordinary pursuits of those elites who are drawn to consume the culture and art of other peoples. And this brings us to Boston, to Frenchman Claude Monet and a kerfuffle over a kimono.

Monet's Kimono

On June 24, 2015, the Boston Museum of Fine Arts (MFA) initiated its "Kimono Wednesdays" exhibit as a way to encourage visitors to celebrate the 125th anniversary of their Department of Asian Art (and a show unfortunately entitled "Flirting With the Exotic").[41] Visitors were invited to pose wearing a replica of the kimono painted in *La Japonaise,* in an Impressonist style, by Claude Monet. The painting, completed in 1876, depicts Monet's wife Camille wearing an *uchikake* kimono, arm upstretched while fanning her face (with an *uchiwa* fan in the colors of the French flag), which is cloaked in a blonde wig hiding her dark hair ("I am *not* Japanese," she appears to say). Commissioned by NHK, Japan's public broadcaster and co-sponsor of the Japanese exhibition, the kimonos in question were historically accurate reproductions, manufactured in Kyoto. Visitors to the exhibit

in Tokyo, Kyoto, and Negoya were invited to wear the garment while posing for photos, and this curatorial approach continued in Boston.

By early July, the museum was embroiled in a national controversy, stoked by protestors self-identifying as Asian American, holding signs and giving interviews to the press decrying the exhibit as racist, "yellowface" Orientalism.[42] They accused the museum and its director of "white supremacy, trafficking in racial stereotypes, and insufficiently grappling with its post-colonial legacy."[43] Demonstrator Christina Wang told the *Boston Globe* that, while she could protest "everything in the museum to some extent" because so many items are tied to colonial conquest, "the reason why this particular event is so offensive is the invitation for the public to participate in this farce."[44]

Members of the protesting group pointed other visitors and the media toward a Tumblr page titled "Decolonize Our Museums." The text on that page made clear that they viewed the exhibit as a form of cultural appropriation, enacted by a historically white institution that retains the "power to represent—and therefore dominate—other ethnic and cultural groups."[45] The page explained: "This exhibit activity reaffirms the notion that Asian-identified folk are the Other, that they do not exist here, and that their cultures' histories with oppressive imperialist practices are mere entertainment fodder. Rather than interrogating these notions of cultural appropriation and Orientalism, the MFA has allowed visitors to participate in a horrific display of minstrelsy."[46]

How did the Japanese react? In the *National Review*, Japan's deputy consul general for Boston is quoted as saying, "We actually do not quite understand what their point of protest is."[47]

Within two weeks, the museum released a statement informing visitors that they would be allowed to touch the kimono, but self-portraits in front of the painting would no longer be allowed. In that public statement, directors of the museum explained that the painting had just toured in Japan. This exhibit, "Looking East: Western Artists and the Allure of Japan," focused on how *japonisme* (a nineteenth-century "craze" for Japanese culture) influenced and inspired nineteenth-century artists like Monet and Vincent van Gogh.[48]

Is Monet's painting itself—of a privileged white woman garbed in another culture's ethnic dress—a demonstration of cultural appropriation: in its themes of *japonisme*, in Monet's capitalization on an art-world craze with Orientalist sentiment, in its thematic content? Monet's painting is understood by most experts to be a wry commentary on the Parisian craze for

japonisme in the 1870s. It is most certainly not an attempt at a faithful rendering of Japanese woodblock prints of kimono-wearing courtesans, although one obviously influenced the other.[49] Monet appears to have painted the work to take advantage of the popularity of Japanese design, yet his later works demonstrate a "deeper and more subtle engagement with Japanese aesthetics." Any view of the work as crass, profit-seeking, or derisive may be distorted to the point of being inaccurate.[50] And it mischaracterizes *japonisme* to report that all such art was inflected with a perverse and harmful obsession with Japan; it is more accurate to depict it as a spectrum of responses, including the respectful and creative.[51]

Looking closely at the museum's decision to allow visitors to pose for photographs (which were not "selfies," as advertised, but photographs taken by bystanders)—are such photographs a form of cultural appropriation? Should Bostonians and museum visitors, of any ethnic background, be posing in a kimono? Are they appropriate for us to wear?

As one scholar put it, "No item in the storehouse of cultural material maintains as strong a hold on the Japanese heart, mind, and purse as the kimono."[52] However, Timothy Nagaoka, who teaches Japanese language lessons to Boston elementary school students, pointed out that the kimono is just clothing and has no particular sacred character; rather, "it's the protestors who placed the kimono up on a pedestal," proclaiming it inappropriate garb for non-Japanese. [53] Nagaoka appeared at the reconfigured (costume-free) Kimono Wednesday wearing a *yukata*, which he described as a summer cotton kimono, holding a sign quoting singer Taylor Swift: "Haters gonna hate, hate, hate."[54] By July 19, Nagaoka was joined in his counterprotest by a half dozen women wearing kimonos, several of whom identified as Japanese, including Etsuko Yashiro. Yashiro, organizer of Boston's Japan Festival, told the *Boston Globe* that she was there to "share the beauty of kimonos with an American audience." In the *Japan Times*, Meiji University Professor Shaun O'Dwyer raised the possibility that the exhibit could benefit the dying kimono industry—an industry that had shrunk from 6,300 tailors in 1984 to only 1,351 by 2014.[55] If this art form would otherwise be doomed to extinction or supported only through federal or international provisions for cultural patrimony, isn't *any* publicity good publicity, he asked? This is similar to arguments that have been made with respect to the preservation and presentation of other fading art forms, whether field songs collected by Works Progress Administration agents or reliquaries sourced by staff from the Museum of Primitive Arts. Is extinction better than giving offense?

At a talkback event hosted by the MFA in February 2016, panelist Xtina Hulian Wang argued that the exhibit "replicated what Monet was supposedly criticizing without interrupting the racist legacy of the painting or any criticality of orientalism both in Monet's time and in our own."[56] One audience member asked the staff on hand what responsibility they felt to address their "access to histories of people who maybe don't even have access to their own history." [57] Both make a call to contextualize the painting, the exhibit, the museum's non-Western collections, and the controversy within a conversation about appreciation and appropriation. They ask us to think about power.

There are innumerable cases in which intellectual property, cultural expressions, symbols, or artifacts, including dress, dance, music, religion, language, folklore, and traditional medicine are "used" or "taken" without permission.[58] But exchanges of material, themes, and aesthetics among culture creators are universal. This is true whether the exchanges are of subject matter (e.g., Gauguin painting Polynesians; African masks of white railway workers), of substance (the Beatles using a sitar or Indians using electrified guitars), or of form (American high school students writing haikus; Thai entertainers writing rock and roll songs).[59] Why are some exchanges morally good, or at least neutral, while others are bad? The pattern of application of the charge of cultural appropriation demonstrates that Western adoption of culture is happening in the context of aesthetic legitimation processes, and this makes the difference. To best illustrate the universality of cultural trading, and the highly conditional description of those trades as appropriation, we turn now to New York's Fashion Week, and the "Chinatown Plaid" controversy.

Chinatown Plaid

In the fall of 2013, the style sections of New York City papers featured coverage of the increasingly popular "Fashion Week," where elite designers presented their collections to a global public of department-store buyers, fashion editors, celebrities, politicians, and critics. Reporters noted that two designers, Céline and Stella McCartney, featured garments with bright, graphic plaid prints that bore a resemblance to the woven tote bags, square in shape and secured by a zipper, often seen on the streets of Chinatown. The reviews of the runway shows were raves; after praise from *Vogue UK* and *Vogue*, *Radar Magazine* declared that "those 'cheap and nonsense' plaids have done a 180 to drop themselves off on the corner from metamor-

phosis to high end."[60] A photographic montage on Phil Oh's celebrated blog *Street Peeper* showed fashionistas wearing clothing and accessories featuring the design.[61] Months later, more affordable versions of the luxury garments were being sold by mass-market retailers TopShop and Zara. Oh nicknamed the print "Chinatown bag plaid."[62]

Inexpensively produced in China by Zhejiang Daxin Industry Co. Ltd. (minimum order, ten thousand units), the bags that provided inspiration for these garments are sold across the world as cheap and durable carryalls.[63] In China, they're colloquially referred to as "mingong" bags, named after itinerant workers who use them to tote personal possessions on their long journeys between home and work. In Trinidad, they're known as "Guyanese Samonsonite," and in Germany they are "Türkenkoffers," or Turkish suitcases. Across most of West Africa, the same bags are referred to as "Ghana Must Go Bags."[64] Around the world, they're referred to as the "refugee bag." These sobriquets reveal a shared global experience of wanting to move away from "some poverty-stricken hell hole," according to a journalist at the *Telegraph*.[65] In each case, the nicknames associate the bags with poor, mobile populations—migrants and immigrants—who use the bags to carry their life's possessions.

After an initial rush of enthusiasm within the fashion world, critics began to question whether the use of this plaid was a form of cultural appropriation. Had the pattern been stolen from the Chinese? By what right did these wealthy designers take this pattern for their own use? And how dare they profit from an association with poverty, displacement, and misery? Charges of hypocrisy quickly followed, given the aggressive policing of counterfeit merchandise by these luxury brands, particularly of imitation designer bags sold in Chinatown, often carried to and from street sales locations in the same plaid bags.

But the truth is that the plaid used for the Chinatown bag didn't originate in Chinatown, or in the Chinese factory that manufactures them, or even in migrant culture. In fact, the plaid is borrowed from garments elite Indonesians have worn for centuries.[66] On the southern peninsula of the Indonesian island of Sulawesi, artisans from the Bugi and two associated ethnic groups have been weaving silk sarongs with this plaid motif since the sixteenth century. Historically, the width of the plaid indicated the wealth, status, power, and heritage of the individual wearing it, and the simple, repeating pattern is believed to express Islamic principles of harmony.

Visitors to Indonesia became enamored of the design, and from at least the mid-seventeenth century, Indian producers on the Coromandel coast

began to manufacture garments from this plaid (but in lower-quality cloth and more vibrant shades of red and blue) for export to Europe.[67] As English and Dutch trading companies bought and sold these Indian garments, Indonesian weavers seeking to compete started to manufacture cheaper versions, made with coarser cotton fabric and polished with shells and rice starch to produce a glossy sheen to the fabric. These most closely resemble the modern Chinatown bag, although the effect is now produced with polymer-based materials.

Who, then, is appropriating the plaid Chinatown bag? Is it the fashion designers of 2013 or Indian entrepreneurs in the seventeenth century? When Indonesians transformed their design to the more cheaply produced, vibrantly colored, and shiny fabric, were they stealing from their Indian competitors? Does the origin of the plaid among Indonesian elite society change how we think about the balance of power? Do we judge contemporary designers Céline and McCartney less harshly because they borrowed from another powerful group? If Indonesia produced a fashion trend, rather than simply serving as a "third-world site for manufacturing cheap commodities," are our basic assumptions of how cosmopolitanism works challenged?[68]

If my experience is any guide, it will be harder for you to view the Indian entrepreneurs as appropriators than it was for you to view Stella McCartney as one. That's less a function of the particularities of this story—it isn't that she's the daughter of a Beatle, or that the plaid eventually was used across the globe—and more of a revelation that debates around cultural appropriation are woven into the fabric of this modern process of artistic legitimation, as well as into conceptions of cosmopolitanism and artistic diversity.

The origins of a cosmopolitan mindset stretch back to the Enlightenment. Living in the late eighteenth century, French philosopher and mathematician the Marquis de Concordet "saw the cosmopolitan position as a natural concomitant of the individual's freedom from received roles and identities."[69] Individuals who were in a position to freely choose could elect to participate in a universal culture, and Concordet, René Descartes, Voltaire, and Benjamin Franklin each argued that this is our ideal state.[70] These Enlightenment *philosophes* belonged to pseudoscholarly societies dedicated to the collection and circulation of cultural and intellectual material, from biology, natural history, geography, geology, anthropology, and art. "Collecting was a means of grasping the world and simultaneously measuring and ordering it," and the public museum grew out of this cosmopolitan orientation.[71]

Cosmopolitanism is marked by a "willingness to attempt to understand and engage with the unfamiliar."[72] It is a form of cultural engagement predi-

cated upon consuming difference; what one author describes as a "delight in difference" and another refers to as "an aesthetic *savoir faire*, and an affective pleasure in experiencing and navigating through cultural difference."[73] It is often characterized as a status that requires intellectual ability: "a reflexive ability to locate one's own society and culture in a broader historical and geographical context; and a 'semiotic skill.'"[74] The cosmopolitan is a person who has disposable income, knowledge, and curiosity about other cultures, and who uses those resources to "consume" cultural difference—very much in keeping with the suggestion of eating conveyed by the term "omnivorousness."

A search for the word "cosmopolitan" in the *New York Times* yields a 1955 profile of Ahmed Shah Bokhari, written upon his appointment to the United Nations Department of Public Information. Then in his fifties, "an Asian who has dedicated his life to a better understanding between the Orient and the Occident," Bokhari was "urbane," "sophisticated"; he "dresse[d] informally," and he gave speeches that

> crackled with humor and bite. Speaking on behalf of other non-Europeans—he was born in Indian Peshawar—Bokhari hints at the demise of old Empires, and comments that "people interested in *people* . . . are the cosmopolitans, and their numbers are growing. They are probably the coming aristocracy of the world—aristocracy in the sense of a certain grandness of sympathy rather than of wealth or position. And the future of the world is in their hands—in cosmopolitanism. They offer the only way out."[75]

In his remarks on the "coming aristocracy," we should hear echoes of Gouldner's theory of the "New Class," and the need to be snobs without being snobbish. Bokhari warned that "the future of the world is in [our] hands," and that being a cosmopolitan consumer has both intrinsic and social rewards: "Through the consumption of ethnic cuisine we demonstrate to ourselves and others that we are cosmopolitan and tolerant: our character is expressed through our behavior in the market."[76]

Conclusion

The question that framed this chapter concerns the impact of artistic legitimation processes on cultural producers and their communities. Each example in this chapter illustrates that the problem is not in the fact of cultural exchange, nor in intercultural artistic influence. Rather, accusations of

cultural appropriation are the consequence of aesthetic legitimation. Every redefinition of culture as art allows for a countermove, in which others redefine the redefinition as a form of symbolic violence by charging cultural appropriation. This dualism creates a situation in which every claim of cultural appreciation is designed to benefit the speaker, and each claim of cultural appropriation aims to criticize someone other than the speaker. Put simply, cultural appreciation is something that "we" do; what *others* do is appropriation.

That's not to sidestep the question of power and control, however. Scholars have demonstrated that elites value characteristics they associate with authenticity, including geographic specificity, simplicity, sincerity, small-batch production, evidence of historical continuity, and links to particular creative individuals.[77] Our power and privilege provide incentives for cultural producers to make and sell objects with these values in mind. Source communities may seek to produce cultural goods and services that lower barriers to access (e.g., reducing the spice in dishes) but convincingly deliver an authentic experience. They orient their work around the customers' values, while both parties pretend those values are universal and uncontested and seek to balance ease and exoticism.

We enjoy highly stylized presentations of other cultures because they fit well within a narrative that positions us at the high-water mark of a civilizing process. We are sophisticated and cosmopolitan because we have these cultural tastes. Yet those tastes are a function of our ease of access, the modification of "exotic" experiences with an eye to our comfort, and they are predicated on the existence of social distance. If this distance collapses, so does our ability to show off our tolerance and sophistication.

In granting importance to the integrity of "tradition," even when tradition is invented, elites seize control over defining membership in cultures of which they are not a part. In the case of Chinatown plaid, the cosmopolitans' right to confirm the "correct" story, and to connect that story with legitimate consumption, remained undiminished. Their right to preserve, protect, or restore other cultures—to see the value where others might only see garbage—remains intact.[78] We seek to save unfortunate others from themselves, like Protestant evangelists and sociological workers stepping intrepidly into nineteenth-century slums. What may appear to be an attempt to reach across social divides reveals itself to be a means by which elites reinforce their social, economic, and cultural superiority. We act as the caretakers of other peoples' cultures.

As these examples illustrate, voracious art-consuming elites treat their broad tastes as a corrective to past prejudices. They articulately identify themselves as rejecting the elitism of their peers. Yet their appreciation of diverse culture—especially that created by the poor, uneducated, or other minority groups—is still predicated on their privileged access to those cultures, and their "right" to affirm them as valuable, beautiful, or interesting.

In the next and final chapter, I draw together the strands of my analysis to think prospectively about the artistic legitimation process. The twentieth century was remarkable in its expansion of access to, and appreciation of, cultural diversity. Are there any patterns to how different fields acquired artistic resources? Do they share any stylistic similarities? Is it possible for any kind of culture to be immune to this process, or for its advocates to successfully fight off attempts to legitimate it? How much control do individuals have, and how much do individual artists matter? What can we expect from the future?

7

Conclusion

One thing is certain: we live in a world in which it is more difficult than ever to tell fish from fowl. The boundaries between good and bad taste, between the museum-worthy and an art-school stunt, may be blurrier than ever. How are we to characterize the impacts of artistic legitimation on the American public and their cultural consumption habits? Are these ongoing processes of expansion to blame for the decline in arts participation? Do our efforts to ennoble diversity overreach, leaving us with new forms of art that just aren't that good?

Social scientists *have* noticed a significant drop in engagement with highbrow culture, alongside a purported rise in the diversity of Americans' engagement with art. The diversification of elite tastes was first reported in 1992 and was based on cultural consumption data from a nationally representative survey conducted on behalf of the research division of the NEA. The authors concluded that the musical tastes of American elites had become more inclusive of "middlebrow" and "lowbrow" genres.[1] They reported that elites—especially those born more recently—are increasingly enjoying highbrow genres like opera and classical music, in addition to show tunes and jazz. In a second article, the authors speculated that the expansion of elite tastes to include low and middlebrow culture involved the "formulation of new rules governing symbolic boundaries." That is, elites expanded the definition of highbrow culture to include their new preferences. They concluded that "snobbish elitism [has been] replaced by cultural relativism."[2] According to their interpretation, elites were not

giving up their status as "sophisticated" art lovers so much as they were selecting some popular and vernacular culture and elevating it to the status of art. Younger elites were no less discriminating—they simply adapted the tools of "intellectualized appreciation" to new domains.[3] These first studies of what came to be called "omnivorousness" linked broadening elite tastes to underlying institutional and organizational changes in the arts. But this last piece of their argument was all but forgotten as dozens of replication studies sought to confirm elites' retreat from exclusively highbrow tastes.

The explosion of research in the wake of these studies is truly remarkable. Omnivorousness has been documented in multiple countries, including Canada, the United Kingdom, the Netherlands, France, Germany, Spain, Austria, and Australia, and in additional analyses of the United States population.[4] These studies document shifting tastes across a range of cultural pursuits, including music, books, art, food, television, and participation at live events.[5]

But as the number of studies proliferated, the focus on elites gave way to a generic interest in the breadth of cultural tastes. Soon, measures of omnivorousness simply captured the width or diversity of any person's taste, irrespective of that person's education or income level.[6] These studies focused only on "the more-more principle": that people who attend any kind of cultural event are more likely to attend another.[7] These scholars neglected the original definition of omnivorousness, which indicated a mastery of prestigious culture combined with a taste for some forms of popular culture. They failed to account for the organizational and institutional practices in art worlds that make these changes possible.

Why did this happen? Why did social scientists abandon a search for the social causes of changes in elite tastes in the service of measuring the diversity of tastes across social groups? The first reason is that, although the authors of these two papers never claimed it to be so, omnivorousness was interpreted as a sign that social class no longer predicted cultural tastes. Yet we know this is not the case. Familiarity with, and appreciation of, the highbrow arts is an acquired capacity. This "cultural capital" is taught in the family and in schools and is particularly imparted to children from upper-middle-class and upper-class backgrounds. Consequently, the capacity to understand and "properly" appreciate art is unequally distributed across social classes.[8] Moreover, this capital is reinforced throughout the life course. Cultural capital works to reproduce the class structure by acting as a filter, helping employers and mates to identify elite candidates.[9] Familiarity

with art also builds class solidarity through conversation about shared interests and attendance at events.[10]

Why were these facts ignored as research on omnivorousness multiplied? Perhaps because many Americans believe they live in a classless society. And even those who recognize the role of class in predicting life chances and lifestyles may wish these divisions would disappear. They might argue that if cultural capital is a means by which social distances can be displayed, produced, and reproduced, perhaps they can be a means by which social distances can be reduced. Some have even claimed that we are witnessing a decline in the impact of class on identity and taste.[11]

The discovery of omnivorousness was celebrated as evidence of the democratization of taste, and, therefore, of the achievement of the most American of ideals. If elites were forsaking the bastions of exclusion and separation—the symphony box and the front row at the opera—and enjoying rock and roll concerts, television, and comics with the rest of America, it might be a sign that we have a nation with a more "inclusive cultural ethos."[12] If we believe that contemporary life "requires social and geographic mobility, 'employability,' and 'social networking' from its highly skilled workers," then perhaps we can extrapolate that an omnivore is "the type of person most likely to be successful in the more rewarding segments of today's society."[13] So-called cultured or sophisticated people may not have season tickets to the ballet, but they have instead a high degree of "openness, ability to cross boundaries, willingness to dip into things, and a degree of integration of the enjoyment of culture into a sociable lifestyle," which reflects our American values more than snobbishness.[14]

Third and finally, scholars may have seen omnivorousness as evidence of democratization because of their eagerness to find evidence of the liberalization of our cultural organizations. From art museums and symphonies to other kinds of museums and school curricula, cultural organizations are dominated by elite culture and run by elite stewards. If elites are increasingly omnivorous in their tastes, and inclusive and egalitarian in their selections, perhaps this new generation will revolutionize the way cultural organizations are run. As it stands, however, the staff of nonprofits are no more diverse than their audiences: while 34 percent of Americans belong to a nonwhite ethnoracial group, they comprise only 9 percent of core museum visitors.[15] Similarly, the staffs of member organizations of the American Association of Museums are 72 percent white, non-Hispanic, with minorities overrepresented in particular job categories (e.g., security).[16] And while 60 percent of the funding for arts organizations comes from individual do-

nors, African American and Latino organizations on average receive only 6 percent of their funding from donors, which limits their size and rate of growth.[17] The majority of organizations of color (or "culturally-specific organizations") do not maintain an endowment fund, and those that do derive limited income from it.[18]

In sum, the redefinition of omnivorousness by scholars may have been motivated by three related rationales: it offered hope that social classes had collapsed, it provided evidence of the democratization of taste, and it was viewed as a harbinger of the liberalization of cultural organizations. These are related because the very notion of democracy is founded in normative principles of equality and meritocracy, ideals with a long history, but which have been reignited in recent years by a rights discourse focused on disadvantaged groups (women, LGBTQIA, African Americans, Native Americans). These calls to celebrate omnivorousness are based in the normative and populist notion of this country as a classless, multicultural society in which every citizen has an equal opportunity to protection and to profit.[19] Omnivorousness—redefined as breadth of cultural consumption—holds that promise.

The results of studies of omnivorousness may indicate a democratization of taste, but not taste born primarily along class lines. They may indicate liberalization, but certainly not a liberalization that has had a particularly immediate or comprehensive effect on the diversity of staff or the equality of funding. The more likely explanation for the original omnivorousness finding is a simultaneous diversification of "benchmark" arts collections and programs to include more (formerly) popular, vernacular, and folk culture ("artistic legitimation") and a push on the part of vernacular-culture advocates to have some works and creators appreciated as art. That is, the diversification of elite tastes is likely a result of *both* the artistic legitimation of vernacular work and a "lowering" of highbrow tastes to include vernacular culture.

I preserve the original definition of omnivorousness because I am interested in the extent to which elites have, in fact, formulated "new rules governing symbolic boundaries." That is, as more recent cohorts of elites carried with them broader tastes for a greater variety of culture, they had an impact on how Americans viewed that culture. The glassblowers, abstract expressionist painters, and photographers of the WPA projects found advocates among subsequent generations. The inclusion of Rockefeller's primitive art collection in the Met encouraged museumgoers to discuss the artistic qualities of African masks.

Unfortunately, most of the surveys in the field are not equipped to answer these questions. In an effort to detect broad patterns, and patterns over time, we query Americans about their tastes at a very general level, asking about preferences for broad styles of visual and performing arts, like "rock and roll" and "outdoor performing arts festivals." The Survey of Public Participation in the Arts, on which most studies of American omnivorousness are based, does not include many questions that measure engagement with folk or popular culture. There is no question about attendance at a zydeco concert, a fancy foods festival, or a photography exhibit. As a result, these data likely distort and underestimate the cultural engagement of Americans.

Moreover, the core cultural participation questions ask about organizational sites where multiple genres of art are presented (e.g., "art museums/galleries"). Museum exhibits now include fashion, design, photography, video, mixed media, digital media, popular music, posters, and other diverse content. This means it can be hard to identify "what kind" of culture you saw or heard. Yet the diversification of art exhibition programming means that your report of recent attendance increases the likelihood that you have been exposed to a broader collection of artworks than your parents or grandparents were.

The absence of questions about vernacular, folk, and popular culture will make the SPPA a frustrating and dull instrument to answer many questions. It provides very little information on participation in many of the forms of contemporary popular culture that are most broadly enjoyed, like video games and NASCAR. Moreover, the categories that do exist are so broadly defined as to obscure salient distinctions.

Patterns of omnivorous consumption have been found outside the United States, raising the question of whether we can attribute them to domestic causes. Evidence of omnivorousness abroad may indicate that organizational and institutional changes in the American arts during the post–Progressive Era is a weak explanation of the shift in tastes. First, it is important to note that none of these studies, to my knowledge, seeks to identify generational patterns that may be present. I hope to inspire scholars working with non-US data to investigate the possibility that omnivorousness can function as a *generational* phenomenon, because group-level measurement is the ideal context in which to adjudicate between these hypotheses. But it is important to emphasize here that I am unaware of any such analysis. We simply do not know if a generational analysis of data collected elsewhere in the world would yield these results.

The global spread of media, transnational economic and political forces, and isomorphic pressures on organizational forms and institutional prac-

tices extends to local settings, shaping our cultural tastes. It stands to reason that the interpolation of global forces into particular communities gives each local instantiation of omnivorousness a specific character. The specificity of places—even in a world we know is linked by global flows of capital, people, and ideas—frustrates international comparisons of cultural consumption.

Detecting omnivorous tastes typically relies on the analysis of nationally representative data, which are best suited to identifying tastes (and shifts in taste) in broadly comparable ways (e.g., a taste for "museum attendance" or "popular music"). But scholars have discovered that such nationally representative data—locally valid and reliable data—prove of limited use in international comparisons of taste. For example, a study of musical omnivorousness in France reported that one of the most widely enjoyed genres is "international pop," a genre defined by the use of a non-French language, and therefore not applicable to nations with a different primary language, or to those with a weaker national language policy than the French.[20] Scholars studying omnivorousness in Korea have argued that since that nation "lacks a traditional highbrow culture," it is "difficult to determine a hierarchy of culture."[21] If the categories of consumption are nationally or culturally specific, our ability to identify transnational patterns in taste is limited at best, until or unless we can identify the *mechanism* of taste creation and maintenance.

In this book, I have focused on the particular features of artistic legitimation as it developed in the United States. I argue that if we wish to develop a deeper understanding of cultural tastes, we must seek to link them to particular organizational and institutional contexts—the environments that support their emergence, development, or decline. Once we have a comprehensive understanding of how social context and group behavior operate in particular circumstances, we can develop a theory of the mechanisms of omnivorousness (however we define it). Such a theory is necessary in order to develop reliable indicators that can guide comparative research. In short, this is a study of a particular form of omnivorousness which I hope can guide future comparative research.

Twentieth-Century American Artistic Legitimation, in Brief

One thing true of all Americans born in the wake of the Great Depression is that they entered a world in which class position largely dictated cultural tastes. When the oldest members of this generation were born, the fine arts

included orchestral music, paintings and sculptures in museums and galleries, modern dance, and some serious theater and opera. But Lincoln Kirsten's Caravan tour was a year away from launch, the first nonprofit opera house was celebrating its fourth anniversary, and rock and roll music still hadn't emerged from the blues.

As you read in chapter 1, classical music, painting and sculpture, opera, theater, modern dance, and ballet enjoyed the benefits of elite endorsement in these years. The reputational entrepreneurs who worked to define the American arts and build them over the first half-century established a pathway toward legitimacy that could be utilized by advocates for later protoart fields. After visual art museums and symphony orchestras were established, a second wave of aesthetic legitimation ensued. It was marked by the expansion of the fine arts to include opera, ballet, modern dance, and theater, which were each viewed, to some degree, as legitimate forms of art-making. While most enjoyed artistic status in Europe, Americans, as I noted, sought to build their own cultural canon.

These efforts were assisted by the Depression-era Roosevelt administration. By defining artistic work broadly, distributing funds through state and local authorities, and encouraging artists to work with local materials and in regional styles, the Works Progress Administration encouraged a thousand flowers to bloom. Native American handicrafts, quilts, cowboy songs, immigrant and former slave storytelling, woodcarving—the list of work encouraged by WPA funds is dazzlingly diverse. This vernacular and folk culture was on display in our courthouses, post offices, and parks, and it was in our most prestigious cultural organizations. Consequently, this culture was increasingly seen as artistically legitimate by millions of Americans. The injection of state subsidy during the New Deal accelerated the pace of artistic legitimation and widened its path. The New Deal diversified the content and personnel in American creative fields, propelling several fields toward the early stages of artistic legitimization.

One of those fields was referred to as "primitive art." Chapter 3 began with the 1930s, when Nelson Rockefeller started collecting handmade objects from the Southern Hemisphere, with the intention of building an art collection. Inspired by his mother Abby's efforts to legitimate modern art, Rockefeller relied on a close set of art advisors, many of whom were ending their jobs as WPA art administrators, to legitimate primitive art. In tracing the work of this "brain trust," I revealed specific features of the legitimation process: the need to establish authorship, provenance, and aesthetic criteria of evaluation. In shaping how the critical establishment viewed this collec-

tion, the Museum of Primitive Art (MPA) staff made arguments about the authenticity and disinterestedness of artists in this field and began to train the public in its appreciation. By sharing its contents through loans and, ultimately, through incorporation into the Met, the museum diffused primitive art's legitimacy across the globe. My analysis of the MPA offers both a refined model of the artistic legitimation process and a case study located at the midcentury hinge moment, between old and new notions of art.

Artistic legitimation doesn't play out in a vacuum; social, political, technological, and economic changes can create an opportunity structure for artistic legitimation to expand and accelerate. The professionalization of arts management, and changes to the sources and methods of financial support for art organizations, prepared the field of art for the growth of new seeds. In particular, we explored the artistic legitimation of jazz and rock and roll; visual art forms including photography, outsider art, and graffiti; African American and graphic novels; tap dance; and film. The resources these diverse fields required in order to grow were remarkably similar. Framed as disputes, these included debates over what objects and creators "belong" within a field and what attributes they must have. These agreed-upon attributes included docility and perceived authenticity. These qualities were shaped by a rising intellectualized discourse, in which the "meaning" of objects as art was negotiated. As spaces for presentation became available, including the opening of the academy to the study of objects as art, the objects' perceived artistic legitimacy skyrocketed.

The reinterpretation and presentation of this work as art came at a cost. As more and more diverse culture was included within the fine arts, audience members were left to debate whether it was being treated faithfully, appropriately, respectfully, while maintaining the integrity of the source culture. These debates over cultural appropriation have been endemic to the artistic legitimation process in America. Critics have argued that the artistic legitimization of folk, vernacular, or "minority" culture is really theft and a specific form of theft that results in the misinterpretation, displacement, and denigration of the source culture. They claim that cosmopolitans have failed to acknowledge creators, honor traditions, and protect communities. Defenders counter that they have preserved culture that would have been lost, honored work as art, and encouraged the education of children and adults in the beauty of these traditions. The examples in chapter 6 illustrate the complexity of differentiating between productive and destructive forms of omnivorous consumption. The evolution of the omnivore has been both cause and result of these changes. To be elite but not elitist,

college-educated Americans have to respond to challenges of cultural appropriation.

In this chapter, I turn to some larger issues that are provoked by this argument and my findings. These include the question of which resources are necessary and sufficient for artistic legitimation, and whether the parallel development of multiple fields resulted in (aesthetic) similarities among them. Given the extraordinary range of types of culture that proceed through the artistic legitimation process, I ask, will any remaining creative forms escape art's grasp? Is it possible for any kind of culture to be immune to this process, or for its advocates to successfully fight off attempts to legitimate it? And what are the consequences of my argument for public policy?

Trajectories

Artistic communities take on different characteristics as they mature, creating for themselves different opportunities and obstacles. To bring these characteristics into sharper focus, I have demonstrated several attributes of artistically legitimate fields, and the efforts that their entrepreneurs made to secure them. These include the emergence of an intellectualized discourse; a bounded set of objects and authors that are described in particular ways (e.g., authenticity); the emergence of classification and specialization within the field; and the role of organizations as hosts of critical resources. In examining sixteen fields (opera, classical music, ballet, modern dance, theater, primitive art, and the ten forms analyzed in chapter 5) I have demonstrated that their progression toward acquiring "artistic" attributes was uneven, impacted by context, social and political attitudes, technological innovations, laws and regulations, and the success of their advocates in making legitimacy claims on their behalf. This progression could be described as a trajectory, a "cumulative, rather than repetitive sequence of linked events, suggesting a certain directionality to change."[22]

Future study should more closely attend to the measurement of legitimation trajectories. To guide such study, I offer some hypotheses on what to expect. There may be particular aspects to legitimation work aimed at the goal of achieving US cultural nationalism. In such situations, entrepreneurs seek to produce and display legitimate American art that is "native" to the country, while rigidly excluding actual native peoples and their culture (at the very least, until the WPA agencies step in). These efforts toward cultural nationalism cut across the art/not art distinction and pre-date the Great

Depression. We witnessed their emergence in both opera and ballet. Such work is largely directed at improving the positioning of the US in the world cultural system, particularly vis-à-vis Europe.

The features of such work are likely to differ from that in a second group: those modernist vanguards who direct their efforts toward improving their own careers by transgressing the prestige norms for inspiration and reference. For example, poet T. S. Eliot's incorporation of Tin Pan Alley songs into his poem "The Waste Land" didn't have a measurable impact on the legitimacy of Tin Pan Alley music as art, but instead served Eliot's career.[23] Or consider avant-garde composer George Antheil's 1925 composition "A Jazz Symphony," one of the first classical compositions with an overt reference to vernacular American music, but which was deemed too radical to be presented, as planned, for Paul Whiteman's "Experiment in Modern Music" concerts and had little consequence for the later legitimation of jazz music.[24] As features of individual creation, they may signal the potential for future consecration, but are not recognized by legitimate experts as meaningful influences on the elevation of the field from which they borrow aesthetic inspiration or compositional elements.

Third (or perhaps third and fourth), we have a pathway by which nonspecialist or nonelite arts, including varieties of folk art, are legitimated. It is possible that the trajectory of works (or fields) made by immigrants and nonwhites may have particularistic features if these are highly professionalized creators. Their familiarity with aesthetic fields, discourses, and experts may make their trajectory toward legitimation quite different from that of untrained creators, who lack this educational, social and cultural capital. From this perspective, we may wish to distinguish features of the legitimation process for "the folk arts" from the process that confers legitimacy on artists who were previously relegated to "the folk."

Throughout the text, I've put forth a set of parallel comparisons in order to show similarities and differences, appropriate to my goal of generating a theory of artistic legitimation. I did not seek to identify necessary or sufficient conditions—indeed, it is difficult to identify much variation in how fields progressed through the process.[25] Moreover, the research on artistic legitimization processes is still relatively thin, so I have no way of asserting whether my findings are representative of any larger group of cases.[26] My focus in this text is on generating a model of the process that fits *some* fields, so that future scholars can modify this model by subjecting it to the test provided by neglected fields, new data, and other forms of analysis. Without a sense of the landscape, fields cannot be rationally selected as potential

representatives of a set of shared characteristics. Thus, these trajectories are not built with an eye to cause and effect, or to necessary and sufficient conditions for change, but rather with the hope of producing some preliminary hypotheses for use in future study. Despite these caveats, let me offer a few thoughts on which resources *might* matter most in producing artistic legitimacy.

First, and most obviously, one critical indicator of broad artistic legitimacy is relatively regular access to art spaces for display and study. Once an art form is represented in encyclopedic collections, reviewed by art experts, or performed on a concert-hall stage, other attributes of legitimacy are usually in place. There is a canon of works and artists that are seen as authentic and producing art for art's sake, there is a critical establishment of journalists and academics that specialize in producing that canon's intellectualized discourse, and there is a cadre of audience members who view the canon as art.

Yet there are exceptions. African American literature professors were "a serious group that asserted national responsibilities" as early as the 1920s, although courses on black writers were not offered until the 1970s.[27] Texts that would later be heralded as anchors to the field, like *Their Eyes Were Watching God*, were reviewed in high-prestige newspapers and journals decades before they would be systematically taught in literature classrooms.[28] Conversely, primitive art, outsider art, and design were inventions of art-world insiders. Aesthetic entrepreneurs like Rockefeller, but also art dealers and academics, invented and then populated these fields with little regard for the varied contexts of their creation. If African American literature had a powerful and rich patron like Rockefeller, would its fate have differed? Or do distinctions in the legitimation process for specific media (literature vs. sculpture) play a strong role? While we can't answer these questions with confidence now, I hope such research will become more viable as more art historical research is done on these new art fields.

Once a cultural field has a home in art organizations, the other locations where the art is made and appreciated still exist—the fact that jazz is performed at Lincoln Center does not mean small-town jazz clubs close. Instead, the process of acquiring legitimacy involves the acquisition of a range of kinds of spaces and places where the work is found. In *Banding Together*, I argued that during the development of music genres, the size and legitimacy of performance spaces intensifies over time. Much the same is true for other artistic work. Tap dance was performed in clubs and ballrooms, then

on television and in films, and on Broadway. Displays of tattoo art moved from storefronts to alternative spaces and folk-art collections, to conventions, galleries, and art museums. Black literature and graffiti had relatively few steps to traverse: texts by African American authors received scattered praise until librarians and scholars advocated for their place in universities and in other major collections of literature. Graffiti moved from city walls and subway trains to galleries and museums in short order. Future research could investigate whether the transition out of small, local, or commercial venues is easier for some fields than others, and what factors influence that transition and determines its pace.

Across these sixteen fields, there are significant differences in how training in practice and theory developed. While ballet performance instruction was available for all ability levels almost from the very start of the field, anecdotal evidence suggests that very few ballet programs taught students about the history of the field, focusing on training performers, not advocates or historians.[29] While the history of graffiti is taught within colleges and universities, I could find little evidence of any formal, credentialed adult training programs. Graffiti artists appear to learn the craft from mentors and some for-profit and nonprofit programs dedicated to serving youth populations. Additional research is required in order to understand how fields develop and systematize secondary education curricula. The dialog between training practitioners and training audience members in modes of appreciation and history is sure to be an important part of that study.

While most of these ten fields are represented, to some extent, on the stages and walls of (nonprofit) art organizations and taught in colleges and universities, they do not equally enjoy the financial and cultural endorsement of the state, foundations, or private funders. Without the resources provided by the New Deal, the legitimization of various forms of primitive art (particularly from Native American culture) may not have been as quick or complete. Harold Lehman, a muralist with the WPA, argued that as a result of the new Deal programs artists "formerly ignored by the government, achieved a place in society they never could have reached otherwise—due to active government support for the arts."[30] National Endowment of the Arts support for jazz, particularly the Jazz Masters program, and organizations like Jazz at Lincoln Center, are viewed as critical to the field's artistic status.[31] Other fields, including tattooing, rock and roll music, and comics, have not enjoyed the same kind of government endorsement, and, at least with respect to rock, one expert finds that "unthinkable."[32] As the

preceding analysis has demonstrated in multiple ways, large and unrestricted grants to artists and art spaces can significantly increase access to art worlds, for artists and audience members.

While there are differences across fields, this preliminary comparison of different fields' trajectories suggests many similarities. Could the similarities be a function of some other, underlying unity among them? Cinema, jazz and rock and roll music, graffiti, and weaving and textiles (especially quilting) are just a few of the many forms of creative expression whose path toward aesthetic legitimation is linked to the same institutions, organizations, and reputational entrepreneurs.[33] Do they enjoy simultaneous "artification" because they are part of the same stylistic or aesthetic movement?

Aesthetic Continuities across Legitimizing Fields

Some experts have argued that there was a movement in the twentieth century to create a distinctly American form of art that combined modernism and vernacular and indigenous art forms—a "vernacular modernist" field that incorporates work in multiple media and traditions. This is not a rare opinion. In his defense of the primitive artworks in his father's collection, David Rockefeller is said to have appreciated their similarities with modern art: "The total composition [of one tribal piece] has a very contemporary, very Western look to it. It's the kind of thing, I think, that goes very well with . . . contemporary Western things. It would look very good in a modern apartment or house."[34] In fact, there is some evidence that collectors see a connection also: "Tribal art collectors also tend to be collectors of modern art, and may purchase tribal objects because they look quite good next to Western works—not surprisingly, since the two aesthetics emerged together and have reinforced one another over time."[35]

Advocates for the notion of a "vernacular modernist" movement in mid-century America may distinguish between its "formalist" arm, which subjects vernacular art to the standards set by art historians and formal analysis, and its pragmatist branch, which focuses on the production of an American aesthetic that reflects democratic culture. The latter, with its suggestion of John Dewey's emphasis on representing experience, is a much closer match to the positions of New Deal artistic entrepreneurs like Holger Cahill, who, after serving as an art administrator at the Newark Museum and MoMA, was the national director of the WPA and the Federal Art Project. He felt that "American artists must derive their subject matter from human experi-

ence and that art was representational to democratic culture, a position endorsed by New Deal advocates."[36] The formalist arm, with its elevation of academic tradition and study, is a closer fit to the approach adopted by MoMA under the leadership of Alfred H. Barr. Barr consciously sought to produce and present a distinctly American form of modernism at the museum, although he excluded American folk art from his diagrams and discussions of academic art movements (and lent little help to African American artists).[37]

If there was a vernacular modernist movement, it emphasized a democratic, accessible, representative American style that certainly echoes the values of the WPA art projects. Administrators of WPA offices encouraged their artists to develop

a local vernacular associated with regional and cultural identity . . . [a] vernacular of authenticity that could plumb native sources of modern art within an academic tradition, the vernacular of folk art, the vernacular of indigenous traditions and ethnography, the vernacular of the everyday, and the vernacular of regional artists, photographers, and filmmakers giving expression to national consciousness during the lean years of the Great Depression.[38]

They did so through Living Newspapers, plays about substandard urban housing, and the collection of Native American folklore and regional song, among many examples.

While the WPA projects were still open, entrepreneurs in particular art forms were adopting this vernacular modernist language to describe their own exploits. For example, in 1938, ballet impresario Lincoln Kirsten described his Ballet Caravan troupe as a "laboratory for classic dancing by, with and for Americans."[39] The new American ballets he supported—like *Pohahontas* and *Billy the Kid*—"evince[d] an explicit commitment to native and vernacular themes," each of which highlighted "regionalist and politically activist trends" in America at the time.[40]

We find similar content in descriptions of Edward Steichen's photographic exhibition *The Family of Man*. Opened at MoMA in 1951, the show was cast against the sustained existence of fascist sympathizers, the rise of McCarthyism, fear of communism and of nuclear annihilation. The show was "not propaganda" but rather was intended to encourage free thought and serve as a "dramatic statement of faith" in the American people.[41] It was

designed to celebrate America's economic and political leadership across the globe, but "it would also make visible its flaws," including "race prejudice and political corruption."[42] The designers did not wish to exploit the differences among people and cultures, but rather to emphasize their equality. The show "sought to make visible a new, more diverse, and more tolerant vision" of the United States "and to do it in such a way as to enhance viewers' intellectual and emotional independence."[43]

In fact, this larger point has been made of the work shown at MoMA throughout this period. When Barr was acting director (1932–33), his essay in the exhibition catalog for "American Folk Art: The Art of the Common Man in America" emphasized the importance of unidentified artists and craftsmen, drawing attention to their connections with modern art, and, in so doing, blunting the customary distinctions between folk art, high culture, and popular culture. This and other early exhibitions "bring into sharp relief, sometimes in a tensional relationship, the dual commitment to the formal search for quality and the institutional mission to democratize an appreciation of modern art."[44] Although they were not advocates for African American artists, the early curators at MoMA "recognized the importance of multiculturalism, [as] evidence of the international diffusion of modern art in the Americas, with its regional roots."[45]

To be sure, describing these aesthetic connections as "vernacular modernism" takes liberties with both concepts. Although many of the works I mean to describe with this term were produced domestically, some were not, or were created by recent immigrants whose work may be viewed as a reflection of their birth culture, not their adopted one. And while some of these works and their creators speak to particularistic concerns or values of "ordinary" life or communities, others are rarely interpreted to have such significance—they may instead be treated without objection as despatialized, global, or "elite." Thus, critics may find the application of the concept of "vernacularism" as ill suited to some cases. Similarly, art-historical discourse links the concept of modernism to the self-consciously experimental arts of the 1910s and 1920s. On this basis, one may argue that art objects or performances created by contemporary, living artists—many of those I describe here—could not fairly be described as "modernists." Future research may reveal a more fitting term to describe the aesthetic continuities that I argue are present.

Given this at least minimal agreement of some aesthetic and political continuities across fields, we might expect to see a high level of cooperation among them. Indeed, alliances between members of different fields have

been shown to assist advocates for film, French gastronomy, and various forms of popular music.[46] Is there evidence from these sixteen fields that advocates rely on their peers in other art worlds to assist in the process of becoming art?

Alliances with Legitimate Fields

One explanation for the similarity of trajectories toward artistic legitimation may be found in interactions among fields. One authoritative study of the emergence of French food culture argues that cookbooks and food writing encouraged its growth, but the realist novels of Honoré de Balzac "define[d] contemporary French society, and, in that definition, food and feeding loomed large." In so doing, Balzac linked the (legitimate) literary field to the nascent gastronomic fields and asserted that the features of both characterized the "industrial capitalism of postrevolutionary France."[47] Similarly, the tango famously depended on the medium of film for its export to the United States. Experts credit the performance in the 1913 musical comedy *The Sunshine Girl* with a rapid diffusion of interest in tango, accelerated still more by descriptions of the style in books.[48] Is this also true for any of the fields I've considered closely?

More than any other field, ballet's development was both hindered and promoted by the influence of those outside the field. The first cohorts of ballet-trained dancers depended on commercial theater, cabaret, and opera stages. As Lincoln Kirstein prepared to separate his ballet corps from the opera, he used the festival stages, audiences, and leaders of modern dance to promote the art form. Ballet would help others too. Lincoln Kirstein lent support to the burgeoning photographic arts community, co-arranging the first museum exhibition to include photographs in 1932. The following year, he personally financed an exhibition of photographs by Walker Evans.[49] Similarly, in jazz, pianist and bandleader Duke Ellington provided significant assistance to black rhythm tap dance in the mid-1960s, inviting Bunny Briggs to tap while his band played "David Danced Before the Lord." The performance has been referred to as one of "the supreme musical performances of the twentieth century."[50] Writer Norman Mailer's endorsement in *The Faith of Graffiti* likely provided some credibility for the form, particularly after he described what he considered to be graffiti's inevitability, given the evolution of the arts.[51] Finally, film depictions of graffiti, in *Wild Style*, *Beat Street*, and, peripherally, in the chart-topping *Flashdance*, promoted the emerging field's legitimacy.

These examples are easily dismissed as endorsements that have no significant effect on the evolution of the field, but given their occurrence across fields, and that they are notable to historians, research should be conducted to determine how and when they do have consequences.

People Power

Changes in who runs nonprofit art organizations have also been important to the artistic legitimation process. The gradual replacement of impresario "art men" with formally trained arts administrators, increases in the number of nonprofit art organizations (and jobs in them), and concentrated efforts to diversify the workforce of such organizations have all expanded access to the arts. It is hard to imagine the embrace of graffiti, jazz, or African American literature in a segregated America, or one in which nonprofit art organizations were governed by a hereditary elite. However, nonwhite curators, museum directors, choreographers, ballet dancers, or record-label owners are still so rare as to be anomalous.

In contrast, the role of educated white men (and to a lesser extent, women) in the artistic legitimation process is enormous. They buoyed jazz in the 1920s in Chicago and in the 1950s in the northeast, and they supported tap dance clubs in the 1930s. The same is true of collectors, who fed the market for works and raised their prestige and value. Many of America's most important modern-art museum collections depend now on gifts from individual collections that were shown in the 1913 Armory show—the patrons who bought work were among America's wealthiest (white) families.[52] These include the Lillie Bliss collection, which became the core of MoMA; the Arensberg collection, which became part of the Philadelphia Museum of Art; the Katherine Drier Collection of the Société Anonyme, which is now at Yale; and the Eddy collection, which became part of the Chicago Art Institute.[53] In fact, it is these elites' near-stranglehold on the artistic legitimation process that frames this book.

This is even more true of arts administrators, many of whom worked for the WPA in the 1930s and early 1940s, and who pushed for the inclusion of folk and vernacular culture within their organizations. As one author noted of the growth of ballet in America, "It depended upon networks shaped by the cultural left of the 1930s and survived in part because of the philanthropy of the mandarin elite."[54] As we gather more data on the careers and contributions of WPA administrators after the projects closed, it is likely that they form a tight and highly influential network. Their work histories reveal their

influence on major folk art exhibitions at multiple benchmark art organizations, including MoMA, the Smithsonian, multiple college art collections and festivals, and even cultural diplomacy organizations like the Office of Inter-American Affairs. These administrators include such luminaries as Alfred H. Barr, the first Director at MoMA (1929–1943), who was once described by the *New York Times* as "the most powerful tastemaker in America."[55]

The impact of a network of wealthy, white, and educated Americans on definitions of art is remarkably strong, particularly in a context where arts advocates are at pains to celebrate vernacular culture. But aesthetic entrepreneurs who can lay native claim to these legitimizing fields have also played important parts in the process. It was African American doctoral students and faculty who played a critical role in the rise of the black novel. Women and the Jewish merchant class supported the rise of avant-garde theater. How much influence did nonelites exert over processes of artistic legitimation in America?

Appropriation from Outside

The artistic legitimation process, at least in the postwar years, involved the adoption of folk, vernacular, and popular culture by elites. But is there a parallel process in play, in which elite art spaces or culture are adopted and then co-opted by the rest of us? This is not a question about indoctrination into elite culture; that has been asked and answered. Hundreds of studies of families, schools, religious groups, and entire nations have demonstrated the ways in which people are formally and informally taught about "good" artistic work.[56] This is instead a question about how much control nonelite groups have exerted over elite spaces.

The danger of focusing on the artistic legitimation of folk and vernacular culture is that we might depict folk and vernacular culture creators as relatively powerless against the forces that seek to ennoble them. In absolute terms, this is obviously false. Throughout history, artists and their advocates have exerted enormous control over the work they make, its availability to others, and how its meaning is shaped. And many contemporary arts administrators are committed to community collaboration in order to facilitate a more mutual exchange between parties, as new works are included among the arts.

One sterling example of this can be found in the techniques of "New Museology" demonstrated in the design of the National Museum of the

American Indian (NMAI) in Washington, DC. The NMAI opened on the National Mall in 2004, after a fifteen-year planning and building process. It was "indigenized" under the initial leadership of Richard West, who began his term as director in 1990 and immediately set about establishing the "cultural sovereignty" of Native Americans over the museum. The NMAI's purview extends from the Atlantic to Pacific Oceans, from Chile to Canada, and the "history" it seeks to present reaches back far before Europeans arrived. Community collaboration and consultation marked every phase of development. In planning, NMAI staff traveled to different places in what they termed "Indian Country," soliciting ideas for the design of the building and its environment, its contents and modes of presentation.

In contrast to the surrounding white marble buildings, the NMAI is made of sand-colored stone and designed to resemble a jagged rock in harmony with its natural environment. Inside, it offers a variety of meeting and performance spaces, designed so that the museum can serve as a community and ritual space for the many Native American visitors it receives. Displays within the museum are designed in consultation with communities, and the museum supports Native American methods of object presentation, care, and classification. The displays are not revisionist: they neither reflect the ethnographic presentation styles of the past, nor do they critique them. Instead, community curators from twenty-four groups chose objects to reflect their perspective on each of the three themes that organize "spines" of the museum. As one critic summarizes, "For the National Museum of the American Indian to be *of* American Indians and *for* American Indians, the NMAI had to fundamentally alter what museums have always meant to Native people in every way, and in this, the NMAI succeeded."[57]

If these modes of "New Museology" pose a potential shift in the locus of power over the artistic legitimation process, they may fundamentally shift the trajectory of that process as I have described it. Alternatively, a conservative pushback against progressive artistic legitimation processes could stall or reverse these trajectories. In order to consider that alternative future reality, I turn toward a consideration of two fields that have resisted, or been resistant to, artistic legitimation: kitsch and designer toys.

Never Art: Kitsch

This text has focused on similarities in conditions and resources that promote artistic legitimation. The question remains: Is it possible for a field to resist or reject the artistic legitimation process, or even to be immune to it?

It's a difficult question to explore, for many reasons, not the least of which is the impossibility of proving a negative, but in these final sections, I explore the various forms of resistance from within fields as they matured toward legitimacy.

When I am asked to conjure up an example of culture that will never be seen as art, my first choice typically comes from a category we call "kitsch." Indeed, one popular definition of kitsch defines it precisely as that which is not art: "Objects that have a widely popular appeal, yet despite this are considered bad by the art-educated elite."[58] The etymology of the term is hotly debated, but not as aggressively as the question of what counts as kitsch. I asked my students to brainstorm synonyms and they came up with the following list: tacky, tasteless, cheesy, boring, effortless, vapid, and nostalgic. Kitsch often overlaps in peoples' minds with collectibles, trash, ephemera, commercial culture, and camp. I would argue that these varying perceptions of the category point toward its utility as a catchall for the unartful.

Perhaps the most commonly cited producer of kitsch is Thomas Kinkade, the Painter of Light.™ In glowing pastel colors, Kinkade produced pastoral scenes of gardens, stone cottages, lighthouses, and quaint American Main Streets. Christian themes, including crosses and churches, often appeared, and some paintings ("The Garden Tomb," "Garden of Gethsemane") narrate Christian theology. While he rarely included people in his work, Kinkade contributed a painting of the Indianapolis Speedway for the 2009 Indy 500 program; nestled among anonymous race fans, viewers could find portraits of both Norman Rockwell and Dale Earnhardt.

Is Kinkade a bad painter? Certainly not. His pictures are skillful representational portraits. His works are immensely popular; according to court testimony, he made more than $50 million from the sale of his prints and licensed product lines, and that's only in the eight years between 1997 and 2005.[59]

You could argue that Kinkade is kitsch because of what and how he paints and for whom he paints. In depicting Impressionistic pastoral scenes, his work is stylistically at odds with virtually all critically acclaimed modern and contemporary art. Research on the subject has generated the following list of aesthetic qualities for works of kitsch: more likely to be figurative than abstract; highly emotionally charged and emotionally relatable; obvious and identifiable subject matter; uses standard conventions; and unable to generate new associations related to the themes or objects depicted.[60] The subject matter of kitsch is immediately identifiable. There are many kitsch paintings

of fluffy kittens. An artistic painting of a fluffy kitten would no longer be kitschy: "A kitten decomposed into multiple time-sliced phases, exhibiting twenty-three legs, would hardly succeed as kitsch, no matter how fluffy it was."[61] Like paintings of fluffy kittens, or large-eyed children crying, Kinkade's paintings evoke broadly relatable emotions. Viewers can be certain that their response to the art is "correct" and that it is universal. As Milan Kundera wrote: "Kitsch causes two tears to flow in quick succession. The first tear says: How nice to see children running on the grass! The second tear says: How nice to be moved, together with all mankind, by children running on the grass!"[62]

Kundera's admittedly snide description of kitsch's impact reveals something important about the role of the audience in assessing artistic legitimacy. As Marshall Sahlins famously said, "There is no such thing as an immaculate perception."[63] Just as we assess the legitimacy of the speaker when we evaluate her argument, we assess the legitimacy of the audience when we evaluate the qualities of the culture they enjoy. Unsophisticated people are rarely associated with sophisticated art. Given that, art-world insiders draw parallels between Kinkade's work and commercial and explicitly nonartistic objects; for example, some argue that Kinkade is "just . . . a branding concept. He might as well be selling hamburgers."[64]

In fact, the aesthetic aspects of Kinkade's work fail to provide the necessary and sufficient conditions for it to be considered kitsch. We learn this by comparison to the work of English painter John Constable. Born in 1776 in Suffolk, Constable is best known for his romantic paintings of village life, painted in broad brushstrokes with thick highlights that produced shimmering surfaces. Constable and Kinkade use similar techniques, could evoke similar emotions (particularly, nostalgia), and even depict the same subject matter. So why is one considered one of the greatest landscape painters to have lived, and the other compared to a hamburger salesman?

The answer lies in the elements we traced to explain the artistic legitimation process. Critics argue that Kinkade does not use *contemporary* artistic conventions in either his choice of subjects or materials. He's deemed "irrelevant" to art, even though he has earned half a billion dollars from his artwork and related businesses.[65] While Kinkade compares himself to Norman Rockwell and Andy Warhol, critics compare him to a neighborhood butcher, or to the makers of collectible Beanie Babies or Hummel spoons. Salespeople in all of Kinkade's retail outlets are required to memorize his biography: he trained at the Art Center College of Design, then as a film set painter in Hollywood, until his religious awakening at age twenty trans-

formed his art. As Susan Orleans noted in the *New Yorker*, "It is as good a story as you could hope for if you want to make a point about perseverance," but it is a terrible story if you want to convince the art establishment of your legitimacy.[66] Worst of all is Kinkade's approach to selling his art. He built the largest art company in the world and it is traded on the New York Stock Exchange, making him the "only artist to be a small-cap equity issue." At one time, there were three hundred and fifty Thomas Kinkade Signature Galleries, and his website and five thousand retail outlets sell Kinkade-licensed products including puzzles, mugs, blankets, cards, calendars, and night-lights. As a 37-percent owner of the company, he was one of the wealthiest artists in the world.[67] Despite the fact that his early original paintings are still being sold on the secondary market for millions of dollars, the art establishment treats him as a commercial hack.

Although Thomas Kinkade (and his circle) should be eligible for artistic status, both the aesthetic and social characteristics of his work and its reception consign him to the world of multiples and collectibles. It is tempting to conclude that collectibles and commercial art are forms of cultural work that are unable to progress through the artistic legitimation process. But the dynamics of so-called "designer toys" provides a counterexample.

Partial Legitimation: Designer Toys

"You're an Asshole for Buying This" was the title of the first retrospective show for artist Morgan Phillips, better known as the Sucklord.[68] Although the retrospective was held in a Chelsea gallery, Phillips is not what most people would consider an artist. He makes what he refers to as "bootleg action figures" by dissembling mass-produced and vintage action-figure toys and remixing their elements.[69] He calls this practice *suckadelic*, a "*transformational* sucking," to emphasize that the toy is "so bad, it's good."[70] You may think that the collectors who are willing to pay hundreds, even thousands of dollars for a Sucklord toy are assholes. But the question to ask is, to borrow the title of a *New York Times* article on designer toys, "Is it a Toy? Is it Art?"[71]

Designer toys arguably emerged in Hong Kong and Japan in the mid-1990s.[72] The inaugural display of such toys in the United States is said to be designer Todd McFarlane's presentation of "highly detailed and exquisitely painted" action figures at the 1994 American International Toy Fair.[73] Since then, designer toys have been displayed in fine-art organizations and been championed by highly regarded artists. The designs for Travis Cain's *Dunny* series were exhibited at the Cooper Hewitt Museum Triennial in 2006.[74]

Within a year, MoMA added ten *Dunnys* and three *Munnys* (by Budnitz and Tristan Eaton) to its permanent collection. Designer toys have been featured in international museums including LACMA (LA) and CMA (Chicago). They have been auctioned at Christie's and Phillips de Pury.

Designer toys are also commercially available. In March 2016, collectors lined up around the block waiting for the MoMA Design Store in Soho, New York, to begin selling eight-inch *Companion* figures by toy designer KAWS (two hundred dollars). They are also sold on eBay and in retail establishments, including high-end toy stores. The primary retailers of designer toys offer a range of objects for sale, from a five-dollar keychain to a seventeen-thousand-dollar "statue," four feet tall, at Toy Tokyo. Offering small, cheap, mass-produced toys in the same location as "serious" designer toys casts doubt on their artistic legitimacy. On the other hand, there is a tradition in the visual fine arts of offering lower-cost "multiples," like sketches and lithographic prints, to provide an access point for beginning collectors. And museum gift stores are chock-full of keychains, scarves, and posters featuring the images of work by legitimate artists. Still, art-world insiders tend to look askance at living artists who produce these low-cost collectibles.

Although the uninitiated may be unable to distinguish between toys and *designer* toys, experts ably employ criteria of assessment in selecting the winners of the annual Designer Toy Awards (DTA). The DTA was founded in 2011 as an opportunity for "celebration within the toy community" and recognition of "the hard work and talent that is sometimes left to go unnoticed."[75] A jury of 130 industry professionals, including artists, collectors, and comic illustrators, selects award winners in multiple categories including design, sales, and criticism.

The DTA is hosted by *Clutter Magazine*, founded in the United Kingdom in 2000 as "the first English-language periodical to focus on designer toys."[76] In the pages of *Clutter* as well as its American peers, *Vinyl Abuse* and *Playtimes*, in articles devoted to initiating newcomers to the field you learn the criteria that award committees use. For example, in the "Designer Toys Dictionary" published in issue 28, *Clutter* treated "designer plush" toys, made from fabric, as synonymous with "soft sculpture," perhaps like those of artists like Yayoi Kusama and Claes Oldenburg.

A quick browse through archived issues of *Clutter* reveals that articles, reviews, and interviews with creators and collectors use the same vocabulary we find in other "highbrow" art worlds: creators are artists, and their creation is art. Objects are described as "unique," "creative," "authentic," and "inspired"; artists are "depicting," "conceptualizing," or "interpreting,"

and some objects are "sublime." These many similarities with high-art discourse suggest a collective effort on the part of designer toys' reputational entrepreneurs to assert their artistic status.

Similarities to existing artworks are also explicitly drawn in the pages of these magazines, in documentaries (e.g., *The Vinyl Frontier*), and in criticism. Designer toy creators are most often compared to neo-Dadaists, pop artists, and folk artists. Neo-Dadaists like Robert Rauchenberg and Jasper Johns use ordinary objects and iconic images as media. The "remixing," "juxtaposition," and "appropriation" we see in neo-Dadaism are comparable with "almost every great designer toy."[77] While Duchamp and others made art from found objects, toy designers like the Sucklord and Michael Lau dissemble readymade action figures and add new components of their own design, or substitute elements from other toys.[78] Given their frequent references to popular culture, designer toy creators are sometimes referred to as pop artists. As leading toy artist Frank Kozik argued, "Warhol is an amazing artist, and he used industrial technique to popularize his work. . . . We do the same thing."[79] Finally, Paul Budnitz, founder of retailer KidRobot, argued that designer toys are "forms of folk art, or pop art—because many of the artists are not formally trained and pop art because the toys appropriate aspects of popular culture in their design, but do so in a way that creates new objects that have aesthetics and meanings that far exceed the culture that they refer to."[80] In each case, drawing comparisons to legitimate fine-arts movements is a sign that the field seeks to profit from such associations, drafting artistic credibility from existing fields.

Advocates emphasize the ways in which designer toys reflect the individual identity of a particular creator. They claim that designer toys are "original objects that come from a personal sensibility" and that communicate the creator's "artistic touch rather than the creation of amusement and merchandise."[81] Advocates promote the authenticity and legitimacy of designer toys by attaching biographies and personal narratives to them. Yet they certainly have not achieved widespread legitimacy as art.

Whatever this next century holds, it is hard to imagine a revolution in taste of the kind we experienced in the previous one. The relatively rapid transformation we've experienced, from a nation with very little art of its own to one eager for more, will not be repeated.

Studies of omnivorousness revealed that younger elites had a higher propensity than their older peers to be omnivores. This suggests that we will see an expanding group of elites with diverse tastes as time passes, and that

what we are seeing is not a radical change, but rather the end of a glacial, decades-long drift in American cultural consumption, particularly for elites. When pundits bemoan the end of culture, they're concerned that our engagement with "the classical arts" is in decline. Setting aside for a moment the question of whether this concern is reasonable, it misleads us into thinking that the canon was always in place (and we have seen that it was, in fact, recently invented) or that it was ever stable (and we have seen it was, in fact, always in flux).

Government subventions to the arts and institutional work dedicated to the aesthetic legitimation of folk culture can produce generations of highly engaged and broadly curious consumers, and a generation or more of creative innovators. It follows that the health and vitality of the arts depends upon robust delivery systems for culture that expose Americans to a diversity of arts at the right moment in their lives—as they are "coming of age." Young people, especially those growing up outside of elite communities, may depend upon these delivery systems to develop a love of the arts and an understanding of other cultures. The erasure of these systems through disinvestment, defunding, or retreat into class-segregated, privatized venues can result in the withdrawal of entire generations from certain forms of cultural engagement. My claims here are consistent with the long-standing argument that artistic producers are better off under high public support systems than market-dominated ones.[82]

The evidence in this book also supports the less-explored idea that broad, public engagement with the arts—the "demand side" of this equation—is dependent on how the arts are framed at the national level, and that governments have a great deal of influence over this framing.[83] It supports comparative analysis that demonstrates that where public support for the arts is generous, as in the Scandinavian social democracies, engagement with the arts is more intense and less divided by markers of status, like educational attainment.[84] The United States enjoyed its own "social democratic" moment, leaving a lasting impact on a voracious generation and facilitating great institutional change, wherein the artistic canon expanded our access to, and understanding of, the *real* American character.

Methodological Appendix

The scope of this book—almost two centuries of artistic legitimation practices in the United States—and its focus on both particular examples and patterns across examples required a diverse array of data and analysis methods. In this appendix, I seek to provide interested readers with an accounting of my data selection and analysis procedures. In brief, I employ archival, survey, and interview data and perform secondary data analysis on primary and secondary documentation of historical events. I describe first the qualitative data and methods employed, and then the quantitative analyses.

Qualitative Data and Analysis Procedures

In several chapters, I report on existing historical and sociological research on the evolution of the arts and cultural practices in the United States. In order to broaden and deepen the analysis of any single case, as is ordinary in comparative-historical research, I consulted dozens of primary and secondary documents. For example, while my analysis of the development of American "benchmark arts" (opera, classical music, museums, modern dance, ballet) relies heavily on the important work in the historical sociology of the arts (by DiMaggio [1982, 1991, 2000], Levine [1988], Zolberg [1981, 1984], Peterson [1986], Duffus [1928], Chansky [2004], Hagood [2000], Vertinsky [2010], and Garafola [2005]), I also rely on industry reports, professional conference documentation, research by arts administrators, and government reports. Similarly, the analysis of the New Deal Era arts projects relied heavily on the work of a few historians (McDonald [1969], Greengard [1986], O'Connor [1969], Matthews [1975], Denning [1997], Bold [1999], Taylor [2008, 2009], Marling [1979, 1981]), but I supplemented this with research to identify relevant news and foundation articles, eyewitness reports, museum studies, and art historical commentary.

The data used in chapter 3 were gathered from the Robert Goldwater Library, in the Department of the Arts of Africa, Oceania, and the Americas,

at the Metropolitan Museum of Art. After completing a project proposal and reading and signing the access policy and procedure document required by the department, my research team scheduled an appointment to review the complete archives from the Museum of Primitive Art. These included several books and nineteen accordion file folders of organizational records, correspondence, photographs and photo negatives, journals, museum publications, and ephemera. In advance of the visit, I constructed a timeline of events at the museum, using scholarly and web sources. Two research assistants and I divided the library materials, armed with a list of events and attributes, seeking documents that would confirm or dispute their importance. We took a conservative approach and transcribed or photographed any potentially useful source document or image. We then compiled the transcriptions and photographs and used them for reference during analysis.

For chapters 1, 4, and 5, I employed well-established methods of "secondary data analysis," identifying patterns in data collected by other researchers through careful parallel comparisons. These secondary data often provide researchers with more information than would be available in primary data sets. In this case, the sheer amount of detailed information and primary data available on the cultural forms in focus here (tap dance; tattoos; graffiti; rock and roll and jazz music; African American literature; outsider art; photography; film; and comics), as well as various forms of vernacular culture legitimized during the New Deal, would make original data collection impossible.

Together with a team of research assistants, I identified a large set of fields that scholars argued had undergone the legitimation process in the United States after the New Deal. Based on fifteen years of teaching and research in the field, I knew scholars had investigated the artistic legitimation of opera, dance, and theater. I knew of excellent research on outsider art, African American literature, comics, photography, and film. Tap dance allowed a contemporary examination of a native form; graffiti provided an innovative visual art form; and tattooing offered a chance to consider embodied culture. Design was initially included in the coding process and eliminated only at the end of the project as it became clear that the field was so large and had such internal diversity as to defy inclusion.

Drawing upon existing theories of the artistic legitimation process within the study of taste and cultural production, particularly Shyon Baumann's excellent work on both film (2007b) and the legitimation process in art (2007a), and Gary Alan Fine's research on outsider art (2003, 2006),

I identified seven attributes of that process denoted in these theories. They are:

- the definition of what *objects and performances* are included in the field,
- characterizations of artistic personas and lists of *artists*,
- qualities of the *evaluative discourse*,
- the appearance of the field in work at *colleges and universities*,
- the number and kind of *publications* in which the work is discussed,
- the emergence of *specialization and segmentation* within the field,
- and a list of the kinds of *places and spaces* that were host to its development.

Working with my research assistants, I identified at least three independent scholarly sources on each field, with an eye to comprehensive histories that might contain information on how and when the fields were perceived as art. During this process, we were able to winnow down the number of fields under study, on the basis of the quality and quantity of scholarly and expert research on their development, to achieve a diversity of media and publics. The resulting list of secondary sources includes sixty-six articles and books.

Three research assistants independently coded content from the texts into seven attributes. They entered the relevant content into a grid organized by decade in order to indicate the emergence of evidence of each attribute over time and across sources. Thus, we would be able to witness how the number and kind of publications, for example, shifted decade by decade. Each research assistant was encouraged to add attributes during the coding process, which resulted in the addition of two more: on connections to other artistic fields and the sources of financial support for those working in the field.

After the initial data entry was complete, my research assistants provided me with a combined file containing all the data used in constructing the matrices, and I performed an independent coding of data to attributes. There was a high correspondence between my own coding and that of the research assistants (a 91 percent intercoder reliability score). All but four code discrepancies were located in the two attributes added by the research assistants before coding began: connections to other artistic fields and financial support. Those were then eliminated from the table of attributes, raising the overall level of correspondence between the ratings, and resolving the impossibility of an additional recoding by all parties.

The resulting matrices illustrate substantive patterns in attributes and resources for ten fields during the process of legitimation. These fields are: rock and roll, jazz, film, graffiti, graphic novels (or comics), photography, tattooing, African American literature, tap dance, and outsider art. These were informed by evidence on primitive art, opera, ballet, modern dance, and theater.

Throughout the final chapters of the text, I reported additional data on the legitimation of kitsch, and designer toys. The penultimate chapter focuses on several case studies: the "Chinatown bag" fad, controversies over a show at the Boston Museum of Art, and slumming, among others. The evidence to support these analyses were drawn from multiple sources, including primary documents, academic and news sources, observation, and a limited number of interviews conducted by me and a research assistant between 2014 and 2015. This project received institutional review board approval at both Vanderbilt and Teachers College, Columbia University, although none of the interviews were completed under the auspices of the first. At the time of these interviews, my focus was on professionals tasked with the identification of folk and minority culture and its presentation to elite audiences, including club DJs, store "buyers," museum curators, fashion designers, and restaurateurs, as well as their advisors, like advertising and marketing professionals. Participants were identified through the publicly available occupational directories of cultural organizations (e.g., company websites), and by suggestion from the team of research assistants working on the project, all of whom were students enrolled in a master's degree program in arts administration. The specific individuals of interest within these organizations were those who manage the provision of goods and experiences to customers/clients.

Twenty-six individuals were contacted with requests for an interview. Five interviews were completed with an assistant buyer at an Asian art museum store, the founder-director of a dance company, the founder-director of an outsider-art gallery, a textile fashion designer, and a museum curator. These interviews were conducted between February and November 2014 and lasted ninety minutes on average; each was audio recorded with permission and transcribed for analysis. I received permission to identify participants by their names, unless they chose to remain unidentified; all participants declined to have their identities hidden. The questions pertained to their work responsibilities and descriptions of their clientele, and then focused on their perceptions of the folk or minoritized culture on offer through their organization. We asked for examples of this culture, and for

descriptions of the sale of these objects and experiences. We finally asked participants to reflect on whether these sales experiences or clients differ from others with which they might be familiar. Only one of these interviews, with Adit Agam, ended up included in the book, but all informed the evolution of the project.

Quantitative Data and Analysis Procedures: Americans and the Arts Survey

The final major data source was the 1973 Americans and the Arts survey (fielded by the National Research Center of the Arts), which contained a series of items in which interviewees were asked about their level of exposure to the arts when they were growing up. Respondents were selected via a multistage cluster random sampling design; thus, when weighted, the data are representative of the US population at the time (fielded by the National Research Center of the Arts). The analyses of these data were done in collaboration with Omar Lizardo, in preparation for a not-yet-published manuscript. They are used here with his permission.

Respondents were asked:

When you were growing up how often did you go to [activity] with your family or with friends—often, sometimes, hardly ever, or never?

The survey ($N = 3,005$) asked this question for seven activities: 1) plays, 2) art museums, 3) concerts, 4) opera, 5) science or natural history museums, 6) historical sites, and 7) ballet/modern dance. Six of these activities (excepting science museums) count as arts participation activities. In the survey, respondent's age comes precoded into eight age-group categories. I calculated the respondent's birth cohort from this variable by subtracting 1973 from the age-group bounds. I address the question of whether cohort differences in early arts exposure exist by specifying an ordered logit model predicting exposure frequency (in the four ordered categories specified in the question wording example above, recoding all "not sure" responses to "never") from the cohort group variable. In the models, I adjust for gender, educational attainment at the time of the survey, race, and region of residence. I allow for (expected) nonlinear trends in the cohort effect estimates by entering the cohort group term as a linear and a square term. The main set of results, in the form of the sum of expected probabilities of response categories indicating some level of exposure to the arts (e.g., "often" and "sometimes") for each cohort/age group, are shown in figure A.1. If the

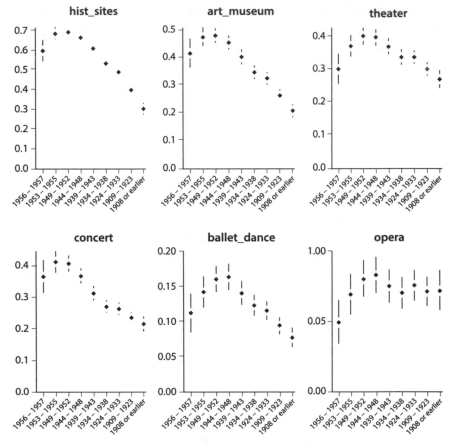

FIGURE A.1. Predicted probability of exposure to the arts while growing up for members of different cohorts. Cohort effects are specified using both a linear and a quadratic term. Panels ordered (from top left to bottom right) according to overall popularity of activity. *Source*: Omar Lizardo and Jennifer Lena.

combined historical-quantitative argument is on the right track, we should find that persons born after 1930 should report greater early exposure to the arts than persons born before them.

As figure A.1 shows, the results provide strong support for the contention that members of the post–New Deal Era generation experienced higher odds of having at least some exposure to the arts when they were coming of age than members of the immediately preceding cohorts. Respondents born in the late 1930s, 1940s, and the first half of the 1950s report having experienced (substantively and statistically) significantly higher levels of early life exposure to theater, ballet and modern dance, music concerts, art museums, and historical monuments than those born before 1930.

For instance, while somebody born in the 1910s or 1920s had less than a 30 percent chance of having been exposed to art museums while growing up, people born in the later 1930s to the early 1950s have closer to a 40 percent chance of the same outcome. Differences are starker with respect to attendance at historical monuments and sites, with those born before 1930 being almost half as likely to have enjoyed these activities while growing up. Only opera demonstrated more equivocal results, but cross-cohort differences can be observed for every other art activity, always favoring this generation over their pre-1930 predecessors. In all, these results provide strong corroborating information for the underlying mechanisms suggested by the historical analysis presented above.

NOTES

Preface

1. From http://www.dailyscript.com/scripts/citizenkane.html. Accessed September 15, 2018.

2. The scene imparts a theme of the film, perhaps best characterized by the description William Troy, writing in the *Nation*, provided for Preston Sturges's earlier film "The Power and the Glory:" "Its subject is the American Myth, and its theme is futility" (Troy 1933: 308). The American Myth, in both films, is that men can transform "from rags to riches" without paying with their souls. According to Pauline Kael, writing in the *New Yorker*, both films depict a business giant as "a Cain figure," fitting for an era when the global depression revealed such leaders to be swindlers.

3. Douglass 1881: 393.

4. Taylor 1876: 88.

5. Troubridge 1884: xii, 169.

6. Chambers 1908: ix, 127.

7. Bourdieu 1984; López-Sintas and Katz-Gerro 2005.

8. Silber and Triplett 2015: x. Data on opera attendance were drawn from the 2012 survey year.

9. Vanhoenacker 2014.

10. Peterson and Simkus 1992.

11. Those arguing in favor of declassification include Vlegels and Lievens 2017, while those noting a shift in what tastes indicate elite positions include Lizardo and Skiles 2009, among others.

12. DiMaggio (1987: 443) has argued that such knowledge can foment sociability (and social capital) because those that share tastes can recognize deeper affinities and interact with a greater intensity than they would without them.

13. Lizardo 2006.

14. Peterson and Kern 1996: 905.

15. Johnston and Baumann 2007: 173.

16. Khan 2010: 39.

17. As Fine writes (1996: 1159): " 'Reputational entrepreneurs' attempt to control the memory of historical figures through motivation, narrative facility, and institutional placement." I treat "aesthetic entrepreneurs" as a subset of that category, including those who attempt to control the memory of art-historical figures and movements.

18. Sullivan and Katz-Gerro 2007. In the text that follows, I frequently rely on this notion of "voraciousness," defined as the "range and frequency of leisure participation" (2007: 123).

Chapter 1. The Invention of American Art, 1825–1945

1. In this text I will utilize "America" as an inexact substitute for "the United States," and solely for the purpose of concision.

2. DiMaggio 1982.

3. On Thomas, see Hart 1973, especially pages 10–47. On Barnum, see, among others, Harris 1973.

4. Levine 1988: 85–168.

5. Regev 2013: 61. However, the authoritative statement on the topic is this: the social construction of art worlds "goes hand-in-hand with the construction of specific principles of perception and appreciation of the natural and social world (and of the literary and artistic representations of that world); that is to say, it goes together with the elaboration of an intrinsically aesthetic mode of perception which situates the principle of 'creation' within the presentation and not within the thing represented, and which is never so fully asserted as when it is able to constitute aesthetically the base or vulgar objects of the modern world" (Bourdieu 1996: 132).

6. DiMaggio 1991: 42, 43, 48.

7. DiMaggio 1991: 35.

8. DiMaggio 1982. See also Trachtenberg 1982; Whitehall 1970; Burt 1977; Hall 1984; and Blau 1991.

9. DiMaggio 1982: 38.

10. Weber 1977: 15.

11. DiMaggio 1982.

12. Zolberg 1981: 106.

13. DiMaggio 2000: 41.

14. DiMaggio 2000: 41.

15. DiMaggio 2000: 41.

16. Zolberg 1981: 105. On "the masses," see Horowitz 1989.

17. Zolberg 1984: 378.

18. Zolberg 1984: 378.

19. Zolberg 1981: 106.

20. American Association of Museums 1910.

21. Zolberg 1981: 105.

22. Peterson 1986: 162.

23. Peterson 1986: 163.

24. DiMaggio 2000: 43.

25. DiMaggio 2000: 42.

26. Lagemann 1983.

27. Zolberg 1981: 110.

28. DiMaggio 2000: 43.

29. Baumann 2007a: 51.

30. DiMaggio 1991: 44.

31. DiMaggio 1991: 23.

32. DiMaggio 1991: 24, 25, 27. On "alternative spaces," see Chansky 2004: 4.

33. Duffus 1928.

34. Chansky 2004: 2, 4.

35. They singled out the Schuberts for following a two week run of Shakespeare with "as commonplace a musical comedy as 'The Midnight Sons," which follows the attempts of Senator Constant Noyes's four sons to find gainful employment (DiMaggio 1991: 24).

36. Duffus 1928: 306.

37. Duffus 1928: 306.

38. Duffus, 1928.

39. Duffus 1928: 306, 301–2.

40. Reports from this event, which featured educators, scholars, and representatives from commercial theater, suggested "'universal agreement' that the regenerative forces in American theatre were centered in the universities, community, and Little Theaters." In 1927, George Pierce Baker, "by most accounts the most influential member of the university community in the Little Theatre Movement," found three thousand representatives from all types of theaters willing to attend a conference on the development of American theater (Chansky 2004: 18–9).

41. Chansky 2004: 4.

42. Chansky 2004: 2.

43. Chansky 2004: 4.

44. DiMaggio 1991: 25.

45. Starting in 1910, the Drama League of America used member committees to select productions, while the New York Theatre Guild organized guild chapters in other cities, and mounted its own travelling productions (DiMaggio 1991: 26).

46. In 1914, the Drama League of America reported the Toy Theatre of Boston was hybridizing a shareholding/investment plan with one more akin to a nonprofit membership model: "Shares of the stock are being sold which entitle the shareholder to a seat for the season of eight performances, besides a share in any profits which may accrue from the letting of the theatre to visiting companies from other little theatres and for such musicals, recitals, and other productions as may find it available . . . such as the Boston Opera House is leased to the present opera management" (Howard 1914: 268–69).

47. DiMaggio 1991: 25.

48. DiMaggio 1991: 26; Duffus 1928: 300–302.

49. DiMaggio 1991: 25.

50. Houghton 1941: 68–73. While initially the director was the Playhouse's only employee, by 1921 it had amateur volunteers supplemented with a nucleus of professional actors; by 1926, its yearly audience numbered forty thousand and the theatre was 90-percent-filled, year round (Duffus 1928: 305). In 1931, CPH became the first professional theatre to collaborate with an institution of higher learning to offer a course for college credit, indicating their commitment to the professionalization of the field.

51. DiMaggio 1991: 30.

52. Chansky 2004: 3.

53. MacGowan 1929: 242.

54. DiMaggio 1991: 27.

55. DiMaggio 1991: 29.

56. DiMaggio 1991: 29 (citing MacGowan 1929: 7).

57. Cleveland Play House. 2016.

58. DiMaggio 1991: 40.

59. Hanna 1988.

60. DiMaggio 1992: 38.

61. Martin 1930. Duncan was said to have "shocked an audience accustomed either to classic Italian ballet, with the dancer on toe in a filmsy tu-tu, or to such popular style dance as Irene and Vernon Castle's mincing 'Walk'" (Palmer 1978: 21). Her dancing style emphasized natural movements, rather than the rigidity of ballet. A *Philadelphia Telegraph* review of one of her performances oozed: "In this present day of elaboration and artificiality Miss Duncan's art comes as a pure breath from some pine-clad mountain height, refreshing as its ozone, beautiful and true as the overarching blue sky. Entirely simple, natural and unaffected, she presents a picture of

beauty, joy and abandon as one believes it must have been when the world was young and youth danced in the sunlight for the mere joy of life" (Palmer 1978: 24). Duncan mystified and electrified audiences, and built a foundation for modern dance that Graham and Humphrey would inherit two decades later.

62. Hanna 1988: 130.

63. Hagood 2000: 69.

64. Hagood 2000: 78.

65. Hagood 2000: 77.

66. DiMaggio 2000: 40.

67. Vertinsky 2010: 1116.

68. H'Doubler served on the executive committee of the Dance Section from its start, but declined to serve when elected National Section chair in 1933, while Hill stepped forward to take several leadership roles. As president of the Eastern District of the APEA, she organized a series of conferences and symposia on dance (Vertinsky 2010: 1122–23). But Hill had already become disaffected with the association between dance and physical education; she said of her work at Bennington: "Taking dance out of the PE Department, from a sport to an art form, that was the big accomplishment of 1932" (Vertinsky 2010: 1123). She similarly withdrew her interest in APEA, and the National Section on Dance withered from declining interest over the subsequent decade as dance teachers placed their support behind arts advocacy.

69. Bonbright 2000.

70. Steichen 2015: 69.

71. Garafola 2005: 20.

72. Steichen 2015: 73.

73. Steichen 2015: 71.

74. Kirstein 1978: 68. Caravan was an official affiliate of American Ballet, not a distinct organization, and it used that affiliation to boast its association with the Metropolitan Opera, particularly in promoting events and press coverage. A brochure for their first season describes Ballet Caravan as "twelve accomplished dancers, all members of The American Ballet Ensemble which has recently completed its first season with the Metropolitan Opera in New York" (Steichen 2015: 72).

75. Steichen 2015: 73.

76. Steichen 2015: 74n20.

77. Steichen 2015: 73.

78. Martin 1936.

79. Steichen 2015: 79.

80. Steichen 2015: 89.

81. Banes 1999: 83.

82. Levine 1988: 85–104.

83. Storey 2003a: 37.

84. DiMaggio 1991: 30–31.

85. DiMaggio 1991: 31.

86. Storey 2003a: 12.

87. DiMaggio 1991: 33.

88. DiMaggio 1991: 33.

89. DiMaggio 1991: 34.

90. Kolodin 1936.

91. DiMaggio 1991: 35; Kolodin 1936: 163–67.

92. DiMaggio 1991: 36.

93. Siefert 2004: 299.

94. DiMaggio 1991: 36–37; Eaton 1968: 250.

95. Siefert 2004: 299.

96. DiMaggio 1991: 44.

97. Blau 1991: 95.

98. Blau 1991: 91.

99. Blau 1991: 91.

100. Keppel and Duffus 1933.

101. Lundberg et. al 1934; Allard 1939.

102. Data files were obtained from the National Archive of Data on Arts & Culture (NADAC) hosted by ICPSR at http://www.icpsr.umich.edu/icpsrweb/NADAC/.

103. Exact response rates for the 1973 survey are not available; for more technical details on the American and the Arts survey series, see http://www.icpsr.umich.edu/icpsrweb/NADAC /studies/35575?archive=NADAC&q=american+and+the+arts#method.

104. In the survey, the respondent's age comes precoded into eight age-group categories. We calculated the respondent's birth cohort from this variable by subtracting 1973 from the age-group bounds. We address the question of whether cohort differences in early arts exposure exist by specifying an ordered logit model predicting exposure frequency (in the four ordered categories specified in the question wording example above, recoding all "not sure" responses to "never") from the cohort group variable. In the models, we adjust for gender, educational attainment at the time of the survey, race, and region of residence. We allow for (expected) nonlinear trends in the cohort effect estimates by entering the cohort group term as a linear and a square term.

105. Note that, in most cases, exposure rates drop for persons born in the second half of the 1950s. We should not read too much into these results, as these individuals were between 16–17 years old at the time of the interview.

106. DiMaggio 1991: 45.

107. DiMaggio 1991: 46.

108. Martin 1930.

109. Lynn 1996: 3.

110. Holland 1987.

111. Charna Lynn 1996.

112. N.A. November 18, 1910.

113. Midgette 2007: 81; N.A. December 11, 1910.

114. The opera was popular enough that it was revived for three performances in the subsequent season, and broadcast on NBC radio in 1929 (Dorris 2013: 85).

115. Hutchins-Viroux 2004.

116. Steichen 2015: 85.

117. Steichen 2015: 87.

118. Steichen 2015: 71.

119. RePass 1953. While there is little research on opera pedagogy from these years, we have some documentation on composer Jack Beeson's Opera Workshop at Columbia University (1941–58). Opera workshops were popular forms of opera education, and existed at the University of California, the Peabody Conservatory in Nashville, the Pennsylvania College for Women, Hunter College, and Indiana University as early as 1940 (RePass 1953: 10–11). At Columbia, students studied the traditional repertoire in its original languages, working with faculty and student conductors to prepare scenes and full productions of traditional and new works. Students learned the nuts and bolts of staging a production by preparing one; the curriculum additionally included "some focus on language and diction study, movement and acting (not necessarily related to opera) and professional development" (Graham 2009: 20). Columbia's curriculum

differed from its contemporaries in one important respect: it trained students to sing in the language of the original composition, while peer institutions tended to instruction in English.

120. McConachie 1988.

121. Midgette 2007: 81.

122. Siefert 2004: 300.

123. Garafola 2005: 18.

124. Garafola 2005: 231–32.

125. Steichen 2015: 82.

126. Kirstein 1970.

127. Nelson 1983: 48.

128. Hanna 1988: 130.

129. Garafola 2005: 20.

130. Siefert 2004: 299–300.

131. Siefert 2004: 300.

132. Edelson 2005: 2.

133. Silber and Triplett 2015: x. Data on opera and ballet attendance were drawn from the 2012 survey year.

134. Chansky 2004: 2.

135. Hagood 2000: 77.

136. Steichen 2015: 71.

137. Steichen 2015: 79.

Chapter 2. The WPA and the Opening of the American Arts

1. Cohen 2005: 95.

2. Biddle 1939: 267–77, quoted in Mathews 1975.

3. Biddle's letter to the president in May was followed in December 1933 by the initiation of the Public Works of Art Project, after his proposal for a mural program was rejected by the Fine Arts Commission. He subsequently generated the support of several influential members of the administration, including, most important, Edward Bruce, a Treasury Department employee and advocate for the arts (McDonald 1969: 357–59).

4. Over the course of the program, "total employment reached 3,749 persons. Works ranging from sculpture, murals, oils, and mosaics to craft articles, Navajo blankets, portraits, and stage sets, totaling in all 15,663 pieces, were completed. The total cost of the project was $1,312,000, of which 90.3 per cent went in wages to the artists themselves" (McDonald 1969: 62). Projects that were unfinished when PWAP was disbanded in 1934 received ongoing support from the Emergency Work Relief Program of FERA. The artworks created were the property of the federal government and were allocated to public and nonprofit private institutions until July 1935.

5. Taylor 2008: 275–76.

6. Greengard 1986: 58–60; O'Connor 1969: 28–29. The output and impact of the Federal One Projects may, in fact, pale in comparison to the achievements of many state and local relief administrations. New York's was first among these, "almost unique in its progressive attitude," and with significant reach: one accounting estimates that twelve thousand people came to see a performance of *Uncle Tom's Cabin* in Crotona Park (McDonald 1969: 70).

7. They were performed by symphony orchestras, small orchestral ensembles, string quartets, chamber music ensembles; grand opera, light opera, and chamber opera companies; vocal ensembles and vocal soloists; and dance orchestras, bands, and theater orchestras (Agency 1947: 64).

8. Marling 1979: 425.

9. Gale Cengage Learning Archives Unbound, 2014.

10. Over the nearly four years in which Federal One programs were in operation, the theater and music divisions (and their state sponsors) were most successful in generating revenue through admission ticket sales. According to McDonald (1969: 288), the theater division generated $2.1 million in revenue, while the music division ticket sales yielded $488,618 and change. Congress repeatedly attacked federal arts divisions based on reports of inefficiency and fraud. The Federal Theatre project was abolished by Congress in 1939, charged with inefficiency, immorality, and infiltration by communist agitators (N.A. 1939, "Relief: Hot Pan"). The other programs limped forward into the war years, when they were abandoned.

11. Mathews 1975: 329. Eva Le Gallienne, director of the Civic Repertory Theatre, said that while she supported a "popularly priced" theater that could create a (new) audience, that she was "terrified" by the sums of money being given to theater by the WPA, and compared the theater it will produce to "very malnutritious and downright bad food" (N.A. 1935).

12. N.A. 1936a. "Art: Government Inspiration."

13. Mathews 1975: 330.

14. Mathews 1975: 332.

15. Taylor 2008: 262–63.

16. Taylor 2008: 287.

17. Bold 1999: 12.

18. Taylor 2008: 280.

19. Taylor 2008: 289.

20. Taylor 2008: 281.

21. Taylor 2008: 523–24.

22. McDonald 1969: 185.

23. Sklaroff 2009: 29.

24. McDonald 1969.

25. McDonald 1969: 320–21. This commitment to amateur folk culture production was even more profound once the WPA was abolished by Congress in June 1939, and these projects were transferred to the states. Operations in most states ended on February 1, 1943.

26. Bold 1999: xiii–viv.

27. Musher 2015: 6.

28. N.A. 1939. "Relief: Hot Pan." It appears that the Theatre Project was a kind of bête noir from the beginning, plagued by accidents and mistakes. Consider the gaffe reported in a March, 1936 issue of *Time Magazine* ("Theatre: Double-Jeopardy"): "FTP Vaudeville Production 4-A was booked to appear at Manhattan's Stuyvesant High School, while Production 3-A was to be sent to amuse US soldiers stationed on Governor's Island. Through some stupid blunder, the soldiers, to their great disgust, were offered 4-A, a skit called School Days in which frisky scholars tossed apples at their teacher and blurted low-caliber puns. To Stuyvesant High School, on the other hand, went 3-A, a divertissement called Parisian Nights. Intended for military consumption, this program included a scene between a bare-legged young woman, a master of ceremonies and an importunate young man. Sample dialog: M. of C.—Meet Lulu, 15 and never been kissed. He—It's a cinch she don't hang out in Battery Park. Give me a kiss. She—Give me a dollar first. He—Aw, you're over 15."

29. Denning 1997: 44.

30. Taylor 2008: 247.

31. Taylor 2009: 77.

32. Greengard 1986: 58–60.

33. Bold 2006: 175, 174.

34. Taylor 2008: 273.

35. The term was allegedly supplied by *Time Magazine* in 1934 (Marling 1981: 73).

36. Marling 1981: 74.

37. Marling 1981: 73.

38. Marling 1981: 79.

39. Marling 1981: 79.

40. Marling 1982: 30.

41. Marling 1981: 79.

42. Quoted in Marling 1981: 94.

43. Bold 1999: 8.

44. Taylor 2009: 225–26.

45. Bold 1999: 9.

46. Bold 1999: 10.

47. Marling 1981: 79.

48. Marling 1979: 425.

49. Marling 1979: 425.

50. Taylor 2009: 76.

51. Marling 1981: 109.

52. Marling 1981: 108–9.

53. Marling 1981: 126.

54. Marling 1981: 126.

55. Marling 1979: 421.

56. Taylor 2008: 273.

57. Taylor 2008: 273.

58. Bold 1999: 11.

59. Greengard 1986: 58–60.

60. Denning 1997: 48.

61. Greengard 1986.

62. How lasting were these changes? The record keeping for WPA federal and state agencies was uneven and distributed across more than a hundred offices. The original 22,000 plates from the Index of American Design are still housed at the National Gallery of Art in Washington, DC. The Newark Museum also has a large number of WPA works, including Minna Citron's painting "Staten Island Ferry." Other arts organizations, like the North Carolina Museum of Art, built their collections in whole or in part from WPA works; the NCMA's paintings were referred to by the editor of *Art News* as "the most important public collection south of Richmond and east of the Pacific" (Foushee 1972: 105). Presenting arts organizations were built, rebuilt, remodeled and rejuvenated with funds and labor from the WPA. Harlem's Lafayette Theatre was one such institution, and it was able to offer a range of performances after the rejuvenation including a performance of Macbeth that eventually was performed to over 130, 000 people (Matthews 1975: 325). Yet, many other works produced in the New Deal era were destroyed, abandoned, or forgotten.

63. N.A. 2017. "Smithsonian: Mission and History."

64. Ripley 1968: 3.

65. Kurin 1989: 15 (emphasis added).

66. DiMaggio 2000: 43, 8.

67. The significance of the aesthetic legitimation of some vernacular culture as art can also be seen in the creation of new organizations, and new regulatory and institutional practices. These include the American Folklife Preservation Act of 1976, the American Folklife Center, the Folk Arts Program at the National Endowment of the Arts, and UNESCO's 2003 International

Convention on the Safeguarding of Intangible Cultural Heritage. These provide additional evidence of the artistic legitimation process taking place.

68. It was transferred to the Department of State in 1945, and continues operation today, via radio, internet, and television platforms.

69. Denning 1997: 46.

70. Saunders 1999.

71. Haines 1977.

72. McDonald 1969: 341.

73. DiMaggio 1991: 22.

Chapter 3. The Museum of Primitive Art, 1940–1982

1. This figure based on consistent attendance figures over 6 million since 2010, as reported in R. Kennedy 2015. It is confirmed on the Met website: https://www.metmuseum.org/press/news/2017/2017-annual-attendance.

2. Metropolitan Museum of Art, 2000–17.

3. Pierre Bourdieu (1986: 250) refers to the "alchemy of consecration" albeit in the broader sense of social legitimacy.

4. To name just two (but important) examples: in one of the central texts from the Harlem Renaissance, Alain Locke's *The New Negro Anthology* (1925), Locke discusses these objects in a chapter titled "The Legacy of Ancestral Arts." Moreover, the text is illustrated with images of African masks. For a second example, look to W.E.B. Du Bois and his *Crisis* collaborators, who utilized an internationalist approach to both politics and culture as early as the 1910s.

5. My sincere thanks to Andrew Goldstone for recommending this clarification.

6. In contrast, biographies of Abby Rockefeller—Nelson's mother—treat with great care and sophistication the telling of her transformation from art collector to co-founder of the Museum of Modern Art (MoMA) in New York (Pillsbury 2014).

7. Reich 1996: 643. Under President Franklin Roosevelt he was coordinator of the Office of Inter-American Affairs (1940) and then assistant secretary of state for the Office of American Republic Affairs (1944) (LaGamma 2014: 9).

8. Reich 1996: 167–88.

9. Rockefeller 1967. "Transcript of Extemporaneous Illustrated Art Lecture."

10. Rockefeller 1967. "Transcript of Extemporaneous Illustrated Art Lecture."

11. Rockefeller 1967. "Transcript of Extemporaneous Illustrated Art Lecture."

12. LaGamma 2014: 4.

13. Myers 2006: 280n5.

14. While I argue this is a fair characterization of these academic discourses, it is both the case that the MPA was not the first space designed for primitive art (see note 255), nor was it the first one proposed in the United States. That history should, at the very least, note the efforts of Franz Boas, who wrote in a 1906 letter to his Columbia colleague Felix Adler of his attempts to "establish an African museum in the United States to help combat racism and raise the self-esteem of African Americans by featuring the past achievements of African civilizations" (Hutchinson 1996:63).

15. Pillsbury 2014: 21.

16. Pillsbury 2014: 18.

17. LaGamma 2014: 4–5.

18. Here I am relying on the definition of boundary object from Bowker and Star (1999: 297) but it is also faithful to the Star and Griesemer (1989) definition.

19. N.A. 1955. "Museum of Indigenous Art Acquisition Policy."

20. Burger 2009.

21. Rockefeller. 1967. "Transcript of Extemporaneous Illustrated Art Lecture."

22. Rockefeller. 1967. "Transcript of Extemporaneous Illustrated Art Lecture."

23. N.A. 1967. "Extemporaneous Illustrated Art Lecture by Governor Nelson A. Rockefeller."

24. Reich 1996: 644; Smith 2014: 123–24.

25. Smith 2014: 123–24.

26. Rockefeller. 1967. "Transcript of Extemporaneous Illustrated Art Lecture."

27. Reich 1996: 166.

28. LaGamma 2014: 4–5.

29. N.A. 1954. "Absolute Charter."

30. The "Minutes of the Adjourned Annual Meeting of the Members of the Museum of Indigenous Art" on December 6, 1956, note that "Dr. Goldwater said that the present name of the museum seemed to be misleading and that the use of the name 'primitive' instead of 'indigenous' would be easier and more suitable. Mr. French said that at the request of the Trustees he has applied of the Board of Regents and hoped they would approve this change at their next meeting on December 20, 1956" (N.A. 1956. "Minutes of the Adjourned Annual Meeting of the Members of the Museum of Indigenous Art.").

31. Smith 2014: 248.

32. The MPA was not the first space designed for primitive art, nor were Rockefeller or d'Harnoncourt the first collectors and curators. Objects stolen and plundered during the Renaissance entered Europe as "oddities," and came to be seen as scientific specimens during the Enlightenment, evidence of the cultures of primitive man (Rawlings 2001: 26). Sir Ashton Lever ran a private museum for primitive art from 1774 until he was bankrupted in 1786. Most of the objects in his collection were then acquired by Berlin's Königlich Preussiche Kunstkammer, which later became the Museum für Völkerkunde, so these works had been on display in Berlin for hundreds of years before the MPA's debut (Newton 1981: 7). German government officials and scientists, during the explosion of colonial exploration and conquest, engaged in a concerted effort to systematically collect art and cultural goods and to put them on display in ethnographic museums. Between 1850 and 1875, ethnographic museums opened in Berlin, Hamburg, Leipzig, and Dresden. By 1900, an elite market for primitive works rapidly expanded, perhaps due to the perception that native cultures were vanishing at a rapid rate (Myers 2006: 281n17; quoting Cole 1985). By midcentury, with the endorsement of their beauty and influence by the early modernist avant-garde, the treatment of primitive works as objects of aesthetic appreciation—as art— began to take root (Rawlings 2001). Moreover, primitivism took a number of forms, including the Gothic revival, the Pre-Raphaelites' turn to a romanticized Middle Ages, the British Arts and Crafts movement, impressionist and post-impressionist interest in Japanese wood block prints (Japanisme), French Nabis painters living with indigenous "primitives" of Brittany, Paul Gauguin in Tahiti, early modernists' interest in African and Pacific religious sculptures and masks, and the surrealists (Gillman 2010: 57).

33. Umbach and Hüppauf 2005: 25.

34. LaGamma 2014: 5.

35. What emerged early and sedimented quickly was a particular approach to acquisitions and curation at MoMA that came to be referred to as "vernacular modernism." The museum held works of European and American abstraction; American realism, romanticism, and folk art; "indigenous" or primitive art, both pre-Columbian and African; and then all manner of "contemporary" American works. In other words, MoMA's collection contained worked that were both vernacular and modern: "In addressing a field of modernism from international and local and from 'high' to 'low,' the museum engaged a range of vernacular expression" (Umbach and Hüppauf 2005: 29).

36. N.A. 1958. "Radio Reports: Dr. Robert Goldwater Interviewed for The Fitzgeralds at the Astor."

37. N.A. 1967. "Extemporaneous Illustrated Art Lecture by Governor Nelson A. Rockefeller."

38. Reich 1996: 644.

39. Price 2001: 83.

40. Regev 2013: 61.

41. N.A. 1956b. "Board Meeting Minutes."

42. Emphasis in original. N.A. 1963. "Background Information on Museum of Primitive Art."

43. Emmison 2003; Fisher and Preece 2003; Johnston and Baumann 2007; Lamont 1992.

44. Newton 1981: 10.

45. Regev 2013: 61.

46. Lindberg et al. 2005: 189.

47. Bourdieu 1996.

48. Rubio 2014.

49. Parezo 1983, quoted in Errington 1994: 205–6.

50. Errington 1994: 205, 208.

51. Rubio 2014.

52. Errington 1994: 206.

53. Price 2001: 32–33.

54. Price 2001: 58, 32–33, 59, quoting Henri Kramer, writing in 1974.

55. Bourdieu 1993b; Baumann 2007a.

56. Foucault 1984.

57. As Baudrillard and Levin (1981: 103) point out, the signature is a decidedly modern preoccupation: "Until the nineteenth century, the copy of an original work had its own value, it was a legitimate practice. In our own time the copy is illegitimate, inauthentic: it is no longer 'art.' Similarly, the concept of forgery has changed—or rather, it suddenly appears with the advent of modernity. Formerly painters regularly used collaborators or 'negros:' one specialized in trees, another in animals. The act of painting, and so the signature as well, did not bear the same mythological insistence upon authenticity—that moral imperative to which modern art is dedicated and by which it becomes modern—which has been evident ever since the relation to illustration and hence the very meaning of the artistic object changed with the act of painting itself."

58. N.A. 1958c. Radio Reports, Inc.

59. Price 2001: 103.

60. Price 2001: 102.

61. Price 2001.

62. Price 2001: 103.

63. This is a topic of substantial discussion in chapter 7, but also a focus of interest in Fine 2004, Becker 1982, Lopes 2002, Peterson 1997, Lena 2012, and many others.

64. Bourdieu 1996: 260; Rawlings 2001: 43.

65. Rawlings 2001: 43.

66. Ardery 1997: 335; Fine 2004: 173, 167.

67. Rawlings 2001: 43; Myers 2006: 273.

68. Hart 1973: 9.

69. Price 2001: 68–69.

70. Price 2001: 76.

71. Price 2001: 69.

72. Peterson 1997: 211.

73. Jones and Featherly 2002: 33.

74. Hedegard 2013.

75. On handmade character, see Bendix 1997, and Beverland 2005; on geographic origins, see Phillips and Kim 2009.

76. Rawlings 2001: 44.

77. This definition is adapted from Grazian 2003.

78. A longer discussion of this issue will follow, but authors who discuss these topics include Bendix (1997) on handmade objects; Grazian (2003) and Johnston and Baumann (2007) on the impact of tradition and specific geographic spaces; and Johnston and Baumann (2007), Grazian (2003), Peterson (2005) on nonindustrial and simplicity/rusticity in the arts.

79. Fine 2004: 175.

80. Fine 2004: 175.

81. Rawlings 2001: 44.

82. Peterson 1997.

83. LaGamma 2014: 13.

84. Baumann 2001.

85. N.A. 1955. "Museum of Indigenous Art Acquisition Policy."

86. LaGamma 2014: 13.

87. LaGamma 2014: 7.

88. LaGamma 2014: 15.

89. LaGamma 2014: 9.

90. Errington 1994: 208.

91. Errington 1994: 206.

92. N.A. 1958b. "Press Release, First Anniversary."

93. N.A. 1966. "Minutes of the Special Meeting of the Members of the Museum of Primitive Art."

94. Rockefeller 1967. "Transcript of Extemporaneous Illustrated Art Lecture."

95. Biro 2014: 38.

96. Biro 2014: 40.

97. Biro 2014: 41.

98. Biro 2014: 44.

99. The list of loans from the museum in 1958 included eight pieces loaned to the Brussels World's Fair, the same number to Boston's Museum of Fine Arts, seven pieces to the Children's Nature Museum in North Carolina, and six pieces to the University Museum in Philadelphia. Museums in Toledo, Houston, and Chicago were planned for 1959 (Goldwater 1959).

100. N.A. 1968a. "Board Meeting Minutes."

101. Houghton 1969. "Statement for the September 15th Hearing of the City Council."

102. Kjellgren 2014: 32.

103. Bates 1958.

104. Bates 1958.

105. Errington 1994: 201.

106. Newton 1981: 9.

107. Myers 2006: 271.

108. Braden 2009: 454.

109. Myers 2006: 271.

110. Vogel 1975.

111. Price 2001: 85.

112. Rawlings 2001: 33; Steiner 1994: 110–24.

113. Rawlings 2001: 26.

114. Errington 1994: 96–101; Rawlings 2001.

115. Rawlings 2001: 40.

116. Rawlings 2001: 40.

117. Rawlings 2001: 39.

118. Price 2001: 25–26.

119. Kramer 1982.

120. Kramer 1982: 62; quoted in Price 2001: 29.

121. Price 2001: 25–26.

122. Price 2001: 25.

123. Campbell 2014: 3.

124. Price 2001: 75.

125. Price 2001: 69.

126. Price 2001: 69.

127. Price 2001: 103.

128. N.A. 1968b. "René d'Harnoncourt."

Chapter 4. Opportunity Structures

1. Baumann 2007a.

2. DiMaggio 1982.

3. Baumann 2001.

4. Lachmann et al 2014: 61.

5. Accominotti, Storer and Khan 2018.

6. Lopes 2002.

7. Peterson 1972; Lopes 2002.

8. Griswold 1987.

9. Corse and Griffin 1997: 196.

10. See White and White (1965) on the invention of the paint tube and Ferguson (1998) on gastronomy.

11. Peterson 1990: 102.

12. Peterson 1990: 102.

13. Baumann 2001.

14. DiMaggio 1982.

15. Peterson 1990: 101.

16. Errington 1994: 208, quoting Lynes 1973: 138.

17. Hill 2014: 158–59.

18. Baumann 2001: 410.

19. Similarly, changes in copyright law impacted what novels were produced in the United States (Griswold 1987). Until 1909, American publishers preferred to print works by English authors because they were exempt from paying copyright fees. A legal decision in that year compelled them to compensate European authors, leading to the emergence of the widely read, distinctive American novel.

20. McLeod 2007: 108.

21. Demers 2006: 23; see also McLeod 2007.

22. Lopes 2006: 400; Nyberg 1994: 129.

23. Nyberg 1994: 142.

24. Nyberg 1994: xii.

25. Sklar 1994: 174.

26. Lachmann 1988: 244.

27. Bound and Turner 2002.

28. Olsen 1974.

29. Allen and Gomery 1985: 27.

30. DiMaggio 2000: 47.

31. Hannan and Freeman 1989.

32. McCarthy, Brooks, Lowell, and Zakaras 2001.

33. Couch 1983.

34. Zolberg 1981; Tomkins 1970; Gersuny and Rosengren 1973.

35. DiMaggio 1983: 158.

36. Peterson 1986: 165.

37. Peterson 1986: 165.

38. Braden 2009: 446; Alexander 1996.

39. Americans for the Arts 2013.

40. Pogrebin 2016.

41. Schonfeld and Sweeney 2016.

42. For one example, see Art Institute of Chicago 1954: 64. Quoted in Zolberg 1981: 111.

43. Taylor 1945: 33, quoted in Zolberg 1981: 114.

44. Zolberg 1981: 113.

45. Lachmann et al. 2014: 63.

46. Lachmann et al. 2014.

47. Rentschler and Potter 1996: 100.

48. Kaplan and Norton 1992.

49. "Third party system" from Cowen 2012; the designations "architect" and "engineer" are from Chartrand and McCaughey's (1989) model of national policies.

50. Hart 1973.

51. DiMaggio 1983: 150.

52. McCarthy, Brooks, Lowell, and Zakaras 2001.

53. DiMaggio 2000: 51; Peterson 1986.

54. McCarthy, Brooks, Lowell, and Zakaras 2001.

55. Landesmann 2012: vii.

56. Landesmann 2012: 2.

57. McCarthy, Brooks, Lowell, and Zakaras 2001.

58. DiMaggio 2000: 51.

59. Dowie 2001: 172.

60. Lachmann et al. 2014: 62.

61. Dowie 2001: 173.

62. Netzer 1978; Zolberg 1983.

63. Peterson 1986: 170.

64. DiMaggio 1981.

65. DiMaggio 1986: 5.

66. NEA News 1979b: 2; see also Handy 1985: 18–20.

67. Farley 2011: 115.

68. Farley 2011: 117.

69. Peters 2011: 86.

70. Hill 2014: 289.

71. Hill 2014: 298.

72. Peterson 1986: 176.

73. Quoted in Glynn and Lounsbury 2005: 1036.

74. League of American Orchestras, n.d.

Chapter 5. Expansion: 1900–2000

1. Zolberg 1984: 390.

2. John Levi Martin is wholly responsible for bringing this to mind.

3. Gouldner 1979.

4. DiMaggio 1991: 35.

5. Hannerz 1990: 239.

6. The Museum of Modern Art. 1968. "René d'Harnoncourt 1901–1968: A Tribute."

7. The research on boundaries in many social fields is substantial (for review, see Lamont and Molnar 2002 and Pachucki, Pendergrass, and Lamont 2007). The research by Gieryn (1999) on the boundary work of scientists is particularly compatible with this account. Research on aesthetic boundaries is also relevant, as well as voluminous. It includes research by Bourdieu (1993c), Velthuis (2013) on artistic value; multiple scholars writing about genre (Roy 2002, 2004; Grazian 2003; Lopes 2005; Baumann 2007b; Lena 2012); and many writing on food and drink (Ferguson 1998, 2004; Johnston and Baumann 2007; Zhao 2005; Rao et al. 2005).

8. Lamont and Molnar 2002: 168.

9. Bowker and Star 1999; Strand 2011; Rubio 2014.

10. Hill 2014: 260–61.

11. Sanders and Vail 2008: 161.

12. Kammer 1999:121.

13. Rubio 2014: 621–22.

14. Bourdieu 1993b; Baumann 2007a, b.

15. Price 2001: 59. Consider Holm's (quoted in Price 2001: 65) article about Kwakiutl artist Willie Seaweed: "Northwest Coast Indian artists, like 'primitive artists' of other cultures, have been largely anonymous in our time. Moreover, when modern man, a product of a society that puts great emphasis on names, fame, and individual accomplishment, looks at a collection of masks or other works of art from such exotic cultures, he is unlikely to visualize an individual human creator behind each piece. Seldom will he be helped toward personalizing the faceless 'primitive artist' by the labels he might read. Work might be identified as 'Northwest Coast,' 'Alaska,' or 'British Columbia Coast.' At best a tribal identification might be made, although the likelihood of its being inaccurate is considerable. The idea that each object represents the creative activity of a specific human personality who lived and worked at a particular time and place, whose artistic career had a beginning, a development, and an end, and whose work influenced and was influenced by the work of other artists is not at all likely to come to mind."

16. Becker 1982: 22–23.

17. Baumann 2007b: 94.

18. Pye and Myles 1979: 194.

19. Clyde Angel, a self-taught folk artist who works with scrap metal, has never met his Chicago dealer, and investigative reporters have been unable to find any official records testifying to his existence. His works might have been made by one or many people using "Angel" as a pseudonym, and who were seeking to profit from the fact that self-taught artists are more valuable when they are thought to be mentally ill, homeless, or transient (Fine 2004: 168, 169).

20. Price 2001: 101.

21. In a fascinating set of experiments, Yale psychologist George Newman and his collaborators have discovered evidence of contagion effects: that, all other things being equal, people prefer items that are closer to the artist or producer. That means they prefer art prints or album pressings with lower serial numbers (Smith, Newman, and Dhar 2016). Consumers are also more likely to buy an item if it was touched by a celebrity or artist (Newman and Bloom 2012; Newman

and Bloom 2014; Newman et al. 2011). It appears this belief is founded in the notion that some kind of essence—luck, talent, beauty, or value—is transferred from the source person through the object to the consumer. The greater the perceived status of the source, and the longer and closer the object was in contact with them, presumably, the more value it has to the consumer.

22. Battani 1999: 619, 620.

23. Christopherson 1974: 134.

24. Rawlings 2001: 43.

25. We say that an artistic field has achieved autonomy when it starts rewarding creators on its own terms, with its own rules. In art, there are two dominant sets of rules: one set rewards artists who appeal to the tastes of a large group of people (so they make a lot of money—that's heteronomy), and the other set rewards artists who appeal to the tastes of a small group of art world insiders (so they have a lot of status—that's making "art for art's sake") (Bourdieu 1996; Baumann 2007b: 81). Generally speaking, artists don't gain both sets of rewards (although there are exceptions; see Lena and Pachucki 2013), and on occasion one group will criticize the motivations of the other.

26. Regev 2013: 72.

27. Metronome 6–1947: 14, 31 quoted in Lopes 2002: 212.

28. Bourdieu 1996: 39.

29. Appadurai 1988.

30. Regev 2013: 74.

31. Ardery 1997: 335. Many of these artists hail from the rural south, they are often African American, sometimes mentally ill, poorly or not at all educated, and can be poor or socially isolated. These works, particularly those by the mentally ill or the incarcerated, "were promoted in all their wretchedness as an answer to commercialization, since they apparently created for no other reason save self-expression" (Rawlings 2001: 45; see also Hall and Metcalf 1994).

32. Fine 2004: 61.

33. Outsider artists, mentally ill artists, and creative producers who endure forms of dislocation and dispossession "were enlisted to shore up mainstream art's eroding credibility, to do what trained artists could only 'aspire' to do: maintain their independence from established cultural institutions and the marketplace" (Ardery 1997: 343). While few modern critics enjoy a comparison between African artists and criminals or the mentally ill, they nevertheless suggest each group may demonstrate a convincing antipathy toward commercial art markets in particular, and (Western) society, in general (Rawlings 2001: 45). When German psychiatrist Hans Prinzhorn published *Bildnerei der Geisteskranken* (Artistry of the mentally ill) in 1922, he argued: "We are touched by a breath of that simplicity which stills us whenever we meet it, whether in the eyes of an animal, a child, or in the works of primitives and earlier cultures" (Bowler 1997: 17). Free of the "inauthentic" values of bourgeois society, asylum artists "seek neither profit nor prestige" (Bowler 1997: 29).

34. On "labor of love," see Freidson 1990; on "calling," see Kris and Kurz 1987; on inner drive, see Jeffri and Throsby 1994; on psychic income and artistic labor markets and prestige more generally, see Menger 1999.

35. Bourdieu 1996: 167.

36. Peterson 2005: 1086.

37. Jones and Featherly 2002: 33.

38. Peterson 1997: 211.

39. Fine 2004: 56.

40. Ardery 1997: 340

41. Lachmann 1988: 242. However, others might argue that peer-to-peer training at the writers' benches spread throughout the parks and subway systems provided a substitute. According

to one study of galleries and museums in New York, "exhibitions of named African art have shown a *de facto* preference for the untrained individual still living in Africa" and not those artists who receive an education or exhibition tour off the continent (Rawlings 2001: 46). In evaluating two exhibitions by self-taught artists, estimable critic Arthur Danto argued that both "are what I have in mind by deeply outside artists, in that the art world does not enter into any explanation of their work. Or: Each was an art world unto himself" (Danto 2001: 64).

42. Kosut 2014: 147.

43. Lopes 2002: 66.

44. Baumann 2007b: 66.

45. Kosut 2014: 1045.

46. Hedegard 2013. For example, it is often assumed that to play bluegrass a musician must be working-class, white, and hail from the Appalachian Mountains, while salsa musicians must be Latin American (on bluegrass, see Rosenberg 1985; on salsa, see Urquìa 2004; on punk, see Laing 1985). Well-meaning fans of the blues arrive in Chicago clubs expecting to find the music played by "uneducated American black men afflicted with blindness or some other disability, playing in ramshackle joints that are simply lit, unbearably smoky, and smelling as funky as their music sounds" (Grazian 2003: 13).

47. Lopes 2002: 190. Similarly, tourists seeking to hear "authentic" New Orleans jazz in places like the famed Preservation Hall expect "to hear jazz played by musicians with a particular racial composition; nobody would expect to find old white men playing at Preservation Hall" (Buerkle and Barker 1973: 121).

48. Hill 2014: 3.

49. Hill 2014: 252. The recent elevation of African American Misty Copeland to principal dancer at the American Ballet Theatre has revived disputes about whether black bodies are beautiful ballet bodies. As the *New York Times* reported, "Balletomanes, choreographers and directors generally concurred that black bodies were unsuited to the lines of classical technique" (Woodard 2015).

50. This definition is adapted from Grazian 2003.

51. Lena 2012: 12; Oberlin and Gieryn 2015; Cheyne and Binder 2010.

52. Battani 1999: 606–7.

53. Schwartz 1986: 168; Marien 2006: 186.

54. Quoted in Newhall 1964: 105–6.

55. Andrews 2010: 6.

56. Twomey 1956: 241.

57. Homer 1983: 43. The exhibition catalog for the Philadelphia show stated: "The possibilities of photography as a method of artistic expression are now generally admitted. . . . The purpose of the Salon is to show only such pictures produced by photography as may give distinct evidence of individual artistic feeling and execution" (Quoted in Doty 1960: 21). By the following year, only photographers judged the submissions; no painters were needed "to certify their work as art" (Doty 1960: 21).

58. Within five years of its founding, the United Hot Clubs boasted approximately 120 registered venues. The United Hot Clubs helped distinguish types of venues, but also provided a (weak) signal of quality to the consumer. This list served as a way for fans to index their tastes against a measure of legitimacy.

59. Hegert 2013: 3. Both the UGA and the Nation of Graffiti Artists (NOGA) attempted to "win their members recognition as serious artists by encouraging writers to produce graffiti-style works on canvas and various other media with a view toward their sale to art collectors" (Lachmann 1988: 246; see also Castleman 1982: 117).

60. Hegert 2013: 3.

61. Sanders and Vail 2008: 157.

62. Lopes 2002: 91.

63. Lopes 2002: 69–70. Bandleader and pianist Vincent Lopez was playing special jazz concerts at the Metropolitan Opera House and Carnegie Hall as early as 1924. In February 1929, jazz bandleader Paul Whiteman played a "Concert of Modern Music" (jazz) in Aeolian Hall in New York City (Lopes 2002: 69–70). Both are considered to be important benchmarks in the introduction of jazz to fine arts organizations.

64. Kosut 2014: 143.

65. Just in New York alone, a four-year period included the following shows: *Pierced Hearts and True Love* at the Drawing Center (1995), *Body Art: Marks of Identity* at the American Museum of Natural History (1999), and *The Art of Gus Wagner* at the South Street Seaport Museum (1999). Kosut 2014: 143.

66. Kosut 2014: 143. The legitimacy of graffiti art was also given a boost by an influential New York show: the "Times Square Show" at the Sidney Janis Gallery in 1983 "was one of the most talked-and-written-about group exhibitions of graffiti art, as it signaled the total shift in the placement of graffiti art from the gritty Lower East Side galleries to the realm of 'high art'" (Hegert 2013: 4). Even comics have been displayed in galleries and art museums, although it is relatively rare. There have been shows at the Smithsonian Cooper-Hewitt Design Museum (2000), the Whitney Museum of American Art (2002), and the Museum of Contemporary Art in Chicago (2006). Lopes 2009: 163.

67. Doty 1960.

68. Doty 1960: 34.

69. Lopes 2006: 408.

70. Hill 2014: 201; Balliett 1962. By the 1990s, tap dance advocates began to stage annual festivals in Atlanta, Austin, Boston, Chicago, Minneapolis, Seattle, St. Louis, and elsewhere. These festivals established "venues for masters to teach the language of tap and develop dancers in the ranks" (Hill 2014: 298).

71. Ardery 1997: 333, 341.

72. Ardery 1997: 343.

73. Baumann 2001: 409.

74. Baumann 2007b: 89. See also Gomery 1992.

75. Baumann 2007b: 90.

76. Baumann 2007b: 90.

77. Bourdieu 1993b.

78. DiMaggio 1991: 44.

79. DiMaggio 1991: 45.

80. Baumann 2001b: 410.

81. Baumann 2007b: 68.

82. Lopes 2002: 174.

83. Lopes 2002: 266.

84. Earlier efforts, including intellectuals and artists participating in the Harlem Renaissance, had promulgated the argument that "black Americans unlike any other group, had been almost completely stripped of their ancestral cultural identity, and precisely because of this had developed the most authentically *American* folk culture" (Hutchinson 1996: 76; emphasis in the original). And some amount of support for the artistic legitimation of African American poetry was generated as early as the 1950s, by which time Langston Hughes (to name one example) was a notable public figure. The slower progression of the legitimacy of the *novel* in America, certainly combined with racist effort toward exclusion, contributed to the slower progression of the African American novel toward legitimacy.

85. Corse and Griffin 1997: 194.

86. At Temple University, the library provided access to Charles Blockson's book collection, and by 1997, readers could find *The Norton Anthology of African American Literature*, all the titles in Oxford University Press's thirty-volume series of Nineteenth-Century Black Women Writers, and Christian's *Black Women Novelists*, among other resources (Corse and Griffin 1997: 195).

87. Griffin 2004: 166. Baker, a prolific writer and critic, would also become the first African American president of the Modern Language Association, in 1992. For many years, black professors of literature were largely limited to positions in historically black colleges and universities, and many belonged to an all-black professional organization: the College Language Association (Griffin 2004: 167). A decade later, in the 1970s, courses on black writers and women writers were "important in establishing that, indeed, such writers existed, were interesting to students, and were valuable to study" (Lauter 1991: 98).

88. Lopes 2006: 389.

89. Lopes 2009: 163.

90. Arslanian 1997: 210.

91. Arslanian 1997: 237.

92. Arslanian 1997: 199. In a study of tap-dance education from 1920 to 1950, researchers found that "when tap is offered, it is often taught by graduate teaching assistants or, occasionally, by adjunct faculty. For the most part, tap dance, when offered, is among the general university elective offerings and, as such, does not fulfill dance major requirements" (Arslanian 1997: 193).

93. For example, film scholars "are able to act as reputational entrepreneurs by choosing to study some directors and their films and ignore other directors and their films" (Allen and Lincoln 2004: 889–90). Alfred Hitchcock, Steven Spielberg, Woody Allen, and Elia Kazan are among those directors who benefited from promotional scholarship. In contrast, highly celebrated directors like William Wyler and Fred Zinneman have received very little attention in scholarly tomes, and as a result are not as well known by the public. In African American studies, early scholars in the field contributed to selecting a canon of core authors including Zora Neale Hurston (*Their Eyes Were Watching God*), Alice Walker (*The Color Purple*), Toni Morrison (*The Bluest Eye*), and Maya Angelou (*I Know Why The Caged Bird Sings*).

94. Nyberg 1994: 9.

95. Nyberg 1994 15.

96. See, for example, Williams 2014 on Savannah and Kino 2015 on Black Mountain College.

97. Lang and Lang 1988: 360.

98. On dance, see DiMaggio 1992; Sussman 1997; on jazz, see Peterson 1972 and Lopes 2002; on popular music, see Lena 2012; on film, see Baumann 2001.

99. van Rees 1983: 400.

100. LaGamma 2014: 13.

101. N.A. 1955. "Museum of Indigenous Art Acquisition Policy."

102. Baumann 2001.

103. Corse and Griffin 1997: 181.

104. Corse and Griffin 1997: 181.

105. DiMaggio 1991: 44. The Brahmins and other founders of the arts in America did not invent these norms. A similar "legitimating ideology" was employed by aristocrats as early as late eighteenth-century Vienna as they sought to categorize "serious" music using aesthetic criteria, resulting in the widespread legitimacy of particular composers as "masters" and works as "masterpieces" of classical music (DeNora 1997).

106. Regev 2013: 61.

107. Baumann 2001: 414.

108. Baumann 2001: 415.

109. Regev 2013: 68. The sonic characteristics of electronic instruments, complexity and sophistication of the production work, techniques of vocal delivery, rhythmic drive, and lyrical content also mattered to the early core of influential rock critics. "Not all of them are used in every pop-rock song, but any combination of them that does exist in a given performance forms the basis for judgment and evaluation" (Regev 2013: 68).

110. Kosut 2014: 153.

111. Fenske 2007: 57.

112. The emergence of a comparative framework is not particular to the legitimization process: "Discussion of high art very often places a given work in the context of other works so that the work can be evaluated in a more sophisticated and informed manner" (Baumann 2001: 415).

113. Lopes 2002: 56–57.

114. Christopherson 1974: 145.

115. Powers 1996: 139.

116. Lopes 2009: 113; Eisner 1990.

117. Phillips 1982: 39.

118. Sanders and Vail 2008: 150.

119. Greenfield et al. 1987.

120. Becker 1982: 164.

121. Lindberg et al. 2005: 189.

122. Powell 1985; Crane 1992: 62.

123. Bourdieu 1985: 14; see also Corse and Griffin 1997: 175.

124. Emmison 2003; Fisher and Preece 2003; Johnston and Baumann 2007; Lamont 1992.

125. Lopes 2002: 262, 263.

126. Sanders and Vail 2008: 165.

127. It published critical essays and was described by art historian Aaron Scharf as "undoubtedly one of the most influential journals ever published to be concerned equally with art and photography" (Wells 2015: 257). See also Scharf 1983 [1974]: 240. Before *Camera Work*, readers interested in artistic photography looked to the work of early professional photo critics, including Charles H. Caffin, Sadakichi Hartmann, and Roland Rood, in the pages of general interest magazines, like the New York *Evening Post* or *Sun, Cosmopolitan,* and *Harper's Weekly* (Davis 1999: 41).

128. Snyder 2006: 94.

129. Course and Griffin 1997: 194; Washington 1990:3 9. Washington also highlights *All the Women are White, All the Blacks Are Men, But Some Of Us are Brave*, edited by Gloria L. Hull, Patricia Bell Scott, and Barbara Smith; Marilyn Richardson's bibliography, *Black Women and Religion*; Ora Williams's bibliography, *American Black Women; The Black Woman*, edited by Toni Cade Bambara; Pat Crutchfield Exum's *Keeping the Faith*; and *Sturdy Black Bridges; Visions of Black Women in Literature*, edited by Beverly Guy-Sheftall, Roseann P. Bell and Bettye J. Parker.

130. As the first book-length treatment of the field, it fell to them to define the category, and they did so by reference to existing art worlds: "If there is any one characteristic that marks folk artists it is that for them the restraints of academic theory are unimportant, and if encountered at all, meaningless. . . . There exists only the desire to create, not to compete, not necessarily to find fame" (quoted in Ardery 1997: 339–40). The irony here is that by rejecting "academic theory" in a work designed for that purpose, the Weissmans assert that artists in this field will reject their works' artistic character.

131. Lopes 2002: 166.

132. Bourdieu 1996: 101.

133. Becker 1982.

134. Becker 1982.

135. In the 1940s, comics authors worked in a variety of thematic areas including adventure, action, mystery, teen, romance, and, of course, "superheroes" (Lopes 2009: 399). After the end of the Second World War, there was a "boom with the diversification of genres such as romance, crime, horror, and science fiction" resulting from "catering to more adult readers" (Lopes 2009: 400). In the late 1960s, "an underground comic book market appeared that centered on the counterculture movement" (Lopes 2009: 401; Nyberg 1994: 137). By the 1970s, "the superhero had fallen from favor" and artists experimented with new styles including sword-and-sorcery titles such as Conan the Barbarian, science fiction, and horror comics," each designed to "lure new readers" into the shrinking field.

136. Personal correspondence with Joe Gross, June 3, 2017.

137. Published essentially "as books," these graphic novels "caught the fancy of the mainstream press, and journalists . . . heralded this as "a new and historically unique trend" (Nyberg 1994: 162).

138. Lopes 2009:161.

139. Kosut 2014: 152. These stylistic innovations used a broader color palette and subject matter and required preparatory sketches, client consultation, broad stylistic proficiency (Kosut 2014: 153). Thus, artists in the field come to be defined by the similarity of their practice to that of legitimate, visual artists; their educational training; and the aesthetic location of their work within these "art styles." One subgenre style, later dubbed "the French School," is attributed to work done in the 1990s by European artists Tin Tin and Stephanie Chaudesaigues. Other styles of that decade include Dark Art, New Skool, and Neo-Japanese (Sanders and Vail 2008: 166).

140. Sanders and Vail 2008: 203.

141. Sanders and Vail 2008: 161.

142. Hegert 2013: 2. The distinction between the first wave of creators and those moving the field toward commercial sale is captured in the difference between "graffiti writers, namely those individuals who predominantly express themselves through signature-based works, and graffiti artists, those who in addition create more aesthetically complicated murals and (master) pieces" (Merrill 2015: 371).

143. Hegert 2013: 3.

144. Hegert 2013: 3.

145. Merrill 2015: 373. These "post-graffiti" artists reject generic lettering styles (found in "tags"), and even marker pens and spray cans, in favor of new graphic forms like logos, paint, and canvas (Merrill 2015: 373).

146. Riesman 1950: 359.

Chapter 6. Cultural Appropriation

1. This definition binds together two conceptions of cosmopolitanism: one, drawn from Kant, stipulates that cosmopolitans hold a philosophical orientation toward world citizenship as a political act. The alternative draws from social science to argue that cosmopolitanism is an aesthetic or intellectual orientation dedicated to openness toward diverse cultural experiences. This distinction is made in Bookman (2013: 57).

2. Johnston and Baumann 2007: 169. The ideology of omnivores is "organized around normative liberal principles of human equality and meritocracy" that have a long history but that "have been reinvigorated with the increasing prominence of a globalization discourse supporting a normative belief in the equality of all people regardless of race, ethnicity, and nationality" (Johnston and Baumann 2007: 172).

3. Johnston and Baumann 2007: 173.

4. Quoted in Johnston and Baumann 2007: 173.

5. Molz 2011: 44.

6. As a coffee house patron told Bookman (2013: 62): "It sort of feels like I don't need to go to Ethiopia, I can go to Starbucks."

7. As one author put it, "being worldly . . . requires confidence, skill and money" (Binnie, Holloway, Millington, and Young 2006: 8).

8. We should not assume, however, that these performers are trying to assimilate into Western modes of signification or acting in "whiteface." Instead, in a slightly different context—although still with African producers and consumers in focus—at least one author concludes that "by adopting European dress and manners . . . African consumers were not imitating their white colonizers or appropriating these goods into indigenous meaning structures. Instead, they were asserting their 'political and social rights to full membership in a wider society'" (Molz 2011: 41).

9. Lu and Fine 1995; Tomlinson 1986.

10. Molz 2011: 38.

11. Molz 2011: 39.

12. Johnston and Baumann 2007: 168.

13. Molz 2011: 42.

14. Halle 1993.

15. Fine 2004: 175.

16. Debate around appropriation regularly erupts, leading one journalist to refer to Halloween as "Blackface Advent" (*Slate*'s Jamelle Bouie quoted in Friedersdorf 2017).

17. On "the heterosocialization of public leisure," see Orsi 1992; and Barrett and Roediger 1997. On the remainder, see Heap 2009: 18.

18. N.A. 1896b. "Brodie is in High Glee. "

19. N.A. 1896a. "Arrest of Booth-Tucker."

20. N.A. 1896b. "Brodie is in High Glee."

21. N.A. 1896b. "Brodie is in High Glee."

22. Heap 2009: 23–24.

23. Heap 2009: 146.

24. Dowling 2007: 9.

25. Bonner 1967: 32.

26. Heap 2009: 53.

27. Heap 2009: 21.

28. Dowling 2008. "'Under the Bridge and Beyond': Helen Campbell on the East Side Waterfront." The importance of slumming by scholars, artists and politicians cannot be overstated. To wit, consider this short list from Dowling (2007: 9): "It was a law enforcement officer . . . who entertained both the popular novelist John Vose and (according to Vose) Charles Dickens by leading them through the rat pits and gambling dens of lower Manhattan in the 1840s and 50s; urban activist Helen Campbell, a prep school graduate and home economics maven, lectured widely to students and philanthropists on the subject of waterfront prostitution; Stephen Crane, the son of two leading middle-class evangelists from New Jersey, acted as a Bowery guide for visiting acquaintances in the 1890s; Hapgood, a Harvard graduate from Puritan New England stock, wrote the first book-length study of the Jewish Lower East Side based on several years of reporting from that district; and Carl Van Vechten, a gay white man from Cedar Rapids, Iowa, was a kind of freelance cabaret promoter to the white elite during the Harlem Renaissance of the 1920s."

29. Ward 1989: 43.

30. Ward 1989: 188.

31. It is the prerogative to consume lower-class culture without fearing one's own status will suffer that characterizes this relation of distance. These elites have "no rules by choice," and thus

free themselves from the confines of old-fashioned discriminating tastes for only consecrated culture. While their catholic consumption across the cultural status spectrum may be "celebrated by some as a significant movement towards the break-up of old hierarchies of fashion, style and taste in favour of an egalitarian and tolerant acceptance of differences and the acknowledgement of the right of individuals to enjoy whatever popular pleasures they desire without encountering prudery or moral censure," in point of fact, this consumption signifies not "the implosion of the social space" but, instead, "merely a new move within it" (Featherstone 2000: 93).

32. Featherstone 2000: 93.

33. Rice 2009.

34. Fiedler 1963.

35. Tate 2003.

36. Sauers 2012 "Navajo Nation." It wasn't the first time the company was forced to apologize for racial insensitivity. Earlier in 2012, it pulled an entire "Go East" lingerie collection from stores after Jeff Yang, a reporter for the *Wall Street Journal*, complained about the line, which included a "Sexy Little Geisha" teddy. The teddy boasted an obi-style belt and was accessorized with a fan and chopsticks for holding up one's hair.

37. Dowd 2000.

38. Dowd 2000.

39. Donnally 1993: B3.

40. Givhan 1996 quoted in Halnon 2002: 505.

41. The celebrations also included the exhibitions "Hokusai" and "In the Water," and the re-opening of their Tenshin-Em Garden.

42. Valk 2015: 380.

43. Hammond 2014.

44. Buell 2016.

45. Valk 2015.

46. Stuttaford 2015.

47. Stuttaford 2015.

48. In this, the show bears a strong resemblance to "Primtivism in the 20th Century," the controversial show at MoMA in the 1980s, in that nineteenth-century European works were displayed alongside the Japanese art said to have inspired them. For example, a Palteelfabriek Rozenburg plate with an image of two birds was presented next to a similar print of cranes and a plum branch, attributed to Katsukawa Shunsho. A Frederic Boucheron 1876 ink stand in silver and cloisonné enamels incorporated details from a print in Katsushika Hokusai's series "Thirty-six Views of Mount Fuji," shown nearby (Hammond 2014).

49. Gedo 2010: 172.

50. Valk 2015: 384.

51. Valk 2015: 385.

52. Dalby 2001: 3.

53. Hammond 2014.

54. McFeeters 2015.

55. O'Dwyer 2015.

56. Gay 2016.

57. Hammond 2014.

58. For example, so-called "Zuni war god figures" were removed from the 1984 MoMA exhibition of primitive art because "knowledgeable authorities" informed the museum's directors that "Zuni people consider any public exhibition of their war gods to be sacrilegious" (quoted in Myers 2006: 278). Anthropological collection projects conducted by scholars and government employees (including the WPA staff) generated recordings of sacred works. These were, in some

cases, preserved for posterity and even saved from extinction by these collection projects. They served the needs and careers of scholars building theories of cultural expression and diversity. And they "entertained the curiosity of bourgeois audiences of the metropolis"—that is, they satisfied the omnivorous, cosmopolitan bourgeoisie (Hilder 2012: 164). For example, between the 1930s and 1960s, anthropologist Laura Boulton made field recordings of fifty-four songs from Hopi Indian men, women, and children and then recorded an additional sixty-six songs while working with the Bureau of Indian Affairs. She released those recordings commercially, on the Folkways Records label, as *Indian Music of the Southwest*. The collection of recordings eventually moved into the possession of my employer, Columbia University, who held them as the Boulton Collection. The Center for Ethnomusicology is now involved in a repatriation effort, since the recordings are not held with the permission of the tribe (in fact, the Hopi Tribe Preservation Office did not know of their existence), nor were the original performers or their descendants given fair compensation or royalties (Reed 2009). According to one count, twenty-eight of the thirty-four ethnomusicological archives holding non-commercial field recordings are participating in some form of repatriation (Lansfield 1993). For its part, Folkways Records, now owned by the Smithsonian Institution, requires signed consent from artists and has developed culturally sensitive forms of remuneration for the use of that cultural property. They have also spent significant resources determining the composers and performers on existing recordings, and sending unpaid royalties to as many of them as possible.

59. These are exactly the examples that John Levi Martin suggested I use to make this point.

60. NA. October 7, 2013. "Killer Plaid."

61. StreetPeeper. N.D.

62. The prints presented in the two Fall 2013 shows were very similar to those Marc Jacobs presented in the Louis Vuitton Spring 2007 ready-to-wear collection. The earlier show included $1,900 tote bags of a similar design, called "Street GM."

63. Hunt 2007.

64. While anecdotal, it seems that many mentions of these nicknames for the bag online trace back to the amateur researcher Koranteng, and his blog Korangteng Toli (accessible here: http://koranteng.blogspot.com/2007/06/plagiarism-in-plaid.html).

65. Hunt 2007.

66. It appears that plaid patterns in a generic sense were thought to be first produced in the Taklamakan area in Xinjiang Uyghur, China between 100 and 700 BCE. Plaids are more commonly associated with Scotland, where the Falkirk tartan is among the earliest known forms, documented since 1707.

67. Morrell 2005.

68. Pham 2014.

69. Gillman 2010; 49.

70. Kymlicka 2001: 203–5.

71. Gillman 2010: 50.

72. Gillman 2010: 52.

73. Hannerz 1990: 239 for the first quote, and Molz 2011: 35 for the second.

74. Urry 1995: 167.

75. Samuels: 1955.

76. Lu and Fine 1995: 539.

77. Johnston and Baumann 2007: 180–86.

78. Remember primitive Yoruba art collector Phillip Allison making a defense of the removal of these objects from Africa: "It was better that these important pieces should be preserved in the national collection than that they should fall into the hands of private dealers and collectors, or be left to rot on neglected shrines. Even works in less perishable materials than

wood were not safe. In Igalla, I found antique brass balls being broken up to mend iron cooking pots'" (Price 2001: 76).

Chapter 7. Conclusion

1. Peterson and Simkus 1992. The musical preference questions on the Survey of Public Participation in the Arts (SPPA), on which the study was based, asked respondents to tick off all the styles (e.g., classical, rock) they enjoy from a list provided to them. The authors of the study argued that college-educated Americans ("elites") are increasingly omnivorous because on average younger respondents in recent surveys indicated a greater number of styles among their preferences than elites who completed earlier waves of the survey, or who were older.

2. Peterson and Kern 1996: 904.

3. Peterson and Kern 1996: 904.

4. See Peterson 2005 for a review.

5. Lizardo and Skiles 2009; García-Álvarez, Katz-Gerro, and López-Sintas 2007, López-Sintas and Katz-Gerro 2005; DiMaggio and Mukhtar 2004; van Rees et al 1999; López-Sintas and Garcia-Alvarez 2002.

6. For example, one operationalization of omnivorousness counted the number of genre preferences for each respondent and labeled them omnivores if they fell above some (arbitrary) count threshold, while another specification treated omnivorousness as a continuous variable in regression analyses (Rossman and Peterson 2015; for a review, see Peterson 2005). Still others subjected reports of attendance at cultural events to Multiple Correspondence Analysis, producing continuous dimensions that allow researchers to identify the most central and distal tastes, the latter of which are defined as "highbrow" activities (Lopes-Sintas and Katz-Gerro 2005). Later works also distinguished omnivorousness, or breadth of taste, from frequency of engagement, or "voraciousness" (Sullivan and Katz-Gerro 2006).

7. Robinson et al. 1985; quoted in DiMaggio 2000: 49–50.

8. Halle 1993: 132–33. I hasten to note, following Emmison (2003), that tastes and knowledge are distinct and blurred in most studies of omnivorousness. Due to the habits of elite socializing institutions, they will reliably have knowledge of legitimate culture, which we would not in most cases want to confuse with their cultural preferences or tastes. A second empirical distinction that gets elided in many studies of taste is that between what is consumed and how it is consumed—that is, between the person who selects music because it is status giving or elite associated, from the person who selects music to conjure memories, or to set the scene for romance, or exercise (see DeNora (1991) in particular for a discussion of music as a framing device for identity and action). While virtually every social scientist agrees this empirical distinction exists, and is important to status and identity questions, almost no survey instruments have been developed to query it successfully. (See Bennett et al. 2005 for a discussion on this point.)

9. Rivera 2010, 2012; Kalmijn 1994.

10. Halle 1993: 133; Accometii, Khan, and Storer 2018.

11. Featherstone 1991; Lash 1994.

12. Johnston and Baumann. 2007: 169.

13. van Eijck 2000: 221.

14. Wynne and O'Connor 1998: 859.

15. Farrell and Medvedeva. 2010.

16. Schonfeld and Westermann, 2015.

17. DeVos Institute of Arts Management. 2015: 15.

18. DeVos Institute of Arts Management. 2015: 21.

19. Johnston and Baumann 2007: 172.

20. Coulangeon and Lemel 2007: 98.

21. Lee, Choi, and Lee 2015: 121.

22. Aminzade 1992: 459.

23. I thank Andrew Goldstone for this example and for inspiring these hypotheses.

24. I thank Jonathan Neufeld for this example.

25. The fields in question vary with respect to how broadly they are viewed as legitimate. I propose that they lie on a spectrum, where more established fields like ballet and symphony music have achieved the broadest consensus, and newer ones like graffiti and rock have the least. That is, it is much easier to find someone who refuses to describe graffiti as art than it is someone who will make the same claim about ballet. In the middle of that spectrum we find a group of fields that includes those with strong support within the art world but weak legitimacy among the public (e.g., photography, tap dance), and those that are no longer seen as coherent fields (e.g., primitive art).

26. As diverse as the fields I've examined are, there are many other candidates, including styles of visual art (conceptualism, abstraction, digital), performing art (blues, "world music," tango, experimental theater), and literature (prose poetry, New Formalism, magical realism) that could be explored.

27. Lauter 1991: 32.

28. Corse and Griffin 1997: 176.

29. Varjacques, 2018.

30. Greengard 1986: 49.

31. Handy 1985: 18–20.

32. Regev 2013: 98.

33. McDonald 1969: 343–44.

34. Appiah 1991: 337.

35. Rawlings 2001: 40.

36. Umbach and Hüppauf 2005: 39.

37. Umbach and Hüppauf 2005: 32.

38. Umbach and Hüppauf 2005: 25

39. Steichen 2015: 85.

40. Steichen 2015:71.

41. Turner 2002: 74.

42. Turner 2002: 74.

43. Turner 2002: 81.

44. Umbach and Hüppauf 2005: 29.

45. Umbach and Hüppauf 2005: 38.

46. See Baumann 2001, 2007a, b on film, Ferguson 1998, 2004 on gastronomy, and Lena 2012 on music.

47. Ferguson 1998: 628.

48. Roberts 1999: 47.

49. Phillips 1982: 30.

50. Hill 2014: 205.

51. Powers 1996: 139.

52. This show at the Armory "has been credited as the most important art exhibition in US history, the watershed moment that ultimately resulted in the US becoming a leader in the avant-garde art world" (Braden 2009: 442).

53. Braden 2009: 442.

54. Garafola 2005: 30.

55. Votolato 1998: 33.

56. Bourdieu 1977. To illustrate the point, Wacquant explains: "Cumulative exposure to certain social conditions instills in individuals an ensemble of durable and transposable dispositions that internalized the necessities of the extant social environment, inscribing inside the organism the patterned inertia and constraints of external reality" (Bourdieu and Wacquant 1992: 13). Positions and dispositions thus describe individuals and groups in relation to one another and their embodied existence in that relational social space. Bourdieu (2002 [1991]: 271) sums up the relationship as follows: "To each class of positions there corresponds a class of habitus (or *tastes*) produced by the social conditioning associated with the corresponding condition and, through the mediation of the habitus and its generative capability, a systematic set of goods and properties, which are united by an affinity of style."

57. Cobb 2005.

58. Kulka 1996: 12.

59. Christensen 2010.

60. Kulka 1996.

61. Kulka 1996: 29.

62. Kundera 1984: 251.

63. Sahlins 1985: 147.

64. Quoted in della Cava 2002. Susan Orlean (2001) also captures the dominant bourgeois/left/intellectual response to Thomas Kinkade's work.

65. Della Cava 2002.

66. Orlean 2001.

67. Orlean 2001.

68. Dodero 2011. I am indebted to Vero Chai for introducing me to the designer toys movement.

69. Garfield 2015.

70. Dodero 2011.

71. Schmidt 2017.

72. Heller 2007.

73. Scott 2010: 70.

74. Heller and Talarico 2016.

75. Designer Toy Awards, "History." 2017b.

76. Scott 2010: 68.

77. Skillshare 2014.

78. Terronez 2015.

79. Schmidt 2017.

80. Budnitz 2006: 9.

81. Terronez 2015.

82. Alexander and Rueschemeyer 2005.

83. Alexander 2008.

84. Alexander and Rueschemeyer 2005.

WORKS CITED

AP. 2016. "2 Counts Dismissed in Navajo Case against Urban Outfitters." *Washington Times*, May 16. http://www.washingtontimes.com/news/2016/may/16/2-counts-dismissed-in-navajo-case-against-urban-ou/. Accessed June 20, 2016.

Abbott, Andrew. 2016. "The Historicality of Individuals." In *Processual Sociology*, 3–15. Chicago: University of Chicago Press.

Abercrombie, Nicholas. 1996. *Television and Society*. Cambridge: Polity.

Abitabile, Kathleen, and Jeanette Picerno. 2004. "Dance and the Choreographer's Dilemma: A Legal and Cultural Perspective on Copyright Protection for Choreographic Works." *Campbell Law Review* 27 (1): 39–62.

Accominotti, Fabien, Adam Storer, and Shamus Khan. 2018. "How Cultural Capital Emerged in Guilded Age America: Musical Purification and Cross-Class Inclusion at the New York Philharmonic." *American Journal of Sociology* 123 (6): 1743–83.

Acocella, Joan Ross. 1984. "The Reception of Diaghilev's Ballets Russes by Artists and Intellectuals in Paris and London, 1909–1913." PhD diss., Rutgers University.

Ahearne, Jeremy. 2014. "*Laïcité*: A Parallel French Cultural Policy (2002–2007)." *French Cultural Studies* 25 (3–4): 320–29.

Ake, David, Charles Hiroshi Garrett, and Daniel Goldmark. 2012. *Jazz/Not Jazz: The Music and Its Boundaries*. Berkeley: University of California Press.

Alberoni, Francesco. 1984. *Movement and Institution*. New York: Columbia University Press.

Alexander, Victoria D. 1996. "From Philanthropy to Funding: The Effects of Corporate and Public Support on American Art Museums." *Poetics* 24 (2–4): 87–129.

Alexander, Victoria D. 1996. "Pictures at an Exhibition: Conflicting Pressures in Museums and the Display of Art." *American Journal of Sociology* 101 (4): 797–839.

Alexander, Victoria D. 2003. *Sociology of the Arts*. Malden, MA: Blackwell.

Alexander, Victoria D. 2008. "Cultural Organizations and the State: Art and State Support in Contemporary Britain." *Sociology Compass* 2 (5): 1416–30.

Alexander, Victoria D., and Marilyn Rueschemeyer. 2005. *Art and the State: The Visual Arts in Comparative Perspective*. London: Palgrave Macmillan.

Allard, Lucille Edna. 1939. *A Study of the Leisure Activities of Certain Elementary School Teachers of Long Island*. New York: Bureau of Publications, Teachers College, Columbia University.

Allen, Emma. 2013. "One World Dept.: Magic Lantern." *New Yorker*, May 6, 27.

Allen, Michael Patrick, and Anne E. Lincoln. 2004. "Critical Discourse and the Cultural Consecration of American Films." *Social Forces* 82 (3): 871–93.

Allen, Robert Clyde, and Douglas Gomery. 1985. *Film History: Theory and Practice*. New York: Alfred A. Knopf.

Almendral, Aurora. 2017. "At 100 or So, She Keeps a Philippine Tattoo Tradition Alive." *New York Times*, May 15.

Alter, Charlotte. 2014. "Will and Kate Just Met Beyoncé and Jay-Z." *Time*, December 8.

American Association of Museums. 1910. *Proceedings*. Vol. 4: 64.

Americans for the Arts. 2013. "Research Report: Local Arts Agency Salaries 2013: A Detailed Statistical Report about the Salaries and Demographics of the Nation's Local Art Agency Employees." Washington, DC: Americans for the Arts. http://www.americansforthearts.org/sites/default/files/pdf/networks/laa/FullReportWithSalaryTables.pdf. Accessed June 2, 2017.

Aminzade, Ronald. 1992. "Historical Sociology and Time." *Sociological Methods & Research* 20 (4): 456–80.

Anderson, Bruce W., and Peter Hesbacher. 1974. "Popular American Music: Changes in the Consumption of Sound Recordings: 1940–1955." Unpublished manuscript. Philadelphia: University of Pennsylvania Press.

Anderson, Kyle, et al. 2004. "Bring the Noise." *Entertainment Weekly*, November 19, 41–56.

Andrews, David. 2010. "Art Cinema as Institution, Redux: Art Houses, Film Festivals, and Film Studies." *Scope: An Online Journal of Film and Television Studies* 18: 1–21.

Ang, Ien. 1985. *Watching Dallas: Soap Opera and the Melodramatic Imagination*. London: Routledge.

Anthony, Amanda Koontz, and Schrock, Douglas. 2014. "Maintaining Art-World Membership: Self-Taught Identity Work of the Florida Highwaymen." *Social Currents* 1 (1): 7490.

Appadurai, Arjun. 1988. *The Social Life of Things: Commodities in Cultural Perspective*. New York: Cambridge University Press.

Appiah, Kwame Anthony. 1991. "Is the Post- in Postmodernism the Post- in Postcolonial?" *Critical Inquiry* 17: 336–57.

Appiah, Kwame Anthony. 2008. "Education for Global Citizenship." *Yearbook of the National Society for the Study of Education* 107 (1): 83–99.

Ardery, Julia S. 1997. " 'Loser Wins': Outsider Art and the Salvaging of Disinterestedness." *Poetics* 24 (5): 329–46.

Arditi, Jorge. 1999. "Etiquette Books, Discourse, and the Deployment of an Order of Things." *Theory, Culture & Society* 16 (4): 25–48.

Argo, Jennifer J., Darren W. Dahl, and Andrea Morales. 2008. "Positive Consumer Contagion: Responses to Attractive Others in a Retail Context." *Journal of Marketing Research* 45 (6): 690–701.

Arian, Edward. 1971. *Bach, Beethoven, and Bureaucracy: The Case of the Philadelphia Orchestra*. Tuscaloosa: University of Alabama Press.

Arslanian, Sharon P. 1997. "The History of Tap Dance in Education: 1920–1950." PhD diss., Temple University.

Art Institute of Chicago. 1954. *Quarterly* 64.

Ashaffenburg, Karen and Ineke Maas. 1997. "Cultural and Educational Careers: The Dynamics of Social Reproduction." *American Sociological Review* 62 (4): 573–87.

Atwood, Tyler. 2015. "Every Met Gala Theme Ever, Ranked from Fabulous to Just Bizarre." BUSTLE, April 11. https://www.bustle.com/articles/74739-every-met-gala-theme-ever-ranked-from-fabulous-to-just-bizarre. Accessed June 27, 2017.

Bachman, Rachel. 2012. "When Top-Tier Coaches Go Slumming." *Wall Street Journal*, December 10. https://www.wsj.com/articles/SB10001424127887324478304578171313565462382. Accessed June 27, 2017.

Baker, Katie J. M. 2012. "A Much-Needed Primer on Cultural Appropriation." *Jezebel*, November 13. http://jezebel.com/5959698/a-much-needed-primer-on-cultural-appropriation. Accessed June 27, 2017.

Bakke, Marit. 2014. "American Folk Culture: An Analysis of the Folklife Center News, 1984–2011." *Journal of Arts Management, Law, and Society* 44 (1): 4–20.

Balliett, Whitney. 1962. "The Inheritors." *New Yorker*, July 21, 64–68.

Banes, Sally. 1999. "Sibling Rivalry." In *Dance for a City: Fifty Years of the New York City Ballet*, edited by Lynn Garafola with Eric Foner, 73–98. New York: Columbia University Press.

Barrett, James R., and David Roediger. 1997. "Inbetween Peoples: Race, Nationality and the 'New Immigrant' Working Class." *Journal of American Ethnic History* 16 (3): 3–44.

Bates, Mary Jane. 1958. "A Report of Papers Presented and General Activities of the Annual Meeting of the Society for American Archaeology." AR.1999.9.24, Box 4, Folder 3. Official Business–Miscellaneous Activities, Miscellaneous Public Reactions to the Museum. Robert Goldwater Library, Department of the Arts of Africa, Oceania, and the Americas. Metropolitan Museum of Art, New York.

Battani, Marshall. 1999. "Organizational Fields, Cultural Fields, and Art Worlds: The Early Effort to Make Photographs and Make Photographers in Nineteenth-Century United States of America." *Media, Culture & Society* 21: 601–26.

Baudrillard, Jean, and Charles Levin. 1981. *For a Critique of the Political Economy of the Sign*. St. Louis, MO: Telos.

Baughman, Jill. 2014. "Kate Middleton Commits Hugely Embarrassing Fashion Faux Pas." Cafemom, December 17. http://www.cafemom.com/articles/celebrities/180693/kate_middleton_same_dress_luncheon?utm_medium=sem2&utm_campaign=prisma&utm_source=taboola-s&utm_content=0&utm_site=dailymail-us&non_us=US#. Accessed April 6, 2015.

Baumann, Shyon. 2001. "Intellectualization and Art World Development: Film in the United States." *American Sociological Review* 66 (3): 404–26.

Baumann, Shyon. 2007a. "A General Theory of Artistic Legitimation: How Art Worlds Are Like Social Movements." *Poetics* 35: 47–65.

Baumann, Shyon. 2007b. *Hollywood Highbrow: From Entertainment to Art*. Princeton, NJ: Princeton University Press.

Baxandall, Michael. 1987. *Patterns of Intention: On the Historical Explanation of Pictures*. New Haven, CT: Yale University Press.

Beck, Laura. 2013. "16-Year-Old White Girl Poses in 'African Queen' Editorial." *Jezebel*, February 25. http://jezebel.com/5986608/16-year-old-white-girl-poses-in-african-queen-editorial. Accessed May 31, 2013.

Becker, Howard S. 1982. *Art Worlds*. Berkeley: University of California Press.

Beeson, Jack. 2000. "Opera at Columbia University, 1941–1958." *Current Musicology* 70: 193.

Bendix, Regina. 1997. *In Search of Authenticity: The Formation of Folklore Studies*. Madison: University of Wisconsin Press.

Bennett, Andy, and Richard A. Peterson, eds. 2004. *Music Scenes: Local, Translocal, and Virtual*. Nashville: Vanderbilt University Press.

Bennett, Andy. 2009. "'Heritage Rock': Rock Music, Representation and Heritage Discourse." *Poetics* 37 (5): 474–89.

Bennett, Tony, Mike Savage, Elizabeth Silva, Alan Warde, Modesto Gayo-Cal, and David Wright. 2005. "Cultural Capital and the Cultural Field in Contemporary Britain." Centre for Research on Socio-Cultural Change, Working Paper No. 3. Open University, Milton Keynes, UK.

Benzecry, Claudio E. 2014. "An Opera House for the 'Paris of South America': Pathways to the Institutionalization of High Culture." *Theory and Society* 43: 169–96.

Best, Harold M. 2002. "Lemonade or Merlot? Authentic Multiculturalism and High Culture." *Arts Education Policy Review* 104 (1): 3–10.

Best, Mark. 2014. "Slumming it with Henri de Toulouse-Lautrec." Sotheby's Multiplicity, April 11. http://www.sothebys.com/en/news-video/blogs/all-blogs/multiplicity/2014/04/slumming-it-with-toulouse-lautrec.html. Accessed August 20, 2014.

Beverland, Michael B. 2005. "Crafting Brand Authenticity: The Case of Luxury Wines." *Journal of Management Studies* 42: 1003–29.

Biddle, George. 1939. *An American Artist's Story*. New York: Little, Brown.

Bielby, William T., and Denise D. Bielby. 1994. "'All hits are flukes': Institutionalized Decision-Making and the Rhetoric of Network Prime-time Program Development." *American Journal of Sociology* 99 (5): 1287–313.

Binnie, Jon, J. Holloway, S. Millington, and C. Young. 2006. "Introduction: Grounding Cosmopolitan Urbanism: Approaches, Practices, and Policies." In *Cosmopolitan Urbanism*, edited by J. Binnie, J. Holloway, S. Millington, and C. Young, 1–34. New York: Routledge.

Biro, Yaëlle. 2014. "The Museum of Primitive Art in Africa at the Time of Independence." In "The Nelson A. Rockefeller Vision: The Arts of Africa, Oceania, and the Americas." *Metropolitan Museum of Art Bulletin* 72 (1): 38–48.

Bissell, Tom. 2010. "A Simple Medium." *New Yorker*, December 6, 34–41.

Blau, Judith R. 1991. "The Disjunctive History of US Museums, 1869–1980s." *Social Forces* 70 (1): 87–105.

Blunt, James. 2015. "James Blunt's Letter to Chris Bryant—In Full." *Guardian*, January 19. http://www.theguardian.com/music/2015/jan/19/james-blunts-letter-chris-bryant-in-full. Accessed January 20, 2015.

Bobo, Lawrence, and Camile Zubrinsky. 1996. "Attitudes on Residential Integration." *Social Forces* 74 (3): 883–909.

Boehm, Mike. 2014. "To Remain Relevant, Music Center Aims to Reflect All of Los Angeles." *Los Angeles Times*, November 14. http://www.latimes.com/entertainment/arts/la-et-cm-music-center-los-angeles-future-20141116-story.html#page=1. Accessed November 18, 2014.

Bold, Christine. 1999. *The WPA Guides: Mapping America*. Jackson: University Press of Mississippi.

Boman, E. 2012. "Tory Burch's Ex Factor." *Vanity Fair*, December 1. http://www.vanityfair.com/business/2012/12/tory-burch-chris-c-wonder. Accessed January 15, 2015.

Bonbright, Jane. 2000. "National Agenda for Dance Arts Education: The Evolution of Dance as an Art Form Intersects with the Evolution of Federal Interest in and Support of Arts Education." Paper presented at the Dancing in the Millennium Conference, July 19–23, 2000, Washington, DC.

Bonilla-Silva, Eduardo. 2006. *Racism Without Racists*. New York: Rowman & Littlefield.

Bonner, Arthur. 1967. *Jerry McAuley and His Mission*. Neptune, NJ: Loizeaux Brothers.

Bookman, Sonia. 2013. "Branded Cosmopolitanisms: 'Global' Coffee Brands and the Co-creation of 'Cosmopolitan Cool.'" *Cultural Sociology* 7 (1): 56–72.

Boschot, Adolphe. 1971."Le Sacre du Printempts, balle en deux actes de MM. Roerich, Stavinsky et Nijinsky." *L'Echo de Paris*, May 20, 1913, as quoted in Truman Bullard, "The First Performance of Igor Stravinsky's *Sacre du Printemps*." PhD diss., University of Rochester.

Bound, John, and Sarah Turner. 2002. "Going to War and Going to College: Did World War II and the GI Bill Increase Educational Attainment for Returning Veterans?" *Journal of Labor Economics* 20 (4): 784–815.

Bourdieu, Pierre. 1977. *Outline of a Theory of Practice*. Translated by Richard Nice. New York: Cambridge University Press.

Bourdieu, Pierre. 1984. *Distinction: A Social Critique of the Judgment of Taste*. Translated by Richard Nice. Cambridge, MA: Harvard University Press.

Bourdieu, Pierre. 1985. "The Market of Symbolic Goods." Translated by Rupert Swyer. *Poetics* 14: 13–44.

Bourdieu, Pierre. 1986. "The Forms of Capital." In *Handbook of Theory and Research for the Sociology of Education*, edited by J. Richardson, 241–58. New York: Greenwood.

Bourdieu, Pierre. 1993a. "The Historical Genesis of a Pure Aesthetic." In *The Field of Cultural Production: Essays on Art and Literature*, edited by R. Johnson, 254–66. New York: Columbia University Press.

Bourdieu, Pierre. 1993b. "The Production of Belief: Contribution to an Economy of Symbolic Goods." In *The Field of Cultural Production: Essays on Art and Literature*, edited by R. Johnson, 74–111. New York: Columbia University Press.

Bourdieu, Pierre. 1996. *The Field of Cultural Production*. New York: Columbia University Press.

Bourdieu, Pierre. 2002 [1991]. "Social Space and Symbolic Space." In *Contemporary Sociological Theory*, edited by Craig Calhoun et al., 335–44. Malden, MA: Blackwell.

Bourdieu, Pierre. 2002. "Habitus." In *Habitus: A Sense of Place*, edited by Jean Hillier and Emma Rooksby, 27–36. Burlington, VT: Ashgate.

Bourdieu, Pierre, and Alain Darbel. 1997. "Cultural Works and Cultivated Disposition." In *The Love of Art: European Art Museums and Their Public*, translated by Caroline Beattie and Nick Merriman, 37–70. Cambridge: Polity.

Bourdieu, Pierre, and Loic Wacquant. 1992. *An Invitation to Reflexive Sociology*. Chicago: University of Chicago Press.

Bowker, Geoffrey C., and Susan Leigh Star. 1999. *Sorting Things Out: Classification and its Consequences*. Cambridge, MA: MIT Press.

Bowler, Anne E. 1997. "Asylum Art: The Social Construction of an Aesthetic Category." In *Outsider Art*, edited by Vera L. Zolberg and Joni M. Cherbo, 11–36. Cambridge: Cambridge University Press.

Boyd, Todd. 2002. *The New HNIC: The Death of Civil Rights and the Reign of Hip Hop*. New York: New York University Press.

Braden, Laura. 2009. "From the Armory to Academia: Careers and Reputations of Early Modern Artists in the United States." *Poetics* 37 (5–6): 439–55.

Bradford, Gigi, Michael Gary, and Glenn Wallach, eds. 2000. *The Politics of Culture: Policy Perspectives for Individuals, Institutions, and Communities*. New York: Free Press.

Brass, Kevin. 2013. "Resort Brings New Meaning to 'Slumming It.'" *World Property Journal*. http://www.worldpropertyjournal.com/middle-east-africa-vacation-news/emoya-luxury -hotel-shanty-town-south-africa-resort-luxury-hotel-stephen-colbert-colbert-report-sandals -resort-game-reserve-7665.php. Accessed August 20, 2014.

Brook, Pete. 2013. "Prison Yard to Paris Photo LA: How an Art Market Hustle Put a $45k Price-Tag on Prison Polaroids." Prison Photography. http://prisonphotography.org/2013/05/02 /prison-yard-to-paris-photo-la-art-market-hustle-and-flow-puts-45k-price-tag-on-prison -polaroids/. Accessed May 31, 2013.

Brooks, David. 2000. *Bobos in Paradise: The New Upper Class and How They Got There*. New York: Simon & Schuster.

Brown, Sterling H. 1969 [1937]. *The Negro in American Fiction*. New York: Atheneum.

Budnitz, Paul. 2006. *I Am Plastic: The Designer Toy Explosion*. New York: Abrams.

Buell, Spencer. 2016. "Facing Pressure from Protestors, MFA Ends Kimono Selfie Exhibit." *Boston Globe*, July 7. http://www.metro.us/boston/group-protesting-mfa-s-kimono-selfie -exhibit/zsJogg---5lwdZSclGWfU/. Accessed April 14, 2016.

Buerkle, Jack, and Danny Barker. 1973. *Bourbon Street Black: The New Orleans Black Jazzman*. New York: Oxford University Press.

Buffett, Peter. 2013. "The Charitable-Industrial Complex." *New York Times*, July 26. http://www .nytimes.com/2013/07/27/opinion/the-charitable-industrial-complex.html?_r=2&&gwh= 5A814BC39EB533494651B21FE93CF584&gwt=pay&assetType=opinion. Accessed August 24, 2013.

Builder, Maxine. 2015. "Why the 2015 Met Gala Is Making Me Nervous—On How 'China:

Through the Looking Glass' Could Go Horribly Wrong." BUSTLE. http://www.bustle.com /articles/65227-why-the-2015-met-gala-is-making-me-nervous-on-how-china-through-the -looking. Accessed February 23, 2015.

Bullard, Truman C. 1971. "The First Performance of Igor Stravinsky's *Sacre du Printemps.*" PhD diss., University of Rochester.

Burger, Richard L., ed. 2009. *The Life and Writings of Julio C. Tello: America's First Indigenous Archaeologist.* Iowa City: University of Iowa Press.

Burns, Lori, and Mélisse Lafrance. 2002. *Disruptive Divas: Feminism, Identity, and Popular Music.* New York: Routledge.

Burt, Nathaniel. 1977. *Palaces for People.* New York: Little, Brown.

Byrd, Rudolph, ed., and Carl van Vechten, photog. 2014. *Generations in Black and White: Photographs from the James Weldon Johnson Memorial Collection.* Athens: University of Georgia Press.

C. W. 2014. "Putting the Boot in Development: The Economics of TOMS shoes." *Economist,* October 27. http://www.economist.com/blogs/freeexchange/2014/10/economics-toms-shoes. Accessed October 13, 2016.

Caffin, Charles Henry. 1902. *Photography as Fine Art: The Achievements and Possibilities of Photographic Art.* New York: Doubleday, Page.

Cain, Travis. 2016. "Toys with Edge." In *Becoming a Design Entrepreneur: How to Launch Your Design-Driving Ventures from Apps to Zines,* edited by Steven Heller and Lita Talarico, 150–51. New York: Allworth.

Calcutt, Lyn, Ian Woodward, and Zlatko Skrbiš. 2008. "Conceptualizing Otherness: An Exploration of the Cosmopolitan Schema." *Journal of Sociology* 45 (2): 169–86.

Campbell, Thomas P. 2014. "Director's Note." In "The Nelson A. Rockefeller Vision: Arts of Africa, Oceania, and the Americas," by Alisa La Gamma, Alisa, Joanne Pillsbury, Eric Kjellgren, and Yaëlle Biro. *Metropolitan Museum of Art Bulletin* 72 (1): 3.

Canada Arts Council. N.d. "Advisory Committee for Racial Equality in the Arts (REAC)." http:// canadacouncil.ca/equity-office/about-the-equity-office/reac-advisory-committee-2. Accessed January 18, 2014.

Cantwell, Robert. 1991. "Conjuring Culture: Ideology and Magic in the Festival of American Folklife." *Journal of American Folklore* 104 (412): 148–63.

Cappeliez, Sarah, and Josée Johnston. 2013. "From Meat and Potatoes to 'Real-Deal' Rotis: Exploring Everyday Culinary Cosmopolitanism." *Poetics* 41 (5): 433–55.

Carlos, Marjon. 2015. "'Native American-Inspired' Fashion Week Collection Offends and Enrages Actual Native Americans." Fusion. http://fusion.net/story/51252/native-american-inspired -fashion-week-collection-offends-and-enrages-actual-native-americans. Accessed February 23, 2015.

Carroll, Jay. 2012. "Four Great US Vintage Shops." *AFAR,* April 10. http://www.afar.com /magazine/four-great-u-dot-s-vintage-shops. Accessed January 15, 2015.

Case, Tony. 2004. "Mass Market: Is More Really Better When It Comes to Luxury?" *Adweek,* September 6. https://www.adweek.com/brand-marketing/mass-market-74632/. Accessed January 15, 2019.

Castleman, Craig. 1982. *Getting Up.* Cambridge, MA: MIT Press.

Chambers, Robert William. 1908. *The Firing Line.* New York: Grosset & Dunlap.

Chan, Tak Wing, and John H. Goldthorpe. 2005. "The Social Stratification of Theatre, Dance, and Cinema Attendance." *Cultural Trends* 14 (3): 193–212.

Chansky, Dorothy. 2004. *Composing Ourselves: The Little Theatre Movement and the American Audience.* Carbondale: Southern Illinois University Press.

Charity, Justin. 2014. "Rap Game Christopher Columbus: A Look at Pop's Colonization of Hip-

Hop." *Complex*, December 12. http://www.complex.com/music/2014/12/cultural -appropriation-in-music-hip-hop-and-pop. Accessed December 16, 2014.

Chartrand, Harry Hillman, and Claire McCaughey. 1989. "The Arm's Length Principle and the Arts: An International Perspective—Past, Present, and Future." In *Who's to Pay? for the Arts: The International Search for Models of Support*, vol. 3., edited by M. C. Cummings Jr. and L. Mark Davidson Schuster, 43–80. New York: American Council for the Arts.

Cherbo, Joni Maya. 1997. "Pop Art: Ugly Duckling to Swan." In *Outsider Art: Contesting Boundaries in Contemporary Culture*, edited by Vera Zolberg and Joni Maya Cherbo, 85–97. Cambridge: Cambridge University Press.

Cheyne, Andrew, and Amy Binder. 2010. "Cosmopolitan Preferences: The Constitutive Role of Place in American Elite taste for Hip-hop Music, 1991–2005." *Poetics* 38: 336–64.

Christensen, Kim. 2010. "Thomas Kinkade Firm Seeks Bankruptcy Protection." *Los Angeles Times*, June 30, http://articles.latimes.com/2010/jun/03/business/la-fi-kinkade-20100603. Accessed April 9, 2016.

Christopherson, Richard W. 1974. "From Folk Art to Fine Art: A Transformation in the Meaning of Photographic Work." *Urban Life and Culture* 3 (2): 123–57.

Chua, Daniel K. L. 2007. "Rioting with Stravinsky: A Particular Analysis of the *Rite of Spring*." *Music Analysis* 26: 59–109.

CIA. 2007. "Field Listing: Distribution of Family Income—Gini Index." Factbook, June 14. https://www.cia.gov/library/publications/the-world-factbook/fields/2172.html. Accessed November 18, 1018.

Cleveland Play House. 2016. "History." http://www.clevelandplayhouse.com/about/history. Accessed October 23, 2016.

Clutter Magazine. http://www.cluttermagazine.com/. Accessed May 5, 2017.

Cobb, Amanda J. 2005. "The National Museum of the American Indian as Cultural Sovereignty." *American Quarterly* 57 (2): 485–506.

Cocks, Catherine. 1996. "Other People's History: Ethnic Slumming in American Cities, 1890–1915." Organization of American Historians.

Cogan, Jeanine C., Satish K. Bhalla, Araba Sefa-Dedeh, and Esther D. Rothblum. 1996. "A Comparison Study of United States and African Students on Perceptions of Obesity and Thinness." *Journal of Cross-Cultural Psychology* 27 (1): 98–113.

Cohen, Randy. 2012. "Local Arts Index: How Many Nonprofit Arts Organizations Are There?" Arts Blog, Americans for the Arts, May 9. http://blog.americansforthearts.org/2012/05/09 /local-arts-index-how-many-nonprofit-arts-organizations-are-there. Accessed June 20, 2016.

Cohen, Ronald. 2005. "Folk Music in the Roosevelt Era." In *Alan Lomax: Selected Writings, 1934–1997*, edited by R. Cohen, 92–96. New York: Routledge.

Colacello, Bob. 2010. "The Prince and The Planet." *Vanity Fair*, November 11, 144–49.

Cole, Douglas. 1985. *Captured Heritage: The Scamble for Northwest Coast Artifacts*. Seattle: University of Washington Press.

Cole, Herbert M., ed. 1985. *I Am Not Myself: The Art of African Masquerade: Exhibition Catalogue*. Los Angeles: University of California Museum of Cultural History.

Conklin, John E. 1994. *Art Crime*. Westport, CT: Praeger.

Connor, Kelly. 2014. "32 Thoughtful Gift Ideas in Celebration of #Givingtuesday." *Vogue*, December 2.

Corse, Sarah M., and Monica D. Griffin. 1997. "Cultural Valorization and African American Literary History: Reconstructing the Canon." *Sociological Forum* 12 (2): 173–203.

Corse, Sarah, and Saundra Westervelt. 2002. "Gender and Literary Valorization: The Awakening of a Canonical Novel." *Sociological Perspective* 45: 139–61.

Cotter, Holland. 1999. "When the Body Is an Art Gallery." *New York Times*, November 19. http://

www.nytimes.com/1999/11/19/arts/art-review-when-the-body-is-an-art-gallery.html ?src=pm. Accessed June 14, 2017.

Cottington, David. 2004. *Cubism and its Histories*. New York: Manchester University Press.

Couch, Stephen R. 1983. "Patronage and Organizational Structure in Symphony Orchestras in London and New York." In *Performers and Performances: The Social Organization of Artistic Work*, edited by J. B. Kamerman and R. Martorella, 109–22. South Hadley, MA: Bergin.

Coulangeon, Philippe, and Yannick Lemel. 2007. "Is 'Distinction' Really Outdated? Questioning the Meaning of the Omnivorization of Musical Taste in Contemporary France." *Poetics* 35 (2–3): 93–111.

Courogen, Carrie. 2012. "New York-Based Designer Elizabeth Suda Crafts Jewelry out of Scrap Bomb Metal: Project Peacebomb Uses Relics from War to Help People of Laos." *New York Daily News*, May 7.

Cowen, Tyler. 2012. "How the United States Funds the Arts." Washington, DC: National Endowment for the Arts.

Crane, Diana. 1992. "High Culture versus Popular Culture Revisited: A Reconceptualization of Recorded Cultures." In *Cultivating Differences: Symbolic Boundaries and the Making of Inequality*, edited by Michèle Lamont and Marcel Fournier, 58. Chicago: University of Chicago Press.

Crawford, Sally. 2014. "Shifting the Beat: Exploring Tap Dance Performance and Identity on a Global Stage." *Congress on Research in Dance Conference Proceedings*, 52–58.

Cray, Claire. 2015. "Victorian Slumming: Jack London Meets a Hottie on the Docks." http://clairecray.com/2015/02/02/victorian-slumming-jack-london-meets-a-hottie-on-the-docks/. Accessed February 10, 2015.

Cruz, Josephine. 2015. "Valentino Just Pissed a Lot of People Off by Featuring Models Wearing Cornrows in Its Latest Campaign." *Complex*, January 16.

Dalby, Liza. 2001. *Kimono: Fashioning Culture*. London: Vintage.

Daniels, Les. 1971. *Comix: A History of Comic Books in America*. New York: Random House.

Danto, Arthur C. 1981. *The Transfiguration of the Commonplace: A Philosophy of Art*. New York: Cambridge University Press.

Danto, Arthur C. 2001. "Outsider Art." In *Self-Taught Art: The Culture and Aesthetics of American Vernacular Art*, edited by C. Russell, 61–67. Jackson: University Press of Mississippi.

Davis, Keith F. 1999. *An American Century of Photography: From Dry-plate to Digital: the Hallmark Photographic Collection*. 2nd ed. Kansas City, MO: Hallmark.

de Graaf, John, David Wann, and Thomas N. Naylor. 2001. *Affluenza: The All-Consuming Epidemic*. San Francisco: Berrett-Koehler.

de Pawlowski, Gustave. 1913. "Au Théâtre des Camps-Elysées: *Le Sacre du Printemps*, ballet de deux acts de M. Igor Stravinsky." *Comoedia*, May 31.

della Cava, Marco R. 2002. "Thomas Kinkade: Profit of Light." *USA Today*, March 11. http://usatoday30.usatoday.com/life/2002/2002-03-12-kinkade.htm. Accessed June 17, 2016.

Demers, Joanna. 2006. *Steal This Music: How Intellectual Property Law Affects Musical Creativity*. Athens: University of Georgia Press.

Denning, Michael. 1997. *The Cultural Front*. New York: Verso.

DeNora, Tia. 1991. "Musical Patronage and Social Change in Beethoven's Vienna." *American Journal of Sociology* 97 (2): 310–46.

DeNora, Tia. 1997. *Beethoven and the Construction of Genius: Musical Politics in Vienna, 1792–1803*. Los Angeles: University of California Press.

DeNora, Tia. 2000. *Music in Everyday Life*. Cambridge: Cambridge University Press.

Deresiewicz, William. 2012. "Upper Middle Brow." *American Scholar*. http://theamericanscholar.org/upper-middle-brow/#.VGtnLlfF8ld. Accessed November 8, 2012.

Designer Toy Awards. 2017a. "Award Description." https://www.designertoyawards.com/. Accessed May 5, 2017.

Designer Toy Awards. 2017b. "History." https://www.designertoyawards.com/history. Accessed June 11, 2018.

DeVos Institute of Arts Management. 2015. *Diversity in the Arts: The Past, Present, and Future of African American and Latino Museums, Dance Companies, and Theater Companies*. College Park: University of Maryland. https://mellon.org/media/filer_public/ba/99/ba99e53a -48d5-4038-80e1-66f9ba1c020e/awmf_museum_diversity_report_aamd_7-28-15.pdf. Accessed December 18, 2016.

d'Harnoncourt, Rene. 1951. "Image of America (Working Title), Outline of an Exhibition," June 25, 1951, 1. Ser. 7, folder 85. Rene d'Harnoncourt Papers. Archives, Museum of Modern Art, New York.

d'Harnoncourt, Rene. n.d. Draft of "Letter to Henry Ford, II." 2. Ser. 7, folder 85. Rene d'Harnoncourt Papers. Archives, Museum of Modern Art, New York.

DiMaggio, Paul. 1981. "The Impact of Public Funding on Organizations in the Arts." Yale Program on Nonprofit Organizations, working paper 31, Yale University.

DiMaggio, Paul. 1982. "Cultural Entrepreneurship in Nineteenth-Centry Boston: The Creation of an Organizational Base for High Culture in America." *Media, Culture & Society* 4: 33–50.

DiMaggio, Paul. 1983. "State Expansion and Organizational Fields." In *Organizational Theory and Public Policy*, edited by Richard H. Hall and Robert E. Quinn, 147–61. Beverly Hills, CA: Sage.

DiMaggio, Paul. 1986. "Introduction." In *Nonprofit Enterprise in the Arts: Studies in Mission and Constraint*, edited by Paul DiMaggio, 3–13. New York: Oxford University Press.

DiMaggio, Paul. 1987. "Classification in Art." *American Sociological Review* 52 (4): 440–55.

DiMaggio, Paul. 1992. "Cultural Boundaries and Structural Change: The Extension of the High-Culture Model to Theatre, Opera, and the Dance." In *Cultivating Differences: Symbolic Boundaries and the Making of Inequality*, edited by Michèle Lamont and Marcel Fournier, 21–43.

DiMaggio, Paul. 2000. "Social Structure, Institutions, and Cultural Goods: The Case of the United States." In *The Politics of Culture: Policy Perspectives for Individuals, Institutions, and Communities*, edited by Gigi Bradford, Michael Gary, and Glenn Wallach, 38–62. New York: Free Press.

DiMaggio, Paul, and Toqir Mukhtar. 2004. "Arts Participation as Cultural Capital in the United States, 1982–2002: Signs of Decline?" *Poetics* 32 (2): 169–94.

DiMaggio, Paul, and Francie Ostrower. 1990. "Participation in the Arts by Black and White Americans." *Social Forces* 68: 753–78.

DiMaggio, Paul, and Michael Useem. 1978. "Social Class and Arts Consumption: The Origins and Consequences of Class Differences in Exposure to Arts in America." *Theory and Society* 5 (2): 141–61.

Dodero, Camille. 2011. "The Suckadelic Era." *Village Voice*, September 28. http://www .villagevoice.com/news/the-suckadelic-era-6433177. Accessed May 5, 2017.

Domínguez Rubio, Fernando. 2014. "Preserving the Unpreservable: Docile and Unruly Objects at MoMA." *Theory and Society* 43: 617–45.

Donnally, Trish. 1993. "Young Designer's Street-Person Chic/More Rags and Tatters from Paris." *San Francisco Chronicle*, March 16.

Dorris, George. 2013. "The Metropolitan Opera Ballet, Fresh Starts: Galli in Charge, 1919–1921." *Dance Chronicle* 36: 77–102.

Doty, Robert. 1960. *Photo-Secession: Stieglitz and the Fine-Art Movement in Photography*. New York: Dover.

Douglass, Frederick. 1881. *Life and Times of Frederick Douglass*. Hartford, CT: Park.

Dowd, Maureen. 2000. "Homeless Chic." *Denver Post*, January 24.

Dowd, Timothy J. 2011. "Production and Producers of Lifestyles: The Fields of Popular and Classical Music in the United States." *VS Verlag für Sozialwissenschaften* 51: 113–38.

Dowie, Mark. 2001. *American Foundations: An Investigative History*. Cambridge, MA: MIT Press.

Dowling, Robert M. 2007. *Slumming in New York: From the Waterfront to Mythic Harlem*. Chicago: University of Illinois Press.

Dowling, Robert M. 2008. " 'Under the Bridge and Beyond': Helen Campbell on the East Side Waterfront." Gotham History Blotter, Gotham Center for New York City History. http://gothamcenter.org/blotter/?p=76. Accessed September 21, 2009.

Drake, Simone. 2014. "Out of the Mouth of Babes: When the Baubles of Diaspora Are up for Sale." NewBlackMan (in Exile). http://newblackman.blogspot.com/2014/07/out-of-mouth-of-babes-when-baubles-of.html. Accessed August 20, 2014.

Drake, St. Clair, and Horace R. Cayton. 1945. *Black Metropolis: A Study of Negro Life in a Northern City*. Chicago: University of Chicago Press.

D'Souza, Miguel. 2002. "Afrika 'Baby' Bambataa of the Jungle Brothers—Interview." *Bomb*, June 11. http://www.bombhiphop.com/jungle.htm. Accessed January 15, 2019.

Ducker, Eric. 2015. " 'Has It Come To This?': A Rational Conversation About Music in Museums." NPR, May 4.

Duffus, Robert L. 1928. *The American Renaissance*. New York: Alfred A. Knopf.

Dunn, Robert G. 2000. "Identity, Commodification, and Consumer Culture." In *Identity and Social Change*, edited by Joseph E. David, 109–34. New Brunswick, NJ: Transaction.

Dunning, Jennifer. 2003. "Dance and Profit: Who Gets It?" *New York Times*, September 20.

Eaton, Quaintance. 1968. *The Miracle of the Met: An Informal History of the Metropolitan Opera, 1883–1967*. New York: Meredith.

E. B. 2015. "It's Oh So Disappointing: Björk at MoMA." *Economist*, March 16.

Edelson, Lawrence. 2005. "Opera—The Irrelevant Art: Uniting Marketing and Organizational Strategy to Combat the Depopularization of Opera in the United States." MA thesis in Performing Arts Administration, New York University.

Eisner, Will. 1990. "Getting the Last Laugh: My Life in Comics." *New York Times*, January 14.

Eksteins, Modri. 1983. "The First Performance of *Le Sacre du Printemps*; or the Audience as Art." *Canadian Journal of History* 18 (2): 227–45.

Ellen, Barbara. 2013. "Wanna Shop Like Common People? More Fool You . . ." *Guardian*, December 14.

Emmison, Michael. 2003. "Social Class and Cultural Mobility: Reconfiguring the Cultural Omnivore Thesis." *Journal of Sociology* 39 (3): 211–30.

Engels, Friedrich. 1973. *The Condition of the Working Class in England*. Moscow: Progress.

Ennis, Philip H. 1992. *The Seventh Stream: The Emergence of Rock-n-Roll in American Popular Music*. Middletown, CT: Wesleyan University Press.

Erickson, Bonnie. 1996. "Culture, Class, and Connections." *American Journal of Sociology* 102: 217–51.

Errington, Shelly. 1994. "What Became of Authentic Primitive Art?". *Cultural Anthropology* 9 (2): 201–26.

Espeland, Wendy Nelson, and Mitchell L. Stevens. 1998. "Commensuration as a Social Process." *Annual Review of Sociology* 24: 313–43.

Eyal, Gil. 2006. *The Disenchantment of the Orient: Expertise in Arab Affairs and the Israeli State*. Stanford, CA: Stanford University Press.

Farago, Jason. 2015. "Björk Review—A Strangely Unambitious Hotchpotch." *Guardian*, March 4.

Farley, J. 2011. "Jazz as a Black American Art Form: Definitions of the Jazz Preservation Act." *Journal of American Studies* 45 (1): 113–29.

Farrell, Betty, and Maria Medvedeva. 2010. "Demographic Transformation and the Future of Museums." Washington, DC: American Association of Museums Press.

Featherstone, Mike. 1991. *Consumer Culture and Postmodernism*. London: Sage.

Featherstone, Mike. 2000. "Lifestyle and Consumer Culture." In *The Consumer Society Reader*, edited by Martyn J. Lee, 92–105. Malden, MA: Blackwell.

Federal Works Agency. 1947. "Final Report on the WPA Program, 1935–43." Washington, DC: US Government Printing Office.

Ferguson, Priscilla P. 1998. "A Cultural Field in the Making: Gastronomy in Nineteenth-Century France." *American Journal of Sociology* 104: 597–641.

Ferguson, Priscilla P. 2004. *Accounting for Taste: The Triumph of French Cuisine*. Chicago: University of Chicago Press.

Ferguson, Sian. 2014. "25+ Examples of Western Privilege." Everyday Feminism. http:// everydayfeminism.com/2014/09/examples-western-privilege/. Accessed January 9, 2015.

Fenske, Mindy. 2007. *Tattoos in American Visual Culture*. New York: Palgrave Macmillan.

Fiedler, Leslie A. 1963. "Race—The Dream and the Nightmare." *Commentary*, October 1.

Fine, Gary A. 1996. "Reputational Entrepreneurs and the Memory of Incompetence: Melting Supporters, Partisan Warriors, and Images of President Harding." *American Journal of Sociology* 101 (5): 1159–93.

Fine, Gary A. 2003. "Crafting Authenticity: The Validation of Identity in Self-Taught Art." *Theory and Society* 32 (2): 153–80.

Fine, Gary A. 2004. *Everyday Genius: Self-Taught Art and the Culture of Authenticity*. Chicago: University of Chicago Press.

Finney, H. 1997. "Art Production and Artists' Careers: The Transition From 'Outside' to 'Inside.'" In *Outsider Art: Contesting Boundaries in Contemporary Culture*, edited by Vera L. Zolberg and J. M. Cherbo, 73–84. New York: Cambridge University Press.

Fish, Stanley. 1980. *Is There a Text in this Class? The Authority of Interpretive Communities*. Cambridge, MA: Harvard University Press.

Fisher, Timothy C. G., and Stephen B. Preece. 2003. "Evolution, Extinction, or Status Quo? Canadian Performing Arts Audiences in the 1990s." *Poetics* 31: 69–86.

Fiske, John. 1989. *Reading the Popular*. New York: Routledge.

Fitzpatrick, Laura. 2007. "Vacationing like Brangelina." *Time*, July 26. http://content.time.com /time/magazine/article/0,9171,1647457,00.html. Accessed June 20, 2016.

Flatt, Collin. 2012. "Is Pat's Steaks Slumming for the Dallas Cowboys?" Eater Philly, http://philly .eater.com/2012/11/12/6523341/is-pats-steaks-slumming-for-the-dallas-cowboys. Accessed May 23, 2013.

Flitch, J. E. Crawford. 1912. *Modern Dancing and Dancers*. Philadelphia: J. B. Lippincott.

Flood, Barry Finbarr. 2002. "Between Cult and Culture: Bamiyan, Islamic Iconoclasm, and the Museum." *Art Bulletin* 84 (4): 641–59.

Flores, Juan. 2004. "Puerto Rocks: Rap, Roots, and Amnesia." In *That's the Joint! Hip-Hop Studies Reader*, edited by Murray Forman and Mark Anthony Neal, 69–86. New York: Routledge.

Fokine, Michel. 1961. *Memoires of a Ballet Master*. Boston: Little, Brown.

Ford Foundation. 1950. Report of the Trustees of the Ford Foundation, September 27, 16.

Foucault, Michel. 1984. "What Is an Author?" In *The Foucault Reader*, edited by Paul Rabinow, 101–20. New York: Pantheon Books.

Foushee, Ola Maei. 1972. *Art in North Carolina: Episodes and Development*. Charlotte, NC: Heritage.

Frazer, Garth. 2008. "Used-Clothing Donations and Apparel Production in Africa." *Economic Journal* 118 (October): 1764–84.

Freeland, Chrystia. 2011. "The Rise of the New Global Elite." *Atlantic*, January/February.

Freidson, Eliot. 1990. "Labors of Love: A Prospectus." In *The Nature of Work: Sociological Perspectives*, edited by Kai Erikson and Steven P. Vallas, 149–61. New Haven, CT: Yale University Press.

Frenzel, Fabian, and Ko Koens. 2014. *Tourism and Geographies of Inequality: The New Global Slumming Phenomenon*. London: Routledge.

Frere-Jones, Sasha. 2003. "Outkast Is Good." *Slate*, October 8. http://www.slate.com/articles /arts/music_box/2003/10/outkast_is_good.html. Accessed April 29, 2017.

Fricke, Jim, and Charlie Ahearn. 2002. *Yes Yes Y'all: The Experience Music Project Oral History of Hip-Hop's First Decade*. New York: Da Capo.

Friedersdorf, Conor. 2017. "What Does 'Cultural Appropriation' Actually Mean?" *Atlantic*, April 3. https://www.theatlantic.com/politics/archive/2017/04/cultural-appropriation/521634/. Accessed April 4, 2017.

Frith, Simon. 1996. *Performing Rites*. New York: Oxford University Press.

Frith, Simon, and Howard Horne. 1987. *Art into Pop*. London: Methuen.

Frith, Simon, Will Straw, and John Street, eds. 2001. *The Cambridge Companion to Pop and Rock*. New York: Cambridge University Press.

Gabler, Neal. 2011. "The End of Cultural Elitism, Tastemakers Beware: The Audience Is No Longer Interested in Your Opinion." *Boston Globe*. January 6.

Gale Cengage Learning Archives Unbound. 2014. "Literature, Culture and Society in Depression Era America: Archives of the Federal Writers' Project." http://go.galegroup.com/gdsc/i.do ?action=interpret&id=3TQA&v=2.1&u=columbiau&it=aboutCollections&p=GDSC&sw= w&authCount=1. Accessed March 24, 2014.

Gans, Herbert. 1999. *Popular Culture and High Culture*. New York: Basic Books.

Garafola, Lynn. 2005. "Lincoln Kirstein, Modern Dance, and the Left: The Genesis of an American Ballet." *Dance Research: The Journal of the Society for Dance Research* 23 (1): 18–35.

García-Álvarez, Ercilia, Tally Katz-Gerro, and Jordi López-Sintas. 2007. "Deconstructing Cultural Omnivorousness, 1982–2002: Heterology in Americans' Musical Preferences." *Social Forces* 86 (2): 417–43.

Gardner, Ralph, Jr. 2014. "Making Peace with War: Article 22 Makes Jewelry from Bombs Dropped over Laos During the Vietnam War Era." *Wall Street Journal*, July 31.

Garfield, Joey. 2015. "The Sucklord: A Bizarre Artist Who Makes Bootleg Toys." *Atlantic*, March 25. https://www.theatlantic.com/video/index/388517/the-sucklord-a-bizarre-artist-who -makes-bootleg-toys/. Accessed May 5, 2017.

Gay, Malcolm. 2016. "Kimono Controversy Erupts Anew at MFA Panel." *Boston Globe*, February 8. https://www.bostonglobe.com/arts/2016/02/08/kimono-controversy-erupts-anew-mfa -panel/olduJEpYVqUUyTM3wunRUM/story.html. Accessed February 29, 2016.

Gedo, Mary M. 2010. *Monet and His Muse: Camille Monet in the Artist's Life*. Chicago: University of Chicago Press.

Gersuny, Carl, and William R. Rosengren. 1973. *The Service Society*. Cambridge, MA: Schenkman.

Gettleman, Jeffrey. 2014. "Nairobi's Latest Novelty: High-End Mac and Cheese, Served by Whites." *New York Times*, October 16.

Gieryn, Thomas F. 1999. "Boundaries of Science." In *Handbook of Science and Technology Studies*, edited by S. Jasanoff, G. Markle, J. Petersen, and T. Pinch, 393–443. Thousand Oaks, CA: Sage.

Gillman, Derek. 2010. *The Idea of Cultural Heritage*. Rev. ed. New York: Cambridge University Press.

Givhan, Robin D. 1996. "PLUG UGLY: Meet the Plastic Flamingos of Fashion: They're All the Rage." *Washington Post*, May 9.

Gladwell, Malcolm. 2004. "The Ketchup Conundrum." *New Yorker*, September 6.

Glueck, Grace. 1997. "A Style That Turned All the Way into Art." *New York Times*, September 5.

Glynn, Mary Ann, and Michael Lounsbury. 2005. "From the Critic's Corner: Logic Blending, Discursive Change, and Authenticity in a Cultural Production System." *Journal of Management Studies* 42 (5): 1031–55.

Goldberg, Amir. 2011. "Mapping Shared Understandings Using Relational Class Analysis: The Case of the Cultural Omnivore Reexamined." *American Journal of Sociology* 116 (5): 1397–436.

Goldwater, Robert. 1959a. "Everyone Knew What Everyone Else Meant." *It Is* 4: 35.

Goldwater, Robert. 1959b. "Loans from the Museum of Primitive Art." January 23. AR1999.9.1, Box 1, Folder 1. Official Business: Board of Trustees Minutes of Annual Meetings. Visual Resource Archive, Department of the Arts of Africa, Oceania, and the Americas. Metropolitan Museum of Art, New York.

Gomery, Douglas. 1992. *Shared Pleasures: A History of Movie Presentation in the United States.* Madison: University of Wisconsin Press.

Goodyear, Dana. 2009. "The Scavenger." *New Yorker*, November 9, 40–45.

Gopnik, Adam. 2013. "Yellow Fever: A Hundred and Twenty-Five Years of National Geographic." *New Yorker.* April 22, 102–8.

Gottschalck, Alfred O. 2008. "Net Worth and the Assets of Households: 2002." US Census Bureau, Current Population Reports, April, 70–115.

Gouldner, Alvin W. 1979. *The Future of the Intellectuals and the Rise of the New Class.* London: Macmillan.

Graham, Carleen Ray. 2009. "Perspectives of Opera Singer Training and Education through an Examination of Collegiate-level Opera Programs." PhD diss., Teachers College, Columbia University.

Grazian, David. 2003. *Blue Chicago: The Search for Authenticity in Urban Blues Clubs.* Chicago: University of Chicago Press.

Greenfield, Patricia M., Lisa Bruzzone, Kristi Koyamatsu, Wendy Satuloff, Karey Nixon, Mollyann Brodie, and David Kingsdale. 1989. "What Is Rock Music Doing to the Minds of Our Youth? A First Experimental Look at the Effects of Rock Music Lyrics and Music Videos." *Journal of Early Adolescence* 7 (3): 315–529.

Greengard, Stephen N. 1986. "Ten Crucial Years: The Development of United States Government Sponsored Artists Programs, 1933–1943: A Panel Discussion by Six WPA Artists." *Journal of Decorative and Propaganda Arts* 1: 40–61.

Griffin, Farrah J. 2004. "Thirty Years of Black American Literature and Literary Studies: A Review." *Journal of Black Studies* 35 (2): 165–74.

Griswold, Wendy. 1987. "The Fabrication of Meaning: Literary Interpretation in the United States, Great Britain, and the West Indies." *American Journal of Sociology* 92: 1077–117.

Guarino, Lindsay, and Wendy Oliver. 2014. *Jazz Dance: A History of the Roots and Branches.* Tallahassee: University Press of Florida.

The Guru. 2002. Directed by Daisy von Scherler Meyer. Universal Studios.

Guttentag, Daniel A. 2009. "The Possible Negative Impacts of Volunteer Tourism." *International Journal of Tourism Research* 11: 537–51.

Hagood, Thomas. 2000. *A History of Dance in American Higher Education: Dance and the American University.* Lewiston, NY: Edwin Mellen.

Haines, Gerald K. 1977. "Under the Eagle's Wing: The Franklin Roosevelt Administration Forges An American Hemisphere." *Diplomatic History* 1 (4): 373–88.

Hall, Michael D., and Eugene Metcalf Jr., eds. 1994. *The Artist Outsider: Creativity and the Boundaries of Culture.* Washington, DC: Smithsonian Institution.

Hall, Peter Dobkin. 1984. *The Organization of American Culture*. New York: New York University Press.

Halle, David. 1993a. *Inside Culture: Art and Class in the American Home*. Chicago: University of Chicago Press.

Halle, David. 1993b. "The Audience for Abstract Art: Class, Culture, and Power." In *Cultivating Difference: Symbolic Boundaries and the Making of Inequality*, edited by Michèle Lamont and Marcel Fournier, 131–51. Chicago: University of Chicago Press.

Halnon, Karen Bettez. 2002. "Poor Chic: The Rational Consumption of Poverty." *Current Sociology* 50 (4): 501–16.

Hammond, Jeff Michael. 2014. "How Japan's Art inspired the West." *Japan Times*, August 14. http://www.japantimes.co.jp/culture/2014/08/14/arts/how-japans-art-inspired-the-west/#.VxATYZMrI_V. Accessed April 14, 2016.

Handy, D. Antoinette. 1985. "Jazz Gets Organized." *NEA Arts Review*. Washington, DC: National Endowment for the Arts.

Hanna, Judith Lynne. 1988. *Dance, Sex, and Gender: Signs of Identity, Dominance, Defiance, and Desire*. Chicago: University of Chicago Press.

Hannan, Michael T., and John Freeman. 1989. *Organizational Ecology*. Cambridge, MA: Harvard University Press.

Hannerz, Ulf. 1990. "Cosmopolitans and Locals in World Culture." *Theory, Culture & Society* 7 (2): 237–51.

Harris, Neil. 1973. *Humbug: The Art of P. T. Barnum*. Boston: Little, Brown.

Hart, Phillip. 1973. *Orpheus in the New York: The Symphony Orchestra as an American Cultural Institution*. New York: W. W. Norton.

Harvey, David. 1990. *The Condition of Postmodernity*. Malden, MA: Blackwell.

Harvey, David. 2005. *A Brief History of Neoliberalism*. New York: Oxford University Press.

Healy, Kieran. 2006. *Last Best Gifts: Altruism and the Market for Human Blood and Organs*. Chicago: University of Chicago Press.

Heap, Chad. 2009. *Slumming: Sexual and Racial Encounters in American Nightlife, 1885–1940*. Chicago: University of Chicago Press.

Heartney, Eleanor. 1998. "Recontextualizing African Altars." *Art in America* 25: 58–65.

Hebdige, Dick. 1979. *Subculture: The Meaning of Style*. New York: Methuen.

Hebert, David G., and P. S. Campbell. 2000. "Rock Music in American Schools: Positions and Practices Since the 1960s." *International Journal of Music Education* 1: 14–22.

Hedegard, Danielle. 2013. "Blackness and Experience in Omnivorous Cultural Consumption: Evidence from the Tourism of Capoeira in Salvador, Brazil." *Poetics* 41 (1): 1–26.

Hegert, Natalie. 2013. "Radiant Children: The Construction of Graffiti Art in New York City." *Rhizomes: Cultural Studies in Emerging Knowledge* 25: 1–10.

Heller, Steven. 2007. "Toy Story." *New York Times*, January 28. http://www.nytimes.com/2007/01/28/books/review/Heller.t.html. Accessed May 5, 2017.

Heller, Steven, and Lita Talarico, eds. 2016. *Becoming a Design Entrepreneur: How to Launch Your Design-Driving Ventures from Apps to Zines*. New York: Allworth.

Herrera, Adriana. 2013. "Questioning the TOMS Shoes Model for Social Enterprise." *New York Times*, March 19. http://boss.blogs.nytimes.com/2013/03/19/questioning-the-toms-shoes-model-for-social-enterprise/?_r=2. Accessed October 13, 2016.

Hibbet, Maia. 2014. "Is Fusion Authentic? Assessing the Appropriation of Asian Cultures in Fusion." *College Voice*, December 2. https://thecollegevoice.org/2014/12/02/is-fusion-authentic-assessing-the-appropriation-of-asian-cultures-in-fusion/. Accessed January 15, 2019.

Hilder, Thomas. R. 2012. "Repatriation, Revival and Transmission: The Politics of a Sámi Musical Heritage." *Ethnomusicology Forum* 21 (2): 161–79.

Hill, Constance V. 2014. *Tap Dancing America: A Cultural History*. New York: Oxford University Press.

Hill, Mark E. 2002. "Skin Color and the Perception of Attractiveness Among African Americans: Does Gender Make a Difference?" *Social Psychology Quarterly* 65 (1): 77–91.

Holland, Bernard. 1987. "Opera: 'Leonora' by Fry." *New York Times*, February 2. http://www.nytimes.com/1987/02/02/arts/opera-leonora-by-fry.html. Accessed November 5, 2016.

Holt, Douglas B. 1998. "Does Cultural Capital Structure American Consumption?" *Journal of Consumer Research* 25: 1–25.

Homer, William I. 1983. *Alfred Stieglitz and the Photo-Secession*. New York: Little, Brown.

Hopkins, Ruth. 2014. "Boycott Ralph Lauren's 'Assimilation Aesthetic.'" Indian Country Today, December 9. http://indiancountrytodaymedianetwork.com/2014/12/19/boycott-ralph-laurens-assimilation-aesthetic. Accessed December 22, 2014.

Horan, Paul. 1996. "American Opera in Higher Education: A Description of Its Status at Selected Conservatories, Colleges, and Universities Offering a Bachelor's Degree." PhD diss., New York University.

Horkheimer, Max, and Theodor Adorno. 2002. *Dialectic of Enlightenment*. Stanford, CA: Stanford University Press.

Horowitz, Helen Lefkowitz. 1989. *Culture and the City: Cultural Philanthropy in Chicago from the 1880s to 1917*. Chicago: University of Chicago Press.

Houghton, Arthur A. 1969. "Statement for the September 15th Hearing of the City Council," May 28, 1969. AR.1999.28.10 Box 4, Folder 3. MPA-MMA Transition-MCR Wing, Planning Stage Correspondence, 1969–1970. Robert Goldwater Library, Department of the Arts of Africa, Oceania, and the Americas. Metropolitan Museum of Art, New York.

Houghton, Norris. 1941. *Advance from Broadway: 19,000 Miles of American Theatre*. New York: Harcourt, Brace.

Howard, Homer Hildreth. 1914. "The Toy Theatre of Boston." *Drama Magazine* 14: 264–69.

Hsu, Hua. 2016. "The Struggle." *New Yorker*, March 7.

Hunt, Liz. 2007. "Immigrants Have Bags of Ambition." *Telegraph*, June 2. http://www.telegraph.co.uk/comment/personal-view/3640310/Immigrants-have-bags-of-ambition.html. Accessed March 8, 2016.

Hutchinson, George. 1996. *The Harlem Renaissance in Black and White*. Boston: Belknap Press at Harvard University Press.

Hutchins-Viroux, Rachel. 2004. "The American Opera Boom of the 1950s and 1960s: History and Stylistic Analysis." *Revue LISA/LISA* 2 (3): 145–63.

Iaboni, Rande. 2013. "'Ghetto' Tours of Bronx Ended after Outrage." CNN, May 23. http://www.cnn.com/2013/05/23/travel/new-york-bronx-ghetto-tours/. Accessed January 4, 2015.

Igarashi, Hiroki, and Hiro Saito. 2014. "Cosmopolitanism as Cultural Capital: Exploring the Intersection of Globalization, Education and Stratification." *Cultural Sociology* 8 (3): 222–39.

Jacobs, Jane. 1995 [1961]. "The Uses of Sidewalks." In *Metropolis: Center and Symbol of Our Times*, edited by Philip Kasinitz, 111–29. New York: New York University Press.

Jameson, Fredric. 1991. *Postmodernism: or, The Cultural Logic of Late Capitalism*. Durham, NC: Duke University Press.

Jana, Reena. 2006. "Product Peek: How Green Are My Blue Jeans." *Business Week*, September 18.

Jane the Actuary. 2015. "St. Patrick's Day and Cultural Appropriation." *Patheos*, March 17. http://www.patheos.com/blogs/janetheactuary/2015/03/st-patricks-day-and-cultural-appropriation.html. Accessed June 27, 2017.

Järvinen, Hannah. 2008. " 'The Russian Barnum:' Russian Opinion on Diaghilev's Ballet Russes, 1909–1914." *Dance Research: The Journal of the Society for Dance Research* 26 (1): 32–33.

Jeffri, Joan, and D. Throsby. 1994. "Professionalism and the Visual Artist." *European Journal of Cultural Policy* 1: 99–108.

Jensen, Joli. 2001. "Fandom as Pathology: The Consequences of Characterization." In *Popular Culture: Production and Consumption*, edited by. C. L. Harrington and D. D. Bielby, 301–14. Malden, MA: Blackwell.

Jhally, Sut, and Justin Lewis. 1992. *Enlightened Racism: The Cosby Show, Audiences, and the Myth of the American Dream.* San Francisco: Westview.

Johnston, Josée, and Shyon Baumann. 2007. "Democracy versus Distinction: A Study of Omnivorousness in Gourmet Food Writing." *American Journal of Sociology* 113 (1): 165–204.

Jones, Layla A. 2014. "Urban Outfitters' Parent Company Sends Offensive Company Email." Philly.com, December 8. http://www.philly.com/philly/blogs/trending/Urban-Outfitters -parent-company-sends-offensive-company-email.html. Accessed January 15, 2019.

Jones, Sarah. 2012. "After Election Defeat, Mitt Romney Caught Slumming It with the 47%." PoliticsUSA, November 20. http://www.politicususa.com/2012/11/20/redditor-spots-romney -local-gas-station-he-tired-washed-up.html. Accessed January 15, 2019.

Jones, Steve, and Kevin Featherly. 2002. "Re-Viewing Rock Writing: Narratives of Popular Music Criticism." In *Pop Music and the Press*, edited by Steve Jones, 134–55. Philadelphia: Temple University Press.

Jones, Tiff. 2012. "The Racial Stir Behind Dolce and Gabbana's 'Blackamoor' Earrings." Coffee Rhetoric, September 27. http://www.coffeerhetoric.com/2012/09/the-racial-stir-behind -dolce-and.html. Accessed January 15, 2019.

Joyce, Joyce A. 1987. "The Black Canon: Reconstructing Black American Literary Criticism." *New Literary History* 18 (2): 335–44.

Joyner, April. 2014. "Beyond Buy-One-Give-One Retail." *New Yorker*, April 7. http://www .newyorker.com/business/currency/beyond-buy-one-give-one-retail. Accessed October 13, 2016.

Kalmijn, Matthijs. 1994. "Assortive Mating by Cultural and Economic Occupational Status." *American Journal of Sociology* 100 (2): 422–52.

Kamerman Jack B., and R. Martorella, eds. 1983. *Performers and Performances: The Social Organization of Artistic Work.* South Hadley, MA: Bergin.

Kamm, Jennifer. 2014. "Elizabeth Suda Collaborates with Laotian Artisans to Create Jewelry from Detonated Bombs." *Haute Living*, August 28.

Kammer, Michael. 1999. *From American Culture, American Tastes.* New York: Knopf.

Kaplan, Jeremy. 2006. "Slumming in Los Angeles; Mexican Food for the Poor in Pocket, but Rich in Taste." http://ezinearticles.com/?Slumming-in-Los-Angeles;-Mexican-Food-for-the -Poor-in-Pocket,-But-Rich-in-Taste&id=327463. Accessed September 21, 2009.

Kaplan, Robert S., and David P. Norton. 1992. "The Balanced Scorecard: Measures that Drive Performance." *Harvard Business Review* 70 (1): 71–79.

Kapp, Jamie. 2014. "White Privilege, Explained in One Simple Comic" Everyday Feminism. http://everydayfeminism.com/2014/09/white-privilege-explained/. Accessed Janaury 15, 2019.

Karthas, Ilyana. 2012. "The Politics of Gender and the Revival of Ballet in the Early Twentieth-Century France." *Journal of Social History* 45 (4): 960–89.

Kasfir, Sidney Littlefield. 1992. *Contemporary African Art.* New York: Thames & Hudson.

Kaufman, Jason, and Orlando Patterson. 2005. "Cross-national Cultural Diffusion: The Global Spread of Cricket." *American Sociological Review* 70: 82–110.

Keene, Adrienne. 2014, "Keene: Dear Ralph Lauren, Our Ancestors Are Not Your Props!" Indian

Country Today, December 18. http://indiancountrytodaymedianetwork.com/2014/12/18/keene-dear-ralph-lauren-our-ancestors-are-not-your-props-158363. Accessed December 22, 2014.

Keightley, Keir K. 2001. "Reconsidering Rock." In *The Cambridge Companion to Pop and Rock*, edited by S. Frith, W. Straw, and J. Street, 102–25. New York: Cambridge University Press.

Kelley, Norman. 1999. "Rhythm Nation: The Political Economy of Black Music." *Black Renaissance/Renaissance Noire* 2 (2): 8.

Kellner, Bruce, ed. 1987. *Carl Van Vechten and the Irreverent Decades*. Norman: University of Oklahoma Press.

Kendall, Gavin, Zlatko Skrbiš, and Ian Woodward. 2008. "Cosmopolitanism, the Nation-State, and Imaginative Realism." *Journal of Sociology* 44 (4): 401–17.

Kendle, Amanda. 2008. "Poverty Tourism: Exploring the Slums of India, Brazil, and South Africa." Vagabondish. http://www.vagabondish.com/poverty-tourism-touring-the-slums-of-india-brazil-and-south-africa/. Accessed January 15, 2019.

Kennedy, Randy. 2015. "Metropolitan Museum Draws Record Crowds." *New York Times*, July 27. http://www.nytimes.com/2015/07/28/arts/design/metropolitan-museum-draws-record-crowds.html?_r=0. Accessed December 29, 2015.

Keppel, Frederick P., and R. B. Duffus. 1933. *The Arts in American Life*. New York: McGraw-Hill.

Khan, Shamus. 2010. *Privilege: The Making of an Adolescent Elite at St. Paul's School*. Princeton, NJ: Princeton University Press.

Kidd, Dustin. 2009. "Democratic Practices in Arts Organizations." *Journal of Arts Management, Law, and Society* 38 (4): 296–309.

Kim, Jennifer. 2009. "The High Low Kashmiri Bangles, $48." *New York Times*, December 8.

King, Geoff. 2002. *New Hollywood Cinema: An Introduction*. New York: I. B. Tauris.

King, Jamilah. 2014. "The Overwhelming Whiteness of Black Art." *Colorlines: News for Action*, May 21. http://colorlines.com/archives/2014/05/the_overwhelming_whiteness_of_black_art.html. Accessed May 21, 2014.

King, Soraya. 2013. "Elegant Slumming: How Have You Solved Your Personal Housing Crisis?" *Guardian*, October 15.

Kino, Carol. 2015. "In the Spirit of Black Mountain College, an Avant-Garde Incubator." *New York Times*, March 16. https://www.nytimes.com/2015/03/19/arts/artsspecial/in-the-spirit-of-black-mountain-college-an-avant-garde-incubator.html. Accessed June 21, 2017.

Kirstein, Lincoln. 1970. *Movement and Metaphor: Four Centuries of Ballet*. New York: Praeger.

Kirstein, Lincoln. 1978. *Thirty Years: The New York City Ballet*. New York: Knopf.

Kjellgren, Eric. 2014. "Returning to the Source: Michael C. Rockefeller, Douglas Newton, and the Arts of Oceania." In "The Nelson A. Rockefeller Vision: The Arts of Africa, Oceania, and the Americas." *Metropolitan Museum of Art Bulletin* 72 (1): 28–37.

Kolodin, Irving. 1936. *The Metropolitan Opera: 1883–1935*. New York: Oxford University Press.

Kosut, Mary. 2006. "An Ironic Fad: The Commodification and Consumption of Tattoos." *Journal of Popular Culture* 39 (6): 10–48.

Kosut, Mary. 2014. "The Artification of Tattoo: Transformations within a Cultural Field." *Cultural Sociology* 8 (2): 142–58.

Koval, Robin. 2005. "Living the High Life." *Adweek*, November 21. https://www.adweek.com/brand-marketing/living-high-life-82715/. Accessed January 15, 2019.

Koven, Seth. 2004. *Slumming: Sexual and Social Politics in Victorian London*. Princeton, NJ: Princeton University Press.

Kramer, Hilton. 1968. "Marsden Hartley, American Yet Cosmopolitan." *New York Times*, January

20. https://www.nytimes.com/1968/01/20/archives/marsden-hartley-american-yet -cosmopolitan.html. Accessed January 6, 2017.

Kramer, Hilton. 1982. "The High Art of Primitivism." *New York Times Magazine*, January 24. https://www.nytimes.com/1982/01/24/magazine/the-high-art-of-primitivism.html. Accessed January 15, 2019.

Kriegsman, Alan M. 1987. "Joffrey's Stupendous 'Sacre': In LA, a Revival that Makes History." *Washington Post*, October 2.

Kris, Ernst, and Otto Kurz. 1987. *L'image de l'artiste: Légende, mythe et magie; Un essai historique*. Marseille: Rivages.

Kulka, Thomas. 1996. *Kitsch and Art*. University Park: Penn State University Press.

Kundera, Milan. 1984. *The Unbearable Lightness of Being*. Translated by Michael Henry Heim. New York: Harper & Row.

Kurin, Richard. 1989. "Why We Do the Festival." In *Smithsonian Festival of American Folklife Program Book*, edited by Frank Proschan, 8–21. Washington, DC: Smithsonian Institution.

Kymlicka, Will. 2001. *Politics in the Vernacular: Nationalism, Multiculturalism, and Citizenship*. New York: Oxford University Press.

Lachmann, Richard. 1988. "Graffiti as Career and Ideology." *American Journal of Sociology* 94 (2): 229–50.

Lachmann, Richard, Emily Pain, and Anibal Gauna. 2014. "Museums in the New Gilded Age: Collector Exhibits in New York Art Museums, 1945–2010." *Poetics* 43: 60–69.

LaGamma, Alisa. 2014. "The Nelson A. Rockefeller Vision: In Pursuit of the Best in the Arts of Africa, Oceania, and the Americas." *Metropolitan Museum of Art Bulletin* 72 (1): 7–17.

Lagemann, Ellen C. 1983. *Private Power for the Public Good*. Middletown, CT: Wesleyan University Press.

Laing, Dave. 1985. *One Chord Wonders: Power and Meaning in Punk Rock*. Milton Keynes, UK: Open University Press.

Lamont, Michèle. 1992. *Money, Morals, and Manners: The Culture of the French and the American Upper-Middle Class*. Chicago: University of Chicago Press.

Lamont, Michèle, and Annette Lareau. 1988. "Cultural Capital: Allusions, Gaps, and Glissandos in Recent Theoretical Developments." *Sociological Theory* 6: 153–68.

Lamont, Michèle, and Virag Molnar. 2002. "The Study of Boundaries in the Social Sciences." *Annual Review of Sociology* 28: 167–95.

Lancaster, John. 2007. "Next Stop, Squalor." *Smithsonian Magazine*, March. https://www .smithsonianmag.com/travel/next-stop-squalor-148390665/. Accessed January 15, 2019.

Lancefield, Robert. 1993. "On the Repatriation of Recorded Sound from Ethnomusicological Archives: A Survey of Some of the Issues Pertaining to People's Access to Documentation of Their Musical Heritage." MA thesis, Wesleyan University.

Landesmann, Rocco. 2012. "How the United States Funds the Arts." Washington, DC: National Endowment of the Arts, Office of Research and Analysis.

Lane, Jeffrey. 2007. *Under the Boards: The Cultural Revolution in Basketball*. Lincoln: University of Nebraska Press.

Lang, Gladys, and Kurt Lang. 1988. "Recognition and Renown: The Survival of Artistic Reputation." *American Journal of Sociology* 94: 79–109.

LaPlaca Cohen. 2017. "Culture Track." https://culturetrack.com/. Accessed June 17, 2017.

Lash, Scott. 1994. "Reflexivity and its Doubles: Structures, Aesthetics, Community." In *Reflexive Modernization: Politics, Tradition and Aesthetics in the Modern Social Order*, edited by Ulrich Beck, Anthony Giddens, and Scott Lash, 110–73. Cambridge: Polity.

Lauter, Paul. 1991. *Canons and Contexts*. New York: Oxford University Press.

League of American Orchestras. N.d. "Orchestra Facts, 2006–2014." https://americanorchestras.org/images/stories/ORR_1213/ORR13%20summary%20report.pdf. Accessed June 16, 2017.

Leal, Odina Fachel, and Ruben George Oliven. 1988. "Class Interpretations of a Soap Opera Narrative: The Case of Brazillian Novella 'Summer Sun.'" *Theory, Culture, and Society* 5: 81–99.

Lee, Sang-Soo, SetByol Choi, and Myoung-Jin Lee. 2015. "Omnivorous Consumer or Omnivorous Producer? Patterns of Cultural Participation in Korea." *Development and Society* 44 (1): 117–42.

Lee, Steve S. 2004. "Predicting Cultural Output Diversity in the Radio Industry: 1989–2002." *Poetics* 32 (3–4): 325–42.

Leland, John. 1992. "Rap and Race." *Newsweek*, June 29, 47–52.

Leland, John. 2005. *Hip: The History*. New York: Harper Perennial.

Lena, Jennifer C. 2012. *Banding Together: How Communities Create Genres in Popular Music*. Princeton, NJ: Princeton University Press.

Lena, Jennifer C., and Daniel B. Cornfield. 2008. "Immigrant Arts Participation in Nashville." In *Engaging Art: The Next Great Transformation of America's Cultural Life*, edited by William Ivey and Steven Tepper, 147–69. New York: Routledge.

Lena, Jennifer C., and Mark C. Pachucki. 2013. "The Sincerest Form of Flattery: Innovation, Repetition, and Status in an Art Movement." *Poetics* 41: 236–64.

Lena, Jennifer C., and Richard A. Peterson. 2008. "Classification as Culture: Types and Trajectories of Music Genres." *American Sociological Review* 73: 697–718.

Lerner, Ben. 2016. "The Custodians." *New Yorker*, January 11.

Levin, Bess. 2009. "Are Hedge Fund Wives Slumming It in J.Crew, No Longer Getting Turned on by Shopping?" DealBreaker.com, May. http://dealbreaker.com/2009/05/are-hedge-fund-wives-slumming-it-in-j-crew-no-longer-getting-turned-on-by-shopping/. Accessed July 17, 2009.

Levin, Peter. 2007. "Constituted Commodities, and Market Culture: How Economic Sociology Uses Culture." Working paper, Department of Sociology, Barnard College.

Levine, Lawrence W. 1988. *Highbrow/Lowbrow: The Emergence of Cultural Hierarchy in America*. Cambridge, MA: Harvard University Press.

Lieberson, Stanley. 2000. *A Matter of Taste: How Names, Fashions, and Culture Change*. New Haven, CT: Yale University Press.

Liebes, Tamar, and Elihu Katz. 1993. *The Export of Meaning*. Oxford: Oxford University Press.

Lindberg, Ulf, Gestur Guomundsson, Morton Michaelson, and Hans Weisethaunet. 2005. *Rock Criticism from the Beginning: Amusers, Bruisers, and Cool-Headed Cruisers*. Vol. 5. New York: Peter Lang.

Lizardo, Omar, and Sara Skiles. 2009. "Highbrow Omnivorousness on the Small Screen? Cultural Industry Systems and Patterns of Cultural Choice in Europe." *Poetics* 37 (1): 1–23.

Lizardo, Omar, and Sara Skiles. 2012. "Reconceptualizing and Theorizing 'Omnivorousness:' Genetic and Relational Mechanisms." *Sociological Theory* 30 (4): 263–82.

Lizardo, Omar. 2006. "How Cultural Tastes Shape Personal Networks." *American Sociological Review* 71: 778–807.

Long, Elizabeth. 1986. "Women, Reading, and Cultural Authority: Some Implications of the Audience Perspectives in Cultural Studies." *American Quarterly* 38: 591–612.

Lopes, Paul D. 2002. *The Rise of a Jazz Art World*. Cambridge: Cambridge University Press.

Lopes, Paul. 2005. "Signifying Deviance and Transgression." *American Behavioral Scientist* 48 (11): 1468–81.

Lopes, Paul D. 2006. "Culture and Stigma: Popular Culture and the Case of Comic Books." *Sociological Forum* 21 (3): 387–414.

Lopes, Paul D. 2009. *Demanding Respect: The Evolution of the American Comic Book*. Philadelphia: Temple University Press.

López-Sintas, Jordi, and Tally Katz-Gerro. 2005. "From Exclusive to Inclusive Elitists and Further: Twenty Years of Omnivorousness and Cultural Diversity in Arts Participation in the USA." *Poetics* 33: 299–319.

Lott, Eric. 1993. *Love and Theft: Blackface Minstrelsy and the American Working Class*. New York: Oxford University Press.

Lu, Shun, and Gary Alan Fine. 1995. "The Presentation of Ethnic Authenticity: Chinese Food as a Social Accomplishment." *Sociological Quarterly* 36 (3): 535–53.

Lubrow, Arthur. 2004. "Cult Figures." *New York Times*, August 15.

Lundberg, George A., Mirra Komarovsky, and Mary A. McInerny. 1934. *Leisure: A Suburban Study*. New York: Columbia University Press.

Lyden, Jacki. 2014. "A Modern Twist on Mexican Tradition Hits the Runway." NPR, June 6. http://www.npr.org/2014/06/28/325801547/a-modern-twist-on-mexican-tradition-hits-the-runway. Accessed January 15, 2019.

Lyn, Kimberly. 2014. "What's Her Secret? Elizabeth Suda, Founder and Creative Director of Article 22: Successful Women Share Their Secrets to Happiness, Life, Success and Style." *29Secrets*. http://www.29secrets.com/wellness/elizabeth-suda-founder-and-creative-director-article-22. Accessed January 15, 2019.

Lynd, Robert S., and Helen M. Lynd. 1959 [1929]. *Middletown: A Study in Modern American Culture*. New York: Harcourt.

Lynd, Robert S. and Helen M. Lynd. 1982 [1937]. *Middletown in Transition: A Study in Cultural Conflicts*. New York: Harcourt.

Lynes, Russell. 1949. "High-Brow, Low-Brow, Middle-Brow: These Are Three Basic Categories of a New US Social Structure, and the High-Brows Have the Whip Hand." *Life*, April 11, 99–102.

Lynes, Russell. 1973. *Good Old Modern: An Intimate Portrait of Museum of Modern Art*. New York: Atheneum.

Lynn, Karyl Charna. 1996. *From the National Trust Guide to Great Opera Houses in America*. New York: Preservation.

MacGowan, Kenneth. 1929. *Floodlights across America: Towards a National Theatre*. New York: Harcourt Brace.

Macklemore. 2005. "White Privilege." *The Language of My World*. NWXMusic, January 1.

Mailer, Norman. 1957. *The White Negro: Superficial Reflections on the Hipster*. San Francisco: City Lights Books.

Malan, Rian. 2000. "In the Jungle." *Rolling Stone*, May.

Malik, Nesrine. 2015. "Madonna's Cultural Appropriation Confirms What a Cliché She Has Become." *Guardian*, January 6.

Malraux, Andre. 1949. *Museum without Walls*. Translated by Stuart Gilbert. New York: Pantheon Books.

Marcotte, Amanda. 2008. "Multiculture Club." *American Prospect*, May 16.

Marien, Mary W. 2006. *Photography: A Cultural History*. London: Laurence King.

Marling, Karal Ann. 1979. "A Note on New Deal Iconography: Futurology and the Historical Myth." *Prospects* 4: 421–40.

Marling, Karal Ann. 1981. "Thomas Hart Benton's Boomtown: Regionalism Redefined." *Prospects* 6: 73–137.

Martha Graham Sch. & Dance Found., Inc. v. Martha Graham Ctr. of Contemporary Dance, Inc. 2004. 380 F.3d 624, 627, 2nd Circuit.

Martin, John. 1930. "The Dance: Creating an American Ballet." *New York Times*, May 4.

Martin, John. 1936. "Odyssey of the Dance." *New York Times*, September 13.

Mason, Rowena. 2015. "Chris Bryant Accuses James Blunt of Missing the Point over Privilege." *Guardian*, January 19.

Massey, Douglas, and Nancy M. Denton. 1993. *American Apartheid: Segregation and the Making of an American Underclass*. Cambridge, MA: Harvard University Press.

Mathews, Jane De Hart. 1975. "Arts and the People: The New Deal Quest for a Cultural Democracy." *Journal of American History* 62 (2): 316–39.

Matloff, Judith. 2013. "Take a Tour of the Barrio Most Mexicans Won't Visit—If You Dare." December 8. *Al Jazeera America*, December 8. http://america.aljazeera.com/articles/2013/12/8/a-cultural-tour-ofthefiercebarriomostmexicanswontvisit.html. Accessed January 15, 2019.

McAuliffe, Cameron, and Kurt Iveson. 2011. "Art and Crime (And Other Things Besides . . .): Conceptualizing Graffiti in the City." *Geography Compass* 5 (3): 128–43.

McCarthy, Kevin F., Arthur Brooks, Julia F. Lowell, and Laura Zakaras. 2001. *The Performing Arts in a New Era*. Santa Monica, CA: Rand.

McConachie, Bruce A. 1988. "New York Operagoing, 1825–50: Creating an Elite Social Ritual." *American Music* 6 (2): 181–92.

McCoy, Charles Allan, and Roscoe C. Scarborough. 2014. "Watching 'Bad' Television: Ironic Consumption, Camp, and Guilty Pleasures." *Poetics* 47: 41–59.

McDonald, William F. 1969. *Federal Relief Administration and the Arts*. Columbus: Ohio State University Press.

McFeeters, Stephanie. 2015. "Tensions, Questions at MFA's reconfigured 'Kimono Wednesdays.'" *Boston Globe*, July 9. https://www.bostonglobe.com/arts/2015/07/08/tensions-questions-mfa-reconfigured-kimono-wednesdays/5VpgDhLrDNK2nPIOSygFNL/story.html. Accessed March 2, 2016.

McGehee, Nancy G., and K. Andereck. 2009. "Volunteer Tourism and the 'Voluntoured': The Case of Tijuana, Mexico." *Journal of Sustainable Tourism* 17: 39–51.

McLaughlin, Paul, and Marwan Khawaja. 2000. "The Organizational Dynamics of the US Environmental Movement: Legitimation, Resource Mobilization, and Political Opportunity." *Rural Sociology*. 65 (3): 422–39.

McLeod, Kembrew. 2007. *Freedom of Expression: Resistance and Repression in the Age of Intellectual Property*. Minneapolis: University of Minnesota Press.

McPherson, Smith-Lovin, et al. 2001. "Birds of a Feather: Homophily in Social Networks." *Annual Review of Sociology* 27 (1): 415–44.

Mejia, Paula. 2015. "Bjork's MoMA Retrospective is Gnarled, Problematic–And Compelling." *Newsweek*, March 8. http://www.newsweek.com/bjorks-moma-retrospective-gnarled-problematic-and-compelling-312242. Accessed June 28, 2017.

Melillo, Wendy. 2006. "The Return of Luxury." *Adweek*, June 5. https://www.adweek.com/brand-marketing/return-luxury-85421/. Accessed January 15, 2019.

Menger, Pierre-Michel. 1999. "Artistic Labor Markets and Careers." *Annual Review of Sociology* 25: 541–74.

Merrill, Samuel. 2015. "Keeping It Real? Subcultural Graffiti, Street Art, Heritage and Authenticity." *International Journal of Heritage Studies* 21 (4): 369–89.

Metcalfe, Jessica R. 2012. "Paul Frank's Racist Powow." Beyond Buckskin, September 9. http://www.beyondbuckskin.com/2012/09/paul-franks-racist-powwow.html. Accessed January 23, 2015.

Metropolitan Museum of Art. 2000–2017. "Arts of Africa, Oceania and the Americas." http://www.metmuseum.org/about-the-museum/museum-departments/curatorial-departments/art-of-africa-oceania-and-the-americas. Accessed July 15, 2015.

Midgette, Anne. 2007. "The Voice of American Opera." *Opera Quarterly* 23 (1): 81–95.

Milanovic, Branko. 2006. "Global Income Inequality: What It Is and Why It Matters?" Working paper, United Nations, New York.

Miller, Craig R., and Mark Darley. 1990. *Modern Design in the Metropolitan Museum of Art, 1890–1990*. New York: Metropolitan Museum of Art.

Miller, Ray. 2014. "Tappin' Jazz Lines." In *Jazz Dance: A History of the Roots and Branches*, edited by Lindsay Guarino and Wendy Oliver, 139–52. Tallahassee: University Press of Florida.

Mills, C. Wright. 1970 [1959]. *The Sociological Imagination*. New York: Oxford University Press.

Mintel. 2008. *Volunteer Tourism International*. London: Mintel.

Mintel. 2010. "Marketing to Affluent Consumers–US–July 2010." Mintel. https://store.mintel .com/marketing-to-affluent-consumers-us-july-2010. Accessed January 15, 2019.

Miranda, Carolina A. 2015. "The Björkatastrophe in Verse: A Girl Critic Takes Her Beating Heart to MoMA." *Los Angeles Times*, April 24.

Mitchell, Timothy. 2002. *Rule of Experts: Egypt, Techno-Politics, Modernity*. Los Angeles: University of California Press.

Mohr, John, and Paul DiMaggio. 1995. "The Intergenerational Transmission of Cultural Capital." *Research in Social Stratification and Mobility* 14: 167–200.

Molz, Jennie Germann. 2011. "Cosmopolitanism and Consumption." In *The Ashgate Research Companion to Cosmopolitanism*, edited by Maria Rovisco and Magdalena Nowicka, 33–52. Burlington, VT: Ashgate.

Moore, Jina. 2009. "Poverty Tours Travel a Fine Line." *Christian Science Monitor*, June 28.

Morrell, Elizabeth. 2005. *Securing a Place: Small-scale Artisans in Modern Indonesia*. Ithaca, NY: Cornell University Press.

Musher, Sharon Ann. 2015. *The New Deal's Influence on American Culture*. Chicago: University of Chicago Press.

Museum of African Art. 1973. "African Art in Washington Collections." Washington, DC: Museum of African Art.

Museum of African Art. 1993. *Home and the World: Architectural Sculpture by Two Contemporary African Artists*. New York: Museum for African Art.

The Museum of Modern Art. 1968. "René d'Harnoncourt, 1901–1968: A Tribute," October 8. René d'Harnoncourt Papers. Robert Goldwater Library, Department of the Arts of Africa, Oceania, and the Americas. Metropolitan Museum of Art, New York.

The Museum of Modern Art. 2015. *Björk* (press release).

Myers, Fred. 2006. "'Primitivism,' Anthropology, and the Category of 'Primitive Art.'" In *Handbook of Material Culture*, edited by W. K. Christopher Tilley, Susanne Küchler, Michael Rowlands, and Patricia Spyer, 267–84. Thousand Oaks, CA: Sage.

N.A. 1896a. "Arrest of Booth-Tucker: He Was Slumming with 'Steve' Brodie and Was Disguised." *New York Times*, April 29.

N.A. 1896b. "Brodie is in High Glee. Good Advertisement in the Booth-Tucker Expedition." *New York Times*, April 30.

N.A. 1906. "Prof. Bailey's Class Here Again to See Us." *New York Times*, May 4.

N.A. 1910. "Great Welcome for New Opera." *New York Times*, December 11.

N.A. 1910. "Puccini Here; His Opera Views." *New York Times*, November 18.

N.A. 1935. "Opposes Wpa Drama Plan: Eva Le Gallienne Says It Will Not Create National Audience." *New York Times*, October 28.

N.A. 1936b. "Art: Government Inspiration." *Time*, March 2, 48–51.

N.A. 1936c. "Music: Relief Melodies." *Time*, April 13, 98.

N.A. 1939. "Relief: Hot Pan." *Time*, May 15, 22.

N.A. 1941. "Mrs. Force Attacks Wpa Project Art." *Art Digest* 15 (9): 24.

N.A. 1949. "Everyday Tastes from High-Brow to Low-Brow Are Classified on Chart." *Time*, April 11. http://kieranhealy.org/files/misc/highbrow-lowbrow.png. Accessed May 8, 2017.

N.A. 1954. "Absolute Charter." December 17. AR1999.9.1, Box 1, Folder 5. Official Business–MPA Charter. Visual Resource Archive, Department of the Arts of Africa, Oceania, and the Americas. Metropolitan Museum of Art, New York.

N.A. 1955. "Museum of Indigenous Art Acquisition Policy." June 11. AR1999.9.24, Box 4, Folder 4. Official Business–General Administrative Details, Policies, and Activities. Visual Resource Archive, Department of the Arts of Africa, Oceania, and the Americas. Metropolitan Museum of Art, New York.

N.A. 1956a. "Minutes of the Adjourned Annual Meeting of the Members of the Museum of Indigenous Art." December 6. AR1999.9.1, Box 1, Folder 6. Official Business–MPA Members: Minutes of Annual Meetings. Visual Resource Archive, Department of the Arts of Africa, Oceania, and the Americas. Metropolitan Museum of Art New York.

N.A. 1956b. "Board Meeting Minutes." June 19. AR1999.9.1, Box 1, Folder 1. Official Business–Board of Trustees Minutes of Annual Meetings. Visual Resource Archive, Department of the Arts of Africa, Oceania, and the Americas. Metropolitan Museum of Art, New York.

N.A. 1958a. "Press Release, First Anniversary." February 21. AR1999.9.1, Box 1, Folder 2. Official Business–Museum Background: Publicity Brochures, Pamphlets, Releases, etc. Visual Resource Archive, Department of the Arts of Africa, Oceania, and the Americas. Metropolitan Museum of Art, New York.

N.A. 1958b. "Primitive Art Museum Celebrates Its First Anniversary," February 21. AR.1999.9.1, Box 1, Folder 2. Official Business–Museum Background: Publicity Brochures, Pamphlets, Releases, etc. Robert Goldwater Library, Department of the Arts of Africa, Oceania, and the Americas. Metropolitan Museum of Art, New York.

N.A. 1958c. "Radio Reports: Dr. Robert Goldwater Interviewed for the Fitzgeralds at the Astor." September 9. AR1999.9.28, Box 3, Folder 3. Official Business–Public Relations Radio. Visual Resource Archive, Department of the Arts of Africa, Oceania, and the Americas. Metropolitan Museum of Art, New York.

N.A. 1963. "Background Information on Museum of Primitive Art." Spring. AR1999.9.1, Box 1, Folder 2. Official Business–Museum Background: Publicity Brochures, Pamphlets, Releases, etc. Visual Resource Archive, Department of the Arts of Africa, Oceania, and the Americas. Metropolitan Museum of Art, New York.

N.A. 1966. "Minutes of the Special Meeting of the Members of the Museum of Primitive Art." April 4. AR1999.9.1, Box 1, Folder 6. Official Business–MPA Members Minutes of Annual Meetings. Visual Resource Archive, Department of the Arts of Africa, Oceania, and the Americas. Metropolitan Museum of Art, New York.

N.A. 1967. "Extemporaneous Illustrated Art Lecture by Governor Nelson A. Rockefeller." March 15. AR1999.14.40, Box 5, Folder 1. Miscellaneous Documents–Individuals Individual Nelson A. Rockefeller–General. Visual Resource Archive, Department of the Arts of Africa, Oceania, and the Americas. Metropolitan Museum of Art New York.

N.A. 1968a. "Board Meeting Minutes." November 26. AR1999.9.1, Box 1, Folder 1. Official Business–Board of Trustees Minutes of Annual Meetings. Visual Resource Archive, Department of the Arts of Africa, Oceania, and the Americas. Metropolitan Museum of Art, New York.

N.A. 1968b. "René d'Harnoncourt 1901–1968: A Tribute," October 8, AR.1999.14.11, Box 1, Folder 11. Rene d'Harnoncourt Papers. Robert Goldwater Library, Department of the Arts of Africa, Oceania, and the Americas. Metropolitan Museum of Art, New York.

N.A. 1977. "Description: State Agency Finding Aid: Art Museum Building Commission, 1967–1976." State Archives of North Carolina. http://digital.ncdr.gov/cdm/ref/collection/p16062coll15/id/1377. Accessed February 14, 2019.

N.A. 1981. *The Art of Africa, the Pacific Islands, and the Americas: A New Perspective*. Vol. 39. New York: Metropolitan Museum of Art.

N.A. 2005. "Inconspicuous Consumption: Now That Luxury Has Gone Mass Market, How Are the Super-rich to Flaunt Their Wealth?" December 20. *Economist*, December 20. http://www.economist.com/node/5323772. Accessed May 29, 2017.

N.A. 2006–16. "Beyond One-for-One." TOMS Shoes. http://www.toms.com/beyond-one-for-one. Accessed October 13, 2016.

N.A. 2011. "Paul Farmer: Accompaniment as Policy." *Harvard Magazine*, May 25. http://harvardmagazine.com/2011/05/paul-farmer-accompaniment-as-policy. Accessed April 13, 2017.

N.A. 2013. "Killer Plaid." *Radar*, October 7. http://radarmagazine.se/fashionandfcuker/2013/10/page/2/. Accessed March 8, 2016.

N.A. 2014. "Paul Budnitz Trains You How to See Beautiful Plastic in Designer Toys." Skillshare. YouTube. March 18. https://www.youtube.com/watch?v=lP-LFvyHk6g. Accessed May 5, 2017.

N.A. 2016a. "Who Plays Video Games in America?" Pew Research Center, January 5. http://www.pewinternet.org/2016/01/05/who-plays-video-games-in-america/. Accessed April 29, 2017.

N.A. 2016b. "About." 92Y, Giving Tuesday. http://www.givingtuesday.org/about/. Accessed June 20, 2016.

N.A. 2016c. "Here's What Happened When We Questioned Macklemore & Ryan Lewis About Their White Privilege." ColorLines, January 29. http://www.colorlines.com/articles/heres-what-happened-when-we-questioned-macklemore-ryan-lewis-about-their-white-privilege. Accessed April 14, 2016.

N.A. 2016d. "About." 92Y, Giving Tuesday. http://www.givingtuesday.org/about/. Accessed June 20, 2016.

N.A. 2017a. "Nielsen Releases 2016 U.S. Year-End Music Report." Nielsen. http://www.nielsen.com/us/en/press-room/2017/nielsen-releases-2016-us-year-end-music-report.html. Accessed April 29, 2017.

N.A. 2017b. "Mission and History." Smithsonian Folklife Festival. https://festival.si.edu/about-us/mission-and-history/smithsonian. Accessed December 27, 2017.

National Endowment for the Arts. 1979a. "Service Organization Study." Washington, DC: National Endowment for the Arts.

National Endowment for the Arts. 1979b. "Jazz Grants at $1 Million Mark." *NEA News*. Washington, DC: National Endowment for the Arts.

National Endowment for the Arts. 2014. Survey of Public Participation in the Arts 1982–2012 Combined File (United States). ICPSR35596-v1. Ann Arbor, MI: Inter-university Consortium for Political and Social Research (distributor), December 22. https://www.arts.gov/sites/default/files/highlights-from-2012-sppa-revised-oct-2015.pdf. Accessed June 25, 2016.

National Endowment for the Arts. 2015. "A Decade of Arts Engagement: The Survey of Public Participation in the Arts, 2002–2012." NEA Research Report #58. https://www.arts.gov/sites/default/files/2012-sppa-feb2015.pdf.

Neal, Mark Anthony. 2002. *Soul Babies: Black Popular Culture and the Post-Soul Aesthetic*. New York: Routledge.

Neal, Mark Anthony, and Brian Coleman. 2007. "Establishing a Hip Hop Canon." Soundcheck, Soundcheck, WYNC, June 29. https://www.wnyc.org/story/39635-establishing-a-hip-hop-canon/. Accessed January 16, 2019.

Nee, Victor, and Jimy Sanders. 2001. "Understanding the Diversity of Immigrant Incorporation: A Forms-of-Capital Model." *Ethnic and Racial Studies* 24 (3): 386–411.

Negus, Keith. 1999. "The Music Business and Rap: Between the Street and the Executive Suite." *Cultural Studies* 13 (3): 488–508.

Nelson, George. 1999. *Hip Hop America*. New York: Penguin Books.

Nelson, Karen. 1983. "The Evolution of Financing of Ballet Companies in the United States." *Journal of Cultural Economics* 7 (1): 43–62.

Netzer, Richard. 1978. *The Subsidized Muse*. New York: Cambridge University Press.

Newhall, Beaumount. 1964. "Forward." In *Photo-Secession: Stieglitz and the Fine-Art Movement in Photography*, edited by Richard Doty, 2–4. New York: Dover.

Newman, Andrew Adam. 2010. "Keds Campaign Claims a First, Then Revises." *New York Times*, March 21. http://www.nytimes.com/2010/03/22/business/media/22adco/html. Accessed July 12, 2012.

Newman, Andrew, Anna Goulding, and Christopher Whitehead. 2013. "How Cultural Capital, Habitus, and Class Influence the Responses of Older Adults to the Field of Contemporary Visual Art." *Poetics* 41: 456–80.

Newman, George E., Gil Diesendruck, and Paul Bloom. 2011. "Celebrity Contagion and the Value of Objects." *Journal of Consumer Research* 38 (2): 215–28.

Newman, George E., and Paul Bloom. 2012. "Art and Authenticity: The Importance of Originals in Judgments of Value." *Journal of Experimental Psychology: General* 141 (3): 558–669.

Newman, George E., and Paul Bloom. 2014. "Physical Contact Influences How Much People Pay at Celebrity Auctions." *Proceedings of the National Academy of Sciences* 111(10): 705–8.

Newton, Douglas. 1981. *The Art of Africa, the Pacific Islands, and the Americas: A New Perspective, the Metropolitan Museum of Art Bulletin* 39 (2).

New York Post. 2013. "When Candidates Go Slumming." Staff report, July 25.

Nolan, Hamilton. 2012. "I Went to the Pre-Oscar Celebrity Gifting Suites and All I Got Was This Sense of Disgust." Gawker, February 26. http://gawker.com/5888267/i-went-to-the-pre-oscar-celebrity-gifting-suites-and-all-i-got-was-this-sense-of-disgust. Accessed January 16, 2019.

Nunberg, Geoffrey. 2006. "A Liberal Interpretation: The Curent Definition of Right- and Left-Wing Politics Comes out of a Consumer-Based Idea of What It Is to Be Liberal or Conservative." *Chicago Sun-Times*, July 30.

Nyberg, Amy K. 1994. *Seal of Approval: The Origins and History of the Comics Code*. Jackson: University Press of Mississippi.

Oberlin, Kathleen C., and Thomas F. Gieryn. 2015. "Place and Culture-making: Geographic Clumping in the Emergence of Artistic Schools." *Poetics* 50: 2–43.

O'Connor, Francis. 1969. *Federal Support for the Visual Arts: The New Deal and the Now*. Greenwich, CT: New York Graphic Society.

O'Connor, Maureen. 2014. "Is Race Plastic? My Trip into the 'Ethnic Plastic Surgery' Minefield." *New York Magazine*, July 27. https://www.thecut.com/2014/07/ethnic-plastic-surgery.html. Accessed January 16, 2019.

O'Dwyer, Shaun. 2015. "Of Kimono and Cultural Appropriation." *Japan Times*, April 8. http://www.japantimes.co.jp/opinion/2015/08/04/commentary/japan-commentary/kimono-cultural-appropriation/#.VxATEpMrI_U. Accessed April 14, 2016.

O'Quinn, Jim. 2015. "Going National: How America's Regional Theatre Movement Changed the Game." *American Theatre*, June 16.

Ogunnaike, Lola. 2004. "Sweeten the Image, Hold the Bling-Bling." *New York Times*, January 12. http://www.nytimes.com/2004/01/12/arts/music/12hiph.html?page wanted=print &position. Accessed January 16, 2019.

Olsen, Keith W. 1974. *The GI Bill, the Veterans, and the Colleges*. Lexington: University of Kentucky Press.

Orlean, Susan. 2001. "Art for Everybody: How Thomas Kinkade Turned Painting into Big Business." *New Yorker*, October 15, 124–46.

Orsi, Robert. 1992. "The Religious Boundaries of an Inbetween People: Street Feste and the Problem of the Dark-Skinner Other in Italian Harlem, 1920–1990." *American Quarterly* 44 (3): 313–47.

Ostendorf, Berndt. 1985. "Literary Acculturation: What Makes Ethnic Literature 'Ethnic.'" *Callaloo* 25: 577–86.

Pachucki, Mark A., Sabrina Pendergrass, and Michèle Lamont. 2007. "Boundary Processes: Recent Theoretical Developments and New Contributions." *Poetics* 35 (6): 331–51.

Palmer, Winthrop. 1978. *Theatrical Dancing in America: The Development of the Ballet from 1900*. South Brunswick, NJ: A. S. Barnes.

Panja, Tariq, and Peter Millard. 2014. "Some World Cup Fans Will Really Be Slumming." Bloomberg Businessweek, April 24. https://www.bloomberg.com/news/articles/2014-04-24/some-of-brazils-world-cup-visitors-will-stay-in-slums. Accessed January 16, 2019.

Parezo, Nancy. 1983. *Navajo Sandpainting: From Religious Act to Commercial Art*. Tucson: University of Arizona Press.

Pattillo, Mary. 2003. "Negotiating Blackness, For Richer or for Poorer." *Ethnography* 4: 61–93.

Peters, Donna-Marie. 2011. "Dancing with the Ghost of Minstrelsy: A Case Study of the Marginalization and Continued Survival of Rhythm Tap. *Journal of Pan African Studies* 4 (6): 82–105.

Peterson, Richard A. 1972. "Lessons in Social Control from the Demise of Rock Festivals." Paper presented at the American Sociological Association.

Peterson, Richard A. 1986. "From Impresario to Arts Administrator: Formal Accountability in Nonprofit Cultural Organizations." In *Nonprofit Enterprise in the Arts: Studies in Mission and Constraint*, edited by Paul DiMaggio, 161–83. New York: Oxford University Press.

Peterson, Richard A. 1990. "Why 1955? Explaining the Advent of Rock Music." *Popular Music* 9 (1): 97–116.

Peterson, Richard A. 1997a. *Creating Country Music: Fabricating Authenticity*. Nashville: Vanderbilt University Press.

Peterson, Richard A. 1997b. "The Rise and Fall of Highbrow Snobbery as a Status Marker." *Poetics* 25 (2–3): 75–92.

Peterson, Richard A. 2005a. "In Search of Authenticity." *Journal of Management Studies* 42 (5): 1083–98.

Peterson, Richard A. 2005b. "Problems in Comparative Research: The Example of Omnivorousness." *Poetics* 33 (5–6): 257–82.

Peterson, Richard A., and Albert Simkus. 1992. "How Musical Tastes Mark Occupational Status Groups." In *Cultivating Differences: Symbolic Boundaries and the Making of Inequality*, edited by Michèle Lamont and Marcel Fournier, 152–86. Chicago: University of Chicago Press.

Peterson, Richard A., and David G. Berger. 1975. "Cycles in Symbol Production: The Case of Popular Music." *American Sociological Review* 40: 158–73.

Peterson, Richard A., and Gabriel Rossman. 2007. "Changing Arts Audiences: Capitalizing on Omnivorousness." In *Engaging Art. The Next Great Transformation of America's Cultural Life*, edited by Steven J. Tepper and Bill Ivey, 307–42. New York: Routledge.

Peterson, Richard A., and N. Anand. 2004. "The Production of Culture Perspective." *Annual Review of Sociology* 30: 311–34.

Peterson, Richard A., and Roger M. Kern. 1996. "Changing Highbrow Taste: From Snob to Omnivore." *American Sociological Review* 61 (5): 900–907.

Pham, Minh-Ha T. 2014. "Fashion's Cultural-Appropriation Debate: Pointless." *Atlantic*, May 15.

http://www.theatlantic.com/entertainment/archive/2014/05/cultural-appropriation-in-fashion-stop-talking-about-it/370826/. Accessed March 8, 2016.

Phillips, Christopher. 1982. "The Judgment Seat of Photography." *October* 22: 27–63.

Phillips, Damon J. 2013. *Shaping Jazz: Cities, Labels, and the Global Emergence of an Art Form.* Princeton, NJ: Princeton University Press.

Phillips, Damon J., and Young-Kyu Kim. 2009. "Why Pseudonyms? Deception as Identity Preservation among Jazz Record Companies. *Organization Science* 20: 481–99.

Phillips, Gene D. 2001. *Stanley Kubrick.* Jackson: University Press of Mississippi.

Picardi, Phillip. 2015. "The Underlying Issue with That Epic Givenchy Show." Refinery29, March 9. http://www.refinery29.com/2015/03/83536/givenchy-fall-2015-runway-chola-inspiration. Accessed January 16, 2019.

Picca, Leslie Houts, and Joe Feagin. 2007. *Two-Faced Racism: Whites in the Frontstage and Backstage.* New York: Routledge.

Piketty, Thomas, and Emmanuel Saez. 2003. "Income Inequality in the United States, 1913–1998." *Quarterly Journal of Economics* 118 (1): 1–39.

Pillsbury, Joanne. 2014. "The Pan-American: Nelson Rockefeller and the Arts of Ancient Latin America." In "The Nelson A. Rockefeller Vision: The Arts of Africa, Oceania, and the Americas." *Metropolitan Museum of Art Bulletin* 72 (1): 18–27.

Pittenger, Mark. 1997. "A World of Difference: Constructing the 'Underclass' in Progressive America." *American Quarterly* 49 (1): 26–65.

Pittenger, Mark. 2003. " 'What's on the Worker's Mind': Class Passing and the Study of the Industrial Workplace in the 1920s." *Journal of History of the Behavioral Sciences* 39 (2): 143–61.

Pogrebin, Robin. 2016. "New York Arts Organizations Lack the Diversity of Their City." *New York Times*, January 28. https://www.nytimes.com/2016/01/29/arts/new-york-arts-organizations-lack-the-diversity-of-their-city.html?_r=0. Accessed June 2, 2017.

Polgreen, Lydia. 2013. "Trading Privilege for Privation, Family Hits a Nerve in South Africa." *New York Times*, September 15. http://www.nytimes.com/2013/09/16/world/africa/trading-privilege-for-privation-family-hits-a-nerve-in-south-africa.html?pagewanted=all&_r=0. Accessed January 15, 2015.

Ponte, Stefano, and Lisa Ann Richey. 2014. "Buying into Development? Brand Aid Forms of Cause-related Marketing." *Third World Quarterly* 35 (1): 65–87.

Porrier, Philippe. 2004. "French Cultural Policy in Question, 1981–2003." In *After the Deluge, New Perspectives on Postwar French Intellectual and Cultural History*, edited by Julian Bourg, 301–24. Lanham, MD: Lexington Books.

Porter, Eric. 2012. "Incorporation and Distinction in Jazz History and Jazz Historiography." In *Jazz/Not Jazz: The Music and Its Boundaries*, edited by David Ake, Charles Garrett, and Daniel Goldmark, 13–30. New York: Oxford University Press.

Powell, Walter W. 1985. *Getting into Print: The Decision-Making Process in Scholarly Publishing.* Chicago: University of Chicago Press.

Powers, Lynn A. 1996. "Whatever Happened to the Graffiti Art Movement?" *Journal of Popular Culture* 29 (4): 137–42.

Press, Andrea. 1991. *Women Watching Television: Gender, Class, and Generation in the American Television Experience.* Philadelphia: University of Pennsylvania Press.

Press, Andrea. 1994. "The Sociology of Cultural Reception: Notes Towards an Emerging Paradigm." In *The Sociology of Culture: Emerging Theoretical Perspectives*, edited by Diana Crane, 221–46. Oxford: Blackwell.

Price, Sally. 2001. *Primitive Art in Civilized Places.* Chicago: University of Chicago Press.

Prinz, Jesse J. 2010. "When Is Film Art?" *Revue internationale de philosophie* 4: 473–85.

Public Enemy. 1990. "Fight the Power." *Fear of a Black Planet.* New York: Def Jam & Columbia Records.

Pye, Michael, and Lynda Miles. 1979. *The Movie Brats: How the Film Generation Took Over Hollywood.* New York: Holt, Rinehart & Winston.

Qin, Amy. 2014. "Chinese Art Sets Record." *New York Times,* November 26.

Quittard, Henri. 1913. "Théâtre des Champs-Elysées: *Le Sacre du Printemps,*" *Le Figaro,* May 31.

R. F. 2014. " 'Behind the Beautiful Forevers' Slumming It." *Economist,* November 20.

Radio Reports, Inc. 1958. "Dr. Robert Goldwater Interviewed," September 9. AR.1999.9.28, Box 3, Folder 3. Official Business–Public Relations. Robert Goldwater Library, Department of the Arts of Africa, Oceania, and the Americas. Metropolitan Museum of Art, New York.

Radway, Janice. 1984. *Reading the Romance: Women, Patriarchy, and Popular Literature.* Chapel Hill: University of North Carolina Press.

Randall, Emily. 2013. "Tattooing Makes Transition from Cult to Fine Art." *New York Times,* May 8. http://www.nytimes.com/2013/05/10/arts/artsspecial/Tracing-the-transformation-of-tattoos-.html. Accessed June 14, 2017.

Ranger, Terence O., and Eric J. Hobsbawm, eds. 1983. *The Invention of Tradition.* Cambridge: Cambridge University Press.

Rao, Hayagreeva, Philippe Monin, and Rodolphe Durand. 2005. "Border Crossing: Bricolage and the Erosion of Categorical Boundaries in French Gastronomy." *American Sociological Review* 70: 968–91.

Rawlings, Craig M. 2001. " 'Making Names': The Cutting-Edge Renewal of African Art in New York City, 1985–1996." *Poetics* 29: 25–54.

Reed, Trevor G. 2009. "Returning Hope Voices: Redefining Repatriation through Community Partnership." Native Americans and Indigenous Studies Association Conference, May 21.

Regev, Motti. 1994. "Producing Artistic Value: The Case of Rock Music." *Sociological Quarterly* 35 (1): 85–102.

Regev, Motti. 2007. "Ethno-National Pop-Rock Music: Aesthetic Cosmopolitanism Made from Within." *Cultural Sociology* 1 (3): 317–41.

Regev, Motti. 2013. *Pop-Rock Music: Aesthetic Cosmopolitanism in Late Modernity.* New York: Polity.

Reich, Cary. 1996. *The Life of Nelson A. Rockefeller: Worlds to Conquer, 1908–1958.* New York: Doubleday.

Renner, Serena. 2012. "Vintage Voyager." *Afar,* April 10.

Rentschler, Ruth, and Brad Potter. 1996. "Accountability Versus Artistic Development: The Case of Non-Profit Museums and Performing Arts Organizations." *Auditing & Accountability Journal* 9 (5): 100.

RePass, Richard. 1953. "Opera Workshops in the United States." *Tempo* 27: 10–18.

Rice, Xan. 2009. "Kenya's Slums Attract Poverty Tourism." *Guardian,* September 25. http://www.guardian.co.uk/world/2009/sep/25/slum-tourism-kenya-kibera-poverty. Accessed January 24, 2011.

Rich, Maria. 1986. "Cause for Concern, US Opera Survey 1985–6." *Opera News,* November, 32–42.

Richter, Linda. N.d. "Inside the Thriving Industry of AIDS Orphan Tourism." Human Sciences Research Council. http://www.hsrc.ac.za/en/review/August-2010/aids-orphan-tourism. Accessed June 20, 2016.

Riesman, David. 1950. "Listening to Popular Music." *American Quarterly* 2 (4): 359–71.

Ripley, S. Dillion. 1968. "The Folk Festival Program." In *The Festival of American Folklife Program Book,* 3–4. Washington, DC: Smithsonian Institution.

Rivera, Lauren A. 2010. "Status Distinctions in Interaction: Social Selection and Exclusion at an Elite Nightclub." *Qualitative Sociology* 33 (3): 229–55.

Rivera, Lauren A. 2012. "Hiring as Cultural Matching: The Case of Elite Professional Service Firms." *American Sociological Review* 77 (6): 999–1022.

Roberts, John Storm. 1999. *The Latin Tinge: The Impact of Latin American Music on the United States*. 2nd ed. New York: Oxford University Press.

Robinson, John P., Carol A. Keegan, Terry Hanford, and Timothy Triplett. 1985. "Public Participation in the Arts: Final Report on the 1982 Survey." Washington, DC: National Endowment for the Arts, Research Division.

Robinson, John. 1985. "Public Participation in the Arts: A Project Summary." College Park: University of Maryland Survey Research Center.

Rockefeller, Nelson A. 1967. "Transcript of Extemporaneous Illustrated Art Lecture," March 15. AR.1999.14.40, Box 5, Folder 1. Miscellaneous Documents–Individuals Individual Nelson A. Rockefeller–General Box. Robert Goldwater Library, Department of the Arts of Africa, Oceania, and the Americas. Metropolitan Museum of Art, New York.

Rogers, Heather. 2007. *Gone Tomorrow: The Hidden Life of Garbage*. New York: New Press.

Rosenberg, Neil V. 1985. *Bluegrass: A History*. Champaign: University of Illinois Press.

Rossman, Gabriel, and Richard A. Peterson. 2015. "The Instability of Omnivorous Cultural Taste Over Time." *Poetics* 52: 139–53.

Rössel, Jörg, and Julia H. Schroedter. 2015. "Cosmopolitan Cultural Consumption: Preferences and Practices in an Heterogenous, Urban Population in Switzerland." *Poetics* 50: 80–95.

Rothman, Joshua. 2014. "The Meaning of 'Culture.'" *New Yorker*, December 26. http://www .newyorker.com/books/joshua-rothman/meaning-culture. Accessed June 25, 2016.

Roy, William. 2002. "Aesthetic Identity, Race, and American Folk Music." *Qualitative Sociology* 25: 459–69.

Roy, William. 2004. "'Race Records' and 'Hillbilly Music': Institutional Origins of Racial Categories in the American Commercial Recording Industry." *Poetics* 32: 265–79.

Russell, Charles. 2001. *Self-Taught Art: The Culture and Aesthetics of American Vernacular Art*. Jackson: University Press of Mississippi.

Russell, James S. 2014. "On Elite Campuses, an Arts Race." *New York Times*, November 13.

Sahlins, Marshall. 1985. *Islands of History*. Chicago: University of Chicago Press.

Said, Edward. 1977. *Orientalism*. London: Penguin.

Saito, Hiro. 2011. "An Actor-Network Theory of Cosmopolitanism." *Sociological Theory* 29 (2): 124–49.

Sales, Nancy Jo. 1996. "Pschoolgangsters2." *New York Magazine*, December 16, 33–39.

Sales, Nancy Jo. 1998. "Caution: These Kids Are About to Blow Up." *New York Magazine*. http:// nymag.com/nymetro/nightlife/barsclubs/features/2937/. Accessed January 16, 2019.

Salganik, Matthew, Peter S. Dodds, and Duncan J. Watts. 2006. "An Experimental Study of Inequality and Unpredictability." *Science* 311: 854–56.

Salinas, Brenda. 2014. "'Columbusing': The Art of Discovering Something That Is Not New." NPR. http://www.npr.org/blogs/codeswitch/2014/07/06/328466757/columbusing-the-art -of-discovering-something-that-is-not-new. Accessed August 4, 2014.

Sallaz, Jeffrey J., and Jane Zavisca. 2007. "Bourdieu in American Sociology, 1980–2004." *Annual Review of Sociology* 33: 21–41.

Sampey, Kathleen. 2006. "Brewers Trying to Adapt to Changing Market Tastes." *Adweek*, March 6, 8.

Samuels, Gertrude. 1955. "Bokhari: Cosmopolitan Crusader at the UN." *New York Times*, October 9.

Sanders, Clinton R., and D. Angus Vail. 2008. *Customizing the Body: The Art and Culture of Tattooing*. Philadelphia: Temple University Press.

Sanneh, Kelefa. 2010. "Word: Jay-Z's 'Decoded' and the Language of Hip-Hop." *New Yorker*, December 6. https://www.newyorker.com/magazine/2010/12/06/word-kelefa-sanneh. Accessed January 16, 2019.

Sanneh, Kelefa 2014. "White Mischief: The Passions of Carl Van Vechten." *New Yorker*, February 17.

Santos, John Phillip. 1990. "Art: In 1940, All Things Mexican Were All the Rage." *Los Angeles Times*, September 30.

Sauers, Jenna. 2012a. "And Here We Have a 'Sexy Little Geisha' Outfit from Victoria's Secret." Jezebel, September 26. http://jezebel.com/5946583/and-here-we-have-a-sexy-little-geisha -outfit-from-victorias-secret. Accessed January 20, 2015.

Sauers, Jenna. 2012b. "Navajo Nation Sues Urban Outfitters Over the Navajo Hipster Panty." Jezebel, March 1. http://jezebel.com/5889702/navajo-nation-sues-urban-outfitters-over-the -navajo-hipster-panty. Accessed January 20, 2015.

Saunders, Frances Stonor. 1999. "How the CIA Plotted Against Us." *New Statesman*, July 12. http://www.newstatesman.com/node/199897. Accessed January 4, 2017.

Savran, David. 2009. *Highbrow/Lowdown: Theater, Jazz, and the Making of the New Middle Class*. Ann Arbor: University of Michigan Press.

Scharf, Aaron. 1983 [1974]. *Art and Photography*. Harmondsworth: Pelican.

Schilling, Vincent. 2015. "Oh No They Didn't: Designers Show 'Squaw' Fashion in Milan." Indian Country, March 3. http://indiancountrytodaymedianetwork.com/2015/03/03/oh-no-they -didnt-designers-show-squaw-fashion-milan-159446. Accessed January 16, 2019.

Schjeldahl, Peter. 2008. "Buying It: A Takashi Murakami Retrospective." *New Yorker*, April 14, 68–70.

Schjeldahl, Peter. 2015. "Outside In: Jean Dubuffet's Campaign for Art Brut." *New Yorker*, December 14, 84–85.

Schmidt, Gregory. 2017. "Is It a Toy? Is It Art? Everyone Agrees It's a Collectible." *New York Times*, March 29. https://www.nytimes.com/2017/03/29/business/smallbusiness/funko -kidrobot-designer-toys-collectibles.html. Accessed May 5, 2017.

Schmutz, Vaughn. 2005. "Retrospective Cultural Consecration in Popular Music: *Rolling Stone*'s Greatest Albums of All Time." *American Behavioral Scientist* 48 (11): 1510–23.

Schmutz, Vaughn, and Alison Faupel. 2010. "Gender and Cultural Consecration in Popular Music." *Social Forces* 89: 685–707.

Schneier, Matthew. 2012, "Spring 2013 Ready-to-Wear Tory Burch". *Style*, February 11. http:// www.style.com/fashion-shows/spring-2013-ready-to-wear/tory-burch. Accessed October 10, 2012.

Schocket, Eric. 1998. "Undercover Explorations of the 'Other Half,' or the Writer as Class Transvestite." *Representations* 64: 109–33.

Schonfeld, Roger C., and Mariët Westermann. 2015. "The Andrew W. Mellon Foundation Art Museum Staff Demographic Survey." Andrew W. Mellon Foundation, July 28. https://mellon .org/media/filer_public/ba/99/ba99e53a-48d5-4038-80e1-66f9ba1c020e/awmf_museum _diversity_report_aamd_7-28-15.pdf. Accessed December 4, 2016.

Schonfeld, Roger C., and Liam Sweeney. 2016. "Diversity in the New York City Department of Cultural Affairs Community." Ithaka S+R. http://www.sr.ithaka.org/publications/diversity -in-the-new-york-city-department-of-cultural-affairs-community/. Accessed June 16, 2017.

Schwartz, Dona. 1986. "Camera Clubs and Fine Art Photography: The Social Construction of an Elite Code." *Journal of Contemporary Ethnography* 15 (2): 165–95.

Scott, Andrea K. 2014. "A Place at the Table." *New Yorker*, January 27.

Scott, Sharon M. 2009. *Toys and American Culture: An Encyclopedia*. Santa Barbara, CA: ABC-CLIO.

Seabrook, John. 2001. *Nobrow: The Culture of Marketing, the Marketing of Culture*. London: Methuen.

Sesame Street. 2015. "Oscar's Trash Savings Plan." Episode 4514, Season 45 (2014–15). Aired January 12, 2015.

Sharp, Kristen. 2006. "Superflat Worlds: A Topography of Takeshi Murakami and the Cultures of Superflat Art." PhD diss, School of Applied Communication, RMIT University.

Shepherd, Julianne Escobedo. 2014. "This Woman Is the Most Stylish Athlete Right Now." *New York Magazine*, September 9. https://www.thecut.com/2014/08/this-woman-is-the-most-stylish-athlete-right-now.html. Accessed January 16, 2019.

Shively, JoEllen. 1992. "Cowboys and Indians: Perceptions of Western Films among American Indians and Anglos." *American Sociological Review* 57: 725–34.

Siefert, Marsha. 2004. "The Metropolitan Opera in the American Century: Opera Singers, Europe, and Cultural Politics." *Journal of Arts Management, Law, and Society* 33 (4): 298–315.

Silber, Bohne, and Tim Triplett. 2015. "A Decade of Arts Engagement: Findings from the Survey of Public Participation in the Arts, 2002–2012." NEA Research Report #58. Washington, DC: National Endowment for the Arts.

Silvester, Abi. 2012. "Elegant Slumming from House of Harlow 1960." ShoeWawa. http://www.shoewawa.com/2012/11/elegant_slummin.html. Accessed January 16, 2019.

Simmel, Georg. 1997. "The Philosophy of Fashion." In *Simmel on Culture*, edited by David Frisby and M. Featherstone, 187–206. London: Sage.

Simon, Bryant. 2009. *Everything but the Coffee: Learning About America from Starbucks*. Los Angeles: University of California Press.

Simon, David, J. Cole, and Patricia Lockwood. 2014. "Race, Class, and Creative Spark." *New York Times*, November 30.

Simpson, Kate. 2004. "Doing Development: The Gap Year, Volunteer-Tourists, and a Popular Practice of Development." *Journal of International Development* 16: 681–92.

Sintas, Jordi Lopez, and Ercilia Garcia Alvarez. 2002. "Omnivores Show up Again: The Segmentation of Cultural Consumers in Spanish Social Space." *European Sociological Review* 18: 353–68.

Sizemore, Charles. 2013. "American Express Is Going Slumming." InvestorPlace, January. http://investorplace.com/2013/01/american-express-is-going-slumming/#.VIdP1mTF8VE. Accessed May 23, 2013.

Sklar, Robert. 1994. *Movie-Made America*. 2nd ed. New York: Vintage Books.

Sklaroff, Lauren Rebecca. 2009. *Black Culture and the New Deal: The Quest for Civil Rights in the Roosevelt Era*. Chapel Hill: University of North Carolina Press.

Skrbiš, Zlatko, Gavin Kendall, and Ian Woodward. 2004. "Locating Cosmopolitanism: Between Humanist Ideal and Grounded Social Category." *Theory, Culture & Society* 21 (5): 115–36.

Skrbiš, Zlatko, and Ian Woodward. 2007. "The Ambivalence of Ordinary Cosmopolitanism: Investigating the Limits of Cosmopolitan Openness." *Sociological Review* 55 (4): 730–47.

Skrbiš, Zlatko, and Ian Woodward. 2013. *Cosmopolitanism: Uses of the Idea*. London: Sage.

Smith, Richard Norton. 2014. *On His Own Terms: A Life of Nelson Rockefeller*. New York: Random House.

Smith, Roberta. 1992. "How 'Outsiders' Opened a Door on Imagination." *New York Times*, December 13.

Smith, Rosanna K., George E. Newman, and Ravi Dhar. 2016. "Closer to the Creator: Temporal Contagion Explains the Preference for Earlier Serial Numbers." *Journal of Consumer Research* 42 (5): 653–68.

Snyder, Gregory J. 2006. "Graffiti Media and the Perpetuation of an Illegal Subculture." *Crime, Media, Culture* 2 (1): 93–101.

Spillman, Lyn. 2014. "Mixed Methods and the Logic of Qualitative Inference." *Qualitative Sociology* 37 (2): 189–205.

Star, Susan Leigh, and James R. Griesemer. 1989. "Institutional Ecology, Translations, and Boundary Objects: Amateurs and Professionals in Berkeley's Museum of Vertebrate Zoology, 1907–39." *Social Studies of Science* 19 (3): 387–420.

Steichen, James. 2015. "The American Ballet's Caravan." *Dance Research Journal* 47 (1): 69–94.

Steiner, Christopher. 1994. *African Art in Transit*. New York: Cambridge University Press.

Stokes, Allyson. 2015. "The Glass Runway: How Gender and Sexuality Shape the Spotlight in Fashion Design." *Gender and Society* 29: 219–43.

Storey, John. 2003a. "The Social Life of Opera." *European Journal of Cultural Studies* 6 (1): 5–35.

Storey, John. 2003b. *Inventing Popular Culture: From Folklore to Globalization*. Malden, MA: Blackwell.

Strand, M. 2011. "Where do Classifications Come From? The DSM-III, the Transformation of American Psychiatry, and the Problem of Origins in the Sociology of Knowledge." *Theory and Society* 40 (3): 273–86.

StreetPeeper. N.d. "Celine 'Chinatown Bag' Plaid." http://streetpeeper.com/fashion-news/celine-chinatown-bag-plaid. Accessed March 8, 2016.

Stuber, Jenny N. 2005. "Asset and Liability? The Importance of Context in the Occupational Experience of Upwardly Mobile White Males." *Sociological Forum* 20: 139–66.

Stuttaford, Andrew. 2015. "The Kimono Kerfuffle: In Boston, a Monet Painting Reveals the Balkanized American Mind." *National Review* 67 (15): 24.

Sullivan, Oriel, and Tally Katz-Gerro. 2006. "The Omnivore Thesis Revisited: Voracious Cultural Consumers." *European Sociological Review* 23 (2): 123–37.

Swidler, Ann. 1986. "Culture in Action: Symbols and Strategies." *American Sociological Review* 51: 273–86.

Taruskin, Richard. 2013. "Resisting the Rite." *Avant* 3: 268–306.

Tate, Greg. 2003. *Everything but the Burden: What White People Are Taking from Black Culture*. New York: Broadway Books.

Taylor, Bayard. 1876. *The Echo Club and Other Literary Diversions*. Boston: J. R. Osgood.

Taylor, David. 2009. *Soul of a People: The WPA Writer's Project Uncovers Depression America*. Hoboken, NJ: John Wiley & Sons.

Taylor, Francis Henry. 1945. *Babel's Tower: The Dilemma of the Modern Museum*. New York: Columbia University Press.

Taylor, Nick. 2008. *American-Made: The Enduring Legacy of the WPA: When FDR put the Nation to Work*. New York: Bantam Books.

Teal, Kimberly H. 2014. "Posthumously Live: Canon Formation at Jazz at Lincoln Center Through the Case of Mary Lou Williams." *American Music* 32 (4): 400–22.

Terronez, Josiah. 2015. "The Art Behind Designer Toys." High Tech High, February 24. http://dp.hightechhigh.org/~jrobin/20th_Box/Student_Work/Student_PDF_20_Box/JOSIAH_full.pdf. Accessed May 5, 2017.

Thurman, Judith. 2014. "The Global Business of Sartorial Slumming." *New Yorker*, July 29.

Tomkins, Calvin. 1970. *Merchants and Masterpieces*. New York: E. P. Dutton.

Tomlinson, Graham. 1986. "Thought for Food: A Study of Written Instructions." *Symbolic Interaction* 9: 201–16.

Trachtenberg, Alan. 1982. *The Incorporation of America: Culture and Society in the Gilded Age*. New York: Hill & Wang.

Traywick, Catherine A. 2013. "Slumming It." *Foreign Policy*, November 13.

Tregaskis, Mona. 1987. "Dance: In Quest of Hawaii's Authentic Hula." *New York Times*, July 5. http://www.nytimes.com/1987/07/05/arts/dance-in-quest-of-hawaii-s-authentic-hula.html. Accessed April 6, 2011.

Troubridge, Laura. 1966 [1884]. "Diary, July." In *Life Amongst the Troubridges*, edited by Jacqueline Hope-Nicholson, 169. Ann Arbor: University of Michigan.

Troy, William. 1933. "Films: Concerning 'Narratage.'" *Nation*, September 13, 308.

Turner, Fred. 2002. "*The Family of Man* and the Politics of Attention in Cold War America." *Public Culture* 24 (1): 55–84.

Turnstall, Jeremy. 1983. *The Media in Britain*. London: Constable.

Twomey, John E. 1956. "Some Considerations on the Rise of the Art-Film Theater." *Quarterly of Film, Radio, and Television* 10 (3): 239–47.

Umbach, Maiken, and Bernd Hüppauf, eds. 2005. *Vernacular Modernism: Heimat, Globalization, and the Built Environment*. Stanford, CA: Stanford University Press.

Urquía, Norman. 2004. "'Doin' It Right': Contested Authenticity in London's Salsa Scene." In *Music Scenes*, edited by Andrew Bennett and Richard A. Peterson, 96–114. Nashville: Vanderbilt University Press.

Urry, John. 1995. *Consuming Places*. New York: Routledge.

Val, Fernán del, Javier Noya, and C. Martín Pérez-Colman. 2014. "Autonomy, Submission or Sound Hybridization? The Construction of the Aesthetic Canon of the Spanish Pop-Rock." *Revista Española de Investigaciones Sociológicas* 145: 147–78.

Valentine, Victoria L. 2015. "ARTnews Publishes Special Report on Women in the Art World, Black Artists Respond." *Culture Type*, May 31. http://www.culturetype.com/2015/05/31/artnews-publishes-special-report-on-women-in-the-art-world/. Accessed December 4, 2016.

Valk, Julie. 2015. "The 'Kimono Wednesday' Protests: Identity Politics and How the Kimono Became More Than Japanese." *Asian Ethnology* 74 (2): 379–99.

van Eijck, Koen. 1999. "Socialization, Education, and Lifestyle: How Social Mobility Increases the Cultural Heterogeneity of Status Groups." *Poetics* 26 (5–6): 309–28.

van Eijck, Koen. 2000. "Richard Peterson and the Culture of Consumption." *Poetics* 28 (2–3): 207–24.

van Eijck, Koen. 2001. "Social Differentiation in Musical Taste Patterns." *Poetics* 79 (3): 1163–85.

van Eijck, Koen, and Bertine Bargeman. 2004. "The Changing Impact of Social Background on Lifestyle: 'Culturalization' Instead of Individualization?" *Poetics* 32 (6): 439–61.

Vanhoenacker, Mark. 2014. "Requiem: Classical Music in America is Dead." Slate, January 21. http://www.slate.com/articles/arts/culturebox/2014/01/classical_music_sales_decline_is_classical_on_death_s_door.html. Accessed June 25, 2016.

van Rees, Kees. 1983. "How a Literary Work Becomes a Masterpiece: On the Threefold Selection Practised by Literary Criticism." *Poetics* 12 (4–5): 397–417.

Van Rees, Kees, Jeroen Vermunt, and Marc Verboord. 1999. "Cultural Classifications under Discussion Latent Class Analysis of Highbrow and Lowbrow Reading." *Poetics* 26 (5–6): 349–65.

van Vechten, Carl. 1916. *Music and Bad Manners*. New York: Alfred A. Knopf.

Varjacques, Myriam. 2018. "Setting the Stage: Incorporating History into Ballet Education." MA thesis, Teachers College, Columbia University.

Veblen, Thorstein. 1994. *A Theory of the Leisure Class*. New York: Dover.

Velthuis, Olav. 2013. *Talking Prices: Symbolic Meanings of Prices on the Market for Contemporary Art*. Princeton, NJ: Princeton University Press.

Vertinsky, Patricia. 2010. "From Physical Educators to Mothers of the Dance: Margaret H'Doubler and Martha Hill." *International Journal of the History of Sport* 27 (7): 1113–32.

The Vinyl Frontier. 2010. DVD. Directed by Daniel Zana. Straylight Collective.

Vlegels, Jef, and John Lievens. 2017. "Music Classification, Genres, and Taste Patterns: A Ground-up Network Analysis on the Clustering of Artist Preferences." *Poetics* 60: 76–89.

Vogel, Carol. 2014. "A Warhol Leads a Night of Soaring Prices at Christie's." *New York Times*, November 13.

Vogel, Susan. 1975. "Plans for the African installation- MCR Wing," December 11. AR.1999.28.10 Box 4, Folder 2. MPA-MMA Transition–MCR Wing, Planning Stage Correspondence, 1971–1976. Robert Goldwater Library, Department of the Arts of Africa, Oceania, and the Americas. Metropolitan Museum of Art, New York.

Votolato, Gregory 1998. *American Design in the Twentieth Century: Personality and Performance.* Manchester: Manchester University Press.

Waldron, Jeremy. 1992. "Minority Cultures and the Cosmopolitan Alternative." *University of Michigan Journal of Law Reform* 25: 754.

Waln, Frank. 2014. "My Family's Thanksgiving on the Reservation Is a Rebuke to America's Colonialism." *Guardian*, November 27.

Walser, Robert. 1993. *Running with the Devil.* Hanover: University Press of New England.

Ward, David. 1989. *Poverty, Ethnicity, and the American City, 1840–1925.* New York: Cambridge University Press.

Washington, Mary Helen. 1990. " 'The Darkened Eye Restored': Notes Toward a Literary History of Black Women." In *Reading Black, Reading Feminist. A Critical Anthology*, edited by Henry Louis Gates Jr., 30–43. New York: Meridian.

Watson, Georgina, Ian Bentley, Sue Roaf, and Pete Smith. 2004. *Learning from Poundbury, Research for the West Dorset District Council and the Duchy of Cornwall.* Oxford: School of the Built Environment, Oxford Brookes University.

Wearing, Stephen. 2001. *Volunteer Tourism: Experiences that Make a Difference.* Wallingford, NY: CABI.

Weber, William. 1977. "Mass Culture and the Reshaping of European Musical Taste, 1770–1870." *International Review of the Aesthetics and Sociology of Music* 8: 5–22.

Weir, Lucy. 2011. "Primitive Rituals, Contemporary Aftershocks: Evocations of the Orientalist 'Other' in Four Productions of *Le Sacre du Printemps*." *Avant* 4 (3): 11.

Wells, Liz, ed. 2015a. *Photography: A Critical Introduction.* New York: Routledge.

Wells, Liz. 2015b. "On and Beyond the White Walls: Photography as Art." In *Photography: A Critical Introduction*, edited by Liz Wells, 289–354. New York: Routledge.

Wherry, Frederick F. 2006. "The Social Sources of Authenticity in Global Handicraft Markets." *Journal of Consumer Culture* 6 (1): 5–32.

White, Arielle E., James C. Kaufman, and Matt Riggs. 2014. "How 'Outsider' Do We Like Our Art? Influence of Artist Background on Perceptions of Warmth, Creativity, and Likeability." *Psychology of Aesthetics, Creativity, and the Arts* 8 (2): 144–51.

White, Harrison, and Cynthia White. 1965. *Canvasses and Careers: Institutional Change in the French Painting World.* New York: Wiley.

Whitehall, Walter Muier. 1970. *Museum of Fine Arts of Boston.* 2 vols. Cambridge, MA: Belknap Press of Harvard University Press.

Wilensky, Harold L. 1964. "Mass Society and Mass Culture: Interdependence or Independence." *American Sociological Review* 29: 173–97.

Williams, Ingrid K. 2014. "An Incubator for Creativity in Savannah, GA." *New York Times*, May 7. https://www.nytimes.com/2014/05/11/travel/an-incubator-for-creativity-in-savannah-ga.html. Accessed June 21, 2017.

Williams, Robert A., Jr. 2014. "Ralph Lauren's 'Racist Ads.'" *Moyers & Co.* http://billmoyers.com /2014/12/29/ralph-lauren-post/. Accessed December 29.

Willis, Paul. 1978. *Profane Culture.* London: Routledge.

Wittstock, Melinda. 2000. "Are you a BOrgeois BOhemian?" *Observer,* May 28. http://www .guardian.co.uk/theobserver/2000/may/28/focus.news1. Accessed September 7, 2009.

Wood, James. 2010. "The Very Rich Hours." *New Yorker,* February 15, 142–46.

Woodard, Laurie A. 2015. "Black Dancers, White Ballets." *New York Times,* July 15. https://www .nytimes.com/2015/07/15/opinion/black-dancers-white-ballets.html. Accessed June 3, 2017.

Woodward, Ian, Zlatko Skrbiš, and Clive Bean. 2008. "Attitudes Towards Globalization and Cosmopolitanism: Cultural Diversity, Personal Consumption and the National Economy." *British Journal of Sociology* 59 (2): 207–26.

Wynne, D., and J. O'Connor. 1998. "Consumption and the Postmodern City." *Urban Studies* 35: 841–64.

Yang, Yang, and Kenneth C. Land. 2006. "A Mixed Models Approach to the Age-Period-Cohort Analysis of Repeated Cross-section Surveys, with an Application to Data on Trends in Verbal Test Scores." *Sociological Methodology* 36 (1): 75–97.

Yang, Yang, and Kenneth C. Land. 2008. "Age–Period–Cohort Analysis of Repeated Cross-section Surveys: Fixed or Random Effects?" *Sociological Methods & Research* 36 (3): 297–326.

Zak, Albin J., III. 2001. *The Poetics of Rock: Cutting Tracks, Making Records.* Los Angeles: University of California Press.

Zakaria, Rafia. 2014. "The White Tourist's Burden." *Al Jazeera,* April 21. http://america.aljazeera .com/opinions/2014/4/volunter-tourismwhitevoluntouristsafricaaidsorphans.html. Accessed June 20, 2016.

Zelditch, Morris. 2001. "Processes of Legitimation: Recent Developments and New Directions." *Social Psychology Quarterly* 64: 4–17.

Zelizer, Viviana A. 1997. *The Social Meaning of Money: Pin Money, Packchecks, Poor Relief, and Other Currencies.* Princeton, NJ: Princeton University Press.

Zhao, W. 2005. "Understanding Classifications: Empirical Evidence from the American and French Wine Industries." *Poetics* 33: 179–200.

Zinko, Carolyne. 2016. "Art Lovers Jan and Maria Manetti Shrem Share the Wealth." *San Francisco Chronicle,* November 21. http://www.sfchronicle.com/style/article/Art-lovers-Jan-and -Maria-Manetti-Shrem-share-the-10621871.php. Accessed December 4, 2016.

Zolberg, Vera L. 1981. "Conflicting Visions in American Art Museums." *Theory and Society* 10 (1): 103–25.

Zolberg, Vera L. 1983. "Changing Patterns of Patronage in the Arts." In *Performers and Performances,* edited by Jack B. Kamerman and Rosanne Martorella, 251–68. South Hadley, MA: Bergin & Garvey.

Zolberg, Vera L. 1984. "American Art Museums: Sanctuary or Free-for-All?" *Social Forces* 63 (2): 377–92.

Zolberg, Vera L., and Joni M. Cherbo, eds. 2001. *Outsider Art: Contesting Boundaries in Contemporary Culture.* New York: Cambridge University Press.

INDEX

A NOTE ON THE TYPE

This book has been composed in Adobe Text and Gotham.
Adobe Text, designed by Robert Slimbach for Adobe,
bridges the gap between fifteenth- and sixteenth-century
calligraphic and eighteenth-century Modern styles.
Gotham, inspired by New York street signs, was designed
by Tobias Frere-Jones for Hoefler & Co.